FEEDING DESIRE

DESIGN AND THE TOOLS OF THE TABLE, 1500–2005

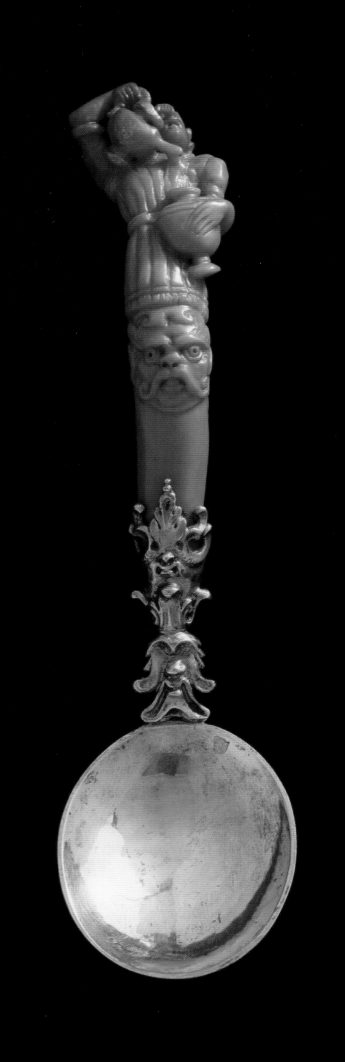

Sarah D. Coffin

Ellen Lupton

Darra Goldstein

Barbara Bloemink

Suzanne von Drachenfels

Philippa Glanville

Jennifer Goldsborough

Carolin C. Young

Feeding Desire

Design and the Tools of the Table
1500–2005

Smithsonian
Cooper-Hewitt, National Design Museum

ASSOULINE

FEEDING DESIRE
DESIGN AND THE TOOLS OF THE TABLE
1500–2005

Copyright © 2006 Smithsonian Institution

Published by Assouline Publishing
601 West 26th Street, 18th floor
New York, NY 10001, USA
www.assouline.com

in association with
Cooper-Hewitt, National Design Museum
Smithsonian Institution
2 East 91st Street
New York, NY 10128, USA
www.cooperhewitt.org

Published on the occasion of the exhibition
Feeding Desire: Design and the Tools of the Table, 1500–2005
at Cooper-Hewitt, National Design Museum,
Smithsonian Institution,
May 5–October 29, 2006.

Feeding Desire is also on view at
COPIA: The American Center for Wine, Food & the Arts,
Napa, California,
January 26–April 30, 2007.

Feeding Desire: Design and the Tools of the Table, 1500–2005
is sponsored by The Tiffany & Co. Foundation.

Additional support provided by Mr. John H. Bryan,
Crate and Barrel, and The Felicia Fund.

First Edition: May 2006

Hardcover ISBN: 2-84323-845-5
Paperback ISBN: 2-84323-847-1
Library of Congress CIP data available from the publisher.

Museum editor: Chul R. Kim, Head of Publications
Design: Catarina Tsang and Susan Brzozowski,
Tsang Seymour Design, Inc., New York

FRONT COVER: Spoon from flatware set. Claude Lalanne.
France, 1966. Silver. © Smithsonian Institution, photo by
Charles Schiller Photography.
BACK COVER: "Flaches Modell" (Flat Model) dessert fork
and knife. Josef Hoffmann. Produced by Wiener Werkstätte.
Austria, 1903. Silver. © Smithsonian Institution, photo by
Matt Flynn.

Color separation by Luc Alexis Chasleries
Printed by SNP Leefung

CONTENTS

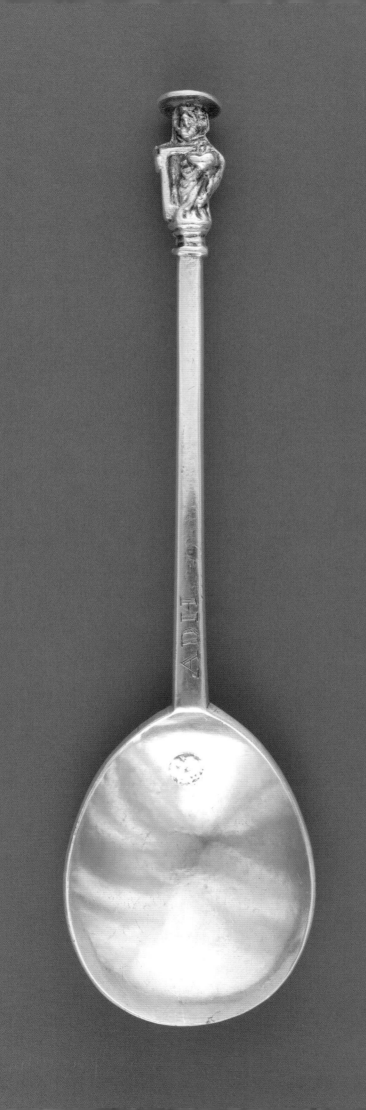

Introduction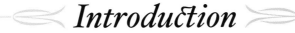

BARBARA BLOEMINK

Eating is a subject that interests everyone. For most of recorded Western history, the daily lives of human beings have revolved around meals, and much thought and energy have gone into the tools and rituals used to consume them. Along with ease of consumption, the prevention of violence was undoubtedly a key factor in the development of traditional dining: We humans began by eating with our fingers, grabbing and tearing at game, plants, and seeds where and when they were available.

With dining's development as a ritualized event came the equitable distribution of food and the rules of etiquette, furthering mealtime as a routine, often social activity. Ironically, today, the many pressures and accelerated pace of life have made eating an increasingly informal, sporadic event, for which it is often no longer necessary to sit down at a table. Instead, we consume our nutrients on the run— while standing, in the car, walking down the street—and dispense with most utensils. We are again eating with our fingers. What is lost, as the use of flatware is increasingly abandoned?

In *Feeding Desire: Design and the Tools of the Table, 1500–2005*, Cooper-Hewitt, National Design Museum curators Sarah Coffin and Ellen Lupton, guest co-curator Darra Goldstein, and other contributors trace the development of flatware and the dining experience in the West across five centuries, from the Renaissance to today. The very look, nature, and character of the "tools" of eating have evolved: from sixteenth-century containers holding an individual's folded spoon and knife to opulent nineteenth-century place settings boasting scores of utensils, each designated for a specific use and food; and from design masters of the last century, such as Josef Hoffmann and Gio Ponti, to those of the present, such as Ted Muehling. Rather than a strictly chronological treatment, the curators of this book and concurrent exhibition have organized their topic according to themes. In so doing, they examine cutlery from various vantage points, including its history, methods, and materials of its production; flatware designed for unusual circumstances, including its use in prisons, in popular modes of transportation, and ergonomically (fig. 1); mass manufacturing and individual craftsmanship; and the concept of dining as a celebration, be it an eighteenth-century banquet or an elegant contemporary occasion.

The subject of cutlery allows the Smithsonian's Cooper-Hewitt, National Design Museum to commemorate and exhibit our significant

collection of flatware, which comprises over 1,550 examples dating from the sixteenth to the twenty-first centuries, with a concentration on eighteenth- and nineteenth-century European works and international modern design. As this book illustrates, the materials that make up and embellish these utensils include gold, silver and silver-plate, coral, mother-of-pearl, carved ivory, glass beads, enamel, and porcelain, in addition to the more customary brass, steel, wood, stainless steel, and plastics.

The earliest examples of flatware to enter the collection were a group of late eighteenth- and early nineteenth-century Scandinavian, Dutch, and Russian spoons, given to the Cooper Union Museum for the Arts of Decoration' around 1898 by the artist and philanthropist Samuel P. Avery (fig. 2). Avery served as the American Commissioner to the 1867 Paris *Exposition Universelle*, and two of the spoons he donated were exhibited in the exposition's Swedish pavilion.[2] As a major donor to the burgeoning collections of the Museum, Avery also donated many textiles, prints, decorative-arts works, and wallcoverings. He followed these gifts with another group of spoons and examples of traveling, hinged, and folded nineteenth-century cutlery in 1903.

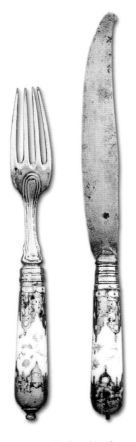

FIG 3. Fork and knife.
Augsburg and Meissen
(near Dresden), 1737–39.
Porcelain, silver-gilt, steel.

The earliest flatware owned by the Museum's founders, Amelia, Eleanor, and Sarah Hewitt, to enter the collection did so after the death of Sarah in 1930. It included German, Dutch, English, and French flatware (fig. 3), ladles, scoops, and sugar tongs (or "nips") from the eighteenth and nineteenth centuries (fig. 4). The largest grouping of cutlery in the permanent collection, which serves as the core of the Museum's pre-twentieth-century holdings, is the Metzenberg Collection of Historic Cutlery, which includes approximately 250 forks, knives, and spoons dating from the sixteenth through the nineteenth centuries. Incorporated into this gift were many of the most ornate, early utensils, made of porcelain, glass beads, and precious metals as well as finely crafted sixteenth- and seventeenth-century folding cutlery and personal traveling sets—which were necessary at a time before the meal's host was expected to provide flatware as part of the dining experience. The collection originated in the late 1940s, when Illinois businessman Robert L. Metzenberg and his wife Eleanor began collecting flatware during a trip to England. This extraordinary gift has inspired Cooper-Hewitt to augment the collection with examples from historic periods as well as of more recent and contemporary flatware. Some great works acquired since the Metzenberg gift are two French naturalistic sets, one from about 1890 by C. V. Gibert (fig. 5) and the other by Claude Lalanne of 1966 (fig 6). Most recently, the Museum added Steuben glass-handled examples designed by Frederick Carder under the direction of Walter Dorwin Teague and an English apostle spoon of Saint Thomas, made in Exeter, circa 1666, a significant form not previously represented (frontispiece).

Throughout its history, flatware has represented far more than merely a means to bring food to the mouth. As the exhibition and essays in this book demonstrate, its differing styles, forms, and uses signify cultural associations, class and gender differences, how different eras and countries regard the rituals of eating, and the changing role food plays in our lives. Beyond design and function, ultimately, the tools of the table feed our desire.

FIG 4. Sugar tongs.
Probably William
Esterbrook. London,
England, 1825. Silver-gilt.

FIG 5. Cake tongs from
an 81-piece dessert service.
Made by C. V. Gibert,
retailed by F. Nicoud. Paris,
France, ca. 1890. Silver.

(NEXT SPREAD)
FIG 6. Forks, knives, and
spoons from a flatware set.
Claude Lalanne. France,
1966. Silver.

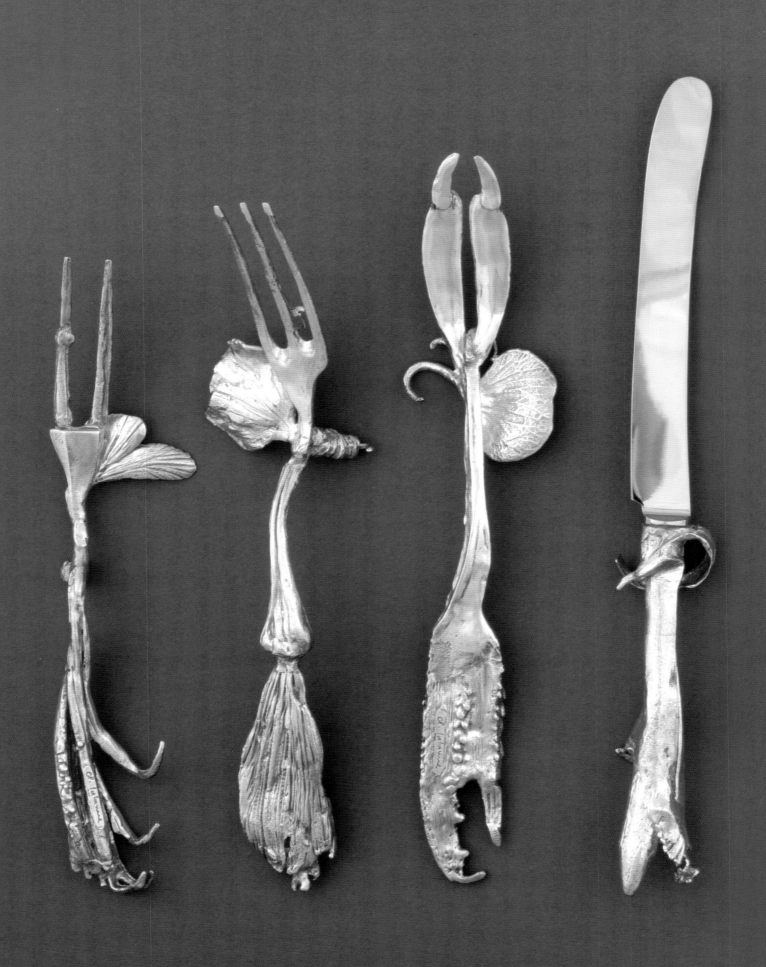

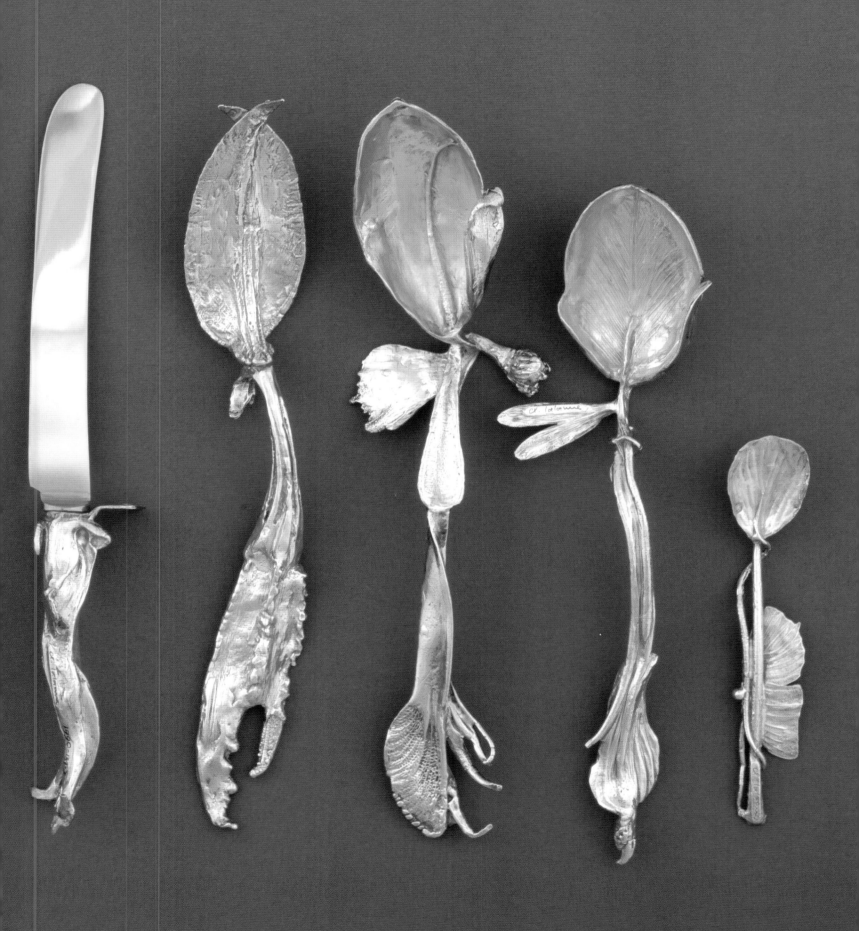

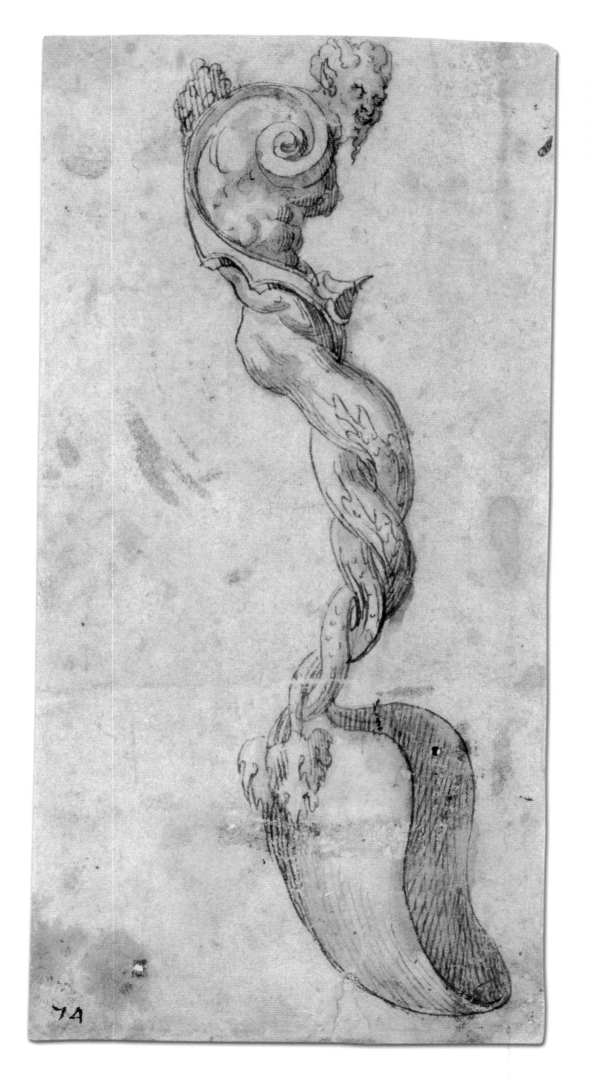

FIG 7. Drawing: Design for a Serving Spoon. Italy, late 16th century. Pen and brown ink, brush and brown wash on brown laid paper.

74

We are grateful for the efforts of the exhibition's curators, Sarah Coffin, Ellen Lupton, and guest curator Darra Goldstein, for creating this fascinating and thoughtful overview of the design and culture of dining in the West. Assistant Curators S. Jordan Kim and Cynthia Trope put in countless hours working on the exhibition and provided invaluable assistance at every stage of this book's production.

Feeding Desire would not have been possible without the generous support of The Tiffany & Co. Foundation. The entire team, led by Fernanda Kellogg, was enthusiastic about the exhibition from the very start. Special thanks to Jacqueline Blandi and Anisa Kamadoli Costa at the Foundation for making the partnership so efficient and enjoyable. Mr. John H. Bryan, Crate and Barrel, and The Felicia Fund also supported the exhibition. Paul Warwick Thompson, the Museum's Director, and Cooper-Hewitt's distinguished Board of Trustees provided continuing support for this project and the Museum's permanent collection.

Our sincere appreciation to our colleagues at the following institutions: at Assouline Publishing: Martine and Prosper Assouline, Publishers, Ausbert de Arce, U.S. Director, Esther Kremer, Editor, and Martin Lavoie, Production Manager; The Tiffany & Co. Archives; The Metropolitan Museum of Art; the Yale University Art Gallery, American Arts Department, Yale Center for British Art, and Beinecke Rare Book Library; The Museum of Fine Arts, Boston; the Smithsonian's National Museum of American History; at Christofle: Albert Bouilhet and Anne Gros; Edward Munves and James Robinson, Inc.; the Minneapolis Art Institute; Ted Muehling; Michele Oka Doner; William Hood; Joseph Holtzman; and Matt Flynn.

In addition, heartfelt thanks to all the Museum staff, including Chul R. Kim, Head of Publications, whose superb attention to detail is manifest again in this latest book; Jocelyn Groom, Head of Exhibitions, who expertly supervised the exhibition and the splendid installation work of Mick O'Shea, Mathew Weaver, and crew; Registrar Steven Langehough and his team; Jill Bloomer, Head of Image Rights and Reproduction, and Annie Jeffrey, who organized the object photography; Jennifer Northrop, Communications Director, and her team, who produced the exhibition's graphic, Web, and press materials; Caroline Baumann, Director of External Affairs, and her team, who ensured the exhibition was properly supported; and Caroline Payson, Director of Education, and her staff for producing an enlightening series of events to complement the exhibition.

Lastly, a special thanks to the exhibition design team at AvroKO and the exhibition graphics team at Tsang Seymour Design, Inc.; and especially to Catarina Tsang and Susan Brzozowski of Tsang Seymour, whose elegant vision and heroic efforts made this publication a reality.

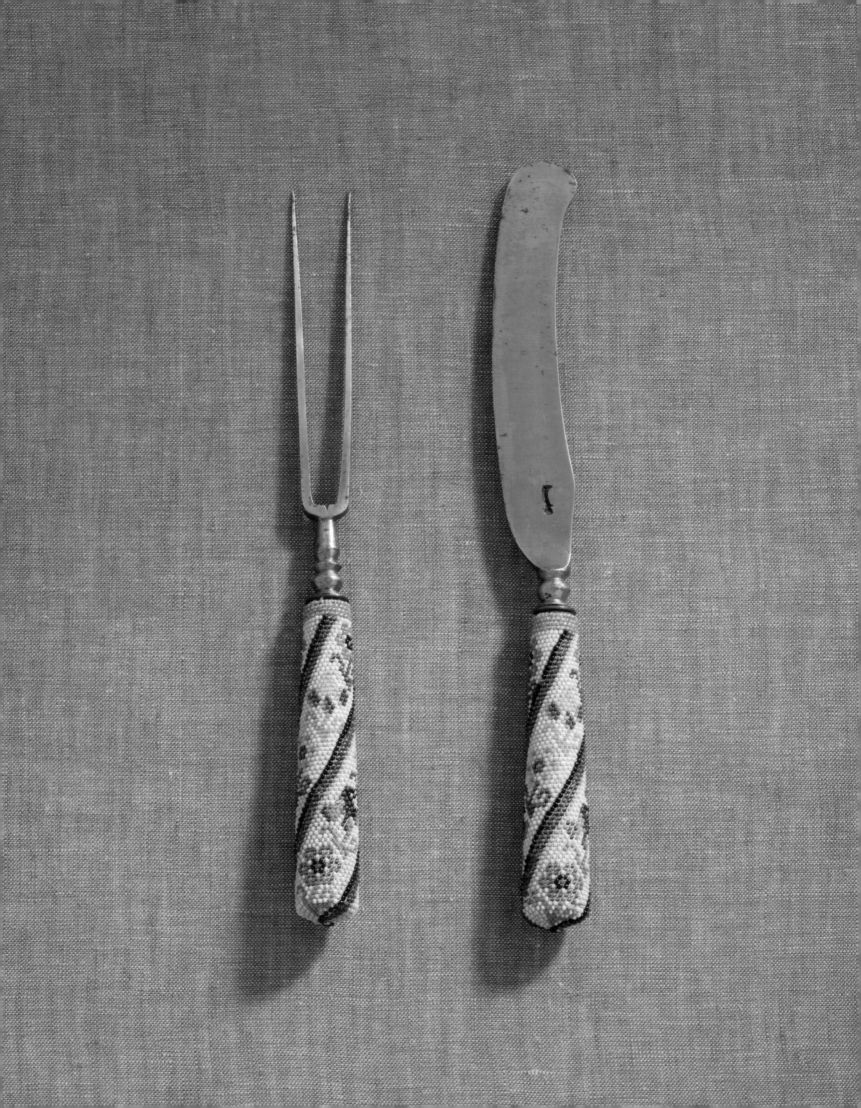

Historical Overview

———

SARAH D. COFFIN

KNIFE, FORK, AND SPOON: FEW IN
AN ERA OF "EAT-ON-THE-RUN" CAN
FATHOM WHAT IMPORTANT ROLE
THESE TOOLS OF THE TABLE HAVE
played in social history. Feasts and fêtes have,
for centuries, marked weddings, ambassado-
rial and religious occasions, and so much
more. The act of dining together can deepen
relationships, and impact the strategies of romance and business;
indeed, the overall effect created by dining together can help to deter-
mine the success of the relationship formed (figs. 1, 2).

In the distinction between eating and dining lie various embell-
ishments, which can transform one into the other. Whatever the
distinction in food served, the idea of dining conjures up a sense of
occasion and certainly, at least in the West, the use of knife, fork,
and/or spoon. Examples of some of these instruments from two thou-
sand years ago are readily identifiable to modern eyes; nevertheless,
their roles and designs have changed with, and in many ways are
emblematic of, the fluctuations in social customs, cuisines, and deco-
rative fashion.

The Knife

For centuries, the knife has served both as a weapon and as a domestic
utensil. In its latter capacity, the primary purpose has been to cut,
a function it has fulfilled since man discovered the ability to use a
flintstone to sharpen metal. It has also served to present and convey
food to plate or mouth. The first edition of the influential chef
Bartolomeo Scappi's *Opera* in 1570 included a plate titled, "Types of
Knives."[1] (figs. 3–5)

More than the fork or spoon, the knife has been associated with
social and financial importance and personal identity. The importance
attached to the task of carving and serving meat to a monarch or at
court, both of which were done with a knife, made this an important

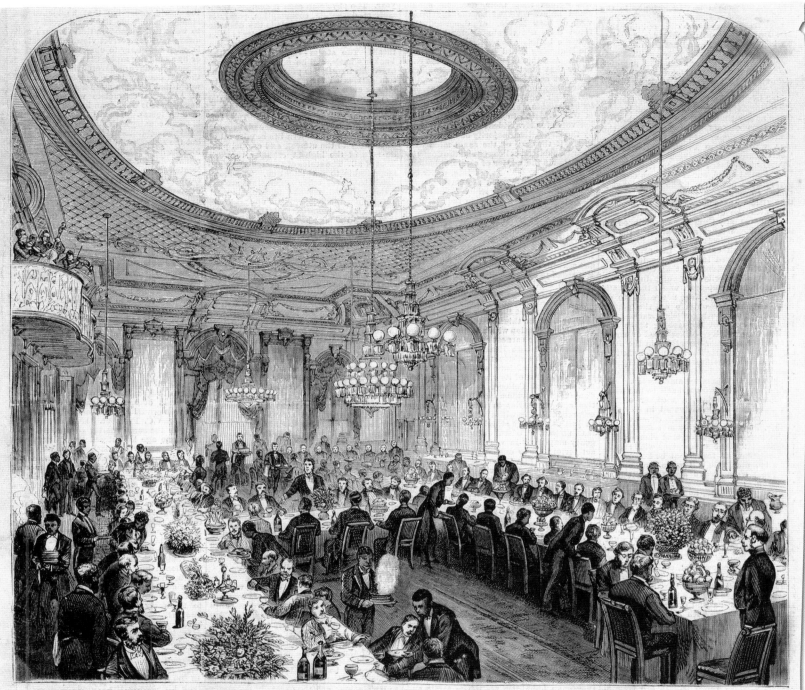

NEW YORK CITY.—DINNER IN CELEBRATION OF THE 45TH ANNIVERSARY OF THE PSI UPSILON FRATERNITY, IN THE GRAND BANQUET HALL OF THE METROPOLITAN HOTEL, MAY 3D.—SEE PAGE 183.

1878

FIG 1. Newspaper image: "New York City. Dinner in Celebration of the 45th Anniversary of the Psi Upsilon Fraternity, in the Grand Banquet Hall of the Metropolitan Hotel, May 3d." 1878.

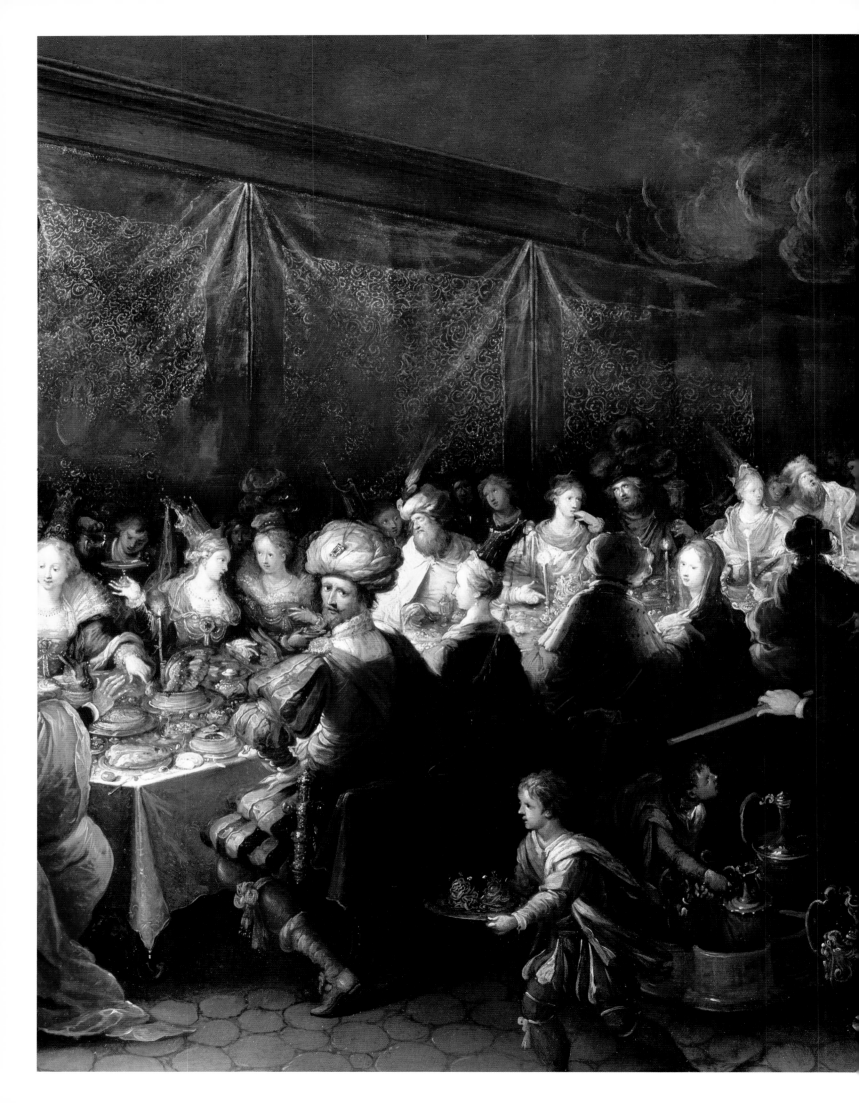

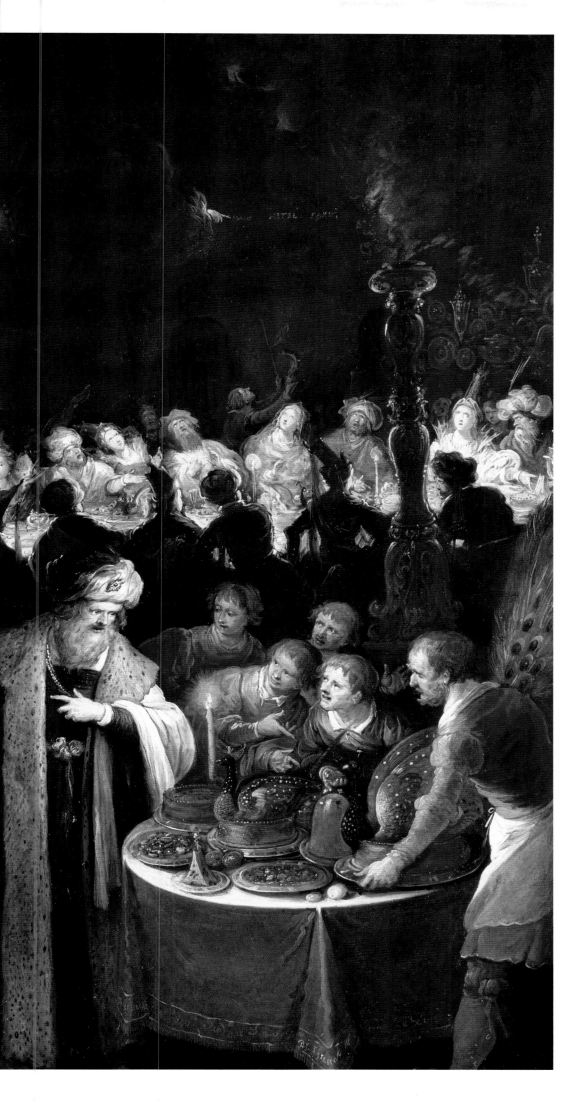

FIG 2. *The Feast of Belshazzar*. Frans Francken II. Flanders, ca. 1616. Oil on copper.

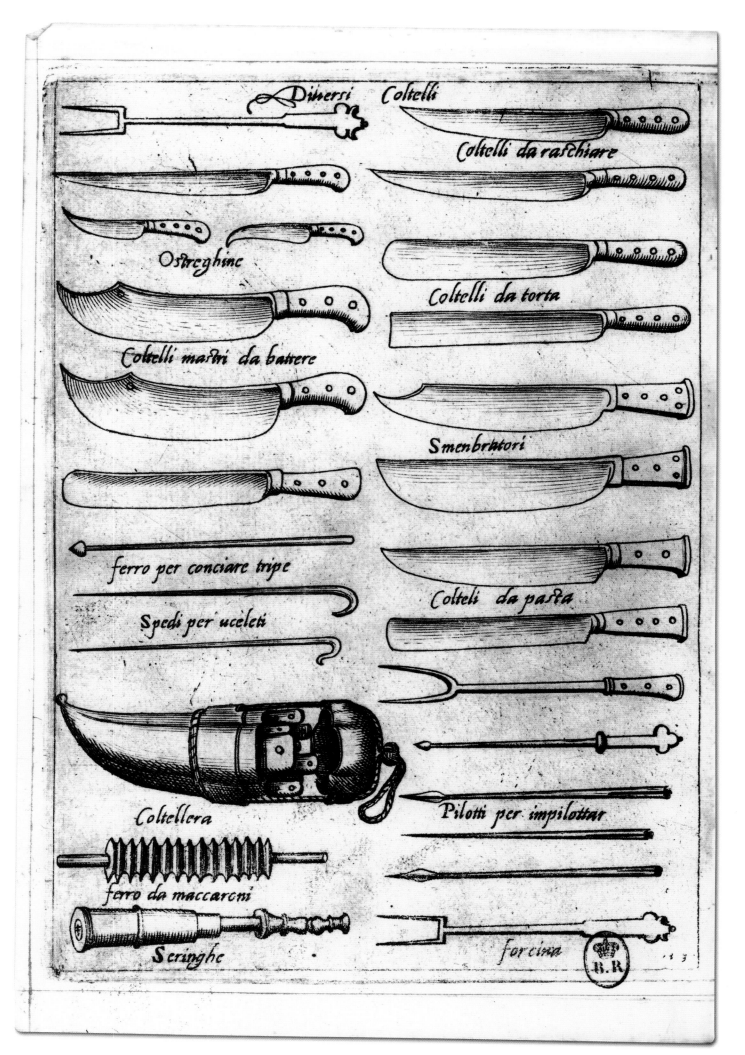

Diuersi Coltelli

Coltelli da raschiare

Ostreghine

Coltelli da torta

Coltelli maistri da battere

Smenbratori

ferro per conciare tripe

Coltelli da pasta

Spedi per uceleti

Coltellera

Pilotti per impilottar

ferro da maccaroni

Seringhe

forcina

B.R

FIG 3. "Types of Knives"
from *Opera*. M. Bartolomeo
Scappi. Italy, 1570. Engraving.

(THIS PAGE)
FIG 4. Print: *Two Knives*.
Francesco Salviati. Italy,
ca. 1640. Engraving on
cream laid paper.

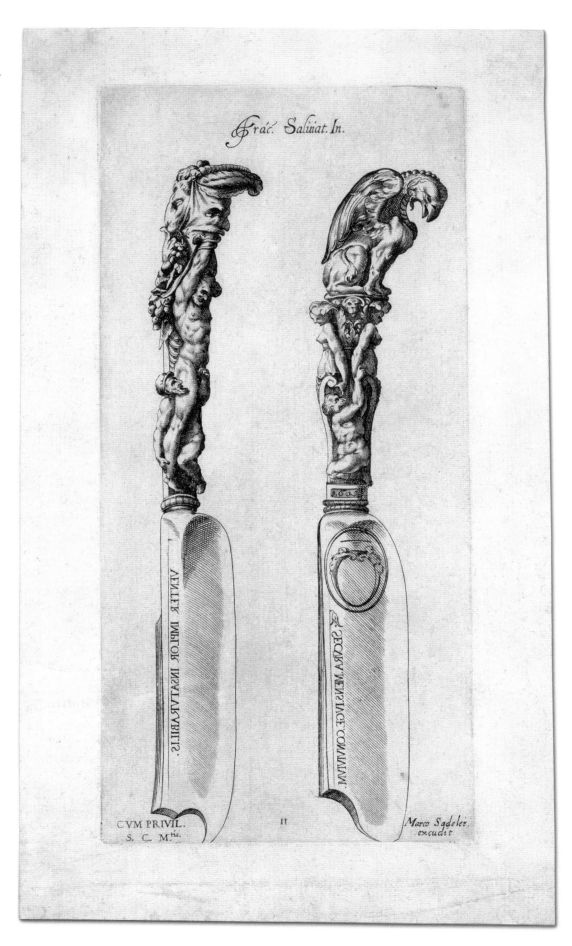

(OPPOSITE)

FIG 6. Plate from
*Schatzbehalter der wahren
Reichtumer des Heils.*
Printed by Anton
Koberger. Nuremberg,
Germany, 1491.

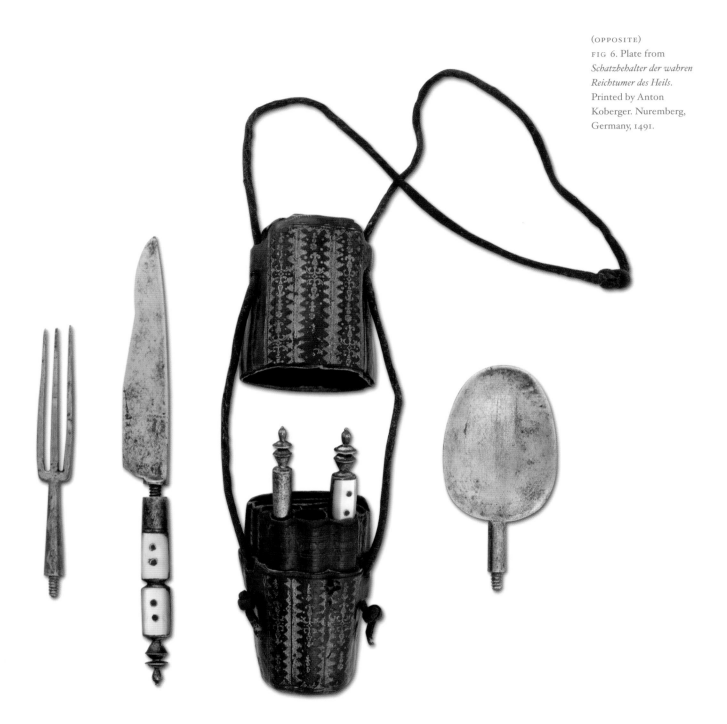

FIG 5. Traveling set in case. Northern Italy, early 17th century. Steel, mother-of-pearl, leather, gilding, cotton cord.

asset in social advancement (fig. 6). The quality of materials and design of a knife, as seen in this late sixteenth- or early seventeenth-century French serving knife (fig. 7) and part of a German carving set (fig. 8), bestow a status and power associated with their size. Balance and function were also important in the handling of a knife, and awkwardness could have been construed as poor manners, a lack of social acceptability, or both.

Inventories of the wealthy were likely to list knives, as the handles frequently featured special materials and workmanship. The specific materials and patterns usually reflected local industry, but designs were often based on drawings and engravings from a greater distance. With the lack of identifying maker's marks on many early pieces, attribution

Die sechszvndachtzigist figur

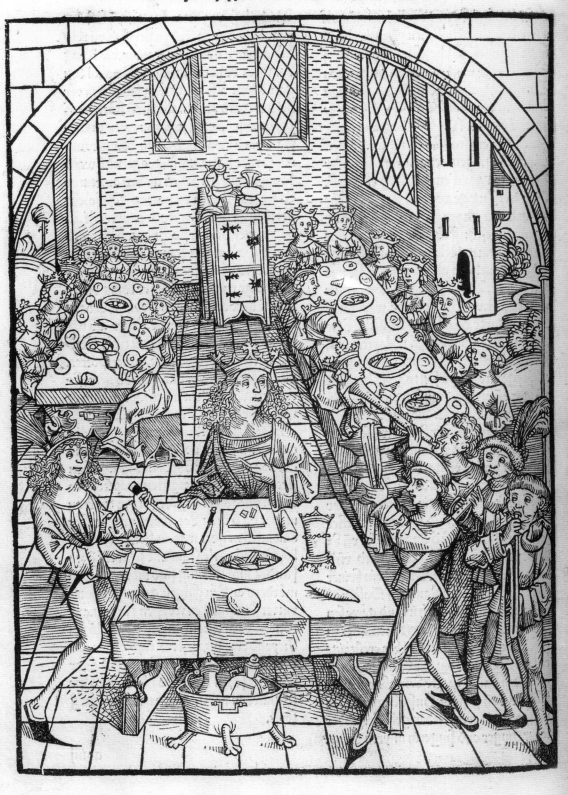

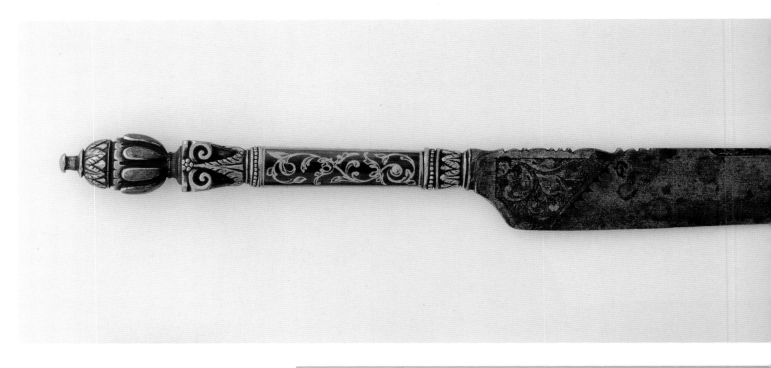

FIG 7. Knife. France or
Italy, late 16th to mid-17th
century. Steel, niello, brass,
enamel, emerald, gilding.

FIG 8. Fork and knife.
Germany, 17th century.
Steel, brass, horn, bone.

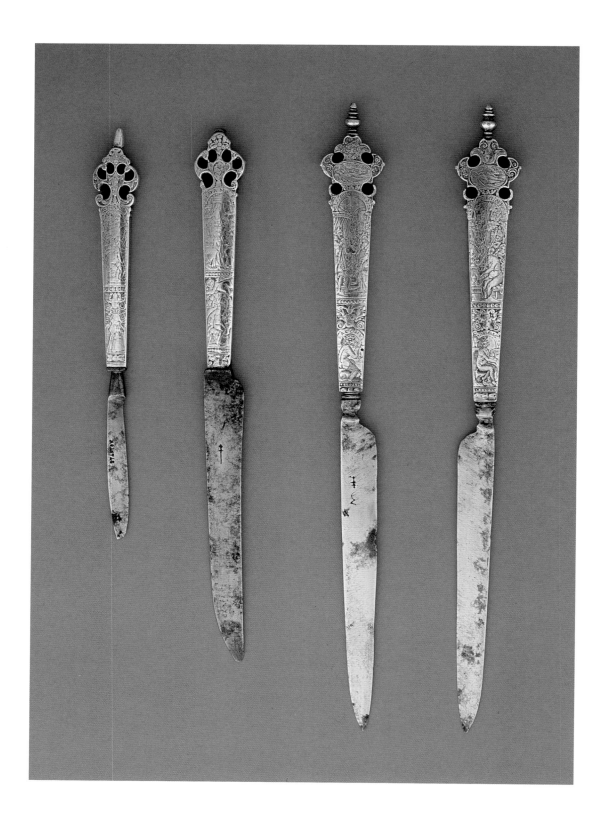

FIG 9. Four knives.
Names and dates engraved
on handles. Flanders or the
Netherlands, ca. 1621–22;
the Netherlands, ca. 1618
(pair). Silver, steel, gilding.

is based on geographic styles of workmanship, materials, and tech-
niques, as well as references to similar types in inventories, and only
sometimes to a design source. Good examples of silver-handled knives,
one pair of wedding knives and two similar knives (fig. 9) closely relate
to engravings by Jan Theodor de Bry (1561–1623) (fig. 10), and also to
German engravings of the day (fig. 11). The names of the betrothed on
the wedding knives and the preference for this shape of terminal on
this group assist in determining that they are not German, but Dutch.

FIG 10. Print: *Designs for Two Knife Handles*. Jan Theodor de Bry. Flanders, 16th century. Engraving on laid paper.

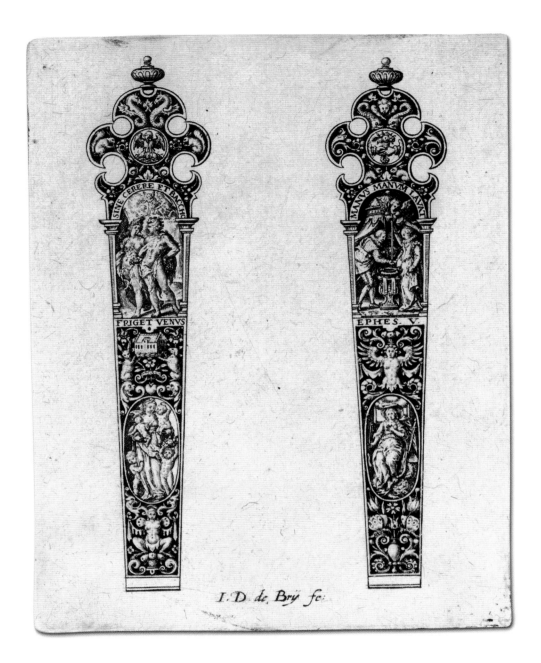

FIG 11. Print: *Design for Knife Handle*. after Heinrich Aldegrever, engraver; Monogramist S.L. Germany, mid-16th century. Niello engraving on paper.

The poor had few possessions made of materials that could serve as personal identification and there are few surviving examples except some knives found in London plague pits and Thames excavations, with plain wood handles into which the tang of a metal blade was fastened.

Generally speaking, up until the late seventeenth century and, in some cases, later, hosts did not provide cutlery to their guests; people traveled with their own sets. Since knives and their cases were made of various valuable materials, it was through the knife that the importance of design, materials, and craftsmanship entered the realm of flatware. Due to its softness, gold was not the ideal choice for a handle; instead, coral, hardstone (figs. 12, 13), enamel (fig. 14), and carved ivory (fig. 15) demonstrated one's taste and wealth.

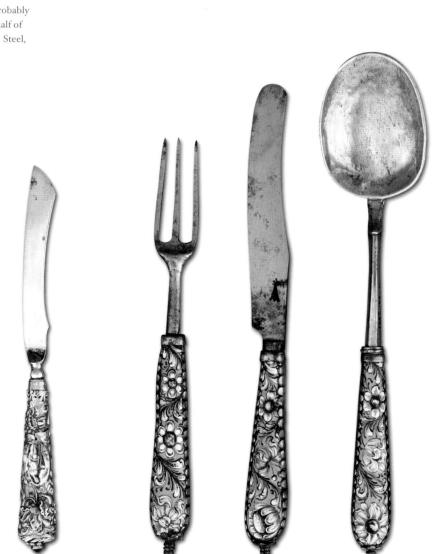

(RIGHT)

FIG 12. Knife. The Netherlands, ca. 1700–20. Agate, silver, steel.

(FAR RIGHT)

FIG 13. Knife. Probably France, second half of the 16th century. Steel, gilding, agate.

(LEFT)

FIG 14. Various forks, knives, and spoon with enamel handles. The Netherlands, ca. 1660. Steel, enamel, brass, silver, gilding, colored glass.

(OPPOSITE)

FIG 15. Two knives. Southern Germany, first half of the 18th century. Ivory, steel, silver, gilding.

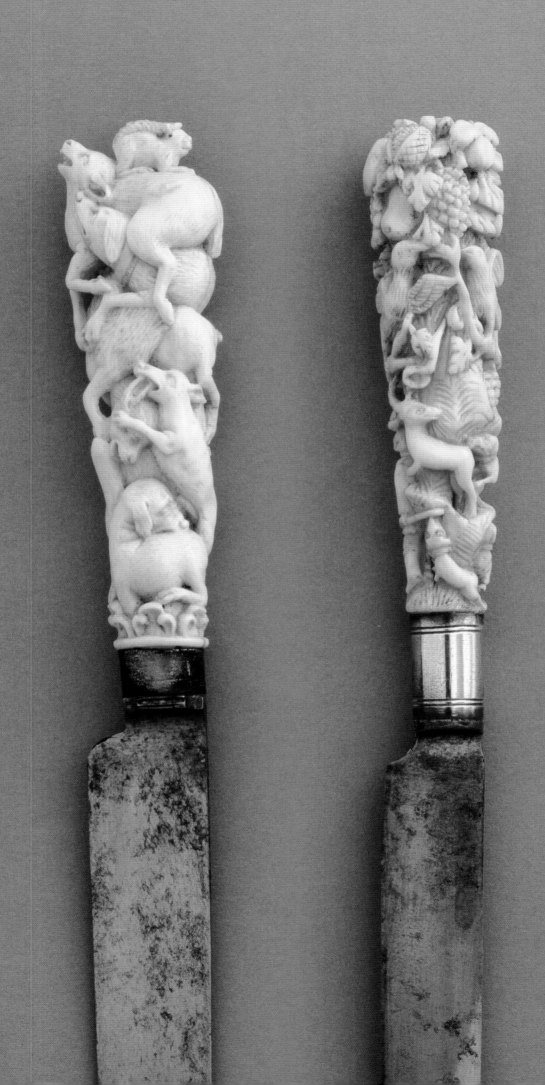

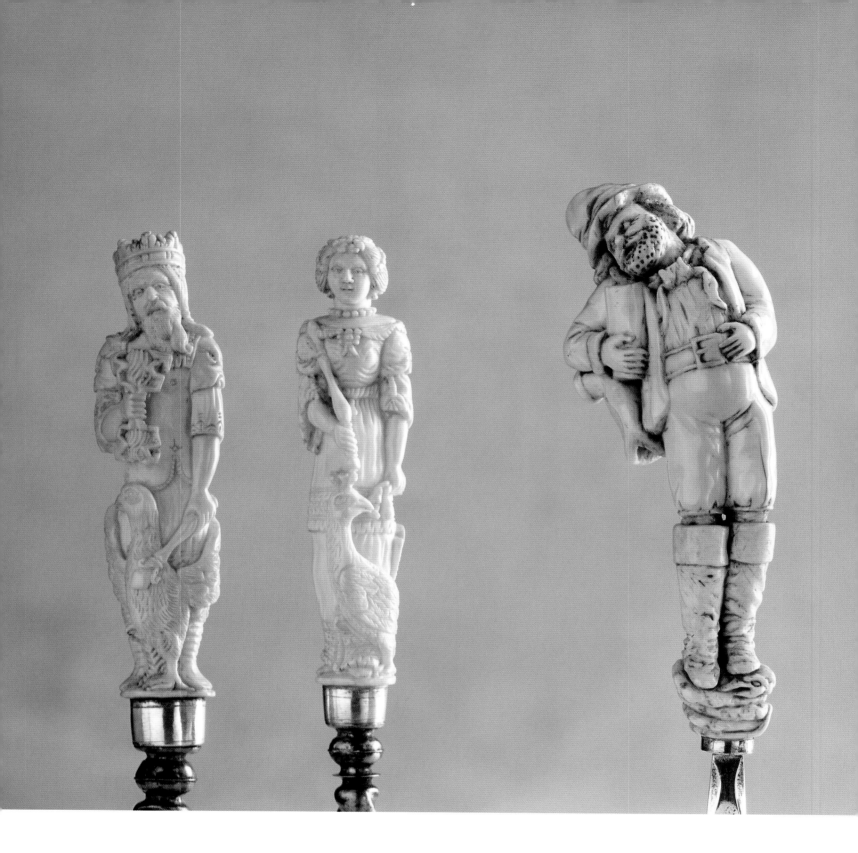

(LEFT TO RIGHT)
Fork and knife. France,
ca. 1675. Ivory, steel, silver.

"Tipsy Tavener" fork. Alpine
region, Southern Germany
or Switzerland, late 18th
to mid-19th century. Ivory,
silver-plated metal.

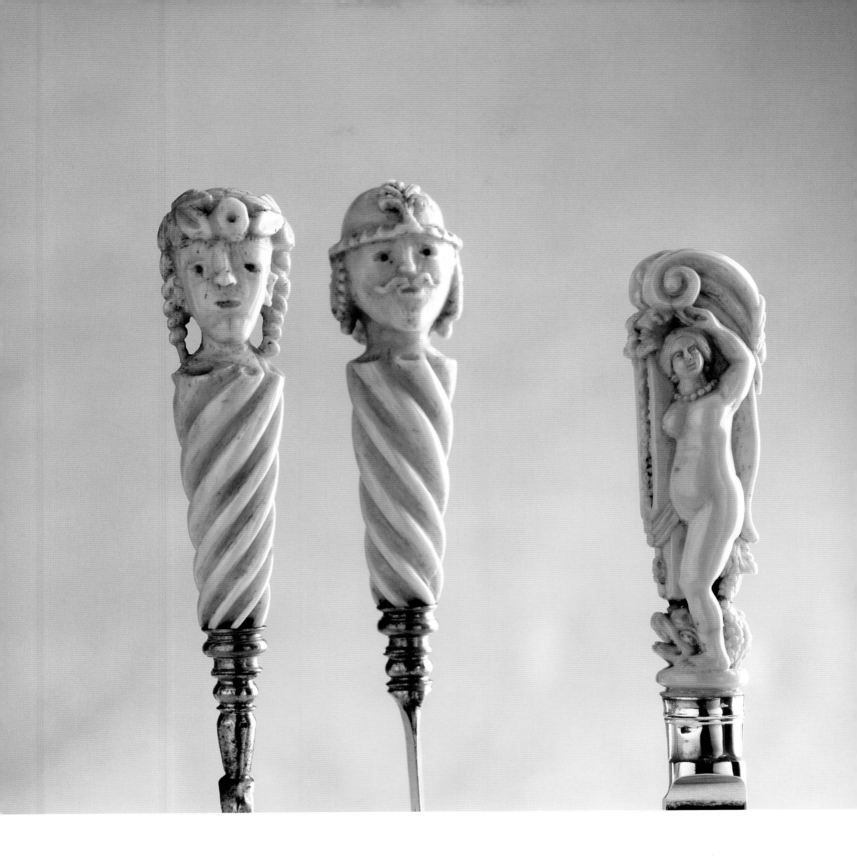

(LEFT TO RIGHT)
Fork and knife. Germany
or the Netherlands
(handle possibly colonial),
ca. 1675–1700. Ivory,
brass, steel.

Knife. Southern Germany,
late 17th century. Ivory,
stainless steel.

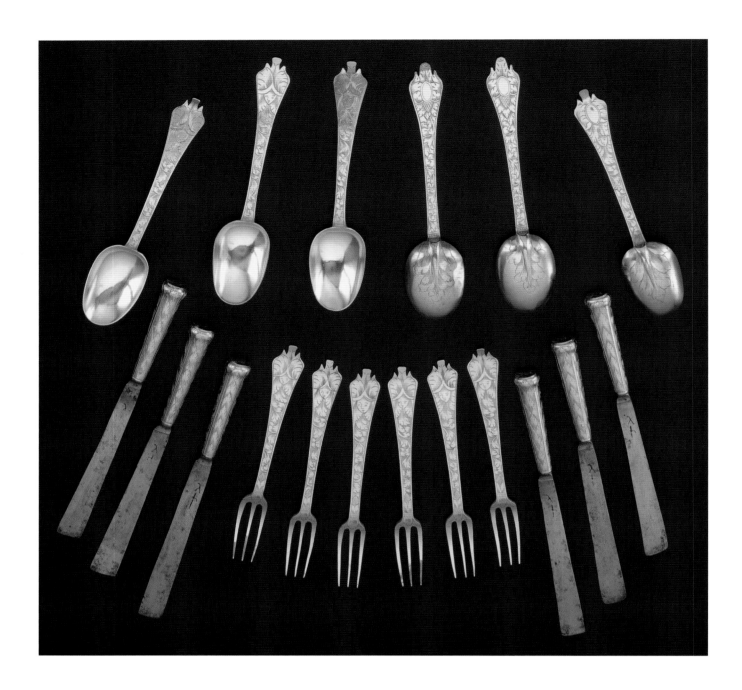

FIG 17. Set of six small knives, forks, and spoons. Thomas Tysoe (2 spoons); some pieces marked IH crowned (possibly Jean Harache); others unmarked. England, ca. 1690. Silver, gilding, steel.

The terms "cutlery" (items with a cutting edge, such as knives) and "flatware" (spoons, forks, and other eating implements) are used rather indiscriminately today to include all the tools of the table. While the word "flatware" can include table cutlery, the reverse is less appropriate. Table cutlery, unlike that used for dessert, was generally not acquired as part of a place setting in a flatware set as we know it—with knife handles, forks, and spoons in matching design and shape—until the late eighteenth century, a century or so after hosts were expected to provide flatware for their guests.[2] The expectation that cutlery would match the dinner flatware service was not well established until the second half of the nineteenth century, when new technology brought an expansion of patterns and methods of producing knife handles, especially in the United States.

The matching of engraved decoration, if not shape, of dessert knives and forks began as early as the second half of the seventeenth

century (fig. 17), when dessert was considered a separate meal, one with its own table setting, tablecloth, and, in more elaborate instances, decorations. In England, starting with the Elizabethan period, this extended to the creation of the "banqueting house," a place used to host the dessert feast. Here, the personal fork was introduced.[3] As a result, traveling sets often included a dessert fork and knife, in lieu of the previously favored two-knife set (fig. 18). As made evident by a painting of around 1640 of a wealthy Basel family, men were not alone in carrying cases of knife or knife-and-fork combinations attached to their belts; well-appointed young ladies carried them, too, seen here entering the room for a meal, adorned with the family's silver and pewter treasures (fig. 19).

FIG 18. Traveling fork and knife with shagreen case. England, 1675–1700. Steel, silver, agate, wood, sharkskin, metal.

The Fork

Based on the existence of a few small forks from antiquity, we can assume there may have been moments when the fork was a utensil for eating. In Europe, however, its primary function as a serving tool endured into the eleventh century, when it was introduced via Italy as a personal implement for eating sweetmeats. Its adoption, though, was slow; its usage did not become widespread among Italian nobles and wealthy merchant classes until the late fifteenth century, followed by France, Switzerland, Germany, the Netherlands, England, and, eventually, Scandinavia during the sixteenth and seventeenth centuries.

The fork, with its connotations of the Devil's pitchfork and seduction (in Veronese's *Marriage at Cana*, a courtesan seductively holds her fork in her mouth) (figs. 20, 21) had to fight more than just aversion to change to be accepted. It was not considered, as were the

FIG 19. Bildnis der Familie des Basler Zunftmeisters Hans Rudolf (View of the family of the Basel guild master Hans Rudolf). H. H. Kluber. Switzerland, 1559. Oil on panel.

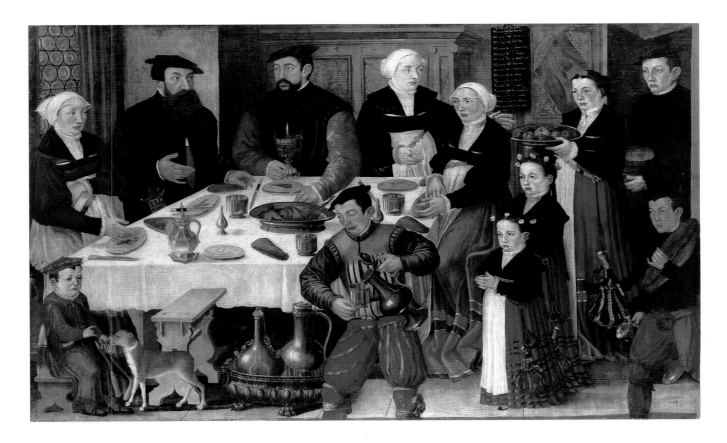

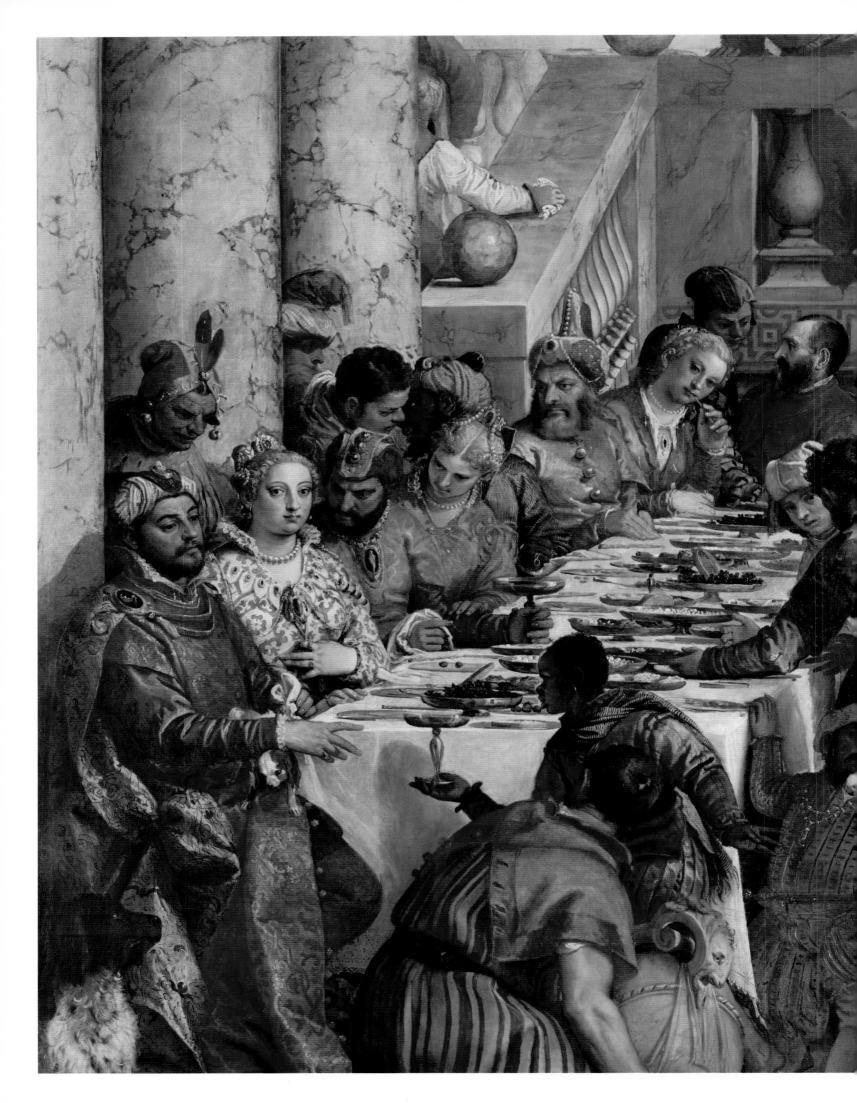

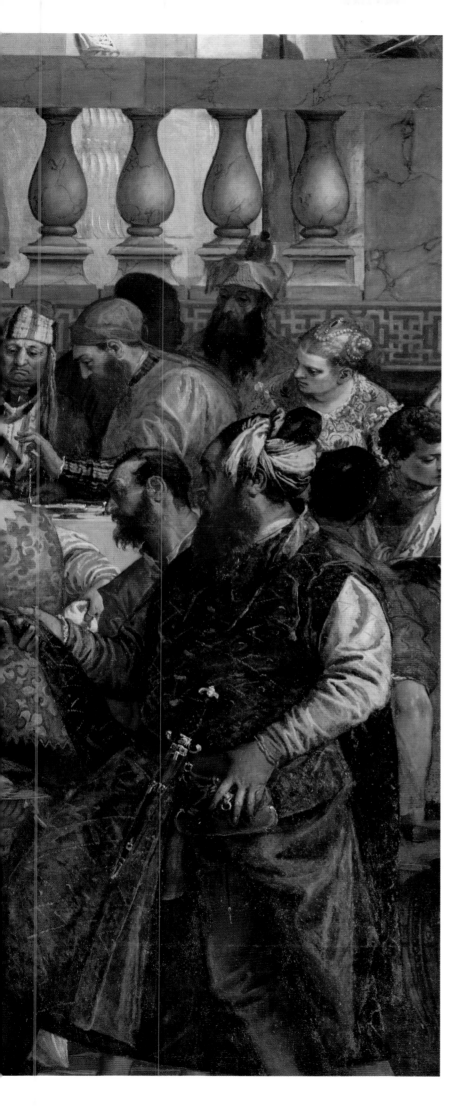

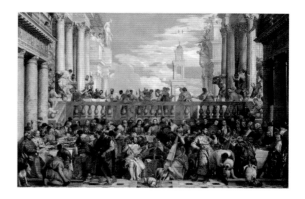

FIG 20. *Marriage at Cana*.
Paolo (Caliari) Veronese.
Venice, Italy, 1562–63.
Oil on canvas.

FIG 21. Detail of *Marriage at Cana*, left foreground to background (includes portraits of King Francis I of France, Sultan Suleyman the Magnificent, and Emperor Charles V).

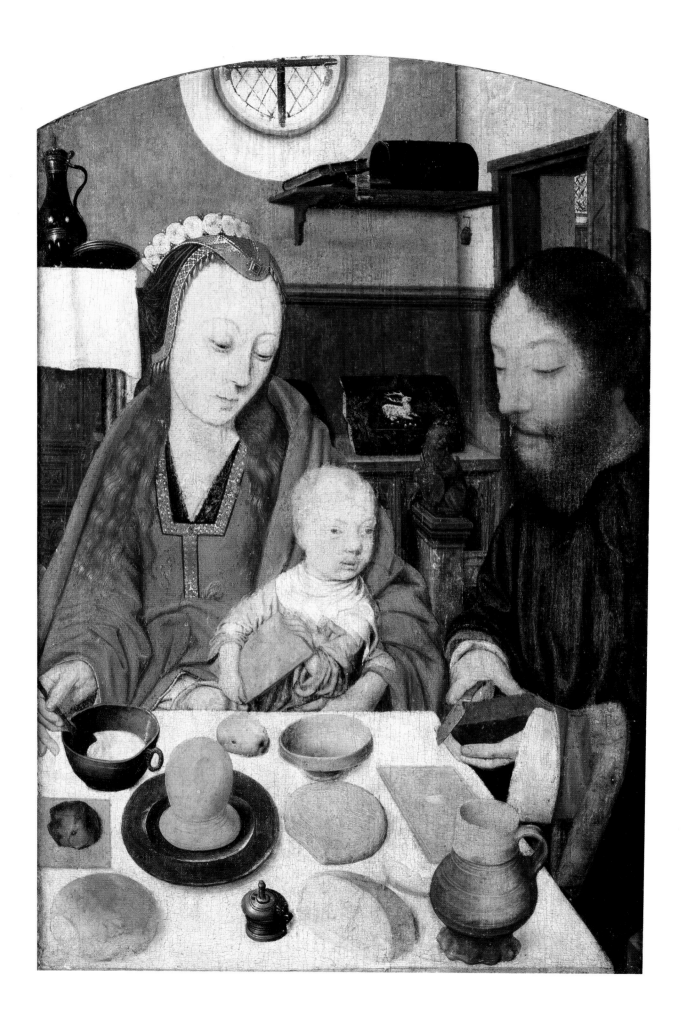

(OPPOSITE)

FIG 22. *Die Heilige Familie beim Mahl* (The Holy Family at Table). Jan Mostaert. The Netherlands, 1495–1500. Oil on oak panel.

FIG 23. Detail of monks at table from *Scenes from the Life of Saint Benedict: the Saint obtains flour*. Giovanni Antonio Bazzi, called Il Sodoma, 1477–1549. Monastery of Monte Oliveto Maggiore, Italy, 1505–08. Fresco.

spoon and knife, essential to eating. Moreover, the Christian Church had not recognized the utensil as a part of life's basics and of domestic arrangements, as it had for both the spoon and knife (fig. 22). In many countries, the spoon was associated with birth and baby's food, becoming associated, in Christianity, with christenings and representations of the Virgin and apostles, as a way to connect the act of eating to spirituality. The knife was associated with life's essence—bread—and also appeared in various versions of the Last Supper or in depictions of monastic life.[4] (fig. 23) In the Netherlands, and sometimes in England, the custom of giving wedding knives, which were often engraved with Biblical scenes, reflects the utensil's religious associations; likewise, the use of black and white on the hafts sometimes held religious significance (fig. 24).

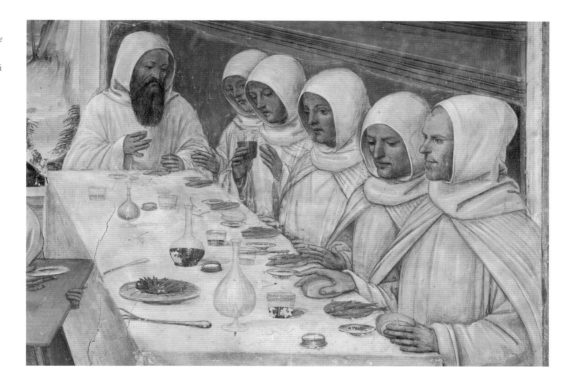

The fork had no such reference points, but its singular practicality—as a utensil that could both secure and hold food being conveyed to the mouth with its tines—eventually earned it a place on the table. Hygiene and propriety toward one's neighbors may well have played a role in giving the fork a more virtuous and, thus, socially acceptable, image. Yet, while the rise of hygienic standards—invoked by treatises exhorting people not to touch food in the serving dish after putting one's fingers in one's mouth—would seem to have elevated the fork's usage, it had less to do with the utensil's importance than modern-day fork users might imagine. Rinsing bowls and napery, for example, which appeared at more august occasions to clean hands, also helped improve hygienic conditions without the addition of the fork. Bread and spoons conveyed more substantial food to the mouth than they do today. The expense of napery, and the time and difficulty of washing it, may have done more to encourage the fork's progress than abstract principles of hygiene.

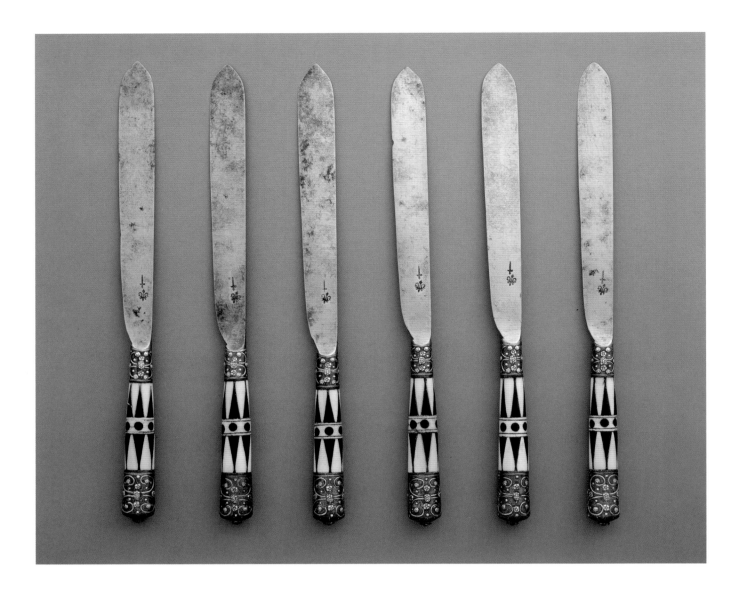

(OPPOSITE)

FIG 24. Set of knives. Steel, silver, gold, ivory, ebony. London, England, ca. 1610.

FIG 25. Drawing: *Design for a Salt Cellar and Egg Dish with Fork and Spoon.* Ottavio Strada after Francesco Salviati. Italy, ca. 1560. Pen and brown ink, brush, and brown wash over traces of charcoal or black chalk, ruled lines in leadpoint on cream laid paper.

On the occasion of his daughter's wedding in 1407, the private accounts of Francesco di Marco Datini, a wealthy merchant from Prato, included a goldsmith's bill for rings, a necklace, gilt leaves for her dress, a cover and clips for her prayer book, a thimble, and a small knife with an ivory handle, but no fork.[5] The wedding banquet, for which a special chef, "Matteo de Stinchese cuoco," was retained at considerable expense, called for large amounts of food, including fresh fish, but the bride "did not touch the meal so that when she dipped her white fingers in the silver washing bowl, the water should still be clear, and the guests praise her fine manners." This suggests that the washing bowl was de rigueur, and cleanliness was part of manners when forks were not used.[6] That Datini was a wealthy merchant, but not a member of the fork-wielding Italian aristocracy of his day, may be inferred by the presence of an ivory-handled knife, but no fork, in his daughter's dowry; and a silver finger bowl, expensive chef, and lavish clothing at her wedding.

Another Italian table creation featuring the fork was the *cadena,* a silver "square," as described by the French essayist Michel de Montaigne in 1580[7] (fig. 25), which often held a salt cellar, napkins, bread, knife, fork, and spoon, and was placed before diners of

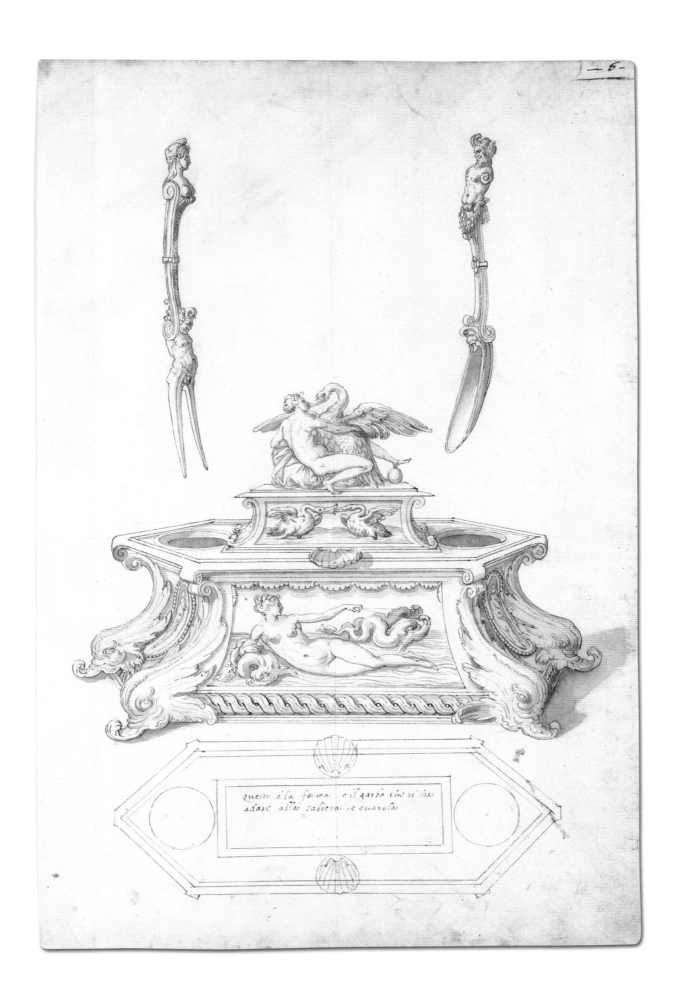

questo è la forma e il garbo che si ha
afare alla saliera e cuarola

honored status—a very early practice of providing flatware, including a fork, to a few. Cadenas were also in use for royalty at the Valois and Stuart courts in France and England.

The table fork, which was used in the main courses, first appeared as a stabilizer to hold meat while cutting, and later to convey meats to the mouth (fig. 26). The number of tines reflected the fork's uses— two tines being more appropriate for stabilizing and some serving (the early forks usually had two flat, or just slightly concave, tines). The more numerous the tines, the more foods could be held on the fork and brought to the mouth. Generally, the three-tined table fork became more common in the early eighteenth century, and three or four tines became the norm in the second half of the century. However, there are earlier examples of both, and there are three-tine forks from the Middle Ages and Renaissance.[8] (fig. 27)

FIG 26. Fork. Probably Northern Germany, second half of 17th century. Steel, brass.

If the fork got mixed reviews to start with in Northern Europe, Charles I of England—with his French wife and continental upbringing—set the fashion straight in England, though widespread use was slow to follow. His children were given small sets of silver knife, fork, and spoon to familiarize them with proper handling.[9] Horace Walpole's correspondence includes a reference to an attempt to purchase a complete set of agate-handled knives and forks, formerly the property of Charles I, if they "can be authenticated, have any royal marks, or at least, old setting of the time and will be sold for two guineas."[10]

When the Pilgrims came to Massachusetts, the only people in England using forks were the monarchy and nobility. Governor John Winthrop is recorded as owning, in 1633, a "case containing an Irish skeayne or knife, a bodekyn, and a forke for the useful application of which I leave to your discretion."[11] Not only does this show the observer to be not totally clear about the role of the *bodkin* (skewer) and fork, but this shows that Winthrop's was imported (figs. 28, 29).

Early politics may have had something to do with the paucity of forks in early North America. Associated with the then-Catholic Stuart monarchy and with a greater acceptance of mercantile prosperity, forks—especially silver or silver-handled ones—along with much of domestic silver in general were affectations the Puritans could live without. In contrast, the well-to-do New Englander Mary Browne (1674–1753), who owned a travel set, complete with five small knives, forks, and spoons in a shagreen case, may well have been the antithesis of the Puritans.[12] Her set is not unlike those owned in England of her day (fig. 30).

FIG 27. Fork. France, ca. 1550. Iron.

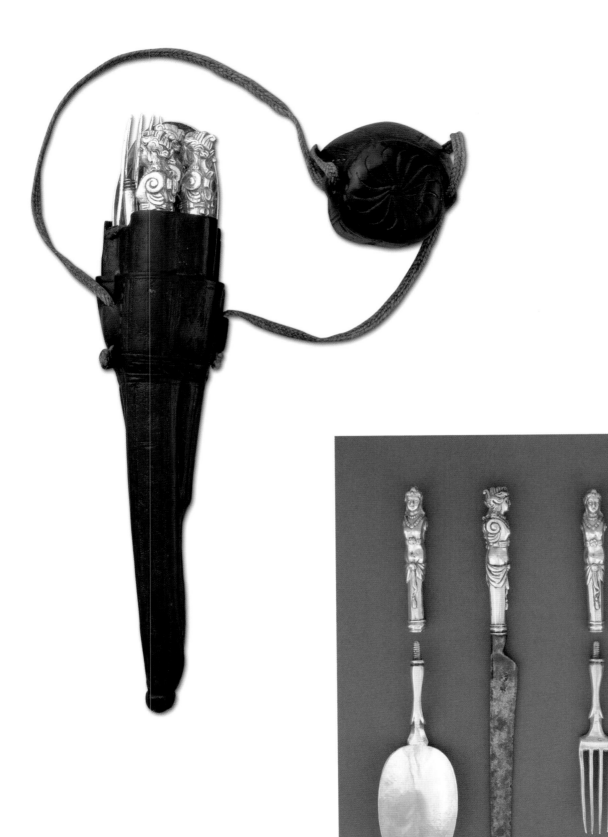

FIG 28. Traveling set with case. Probably Italy, late 17th century. Silver, steel, leather, silk.

FIG 29. Implements from fig 28. Probably Italy, late 17th century. Silver, steel.

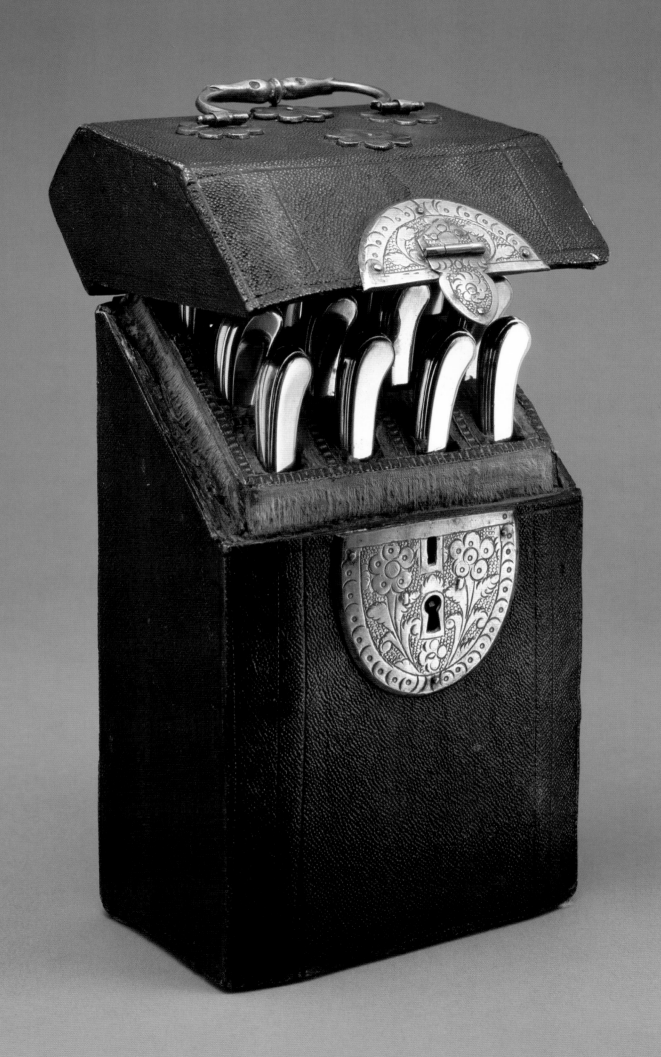

Interestingly, the earliest known American-made silver forks were made in Massachusetts for something not very puritanical: sweetmeats. However, this is not too surprising since sweet foods were invariably brought out to receive company. A few examples of sucket-forks, which usually had a spoon at the opposite end, exist from the late seventeenth century (see Goldstein, fig. 5). Small silver forks were created in Boston starting around 1700; such as one, with a matching spoon, by John Coney (fig. 31); another by Samuel Gray dates from 1705–07. These two forks are nearly identical, and, with their small size, both almost exactly replicate known English examples for sweetmeats; such as one, albeit with three tines, with an early eighteenth-century Boston provenance to a member of the Hurd family (fig. 32). Patricia Kane, in her book *Colonial Massachusetts Silversmiths and Jewelers,* lists only three other silver forks made in Massachusetts for the colonial period, made by John Noyes, approximately in 1710.

In Virginia, where attachment to all things English remained strong, there was little locally produced silver for most of the eighteenth century, and no record of locally made forks. However, there is evidence of fork usage, including by George Washington, who ordered matching English silver pistol-gripped knives and forks made around 1757.[13] (fig. 33). His *Rules of Civility and Decent Behavior,* which was written in 1746 when he was fourteen, included advice to "cleanse not your teeth with the table cloth napkin, fork, or knife; but if others do it, let it be done with a pick tooth,"[14] showing that he dined in the company of people who used forks, even in the 1740s.

Inventories in England in the eighteenth century, and in the American colonies until well into the nineteenth century, especially in rural areas, show fewer forks than spoons and knives.[15] There are only two inventories mentioning table forks in Suffolk County excluding Boston, in Massachusetts, from 1675 to 1775. The 1732 inventory of the estate of the Honorable Colonel William Tailer, Esquire of Dorchester, shows an unusually large number: "In the Closet in the Parlour, 1 Dozen white handle knives and forks £2.-.- / 1 Dozen black ditto £1.-.-"[16] Under "Wearing Apparell Cloathing," the second inventory of the Honorable Andrew Belcher of

FIG 31. Miniature fork and spoon set. John Coney. Boston, Massachusetts, about 1700. Silver.

FIG 32. Fork. Probably England, ca. 1700–10. Silver.

FIG 33. Fork and knife used by George Washington. London, England, 1755–57. Silver, steel.

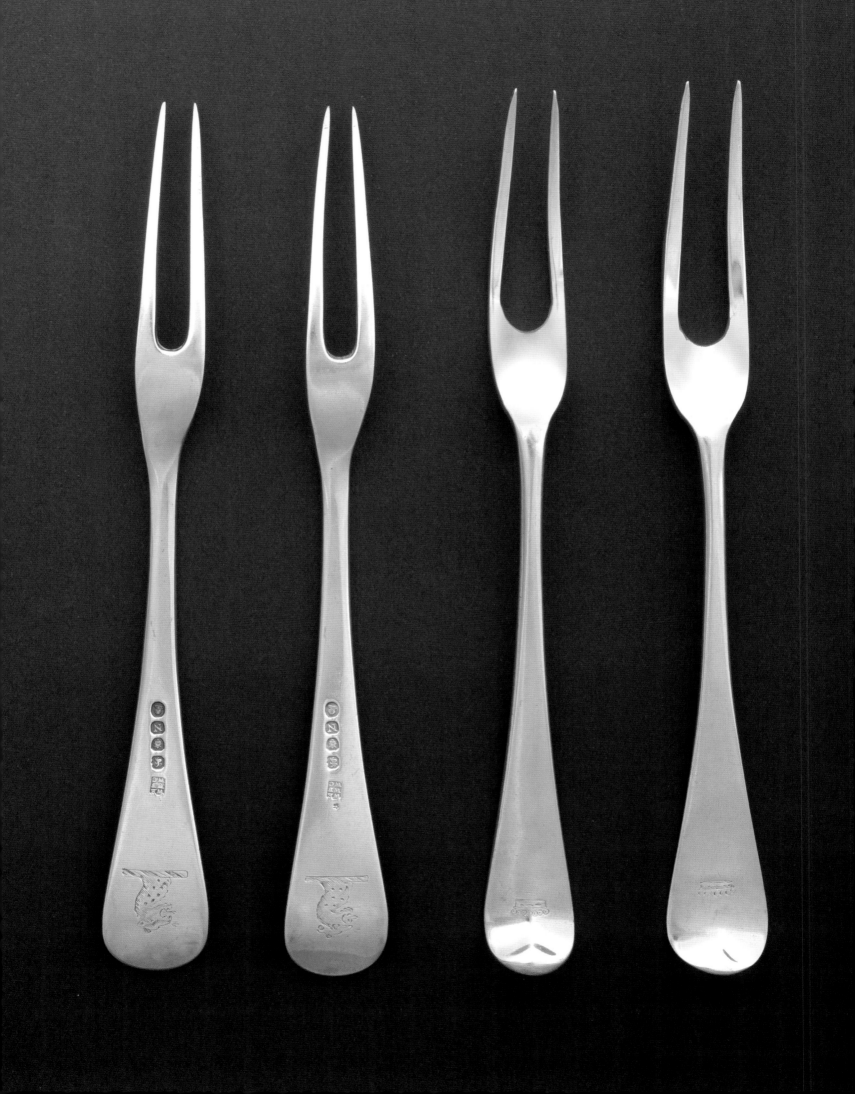

FIG 34. Four meat forks: one by William Sumner I, 1799; two by William Eley, William Fearn, and William Chawner, 1808; one by William Chawner, 1825. London, England. Silver.

FIG 35. Ingots to finished handmade Hanoverian pattern dessert fork. Made for James Robinson, Inc. England, 1999. Silver.

Milton, in 1771, lists a number of silver items, including "1 Pocket Knife & Fork & Silver Spoon in a Case" as well as a "Pocket Buckhorn Knife and Fork in a Case." Under "Furniture," Belcher's inventory lists "a Case of 2 Doz: Silver handle knifes & Forks" at twenty shillings as well as "171 ? ozs of Plate @ 6 shillings 8 pence totaling £56. 13 shillings and 4 pence- and a dining room."[17] Belcher was evidently a very wealthy man. In another indication of regional distinctions in Colonial American habits, by the mid-eighteenth century, between 32 and 57 percent of decedents of two counties of northern Delaware and Chester, Pennsylvania had knife and fork sets and about half the inventories in Massachusetts in 1774 included knives and forks.[18]

In England, even if numbers were low compared to spoons, enough sets of eighteenth-century English table forks existed, increasingly from the period of George II (r. 1727–1760) on, to prove that the aristocracy and much of the gentry used forks either all or some of the time by his reign (fig. 34). Bone- and ivory-handled table forks supplemented the increasing numbers produced by silversmiths. The shape of the silver fork's handle started to resemble that of the spoon. In English and much French silver of this period, this resulted in a flat stem, which widened as it curved up at the terminal, or tip, forming a useful rest for the thumb. This design was highly successful, as there were little changes to it through much of the eighteenth century, and it is still in production today (fig. 35).

Even in the French court, forks were not abundant. In Louis d'Anjou's inventory of 1638, a single gold fork is recorded.[19] Louis XIV,

FIG 37. Set of table forks with Royal Bourbon arms of France and table knives in case. Forks made by Jean-Charles Cahier (knife handles unmarked). Paris, France, 1819–38. Knife blades by Gerlach, Warsaw, Poland. Silver, steel, leather, velvet, brass (case).

FIG 36. Table fork. John Blake. London, 1792. Silver.

despite the acceptance of forks by his royal predecessors, did not approve of their use and ate with his hands. When he asked nobles to melt down their silver to support his wars, silver flatware, including forks, went, too. This, combined with later silver and gold meltdowns during the French Revolution, leaves far less extant physical evidence of precious metal usage in the late seventeenth and eighteenth centuries in France than is available in England, necessitating a greater reliance on inventories, designs, and descriptions.

The 1741 inventory of silver-gilt and silver table articles of Louis Philippe, Duc d'Orléans, lists three sets of spoons, forks, and knives in gold, the functions of which were unspecified but, given the material, were probably a dessert set. Among his ungilded silver were five other forks described as "large," presumably serving articles, followed by ninety-six spoons, ninety-eight forks, and ninety-six knives listed together, suggesting a set of table flatware.[20]

Forks and spoons of pewter and silver in eighteenth- and nineteenth-century France were often of a shape somewhat similar to a violin, and hence now known as the "Fiddle" pattern. At first, the decoration of the flatware, usually the crest, coat of arms, or, later, the initials of the owner, were invariably placed on the back of the fork or spoon. This flat, even slightly convex surface was easier to engrave and the decorations easier to see, encouraging their face-down placement and reinforcing the common etiquette of placing fork tines away from one's neighbor. Like the simple, classic English pattern often called Hanoverian, named for the monarchy in which it originated, this pattern, after evolving into a squared-off variation of the "fiddle" shape, was used for pewter as well, and has remained in production and been adopted in many other countries (figs. 36, 37).

The Spoon

The spoon is necessary for the consumption of liquids and semi-liquids, from broth to gruel or even, in more recent culinary history, vichyssoise. The etymology of the Greek *kochlos* and Latin *cochleare*—a type of spoon with a pointed end for opening shellfish—is related to the Greek *cochlea*, a small, spiral-shaped snail shell. The shape and function may be derived from this shell; the word *cochleare* still appeared in medieval English inventories to distinguish this type of spoon. The word is at the origin of the French and Italian words for spoon, *cuillère* and *cucchiaio*. Another type of spoon, often a ladle or one used for preserves, but generally with a knop (knob) terminal, existed in ancient Rome and was called *ligula* or, alternately, *lingula*, which relates to the word for "tongue," *lingua*. The bowls of many medieval and Renaissance spoons relate to this type, as they appear similar to tongue shapes. The multipurpose essential spoon varied slightly from almost circular to slightly ovoid, depending on locale and date, from the early Renaissance until the early eighteenth century. It was used to eat a variety of foods with solids and liquids, as the German word for spoon, *löffel*, derived from the word for slurping, suggests. The English spoon, from the Anglo-Saxon *spon*, meaning "a chip of wood," suggests a Northern tradition of wood utensils (fig. 38), and wood spoons were popular, especially for the less well-to-do, in many places, although early Saxon examples do exist in silver.

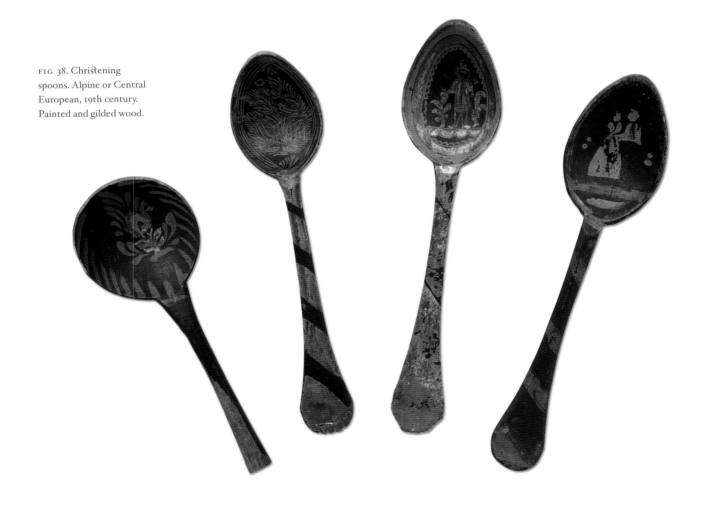

FIG 38. Christening spoons. Alpine or Central European, 19th century. Painted and gilded wood.

Spoons in antiquity were made of bronze, silver, occasionally gold for presentation, and bone, and most of these materials continued to be present well into the nineteenth century, along with ivory, wood, and other materials.

The fact that silver was a desirable material for eating utensils was first discovered through the spoon in antiquity, as it was the first implement whose primary function included entering or touching the mouth. Not only does silver impart a sense of grandeur to any occasion, but also, importantly, interacts less with foods than most other metals. Beyond church use, the use of silver spoons, especially for the upper classes, was sufficiently widespread by the beginning of the seventeenth century for Cervantes to write in *Don Quixote*, "Every man was not born with a silver spoon in his mouth."[21]

Cast terminals took on religious and political significance from the medieval ages through the seventeenth century. "Apostle" spoons—haloed figures of apostles with other saints—were made in England, Holland, Germany, Switzerland, and Italy, starting in the mid-fifteenth century. (An extraordinary surviving example of a complete set, with twelve apostles and a master (Christ) spoon, all by William Cawdell of London (r. 1592), except one, St. Andrew, by his apprentice, Martin Hewitt of 1613, is at the Metropolitan Museum.) Early antiquarians and collectors, such as Horace Walpole,[22] attempted to assemble sets of early apostle spoons, but most surviving sets are copies or adaptations of the late nineteenth century.

One manifestation of the figural spoon that dates earlier than the apostle spoon, was the "Maidenhead," depicting the Virgin Mary, a popular spoon used by clerics and monks. One of the first published records is an inventory of Durham Priory in 1466, which refers to a silver-gilt spoon "cum ymagnibius Beate Mariae."[23] The 1523 inventory of Dame Agnes Hungerford included "Halfe a dossen of sylver spoonys w/ mayden heedes on the end, gylte."[24]

Another English figural type, which appeared in the fifteenth century, was the "lion sejant" (lion sitting), a figure from the royal badge (see Glanville, fig. 12). While it is not surprising that apostle spoons were occasionally made in sets of twelve, it is interesting that the will of Robert Le Strange, dated 1505, mentions "a dosen sponys wt Lyons."[25] Henry VIII received and owned a number of spoons. Significantly, a "spone," made of enamel and even precious stones in accordance with stature, was among his favorite New Year's gifts to receive from noblemen.

Many of the figural and other cast-terminal spoons were made simultaneously in silver, pewter, bronze, and latten, a yellow alloy resembling brass. The less expensive metals were frequently associated with religious usage, the designs being essentially the same as those in silver (fig. 39). It was not until the spoon was integrated into the design of secular traveling ensembles, followed shortly by place settings, in the late seventeenth and early eighteenth centuries that the stylistic discrepancies between the designs for silver and other less valuable materials emerged, as the secular spoon design moved away from the form in religious usage toward food-oriented shapes.

Stylistically, it was the spoon handle that developed the most. During the sixteenth and seventeenth centuries, this ranged from a round or quadrangular section to a flattened rectangular section,

FIG 39. Spoon. Germany or Holland, early 18th century. Pewter.

and, by the end of the seventeenth century, had broadened out to a
flat handle useful for resting the thumb. This flatter terminal could be
trefoil-shaped, and decorated with chasing or engraved with initials or
armorials (see fig. 17).

Since antiquity, silver and gold spoons were objects of presenta-
tion, a custom that evolved into silver baby spoons for births and
christenings. In England, and more commonly in the Netherlands,
and by extension, in Dutch New York, spoons were not only associated
with birth but also with death, and often given as a memento mori at
funerals, frequently with a cast hooded owl at the terminal (fig. 40).
While the tradition of memento mori spoons did not survive the eigh-
teenth century, the presentation of spoons at births and christenings
did. Later, in more affluent households, this evolved into christening
sets, complete with porringers and other baby utensils (fig. 41).

An eighteenth-century American family of some means, that
of Samuel Lane of Stratham, New Hampshire, presented each daugh-
ter with one piece of silver for her wedding: a spoon. The fact that it
was a teaspoon might have been intended to suggest a certain refine-
ment. Yet, in this same family, only one daughter, who married in 1786,
received any forks at all, and these were not listed as silver, suggesting
probably steel-tined, bone-handled examples popular at the time.[26]
Not only does this suggest that fork usage still was very limited, but
also that a silver spoon conveyed more of a sense of refinement and
pride than a set of forks did, especially for someone in rural American
settings, for whom fork usage would not be expected.

Similarly, at an earlier date in England, Celia Fiennes (1662–1741),
a gentlewoman who traveled the English countryside, observing coun-
try houses and the landscape alike in her *Illustrated Journeys,* included
in her will of 1738, among a few articles of silver, "2 silver spoons with

FIG 40. "Funeral" spoon.
Cornelius van der Burch.
New York, 1684. Silver.

FIG 41. Sloane Christening
set. Tiffany & Co.
New York, New York,
ca. 1882. Silver.

C.F.," "6 gilt teaspoons," and a "case of knife fork spoon and gold thimble," with no other silver forks or knives. As she traveled so extensively, it is not surprising she had a traveling set. However, spoons, most of them gilt teaspoons, formed all of her domestic silver flatware, apart from the traveling set.[27] The creation of concurrent multiple sizes of individual spoons for different foods started to expand in the late seventeenth century, and more pronouncedly in the early eighteenth century, with the separate tables laid for dessert, coffee, or tea.

(OPPOSITE)
FIG 43. Folding fork, knife, and spoon. Northern Germany or Denmark, ca. 1827. Silver, steel, gilding.

The Eighteenth Century

The eighteenth-century table spoon, which appears to be almost serving-size to modern-day eyes, was good for the cuisine of the earlier part of the century, in which solids and liquids were mixed. French cuisine introduced purées to the world of soups and sauces. The need for a smaller spoon, with a less rounded bowl, became apparent, and such a spoon emerged, sometimes doing double duty for these foods as well as for dessert (fig. 42). The eighteenth century also saw the introduction of between-course ices, which became the rage. Small shovel-shaped spoons, the precursor of the modern-day ice-cream paddle, were introduced, but these were rare, and teaspoons were no doubt used as well. The bowl became increasingly ovoid as the century wore on (fig. 43). By 1760, in England, the handle switched to a downcurve, for better balance with the new soup dish. With this change, the spoon, and often the fork, were laid bowl and tines up, in contrast to continental practice. This resulted in engraved armorials being upside down to the diner, but right way up in sideboard boxes.

FIG 42. Folding spoon. Germany, ca. 1700–10. Brass.

The teaspoon first appeared in response to the importation of and fashion for drinking tea in the latter half of the seventeenth century, when, based on the dates of early milk or cream pots, the English started adding milk to their tea. The addition of milk and sugar would have created a need in the upper-class English household for the tea-spoon, which was generally acquired separately from the flatware for dinner. It thus emerged as a separate luxury utensil, as tea was a separate meal, initially only for the upper classes, and predominantly in England and its colonies, as it found less favor in France. This is made clear by the 1741 inventory of the Duc d'Orléans, where forty-four silver-gilt coffee spoons were listed, but no teaspoons in either gilt or silver.

While the teaspoon was frequently of the same or similar design to other pieces of flatware owned in the eighteenth century, its annexation into the flatware service was a nineteenth-century phenomenon, mostly in the United States. The English teaspoon is generally smaller than the American one. Whether this is due to an earlier popularity from the days when tea was served in smaller pots and cups during the early years of the eighteenth century, or whether it is simply another example of the American enthusiasm for the maxim "bigger is better," this size discrepancy is not just true of teaspoons, but occasionally of early nineteenth-century teapots and eighteenth-century American coffee-pots as well. For teaspoons, the difference is most noticeable after the Revolution, when most American teaspoons were made. However, one interesting example of direct influence is found in a pair of English bright-cut teaspoons owned by Gulian VerPlanck of New York, engraved with a crest and motto, and a matching pair made by Daniel van Voorhis

FIG 44. Pair of teaspoons. Daniel van Voorhis. New York, New York, ca. 1790–1800. Silver.

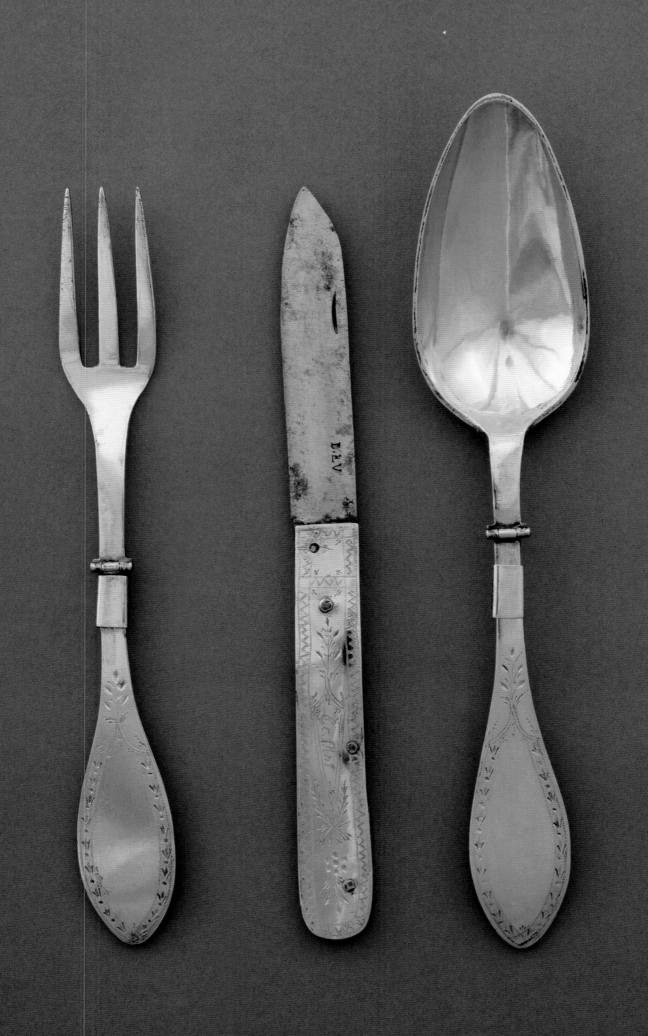

in New York (fig. 44). Perhaps the Americans wanted to show they could afford to drink tea in quantity, and evening tea parties were a popular way to entertain. Whatever the origin, the distinction often exists to this day. As the French never really adopted tea as an event or meal in the way the English did, the teaspoon in France never had its own identity as it did in England and its former colonies.

By the early nineteenth century, the egg spoon, salt spoon for individual salt cellars, mustard spoon, and marrow spoon or scoop, a form which first dates to the end of the seventeenth century, vied with the teaspoon as specialized forms of this utensil.

Travel

Early travel cases were generally just for knives, usually in pairs of different sizes, but began to include the fork as soon as it became generally accepted in each region. Such sets with cases are represented by examples in Cooper-Hewitt's collection from a variety of geographical locations, which include cases with various combinations of knives, forks, and/or spoons (figs. 45–48). Sometimes, the knives were carried separately, and folding forks and spoons, some of which used the same handle, traveled together (fig. 49).

Although it was the norm for individuals to travel with cutlery and other flatware until the late seventeenth and early eighteenth century, this custom did not die out when hosts started to provide flatware for their guests. Traveling sets continued to be used when visiting inns, as exemplified by Celia Fiennes's will cited above, and for picnics, hunts, and other outdoor occasions, well into the twentieth century. The sets often were hinged to fold (figs. 50, 51), and may have had fittings on the spoon to hold the tines (fig. 52) rather than having small or removable handles as earlier pieces did. Fancier sets sometimes included the addition of a beaker, and such amenities as salt, pepper, or mustard holders fitted in a leather case (fig. 53). In other sets, both handles had pockets to receive the blades or tines of the other implement, so when shut they formed an etui (fig. 54). This enthusiasm for packability can be seen in twentieth-century manifestations such as "Port a Pac" (see Lupton, fig. 57), or George Schmidt's "Colorings" (fig. 55). Flatware for ships, trains, and airplanes up through the 1980s was more preoccupied with the overall design aesthetic than with portability, as the flatware was supposed to remain on board (see Lupton, fig. 40).

When hosts of the late seventeenth and early eighteenth centuries did start to order up flatware to receive their guests, they purchased forks as well as knives and spoons. This provision of implements for the guests exactly coincides with the introduction of the specifically designated dining room, especially favored in England.

With the lowering of royal fanfare in eighteenth-century England, due to the modest tastes of Queen Anne (r. 1702–14) and the German-speaking George I (r. 1714–27) from Hanover, simplicity of style reigned. After the death of Louis XIV in 1715, much of the French court removed itself from Versailles into the more domestic interiors of Paris. This was the period when architectural design started to include specific dining rooms for more intimate eating. Vitruvius, in his first-century BC work, *De Architectura*, had designated

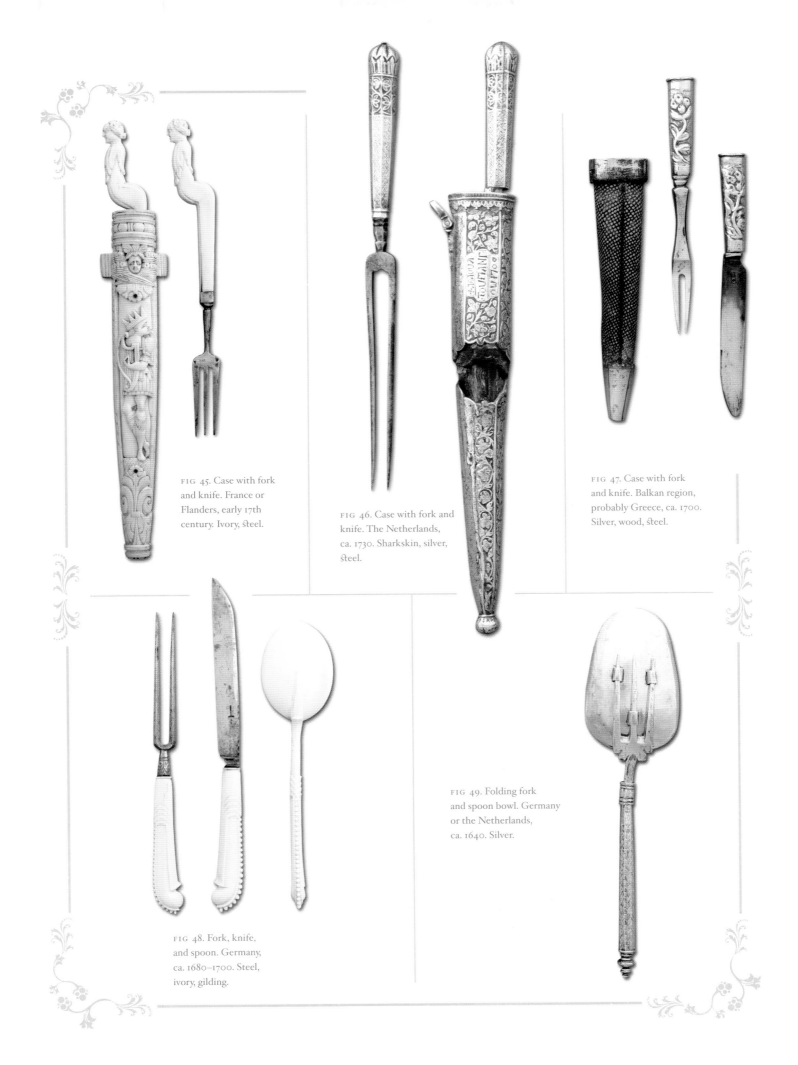

FIG 45. Case with fork
and knife. France or
Flanders, early 17th
century. Ivory, steel.

FIG 46. Case with fork and
knife. The Netherlands,
ca. 1730. Sharkskin, silver,
steel.

FIG 47. Case with fork
and knife. Balkan region,
probably Greece, ca. 1700.
Silver, wood, steel.

FIG 49. Folding fork
and spoon bowl. Germany
or the Netherlands,
ca. 1640. Silver.

FIG 48. Fork, knife,
and spoon. Germany,
ca. 1680–1700. Steel,
ivory, gilding.

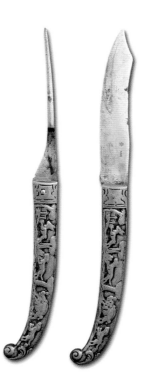

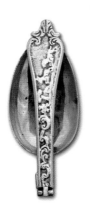

FIG 50. Folding fork, knife, and spoon. Bohemia/Germany, ca. 1720–50. Brass, steel.

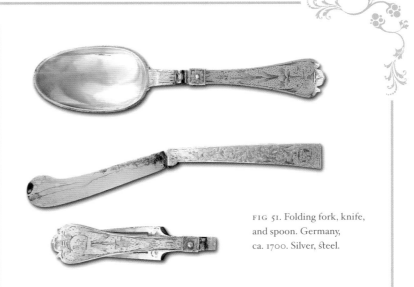

FIG 51. Folding fork, knife, and spoon. Germany, ca. 1700. Silver, steel.

FIG 52. Folding fork and spoon bowl. Germany, ca. 1690. Silver.

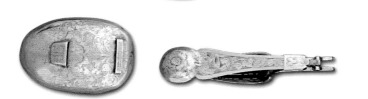

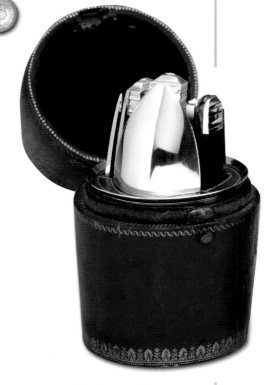

FIG 54. Two traveling sets (closed and open). Left: Fork, knife, and spoon with case. France, ca. 1798–1809. Ivory, silver, steel, sharkskin, copper. Right: Etui fork and knife. Probably Germany, ca. 1790. Ivory, mother-of-pearl, pewter, steel.

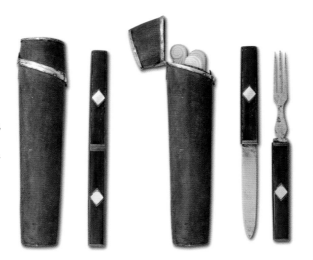

FIG 53. Traveling set with case including fork, spoon, knife, corkscrew, salt and pepper container, and cup. Paris, France, 1809–19. Silver, steel; ebony, ivory, horn, leather.

rooms for dining in his designs. The late sixteenth-century Italian buildings and plans of architect Andrea Palladio, who embraced Vitruvian design, featured proportional rooms readily useable for dining. His work had the greatest influence in England in the first half of the eighteenth century. The architect Colen Campbell produced three volumes of *Vitruvius Britannicus* starting from 1715, a compilation of designs of important English buildings, many of which were "Palladian" in style, designed by Campbell and other like-minded architects. While most of the rooms were not designated for function in the 1715 and 1717 editions, some were appropriately placed and shaped to be dining rooms. However, by the 1731 edition, there were dining-room designations, including one designed by Vanbrugh in 1718, at Eastbury in Dorset, which had an "Eating room" and another "Great Eating Room," the latter presumably to replicate the Great Hall style of eating known in the previous century for special occasions. Because of the enthusiasm for Palladio in England, the resulting architecture there appears to have included more domestically scaled dining rooms at a slightly earlier period than in France.

FIG 55. "Colorings" portable flatware with holder. George Schmidt. U.S.A., ca. 1986. Plastic.

The importance of these often almost square-shaped rooms is that they generally held round or oval drop-leaf tables, which could be stored against the wall and brought out for meals. This meant that non-banquet meals were limited by the size of a drop leaf table, generally with a maximum of eight, with no perceptible head. The vast, long rectangular tables of the seventeenth century involved lots of hierarchy, and would have entailed providing matching flatware for enormous numbers had they still been in fashion. The reduction in size and more relaxed seating arrangements went hand-in-hand with the simpler, less ornamented designs of eighteenth-century English flatware, which started with Queen Anne and became more prevalent in George I's reign. George I's own household "Civil List: Establishments" has a "Declaration of His Majesty's own Dyett of Twelve Dishes att Dinner and Tenn Dishes at Supper," which are itemized for "the First Day of October 1714" (fig. 56) as "potage profiterole" and then mostly meat and game for dinner. Supper included "300 sparragrass"[28] or game compotes and tarts; also listed were "fresh morels." While this may seem like a lot to modern eyes, it comprises vastly fewer dishes than are visible in most royal repasts in late seventeenth-century and early eighteenth-century Europe.

Not surprisingly, with Hanoverian monarchs in England, a visual connection in the flatware between the German states and England is evident. Both favored the ergonomically successful pistol grip for knives and some steel-tined forks (fig. 57) in the second and part of the third quarter of the eighteenth century, although England did so more pronouncedly. Both had good steel production, encouraging quality cutlery. The scimitar-shaped cutler's marks and blades made in London and in Solingen, Germany, were similar, as were their handles, particularly in the use of porcelain and beadwork. In London, Bohemian imported handles may have been combined by the cutler with English blades. Glass beadwork, and glassmaking in general, was a principal industry in Bohemia. Some knives with beadwork handles have German cutlers' marks on them, while others may have London cutlers' marks. As a result, many beadwork-handled knives have been called English, and, as English glassmaking was also advanced at this

G.R.

A Declaration of His Majesty's own Dyett of Twelve Dishes att Dinner and Tenn Dishes at Supper.

Dinner		Supper	
Potage Profitrole w.th 4 pat.	‖	Veal 2 ‖	‖
Westphalia Ham & 6 Chickins	‖	Chickens fricacie 6 Oys.ters Pattes	‖
Bisq.ts of Pigeons 8	‖	Mutton. 4 ‖	‖
Chins of Beef 53	‖	6 Cocks Salmie. or	‖
Turkeys 2 a la Roy.al pattys 1 poull	‖	300 Sparragrafs. or	‖
Chine Mutton & Cutletts	‖	8 Pigeons Compote, or	‖
Hind Quarter of Veal	‖	6 Partriges, or	‖
Partridge Pye 6	‖	Tarts. 1 Dish, or	‖
Lamb Roast ex.ca	‖	12 Snipes, or	‖
6 Partridges, 2 Pheasants	‖		
6 Cocks, 3 Ruffs, 3 Knotts	‖		
		‖ Signifys One Mefs.	

Plates.		Plates.	
Ortelanns 12		Fresh Morells	
Beans 1		Patty Hasht Partridges	
Ragou 1.ts Combs	‖	3, New laid Eggs 6	
2 Sw.t breads	‖	Mushrooms.	

Desert	Desert

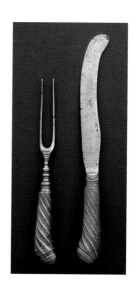

FIG 56. Manuscript: *The Establishment of the Yearly Change of our Dyett with Incidents for Housekeeping...*, p. 3, with lists of foods to be served, by George I, King of England (r. 1714–27). England, 1714.

FIG 57. Fork and knife. Sheffield, England, or Germany, ca. 1760. Steel.

period, some may have been. However, the specific manufacture of glass beads, also used on accessories and clothing, seems to have been a Bohemian industry (fig. 69). Hence, as the cutler supplied knives, putting handles and blades together, often with handles made by a silversmith or enamel or hardstone worker with imported hardstone. Hence, it would not be surprising to find an English cutler putting blades on Bohemian beadwork handles, in a manner similar to that used in Germany.

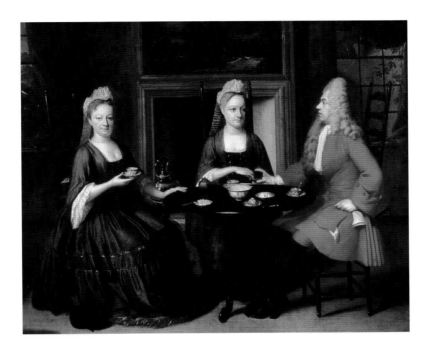

FIG 58. *Two Ladies and an Officer Seated at Tea.* Attributed to Nicolaas Verkolje. The Netherlands, ca. 1715–20. Oil on canvas.

No doubt, the similarities in form and materials were, in large part, due to the patronage in London, initiated by the Hanoverian Georges I and II, of German artisans and craftsmen: the Kandlers in silver and porcelain, Abraham Roentgen in furniture, Christian Friedrich Zincke in enamel miniatures, and George Frideric Handel in music.

The depiction of people seated at a table was not a primary subject for painting until the eighteenth century, when "conversation pieces"—paintings of informal groups, such as friends and family, engaged in habitual routines or diversions—became popular. Such pictures were generally confined to a breakfast scene or teatime, which might stage a portrait of a family or individual, and was not aimed primarily at depicting the event. These meals would have occurred in a breakfast room, parlor, or salon, rather than in the main dining room. In England, teatime often provided the occasion for entertaining, and the depictions of receiving at tea, which in the early eighteenth century was for the wealthy, also was a way to display one's sophistication (fig. 58).

We must rely on engraved or painted views of state banquets and other major festive occasions, rather than the private dinner party, for pictures of actual dinners. As these paintings are generally large in scope, they do not concentrate on flatware. An extreme example of the focus on display is in the depictions of sugar sculptures for the banquet for the Ambassador of the Catholic James II of England to the

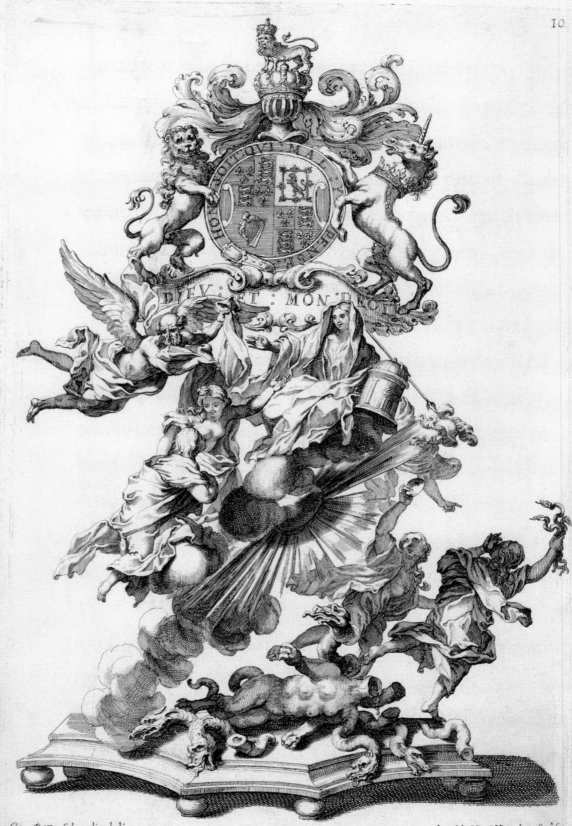

DIEV · ET · MON · DROIT

Gio. Batta Lenardi delin.

Arnoldo Van Westerhout fiam fc.

(OPPOSITE)

FIG 60. Sugar sculpture from *Raggvaglio della solenne comparsa fatta in Roma, gli otto di gennaio MDCLXXXVII...*, p. 65. John Michael Wright. Rome, Italy, 1687.

This sugar sculpture includes the coat of arms of James II of England, whose ambassador was being honored.

Vatican in Rome in 1685, complete with modeled English royal arms and supporters (figs. 59, 60). Another, in 1685, in honor of Ernest Augustus, Duke of Brunschwig-Luneburg and Bishop of Osnaburg in Piazzola, featured an outdoor ceremonial dinner, arrived at by boat, and followed by an indoor dinner, where the most important guests dined using forks in front of a viewing gallery.[29] A third, highly lavish example is the depiction of the wedding of Princess Louise-Elizabeth of France, daughter of Louis XV, to Dom Philippe, the Grand Infante of Spain, in August 1739 (figs. 61, 62), in which the architectural designs of pavilions, the reviewing stands for fireworks, and the elevation of the ballrooms for the wedding ball were all depicted. The ball, which did not conclude until eight o'clock in the morning, included rooms with food, described in some detail as being on "buffets which rose to the ceiling. One part of that which was destined for the meal was

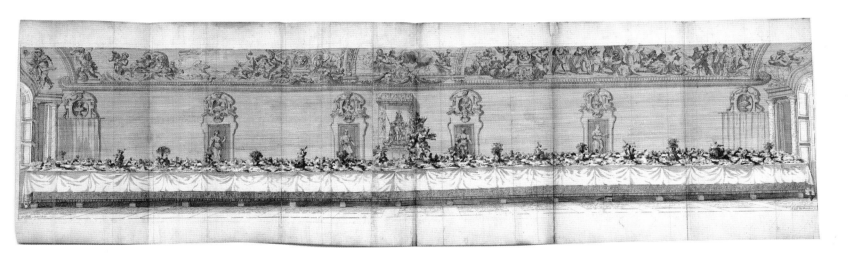

arrayed there with order on an infinity of small tables arranged in rows. The mélange of fruit, crystal, and lights decorated in an agreeable manner this part of the room, where a long table shielded the entry. Behind this table, a great number of officers were pressing to serve to the "masques"[30] all that they could desire in "meats, pastries, fruits, wines, ices, and liqueurs."[31] From the paucity of seating, we must presume that much of the food served was cut on demand and/or served as pre-cut finger food, not uncommon at that time since it obviated the need for personal flatware to be supplied for all. However, the French continued to carry a personal folding knife (fig. 63), used for cutting food, and it may be that the officers carried these to cut the fruit (fifteen thousand peaches were ordered). Although a few may have been provided with flatware at such occasions, it was not part of the feast design.

Other countries had various degrees of spectacle dependent on the tastes of the monarch or ruler. England had few great court feasts until the Regency and Coronation of George IV of England.

Quite a contrast is presented by a description of a dinner at the court of Peter the Great by an English visitor, in comparison with one of a grand dinner at the time of Catherine the Great, the latter showing a lavishness probably surpassing most of Europe. At the court of Peter the Great, a Doctor Birch noted, sometime between

FIG 59. Page spread from *Raggvaglio della solenne comparsa fatta in Roma, gli otto di gennaio MDCLXXXVII...*, p. 62–63. John Michael Wright. Rome, Italy, 1687.

This fold-out page shows a dessert banquet set-up for a lavish ambassadorial dinner.

COUPE DU BATIMENT DE L'HÔTEL DE VILLE VEU EN PERSPECTIVE SUR SA LARGEUR OU SONT RÉPRÉSENTÉES LES
DÉCORATIONS ET ILLUMINATIONS DE LA COUR OU SÉST DONNÉ LE BAL LA NUIT DU XXX AU XXXI AOUST MDCCXXXIX
Cette Feste Donné par la Ville de Paris a l'occasion du Mariage de Madame Louise Elizabeth de France et de Dom Philippe Infant d'Espagne

(OPPOSITE)

FIG 61. Plate from
*Description des festes données
par la ville de Paris : à l'occa-
sion du mariage de Madame
Louise-Elisabeth de France,
et de dom Philippe, infant &
grand amiral d'Espagne, les
vingt-neuvième & trentième
août mil sept cent trente-neuf.*
Jacques-François Blondel.
France, 1740.

FIG 62. Detail of plate from
Description des festes données...

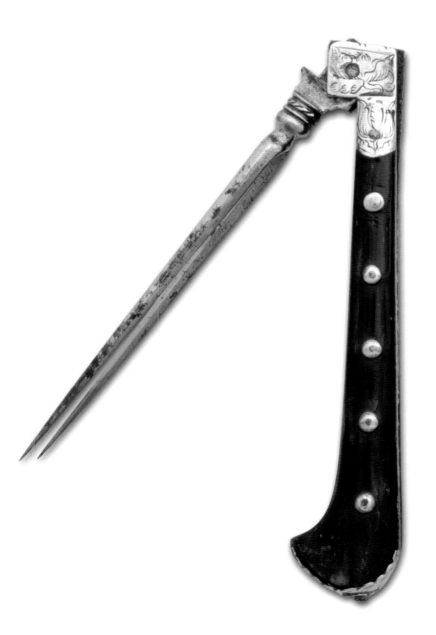

FIG 63. Fork and knife.
France or Germany,
ca. 1680–1700. Steel,
silver, horn.

1711 and 1725, the chaos of two to three hundred guests at tables with seating for a hundred, fighting for chairs to the point of cuffing and boxing to keep them. He went on to say, "They all sit so crowded together that they have much ado to lift their hands to their mouths," clearly indicating a lack of eating utensils. He described three courses, the first of cold meats, which "strangers ordinarily make their whole meal of them," suggesting that Birch, accustomed to service *à la française*, where everything except dessert is served at once, was not familiar with service *à la russe*, in which courses are served sequentially. At this dinner, a soup and roasted meat course, then a pastry course, followed the cold meats before the dessert. Dessert at the Russian imperial table, especially on great festival days and special occasions, consisted of sweetmeats; they were included at the Tsarina's table, once again equating sweets, associated with the earliest European fork usage, with the feminine. The lack of flatware at Peter the Great's dinner was consistent with the random placement of a ship carpenter next to nobleman, which Birch also noted[32] and which reflected Peter's tastes.

FIG 64. Spoon. Made by "PB." Bergen, Norway, 1804. Silver, gilding.

As with Scandinavia (figs. 64, 65) and the Low Countries, the prevalence of spoons among the extant flatware from eighteenth-century Russia implies that fork usage probably only made major strides with the arrival of Catherine the Great, a German princess who came to the throne in 1762 and set out to make St. Petersburg an enlightened Western capital. Catherine imported Italian architects, Voltaire and other French thinkers, English Wedgwood, and German and French silversmiths and furniture makers; hence the accoutrements of court dining would have a Western European style, rather than advancing an indigenous Russian style. By 1791, another traveler observed, "Six hundred persons sat down to a meal. The other guests were served standing: gold and silverware were used and exquisite food was served in sumptuous dishes. From antique bowls flowed precious liquors, and the tables were lit by costly chandeliers. The desires of every guest were anticipated by the elaborately dressed majordomos and servants."[33] Russia had one of the most advanced productions of large plate glass in the eighteenth century. Large mirrors, combined with candles, produced much better lighting, which allowed the wealthy to dine and entertain late into the evening.

FIG 65. Spoon. Erik Barck. Västeras, Sweden, ca. 1715. Silver.

Eighteenth-century Color

Not only did the use of light increase in the eighteenth century, but also more color was added to the dinner and dessert tables. Previously, the random hafts of visitors' knives had provided much of the color on the table; an exception was the dessert table, which was decorated with colorful sweets, especially during the late seventeenth century. Color as an element of table design became popular concurrently with the introduction of European-produced porcelain flatware handles from Meissen, Vienna, St. Cloud, Mennecy, and Chantilly, followed by Vincennes, Sèvres, Chelsea, Bow, and Worcester. Production started in France and Saxony at about the same time as the introduction of the host-provided flatware in the late seventeenth and early eighteenth centuries. However, porcelain handles were made for export in China and given European blades (fig. 66). In France, the production of

FIG 66. Knives. China (handle) and France (blade), early eighteenth century. Porcelain, silver, steel.

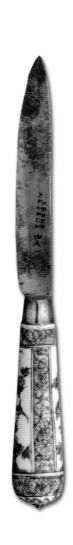

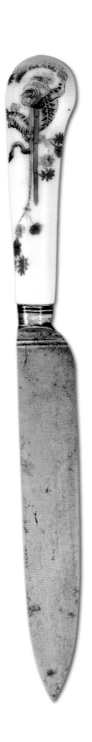

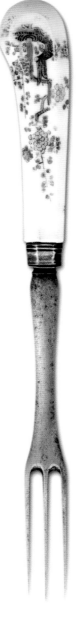

FIG 67. Fork and knife. Meissen, Germany, ca. 1730–40. Porcelain, steel, silver.

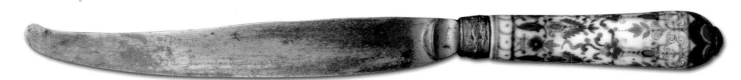

FIG 68. Knife. Ferner Workshop. Thuringen, Germany, ca. 1750. Porcelain, steel, gilding.

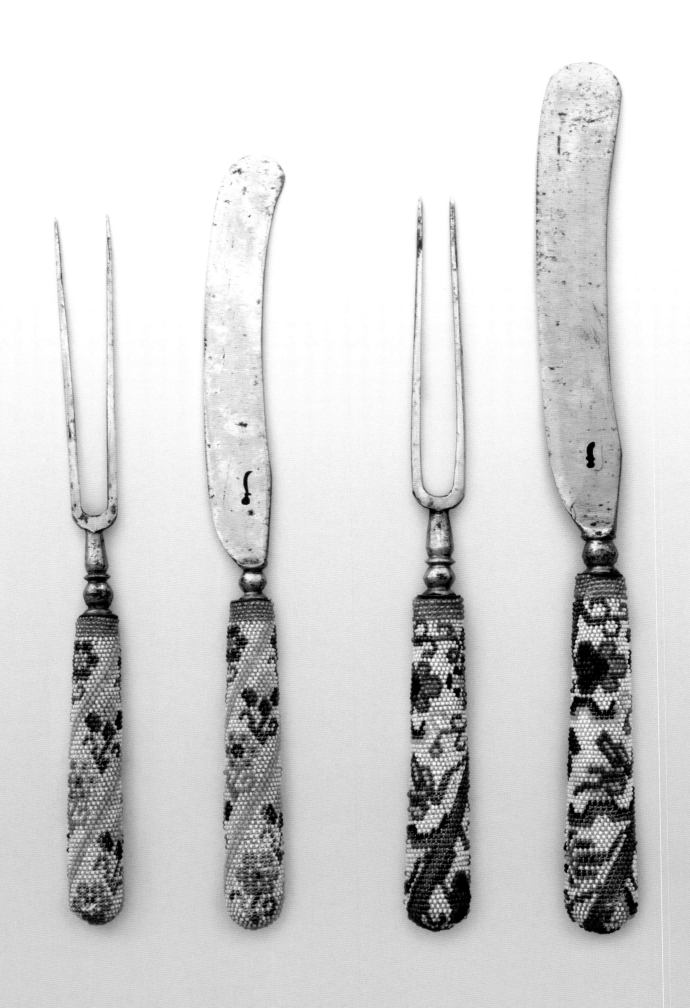

FIG 69. Forks and knives. Germany, ca. 1730–50. Steel, glass beads, thread.

porcelain handles initially was confined to blue and white. The hard-paste porcelain produced by Augustus the Strong's Meissen man-ufactory started adding color in the decade between 1710 and 1720, and expanded later (figs. 67, 68).

There was a newly festive air to the table in the mid-eighteenth century when the production of porcelain-handled forks and knives reached its peak. The use of figurines for decoration and the increased presence of porcelain dishes, instead of silver ones, further contributed to the dining table's liveliness. Initially, porcelain had been the province of the dessert table, but by the 1750s and 1760s, quite a few table forks and knives were produced, which corre-sponded to the increase in porcelain entrée dishes and tureens being used in ever-larger services. Much of the new porcelain production incorporated floral decoration, reflecting the increased interest in botany and gardens.

Beadwork handles, which also featured naturalistic colors and floral decoration, were contemporaries to, but rarer than, porcelain handles. They were generally decorated with a combination of formal-ized floral and band decoration (fig. 69). Judging by the range in styles of floral decoration, the popularity of this technique seems to have been predominant during the first half of the eighteenth century. The technique of weaving—in this case, glass beads—in these patterns may account for their resemblance to textiles of the period.

Another way in which color came to flatware was through the use of green-stained ivory or bone on knife handles. These were popular for dessert and table knives, and sometimes used with steel-tined forks in France, England, the United States, and elsewhere for much of the second half of the eighteenth and first quarter of the nine-teenth centuries (fig. 70).

In England and France, the advent of the extension dining table by the late eighteenth century was accompanied by larger and more formal domestic entertaining. The neoclassical formality of din-ing in Napoleonic-era France and Italy led to new designs (fig. 71). In England, George IV as Prince Regent (1810–20) and King (1820–30) liked to entertain in a lavish French manner, in contrast to his father, George III.

In late eighteenth-century America, Paul Revere's accounts for wealthy merchants show that the only form of flatware ordered was spoons,[34] despite the fact that entertaining had become popular in the colonies. In the period leading up to the American Revolution, there must have been considerable acquisition of cutlery from England, as witnessed by the earlier example of George Washington. Paul Revere also had a hardware store as early as 1783.[35] Based on the presence of forks available for purchase in other hardware-store advertisements of the early nineteenth century,[36] it is tempting to speculate Revere may have sold imported forks with steel tines and horn, bone, or ivory handles.

Another American patriot, John Jay, signer of the Declaration of Independence, also acquired foreign-made flatware like those on the hardware-store invoices. In correspondence, Jay's nephew William recommended to him, in 1812, that he buy apparently British-made, certainly imported, cutlery from another relative, Andrew Munro. William wrote, "I do not hear of any cutler in town who makes table

FIG 70. Forks and knives. Probably Sheffield, England, ca. 1790. Green-stained ivory, steel, silver.

knives; and in all probability-knives made here would be inferior in quality and dearer in price than the imported ones...there are 2 Doz; large and 1 doz dessert knives together with 2 carfing knives and forks. The price is $44. The handles are horn neatly ſtained."[37]

The "knife" boxes in his house in Bedford, New York, were fitted to hold these knives, as well as some matching forks and silver tablespoons made by Isaac Hutton of Albany. This occurrence suggeſts once again the confidence in the ability of American spoon makers, but not in their knife- and fork-making abilities at a refined level.

Another New Yorker furnishing a house, called Boscobel, on the Hudson River was Staats (or States) Dyckman. Dyckman traveled to London, shopping extensively for ceramics and silver. During a 1787 trip, he purchased, along with wallpaper, silk hose, tea caddies, and engraved teaspoons, mahogany cases—complete with shield silver

escutcheons and engraved with his initials — to hold carvers and gravy
spoons, and knives with "2 setts town made white Ivory Chinese knives
and 3 pg. fks" (later listing), and "14 silver Table spoons French ptn 18
Blk. Horn handle Table Knives and Forks." The list also included one
silver marrow spoon and another of undesignated material.[38]

Letters back to his wife and invoices from his trips indicate that
Dyckman intended to live in grand style, as he acquired the newly fash-
ionable covered silver vegetable and entrée dishes as well as flatware.
Clearly, forks were considered the necessary possessions of a gentle-
man who wanted to live in a manner that showed him being on par
with London fashion.

The desire to live in a stylish way, and to display possessions and
manners refined enough to compare to Europeans, continued to grow
and preoccupy many Americans as the nineteenth century progressed.

FIG 71. *Design for a
Centerpiece*. Russia,
1800–25. Pen and black
ink, brush and watercolor
and gouache, graphite
on off-white wove paper.

Later in the century, the perceived connection between education and the knowledge of how to correctly hold and use one's flatware spawned hundreds of etiquette books. This need for instruction led to the milieu which inspired William Dean Howells's portrayal of the confused, self-made Silas Lapham, who lacked the etiquette necessary to be accepted among Boston's old guard. Henry Sargent's *The Dinner Party*, which was painted in Boston in 1814 and depicts the scene of the fruit and sweet wine course, tablecloth removed, with gentlemen only (fig. 72), also evokes this milieu, albeit at an earlier date.

Much has been made of the importance of the switch, in Western Europe and the United States, from service à la française to à la russe. In the former, there may have been a couple of stages of the meal before dessert, but essentially, all the dishes were placed on the table at once, and diners ate a selection from them with the same utensils, at times changing plates from soup and stew-like dishes to meats. The service à la russe involved a succession of courses, each of which was served to the diners individually, then removed before the next. This tradition became increasingly prevalent in France and England, then in the United States, during the first half of the nineteenth century, at least in circles with the staff necessary to serve, reaching a more middle-class household than that would imply today. With plates being replaced, flatware also could be changed, and the idea developed that the utensil most suitable to a specific food should be used just for that course. However, the explosion of numbers and varieties of utensils invented or developed in America probably spoke more to its inventive technological and financial boon and increased availability of silver than it did to the adoption of service à la russe.

Many of the nineteenth century's contributions to the history of flatware evolved out of developments of the Industrial Revolution. Sheffield plate was succeeded by the production in the early 1840s, first by Elkington in England, and almost immediately thereafter by Christofle in France, of an electrolysis-based plating process called electroplate. Skillful marketing established electroplate as a fashionable new material, much as it did for jewelry made from the newly manufactured material, aluminum. The increased variety of designs, and the look of silver or silver-gilt at a substantially reduced price, added to the popularity. Aluminum, however, was sought after despite being expensive, though its high cost may partially explain why it was not used for flatware. In France, the democratization of style was also very much in vogue in the era of Louis-Philippe and the Second Empire. Writing about electroplating in 1867, F. Ducuing stated, "Elkington and Christofle have replaced the place settings of our fathers costing 60 pounds with those of ours for 6 francs, made the same, sounding the same, being used the same...It is the outside which shines, not the inside."[39] The ultimate seal of approval came from Napoleon III, who, interested in the technological innovations of electroplating and electrotyping, ordered a flatware service of five hundred place settings in electroplate, also ordering pieces for Emperor Maximilian of Mexico.

In the eighteenth century, Robert Adam concerned himself with coordinating the design of rooms, including dining rooms, from ceiling to carpets, architectural woodwork to furniture design. He did not design silver or other flatware, being more concerned with the

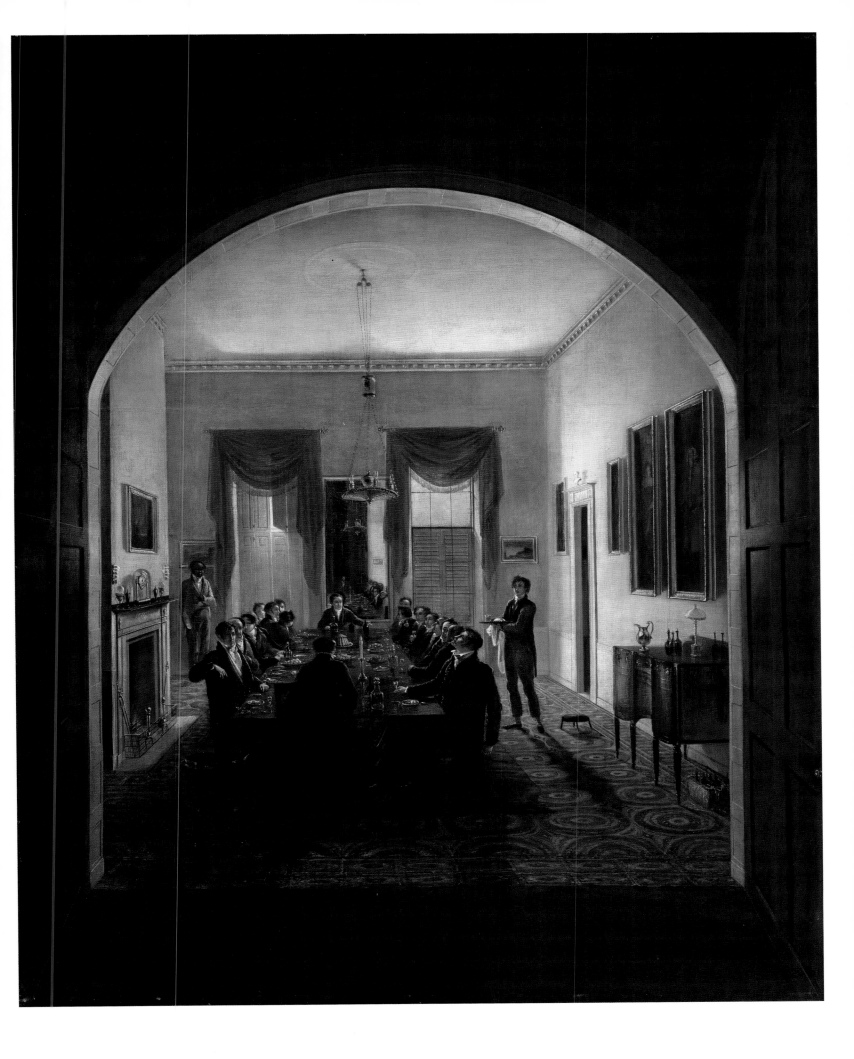

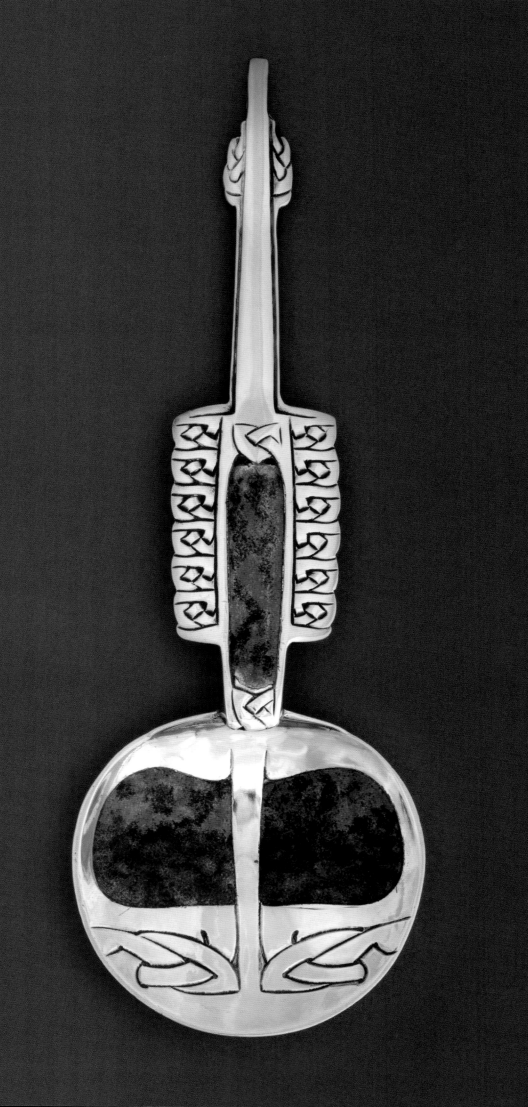

(OPPOSITE)
FIG 73. "Coronation"
presentation spoon.
Archibald Knox.
Birmingham, England,
1901. Silver, enamel.

surroundings than with the French approach to a magnificent table. In the nineteenth century, William Morris and Christopher Dresser were early proponents of a total look in England, but they are not known to have designed flatware. The closest linkage of architectural and flatware design before the late nineteenth century may have been in the neo-Gothic mode. William Gale produced silver flatware with Gothic tracery in 1840s New York, while Alexander Jackson Davis and others produced houses in the Gothic taste, including dining rooms. However, the flatware appears to have been a part of the neo-Gothic movement rather than as part of a total design for a particular room.

Late Nineteenth Century

In the second half of the nineteenth century, some commissions included both architecture and related silver, such as that of the neo-Gothic Manchester Town Hall in England and the Agnes Chapel of 1892 in the Trinity parish on the Upper West Side of New York City. The architect, William Potter, featured the lamb of God (*Agnus Dei*) in the architectural metal and woodwork and in the silver.

More generally for domestic and public buildings, there was an international movement toward the *Gesamtkunstwerk*, or unified artistic work, from the architecture down to the last detail. A few of the designers who espoused this idea were Charles Rennie Mackintosh, Charles Ashbee, Josef Hoffmann (see Lupton, fig. 3), Peter Behrens (see Lupton, fig. 58), Willem van de Velde, and, in the U.S., George Washington Maher, who designed flatware made by Gorham for Rockledge, a house he designed (see Lupton, fig. 5).

Other designers, like Archibald Knox, most of whose designs were for Liberty & Co., worked in metalwork, often silver and enamel, to create pieces to coordinate with a particular look (fig. 73). The coronation spoon, with its enamel blue-green coloration, was similar to some of the Liberty fabrics as well as to the lapis used on early examples of anointing spoons used by bishops. It commemorates the coronation of Edward VII as king, thereby showing the continuation of the idea of a spoon as a commemorative piece. Knox's is based loosely on the coronation spoon in the Tower of London, thought to have been made in about 1200, itself a type of anointing spoon.[40] (see Young, fig. 7)

FIG 74. Spoon. Made
by "P. Ya." Vologda, Russia,
1844. Silver, niello, gilding.

FIG 75. Detail of back
of spoon in fig 74 with
view of a city, possibly
Vologda, Russia.

This tradition of the commemorative spoon, which harks back to birth, funereal, bridal, and other occasions, continued through a new outlet in the late nineteenth and twentieth centuries with the souvenir spoon. These naturally found a home in the international expositions of the late nineteenth century, and became standard collectibles at world's fairs as well as for specific historical anniversaries and touristic spots (see Young, figs. 5, 6). Some were designed with considerable creativity, especially when they were a novelty.

In many countries at this time, especially in Scandinavia and Russia, there were "national romantic" movements, which produced renewed interest in traditional local handicraft styles of earlier eras. As part of this movement, nielloed, or oxidized, silver spoons (figs. 74, 75), enameled spoons, and kovshs (Russian vessels, usually for drinking and ladling, with a handle evoking the aspect of a ladle or a spoon) decorated with trompe l'oeil motifs or Slavonic inscriptions (fig. 76) reappeared, especially in Russia.

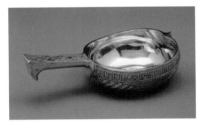

FIG 76. Kovsh. V. Sasikov.
Moscow, Russia, 1861.
Silver, niello, gilding.

The Cyrillic inscription
around the edge refers to
drinking from the kovsh,
but the utensil functions
as a ladle as well.

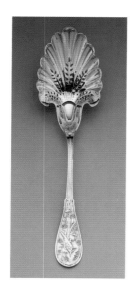

Despite the preponderance of European designers working in the *Gesamtkunstwerk* mode, it really was an American idea to think of flatware as something to be decorated with designs originally intended for other uses, such as architectural pillars or friezes, relating thematically to the room or to architectural designs, past and present. New die-stamping processes made a great deal of detail possible, including the use of Renaissance architectural designs, naturalistic motifs such as birds, and Japanese-inspired ornament previously unknown on flatware.

While Edward C. Moore (1821–1891) of Tiffany's was not an architect, he did respond to the popularity of the "Renaissance" revival for buildings and furniture from the mid-nineteenth century. Furthermore, he was an early promoter of the enthusiasm for Japanese design brought about by the opening of Japan by Admiral Perry in 1854. His "Japanese" pattern (fig. 77), the basis of the later-named "Audubon" pattern, was patented in 1871, five years before Tiffany's (and Londos & Co. in London) hired Christopher Dresser to collect Japanese objects for study in Japan. This was seven years before the Paris exhibition of 1878 at which Gorham and Tiffany's introduced hand-hammered mixed-metal pieces which reflected an even stronger Japanese aesthetic, including the use of Japanese knife handles and copies thereof as handles for knives (fig. 78), introducing this idea

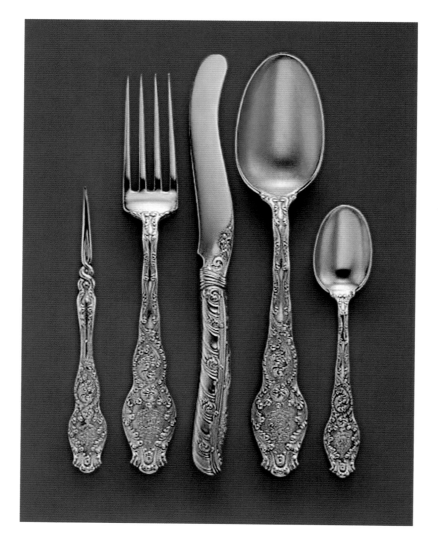

to Europe. The idea of making flatware design unrelated to the variants on the previous standard design models opened the field wide.

The most receptive country for this expansion of ideas was Germany, where considerable industrial wealth produced a ready market for new designs and forms of silver flatware. The number of patterns available in Germany in the late nineteenth century was substantial. However, some new motifs were produced by Cardeilhac and Christofle in France as well.

Going into the Twentieth Century

The advent of the twentieth century saw a great diversity of designs for flatware. There were theme-based designs and lavishly ornamented pieces produced for special commissions, such as Maher's work for Rockledge or a silver-gilt dessert set commissioned from Tiffany's by the directors of the New York Central Railroad to present to J. P. Morgan (fig. 79). There were myriad patterns produced by dozens of firms making silver flatware and others who produced plated wares. There was a high-end interest in the Art Nouveau styles, especially in France and the Low Countries (it is interesting to note that in the United States, the work of William Codman and others in Gorham's Art Nouveau "Martelé" silver line did not include flatware). In addition, there was a growing revival of eighteenth-century simplicity in England, as exemplified by the work of Crichton Brothers, and in the United States by Arthur Stone (fig. 80), Gebelein, and others, especially in the Boston area. Concurrently, Arts and Crafts handcrafted flatware was occasionally produced by the same firms who worked in the revival styles, as well as by others who specialized in this movement, such as the Kalo workshops in Chicago (1904–20).

The silver made in the earlier tradition was usually heavy, often heavier than their eighteenth-century counterparts, to show that it was not meant to be a cheap substitute for the lavish styles. The flatware reflected the Georgian and Colonial revivals which were becoming increasingly fashionable early in the century, with the *Hudson-Fulton* exhibition at the Metropolitan Museum in 1911 showing many examples of American eighteenth-century decorative arts.

A return to the simple elegance of the past reflected the thinking of such arbiters of taste as Edith Wharton and Ogden Codman, Jr., who wrote *The Decoration of Houses* in 1897, in which they stated that "architecture and decoration, having wandered since 1800 in a labyrinth of dubious eclecticism, can be set right only by a close study of the best models."[41] And "the vulgarity of current decoration has its source in the indifference of the wealthy to architectural fitness... the most magnificent of palaces of Europe contain rooms as simple as those in any private house; and to point out that simplicity is at home even in palaces is perhaps not the least service that may be rendered to the modern decorator."[42] While Wharton and Codman did make a number of suggestions for dining-room lighting, fabrics, and painting, they did not specifically address the subject of flatware. William Odom, founder of the Parsons School of Design in New York, studied the book and its exhortations toward classic design and simplicity, and extended the ideas to many media Wharton and Codman didn't mention specifically.

FIG 80. "Pointed End" fork, 1918–32; butter knife, 1911–36. Arthur J. Stone. Gardner, Massachusetts. Sauce ladle. Old Newbury Crafters. Newburyport, Massachusetts, 1955–65. Silver.

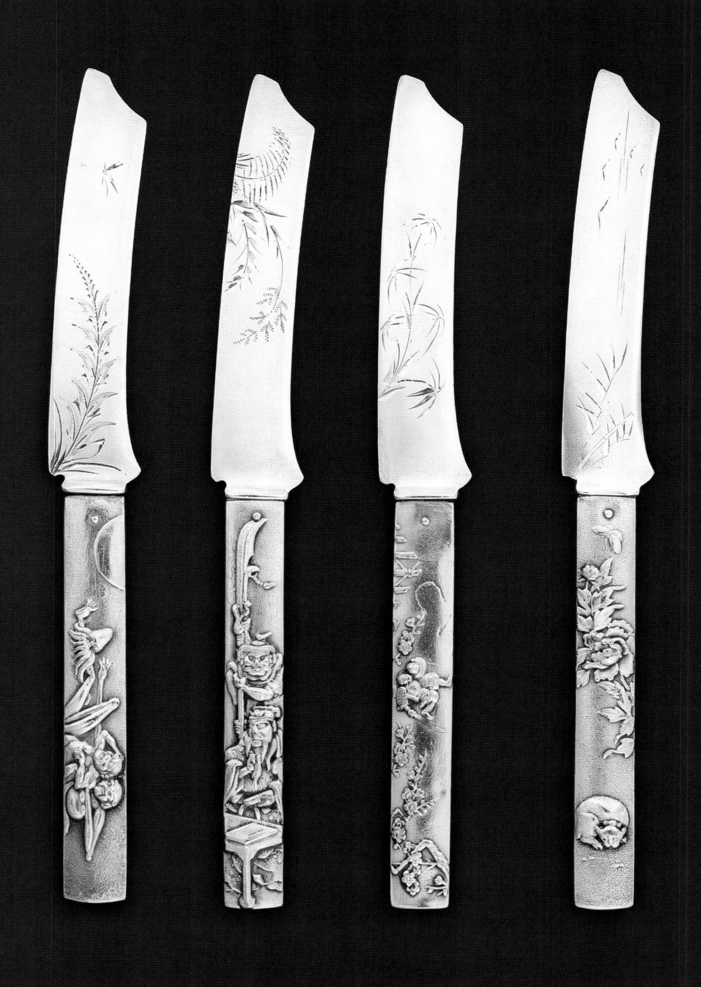

FIG 78. Set of knives. Gorham Manufacturing Company. Providence, Rhode Island, ca. 1880. Silver.

World War I and its aftermath led to some pairing down of design in the 1920s, but the Depression created a need for simplicity to succeed. In addition, the development of stainless steel immediately suggested itself as a flatware medium to designers in the modernist taste. Early sets, in an attempt to show their appropriateness for the dinner-party table, sometimes included a large assortment of specialized pieces (see Lupton, fig. 8).

The Scandinavians excelled at designs in this medium, notably Georg Jensen of Denmark. By the 1950s, they were transmitting their aesthetic, through direct visits as well as objects, to the Japanese, who produced much innovative flatware with Western utensils.[43]

The recent developments in "fusion" cooking have led to an increased attention in the West to chopsticks as part of table flatware. Various sets sometimes include them along with Western knives, forks, and spoons (see Goldstein, fig. 53). However, it is clear from some silver examples (fig. 81) that the Japonism movement seems to have inspired Westerners to try to use them as early as the late nineteenth century.

While the use of stainless steel, Lucite, and other plastics has increased with the reduction of more formal dinners in late twentieth- and twenty-first-century life, studio-crafted flatware has recently enjoyed a renaissance, including, and perhaps especially, in silver. These works are inspired by artistic development (fig. 82; also see Lupton, fig. 79), or by artistic expression in the function of the piece, such as Michele Oka Doner's tribute to the spoon as being an extension of the arm and hand. This forearm-length serving spoon (fig. 83) also acts as an elegant reminder of the utensil's history, evolving as it did from existing as a cup on a stick.

If one thinks of the table as a work of design that includes food flavors, aromas, and presentation, the range of media and styles of flatware design takes on new meaning. A dinner can be festive, to honor a guest or mark an occasion by conceiving of it as a designed whole. For some, this means sleek outlines and materials; for others, the result may be more tactile or sensory. For many, creating ambiance is paramount. To this end, silver—which gleams while honoring the food by avoiding any taint—reflects the glow of a warm occasion, harmoniously combining all these ingredients as it has for centuries. In whatever the chosen medium, the best-designed knives, forks, and spoons help turn a meal from mere necessity into a creative and pleasurable experience, giving full meaning to the phrase "the art of dining."

FIG 81. Pair of Chopsticks. Possibly retailed by Tiffany & Co. New York, New York, early 20th century. Silver.

FIG 83. Large serving spoon. Michele Oka Doner. U.S.A., 1997. Silver.

FIG 82. "Padova" pasta server. Elsa Peretti. Made for Tiffany & Co. Padova, Italy, ca. 1984. Silver.

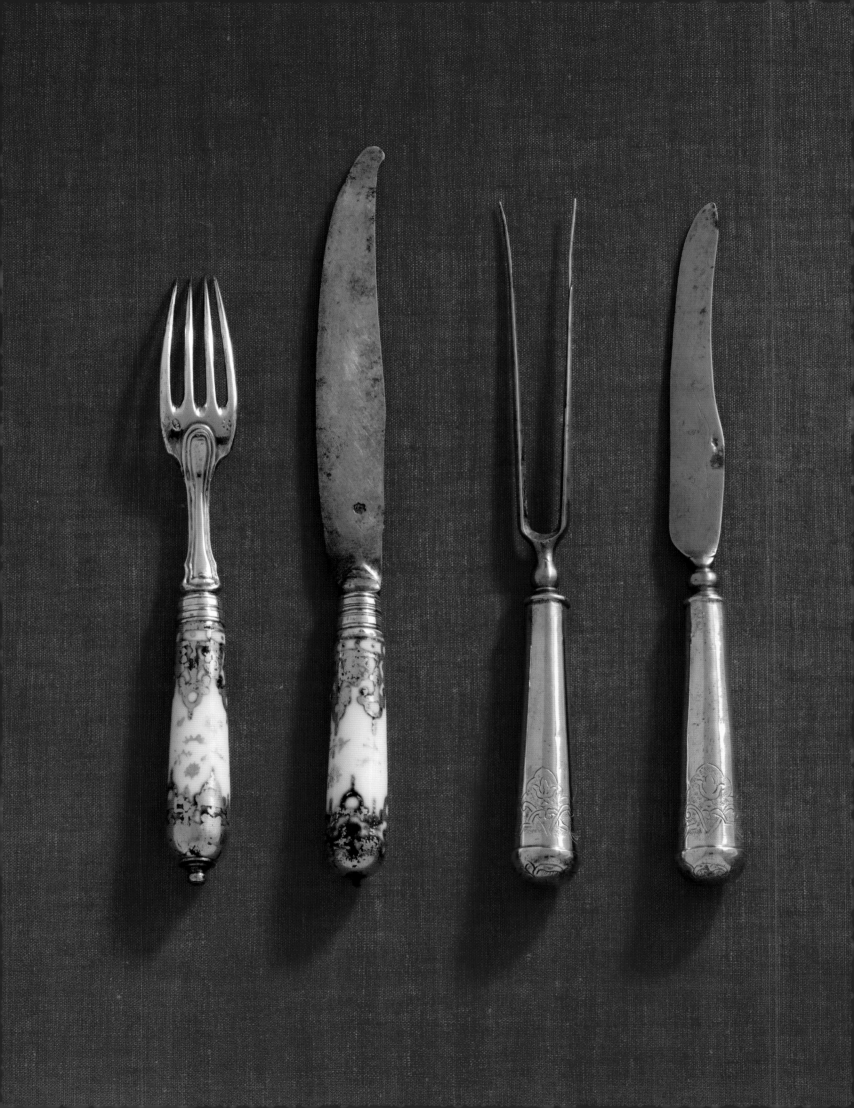

Manufacturing and Marketing in Europe, 1600~2000

PHILIPPA GLANVILLE

M ETAL IS AT THE HEART OF THE STORY
OF FLATWARE IN THE WEST. EACH
ALLOY—A COMBINATION OF TWO OR
MORE METALS, OR OF A METAL AND
non-metal—has its attributes: pewter and
paktong (a Chinese alloy containing copper,
zinc, and nickel) are too soft for knives and forks but easily cast into
spoons; carbon steel can be ground to a keen edge for blades, but rusts
quickly and gives a taint to acid-based foods. The tang, or shank, of
a knife wrought from iron is sharp and needs to be encased in some
other organic substance, such as horn, wood, ivorybone, or ceramic,
comfortably shaped to the hand and rigid enough to drive a cutting
action (fig. 1). Brass and copper are too soft to serve for cutting or
spearing food, and taint the taste of food unless coated with tin or
silver. Silver—in addition to lending an air of politeness to the table—
is clean, hygienic, and practical for basting and stirring in the kitchen,
but it is costly and too soft for knife handles without reinforcement.

Once substitutes for solid silver were developed—notably close,
French, and Sheffield plating in the eighteenth century, and electro-
plating a century later—inexpensive base-metal flatware became widely
available. Distinctive regional customs, such as the French practice of
carrying personal folding knives, or using a spoon and knife without
a fork, disappeared. Simultaneously, manufacturers stimulated demand
with novelties, such as cucumber slicers and butter ladles, mentioned
as early as the 1760s (see Goldstein, fig. 44), or the huge variety of spe-
cialized servers, from sardine tongs to shank holders, nut picks to
lobster crushers, toast tongs to knife rests, which adorned nineteenth-
and early twentieth-century catalogues and bridal lists.

Four centuries ago, simple hand techniques of stamping, casting,
striking in a die, riveting, soldering, sawing, and sharpening required
little equipment and were employed in producing knives for spearing
and slicing and spoons for scooping—the essential eating maneuvers.
A silver spoon was shaped from a rod with a few blows, the bowl
hammered into a die, and a cast finial applied. Even with the arrival

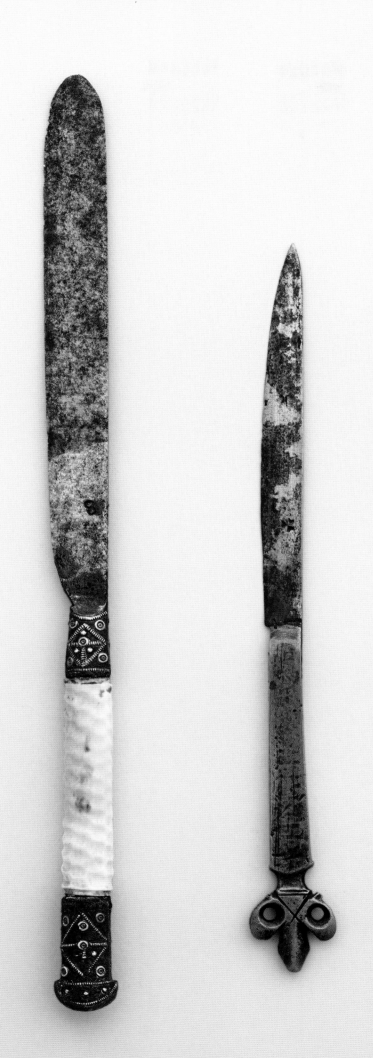

FIG 2. Set of forks and knives. William Boswell. London, late 17th century. Agate, steel, silver.

Agate handles could be cut with one tool and did not involve decorative carving.

FIG 3. Detail of cutler's mark on knife in fig 2. William Boswell. London, late 17th century. Steel.

An English cutler's mark was required to give reassurance to the buyer that the steel used was well-tempered and would not snap in use.

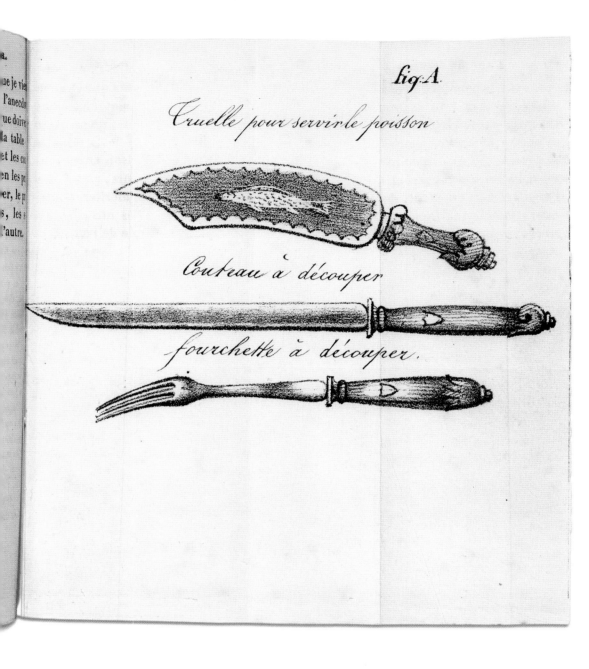

Truelle pour servir le poisson

Couteau à découper

fourchette à découper.

Fig. A

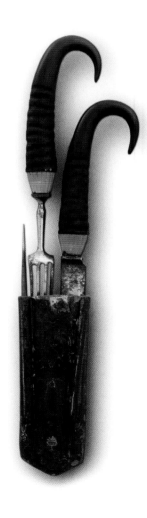

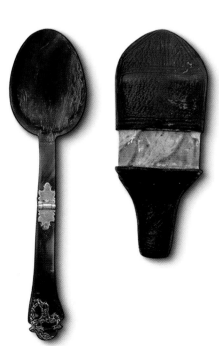

of the flypress, a machine which applied weight for stamping, the method was still effectively a marriage of skillful hand and eye. From the earliest times, processes were split between workmen, and subcontracting flourished. Apart from the engravings and descriptions in the *Encyclopédie* of Denis Diderot, few illustrations of techniques exist. Machines and tools were simple, and labors learned at the workbench were considered of little interest before the craft revival of the mid-nineteenth century (figs. 2, 3). Because metals were recyclable and of economic value, their use was regulated, and in many European centers the cutlers and silversmiths were expected to register marks with their respective guilds.[1]

Documentary evidence for making and selling flatware, plus a myriad of serving and eating tools, is distorted. Silver, a precious metal with a known value, has left a rich paper trail. High-style objects, particularly those embellished with porcelain or amber, gilded, or with princely associations, have been treasured for centuries, and predominate in museum collections.[2] Household books describe table etiquette for the elite, their staff, and those aspiring to be seen as elite (figs. 4–6). Archaeology can help, revealing, for example, the crude knives found on Henry VIII's ship *Mary Rose*, wrecked in 1545, or the wooden spoons used on mid-eighteenth-century ships, or waste dumped from cutlers' workshops in Sheffield.[3] (fig. 7)

Add to the core metal the decorative effects achievable with engraving, silvering, close-plating, gilding, enamel, or by encasing hafts in carved ivory or boxwood, rock crystal, beadwork, or porcelain, and a huge diversity of design and form in flatware emerges. Swiss spoons, for example, had leaf-shaped bowls often carved in wood and fitted to silver handles. In Scandinavia, distinctive forms persisted well into the eighteenth century.[4] (fig. 8)

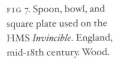

FIG 7. Spoon, bowl, and square plate used on the HMS *Invincible*. England, mid-18th century. Wood.

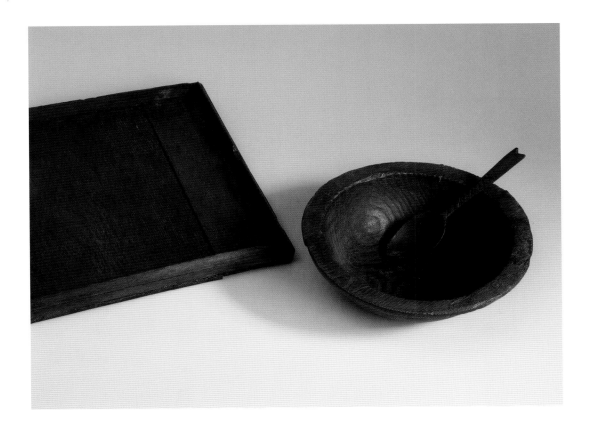

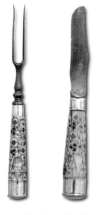

FIG 9. Fork and knife. England, ca. 1660–90. Ivory, silver, steel, iron, enamel.

These decorated ivory handles with silver at the ends would have cost less than solid silver, but still at the upper range of price.

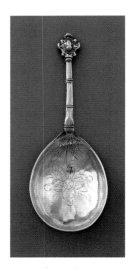

FIG 8. Spoon. Hans Henrikson Wetterten. Vadtena, Sweden, ca. 1700. Silver.

The round bowl and cast handle in this Swedish example are reminiscent of earlier spoons.

Qualities and prices reflected this diversity of choice: The late Stuart London cutler John Waters, in 1671, had in tock fifty-two dozen forks and six times as many knives. His prices ranged from one shilling and sixpence for a dozen "ordinary Sheffield" (base-metal) knives to silver "graven Massy silver haft knives" at seventy shillings a dozen. Handles were of "buckshorn," "Green fish skin," amber, tortoiseshell, or agate; at thirty-six shillings, the most costly per dozen were "Massy silver." (fig. 9) Forks were a novelty rather than a necessity, demanding a new manner of eating; some were in the tock of a London toyman in 1672, along with whips, scissors, and kit for hawking and cockfighting. Toy forks of pewter have turned up recently, found by mudlarks on the foreshore of the Thames River, but these were playthings for wealthy Stuart children, not everyday implements. By 1688, however, the royal household had adopted silver forks for almost all ranks.[5]

The English, French, and Americans had ditinctive eating tyles, as is clear from the silver from London ordered by Joseph Richardson of Philadelphia—spoons, but no forks. In mid-eighteenth-century Jamaica, a society of exceptionally wealthy planters made lavish use of London-made silver flatware. A group of twenty-three inventories from the 1740s shows that all but one had imported sets of silver knives, forks, and spoons in decorative wooden cases.[6] (fig. 10)

In 1763, John Inch, a Maryland tavern keeper and silver dealer, carried a tock of "white metal" and bell metal spoons at two pence each, but no knives or forks.[7] Fifty years later, a Salem girl dining with the Monroes in Washington was truck by the weight of the

(OPPOSITE)

FIG 10. Knifebox containing dinner and dessert knives and forks. London, England, ca. 1775. Mahogany veneer with silver mounts, silver flatware (Mark of William Abdy), teel blades (Marked 'LOOKER' possibly for William Henry Locker, London).

Knife boxes enabled costly silver flatware to be both displayed and protected for transport in a fashionable container.

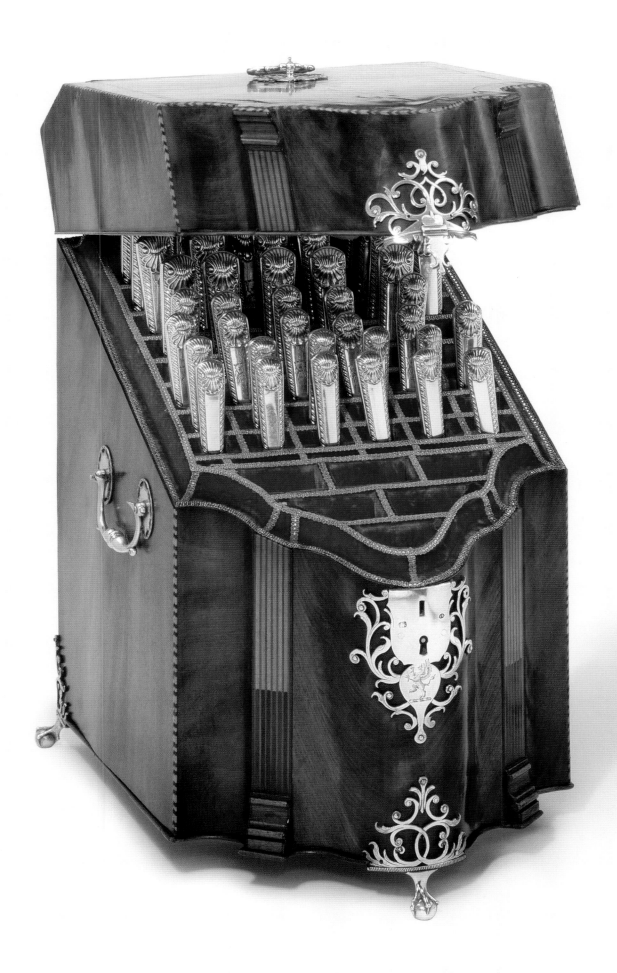

flatware: "I could hardly lift them to my mouth, dessert knives, silver, and spoons…you would call them clumsy things." She was accustomed to the light (less than an ounce) spoons produced in most American shops.[8] A young Charlestonian, about to take ship for his "Grand Tour" in 1831, was advised by his mother on "how to eat in the European manner." Does this indicate that the American habit, like the French, was to carry a personal folding knife, and to manage without a fork, or is this a reference to the distinctive tradition of eating with a fork in the right hand?[9]

Folding knives were clearly recognized as a French specialty across the Channel in England. In 1769, Joseph Baretti, French secretary of the Royal Academy in London, was accosted at night in the Haymarket, and killed his attacker with his pocket knife. Its blade was protected with a silver sheath, and the whole folded into a shagreen case. "I wear it to carve fruit and sweetmeats…it is a general custom in France not to put knives on the table, so that even ladies wear them in their pockets," he explained to the judge. A witness testified, "The outside is silver, the inside is steel, to cut a little bit of bread with." He was acquitted since he carried it as an eating tool, not a weapon.[10] (fig. 11)

In the traditional version of craft history, makers were thought not only to master all stages of manufacturing, but were believed to act as retailers, too. But there were many layers in this trade: for cutlery, one man made the one-piece blade and tang; another ground the blade; and a third added the handle and its decoration. Wholesalers bought their stock and passed small parcels onto retailers, even in the sixteenth century. English spoons, raised and hammered into a shaped die, had separately applied cast terminals (fig. 12). Dutch and New York spoons had cast handles, soldered to the hammered round bowl (see Coffin, fig. 40). Networks of spoon-making workshops can be identified through their sharing of castings; specialist makers supplied complex finials, such as figures of the apostles or heraldic devices.[11]

From the fifteenth century, retailers in market towns across England, France, and Flanders stocked spoons in silver, the less costly pewter, or cheaper substitutes in base metal. Across northern Europe until the eighteenth century, a personal silver spoon, costing between five and seven shillings—about a week's wages for an artisan—became an essential index of standing. Until the early eighteenth century, one in ten inventories for English and Dutch yeomen and prosperous artisans listed silver spoons.[12] In France, a rich hoard of documents about provincial silversmithing is available, although relatively few objects survive. Robert Morel of Bourges sold spoons and forks, but no silver knife hafts, at the rate of three to four sets a month in about 1710; he sold *quillare a ragoust*, serving spoons for stews, and others for potage, a reflection of the new refined French table practice.[13] By contrast, pewter spoons were rarely valued separately and retailed for a penny or less each. Colonel Shorey, a large London retailer of pewter, had in stock in 1710 thirty-seven dozen spoons, such as "Spanish, British, Large, Small, Childs," but his stock was worth far less than his molds and patterns.[14]

Silver spoons were small luxuries, light and portable, offered as lottery prizes in London and Amsterdam between the 1550s and the late seventeenth century and widely sold through fairs, such as St. Bartholomew's in London and Stourbridge, outside Cambridge;

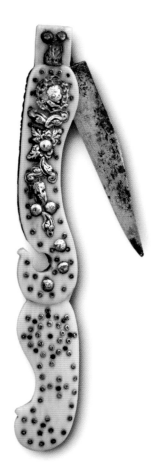

FIG 11. Folding pocket knife. France or England, ca. 1695–1700. Ivory, silver, steel, brass, enamel.

Great attention was paid to the decoration of pocket knives, which appeared at table as fashionable accessories.

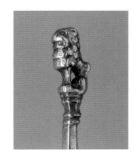

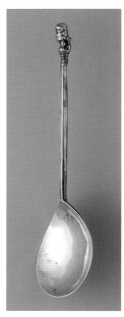

FIG 12. Spoon with *lion sejant* handle and detail (ABOVE). Made by AB. Provincial England, ca. 1630–35.

The *lion sejant*, a symbol of royalty, and spoons with figures of the apostles were popular forms for spoon handle terminals. These spoons were frequently presented as gifts.

LA FOIRE DE GVIBRAY EN NORMANDIE PRES LA VILLE DE FALLAIZE

Leipzig or Frankfurt, in Germany; or Guibray, in Normandy.[15] (fig. 13) Analyses of thousands of silver spoons, coupled with the regional searches of the Goldsmiths Company, show that London entrepreneurs were already managing subcontractors or outworkers in the sixteenth century. Wholesalers such as Robert Tyte of Salisbury in the 1630s handled large quantities of spoons, which were then retailed in the region; thus, a spoon might have passed through many hands before reaching its end user.[16]

References to tools are rare; makers of silver spoons, such as Humphrey Clovill of Bristol (d. 1627), left at his death "one spoon mould and hammer...4 spoon hammers...drawing bench, swaging hammer, tongs." In 1709, the Boston silversmith Richard Conyers, in an unusually complete and detailed list of equipment, left "4 Spoon Punches" weighing fifteen pounds, plus six lighter ones, "4 Small Teasts and Swages." He was equipped to produce a full range of silver and jewelry, as was a French silversmith, Robert Sionnest, who, in 1756, left "onze etampes a cuillier"—eleven spoon punches.[17]

From the mid-seventeenth century, spoon-making across Europe, from Stockholm to London, adopted a new French form. The stem was flat, not a faceted rod, and the end was splayed, offering more space for initials. This "French-pattern spoon," as the Goldsmiths Company described it in 1663, was laid with a trencher (table) fork and knife, making up a *couvert* (place setting) for each diner, in the new polite way of serving. Sawing and finishing the fork tines were new skills.[18] West Country makers struck bowls with floral scrolls, the so-called "lace backs," sharing the soft metal dies (fig. 14). A similar picture emerges in France; the cost and trouble of die-cutting was better left to a specialist. In about 1700, wanting to undercut London competition, the enterprising John Elston of Exeter offered to supply forks and "swage," or die-struck spoons, at contract prices to shops in Devon.[19]

Trade cards of London silver dealers often claimed that goods were "made on the premises." The reality was that a hundreds of small workshops of "Little Masters" supplied both wholesalers and retailers. Matthew Boulton in Birmingham had a reputation far larger, where flatware was concerned, than his capacity to manufacture. He sold a mere twelve silver forks to the trade in 1780 and supplied account customers with French-plated spoons from Sheffield (fig. 15). A further thirty-six plated knife handles were ordered from Winter, Hall, and Parsons of Sheffield.[20] In London, Dru Drury supplied the silver dealer Charles Kandler with knife hafts and three-pronged forks in 1762, and in the 1780s sold shell butt table knives to the Duke of Ormonde's retailer, John Locker of Dublin, buying in steel blades from Sheffield cutlers such as Mr. Trickett senior and James Woolhouse.[21] Workmen's books from the London retailers Parker and Wakelin, precursors of Garrards, show that they were supplied by several cutlery workshops in London and Sheffield.[22] Thirty-six London spoon makers signed a petition in 1773 against opening new assay offices in Sheffield and Birmingham. The Fleet Street, London, retailer Joseph Brasbridge, active from 1770 to the 1820s, disliked the aggressive discounting and unscrupulous pirating of designs in Sheffield. He preferred to deal with the well-established London cutlery houses like Richard Crossley, whom he had seen rise from humble beginnings as an apprentice who brought charcoal to a thriving manufacturer and wholesaler of silver spoons and forks.[23] (figs. 16, 17)

Even at the top end of the market, knives and spoons outnumbered forks until the early nineteenth century. In 1694, the Dublin assay office marked, in six months, three times as many spoons as forks, and in 1787, four times as many table spoons as forks and fifteen times as many dessert spoons as forks.[24] London criminal records confirm this relatively low occurrence of silver forks. At the Old Bailey Sessions, some three thousand cases of theft over 150 years concerned

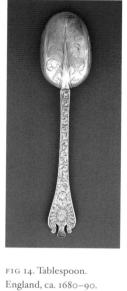

FIG 14. Tablespoon. England, ca. 1680–90. Silver.

The relief achieved on this spoon was created by hammering into molds.

FIG 15. Ladle. Sheffield, England, ca. 1770–80. Silver-plated copper.

Fashionable for its novelty, Sheffield plate recreated silver styles at a third of the cost of solid silver.

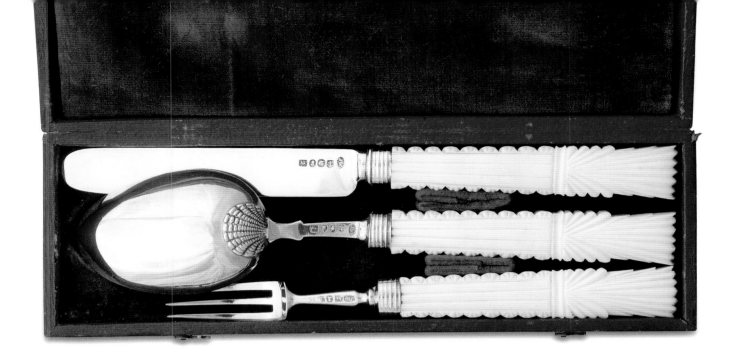

silver spoons, compared to fewer than three hundred that cited forks.[25] In Birmingham, only two spoon makers, and no fork makers, registered marks between 1773 and 1800 among 120 names of silversmiths; and no forks were marked at the Chester assay office. Exeter assay office records for 1755–73 and 1780–84 also list no forks, other than the occasional "Sallad Fork."[26] Did West Country customers use steel-tined forks with pitch-filled Sheffield silver handles, which were considered hardwearing and practical by Joseph Brasbridge? Base metal knives, with forks, were listed in large numbers in the inventory of Sheffield cutler and exporter Elizabeth Parkin in the 1760s. She bought locally made flatware by the gross, holding 232 dozen "bone scale table knives" and forks in 1766, at a modest two shillings a dozen, with pressed cow horn, "sham buck," and "sham stag," imitating more costly deer horn. By contrast, a pair of fluted ladles in silver cost ten pounds seventeen shillings, a year's salary for a cook.[27]

The steady accretion of more—and more elaborate—silver flatware can be seen at the Goldsmiths Company. The move from spoons alone (they had thirty "Slipp" spoons in 1680) to knives and forks culminated in their splendid service of Kings pattern for 144 settings, listed in 1852, when they added the newly fashionable "fish eating knives." Nearly a century earlier, in 1762, they had added two dozen butter ladles. They constantly upgraded their plate cupboard, moving in 1756 to "ivory Pistol Handle" knives and forks, to which six matching carving sets "stained green" were added in 1764. The silver components of these boxed sets, now out of fashion, were melted in 1826 and their silver-ornamented wooden cases sold; the company had invested in, and discarded, French fiddle-pattern flatware. These heavy, handsome services were far removed from the everyday eating equipment typical of inns and taverns in Britain and the Americas and used by those lower in status. In 1718, John Boddington, the company steward, had a set of a dozen black-handled iron knives and forks for entertaining tradesmen.[28]

Europe's discovery of porcelain offered a new means of adding color to tableware. Meissen and the early French factories were quick to produce flatware handles, at St. Cloud and Chantilly, for instance. Governor Botetourt had, in 1770 at Williamsburg, a case of flatware

FIG 16. Regency flatware dessert service. William Eley, William Chawner, and William Fearn. London, England, 1808. Silver, gilding.

The shell and modified "fiddle" patterns are representative of the lavish uniformity of the period.

"with China handles," plus a gilt-handled dessert set, thirty-four
"Large" knives and forks, French plate soup ladles, and fifty plated
teaspoons. Porcelain ladles were perfectly suited to serving soup and
sauces, which was central to a refined meal. A handle design for a
Sèvres soup ladle is in Cooper-Hewitt's collection, and Catherine the
Great's Frog service, supplied by Wedgwood and proudly exhibited
in London before it was dispatched, included both ladles and knife
rests in creamware.[29] (fig. 18)

Experiments flourished in the eighteenth century in the search for
silver substitutes, such as Jonathan Parfitt's Wells metal, a gold-colored
compound for coffee spoons, described by a German visitor in 1709.[30]
Coating base metal with silver in various ways was one way to satisfy
the market for flatware without the cost of solid silver. In the 1740s,
Sheffield makers of knife hafts discovered that silver and copper fused
together could be worked as one metal. Thomas Boulsover's obituary
in 1788 claimed the credit for him, but at least one other maker, John
Osborne, "plated the Knife Hafts and sold them as Silver." His knife
hafts were exposed as "a Fraud on the Publick" at the famous Leipzig
Jubilate Fair in 1783, where many Sheffield goods were sold, and the
resulting scandal forced the closure of his business. But fused plate
was to be a success story in the long run. The ancient process of close-
plating, in which iron or steel articles were coated with a thin layer of
silver; or the early eighteenth-century French-plate, in which brass
objects had many layers of silver leaf applied with heat and burnishing,
were both suited to serving tools such as fish and cake slices.[31]

Because both objects and documents survive, the broad history
of manufacturing flatware is well understood. Technical ingenuity
and exploiting advances in metallurgy to create a better or cheaper
product were constant factors. Sheffield was already a famous center
for knife making by 1500. Swedish bar iron was being imported for
making knives in the early seventeenth century. Its cutlers collabo-
rated to develop techniques, exploiting waterpower and steam, and
machine-stamping for hafts, the 1743 Huntsman crucible method
of producing steel for dies, and Sheffield plating (fig. 19). Machines
such as the flypress sped up production of standard forms from dies
with minimum effort. Visitors commented on Sheffield's distinctive
industrial character, willingness to innovate, and close-knit social
organization, in which whole families worked at some aspect of cutlery

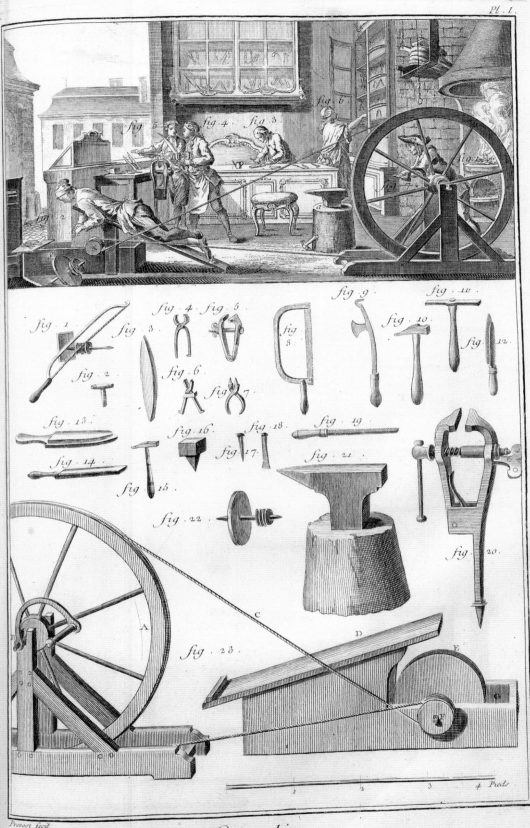

636

Pl. I.

fig. 1. fig. 3. fig. 4. fig. 5. fig. 9. fig. 11.
fig. 2. fig. 6. fig. 8. fig. 10. fig. 12.
fig. 7.
fig. 13. fig. 16. fig. 18. fig. 19.
fig. 14. fig. 17. fig. 21.
fig. 15. fig. 22. fig. 20.
fig. 23.

1 2 3 4 Pieds.

Prevost fecit.

Coutelier.

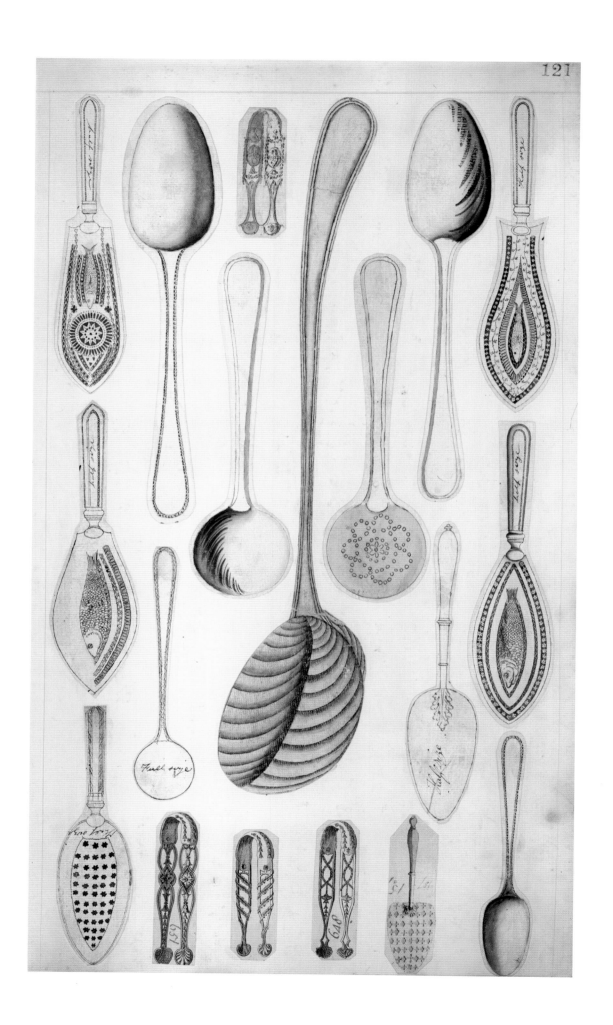

making. In 1821, eighty-five hundred of Sheffield's population of sixty-five thousand worked in the cutlery trades, still mostly in small units.

Curiously, a recent analysis of local inventories shows that few owned refined tablewares, even the knives and forks that they were making.[32] Similarly, at Thiers, France and Solingen, Germany, the presence of water to drive mills was probably key to their early cutlery focus; but the German industry benefited from the nearby arms industry, exploiting in particular techniques such as the production line and the drop-forge (a forge between dies by means of a drop hammer or punch press).

French philosopher Denis Diderot's *Encyclopédie*, first published in 1772, and of which eleven of the twenty-eight volumes were devoted to the industrial arts, included depictions of hand techniques, such as grinding knife blades, as well as several machines for replicating forms and pattern. Smaller workshops could not achieve more refined techniques such as saw piercing, and the perfect finishing essential for strainers; Joseph Richardson of Philadelphia ordered his lemon and punch strainers from London, and in France, a sugar spoon, a distinctive element of desserts, was sometimes selected as a maker's masterpiece to demonstrate his skill at piercing.[33]

The interest of flatware is as much in its marketing and distribution as its production. Although retail prices are hard to establish, wholesale orders across the Atlantic hint at the sheer volume being shipped by mid-eighteenth century and cite the price per gross or dozen. "Let the whole be of the newest fashion" is a recurrent phrase, a reminder that price was not the overriding factor, for silver flatware at least. There were recognized qualities and price points, so that in 1754, the New York retailer Gerard Beekman could confidently order a shagreen case of flatware "as neat as can be bought...for about £5." (see Coffin, fig. 30) These boxes were sold in many forms, rectangular and decorative for the sideboard or as slim cylinders for easy transport on horseback, as depicted around 1740 on the trade cards of H. Pugh of Racquet Court or the jeweler Mary Anne Viet.[34] Commercial innovation helped, such as the factors employed by Sheffield manufacturers. By the mid-1740s, the Broadbents and Roebucks were trading directly through Hull with continental retailers. Agents flourished in London, Liverpool, and Bristol. This system eased the flow of goods in volume to the West Indies and the Atlantic seaboard, as the correspondence of Joseph Richardson in Philadelphia and the Beekmans in New York shows. In 1753, Gerard Beekman ordered pewter tablespoons and teaspoons by the gross, to be distributed to retailers in Rhode Island and Connecticut. James Beekman in 1770 ordered from Bristol twenty-four dozen *couteaux* (knives), presumably French-style folding knives, graded from two to three shillings a dozen.[35] At the Dublin assay office in 1787–88, twenty-eight thousand teaspoons were sent for marking, suggesting an export market well beyond Ireland. Starting in the 1780s, pattern books were issued by large British manufacturers, priced in the local currencies of France and Germany.[36] (fig. 20)

Advertisements and trade cards circulating in Jamaica, Bermuda, and along the American seaboard stimulated demand. Showing new designs, they exploited the reputation of London goods, emphasizing stock "in the latest fashion," rather than country-made. Cox and Berry of Boston advertised in 1772 "just Imported in the last ships

FIG 21. Trade card for the London Silver Plate Manufactory. London, England, 1788. Engraving.

This trade card for a wholesale business lists table articles ranging from tureens to wine funnels and bottle labels. Table spoons and four-pronged forks, presumably silver, as well as ivory-handled knives and forks are also included.

from London…Tureen Ladles, Table and Tea Spoons, Salt Ladles and Shovels," as well as plated wares. In Charleston, Daniel Carroll from Philadelphia advertised his manufactory and store at the sign of the Coffee Pot in 1796, and sold "spoons of all kinds finished in every respect and sold cheaper than those imported."[37]

High-style pieces, or special commissions, served as models; in Copenhagen and Hanover, royal goldsmiths made exact copies of French flatware supplied to their masters. Elegant French designs for flatware were rarely available for export, although American, Swedish, and British diplomats took the opportunity to acquire services in Paris. A lively secondhand market in flatware flourished; it could be bought at auction, or from warehouses such as The Silver Lion in Foster Lane, London, or from pawnbrokers.[38] (fig. 21)

The system of using outworkers, typical of the London, Sheffield, Newcastle, and Exeter trades in the eighteenth century, accounts for the small initials and symbols often found on English flatware near the hallmarks. These are "workmen's marks," put on by the outworker to whom a certain weight of silver had been delivered. When he returned the spoons and forks, the wholesaler or retailer could check back if there was any problem with weight or quality. Another recently identified mark on silver from the Bateman and Chawner workshops, known as the "three cusped duty mark," shows the wholesale trade in volume production silver, bought in part marked, and then marked locally as convenient. So flatware might bear York marks though there was no actual production at York. Barnards, the largest manufacturing business in Britain for much of the nineteenth century, punched marks for businesses as far afield as India.[39]

New serving implements forced manufacturers to experiment with suitable materials. Matthew Boulton complained of the impracticality of Sheffield plate for serving implements, particularly fish slices, an eighteenth-century innovation: "Fish trowels of plated metal will

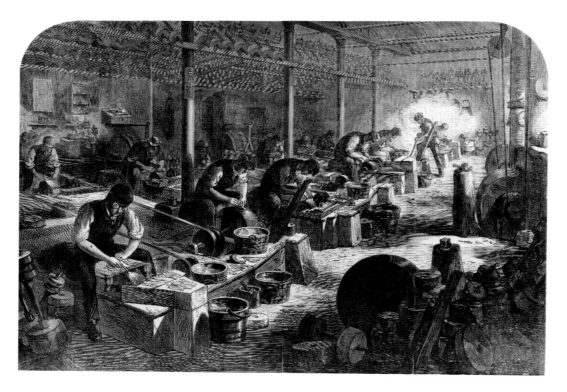

FIG 22. "The Steel Manufacturers of Sheffield: The 'Hull' or Workshop, of the Razor-Grinder. With the Use of a Fan." *Illustrated London News*, pg. 56. London, England, January 20, 1866.

This image depicts workers grinding razors. The technique and machinery were the same for both razors and knives. Reformers fought for healthier working conditions through the use of extractor fans and greater workspace to reduce dust inhalation.

be bad things, let them be made ever so well; indeed we never recommend anyone to have plated trowels, silver ones being so much more durable."[40] An advertisement of 1818 for the platers James and Gibbs in a Birmingham directory depicts ladles, fish slices, skewers, knives, and forks "Plated on Steel...in imitation of Silver," with the advantage that the steel gave a sharp edge or point, although the finish would wear off in time. They complemented articles in Sheffield plate, a sandwich of copper and silver available from the mid-eighteenth century. It was unsatisfactory for cutting implements because of the exposed copper at the edge. Sealing this with a strip of silver wire was an extra process, which pushed up the cost of Sheffield plate.[41]

Joseph Brasbridge disliked the "falsehood" as to quality and discounts of some Sheffield manufacturers of plated goods, claiming, "As to pretending to supply goods of equal quality 10 percent cheaper than any other house will do, or to plate on steel with a solidity equal to silver itself, all the world knows there never was any Plating used thicker than a goldbeater's skin." A London tavern, Gerrards Hall, had a basketful of plated knives and forks stolen in 1823, suggesting that the articles had a pawn value.[42]

A cheap substitute at the lower end of the market from the late eighteenth century was Britannia metal, an alloy of 90 percent tin, with antimony and copper, which could be plated. Rejected by Boulton after experiments in the 1770s but adopted by peddlers, sometimes old women, to make crudely cast spoons from scrap metal supplied by the purchaser, these cost as little as a halfpenny each.[43]

Forms of tableware converged inexorably from the early nineteenth century, driven by universally adopted dining practices, coupled with industrial innovation, and aggressive international marketing, trade discounts, and constant novelties. Driven by the market demand, a constant objective was to increase productivity. Thomas Bruff of Maryland invented a spoon-making machine in about 1801. In 1826, the manufacturer William Gale of New York City patented a "machine with improved die rolls for impressing designs on both sides of handle blanks simultaneously"; and over fifty years earlier, in 1771, the London silversmith Dru Drury patented a method to reproduce knife handles, increasing production from twelve to up to fifty a week.[44] (fig. 22)

Even in the 1830s, a report on the Sheffield industry emphasized its dependence on handwork: "Almost exclusively formed by manual labour," spoons were "pierced out of sheets by means of the fly, and afterwards fashioned by striking in bosses and filing...the embossed work (on Kings pattern) being produced by squeezing them when red hot between figured steel dies by means of a Bramah's press. They are got up by brushing and buffing with oil and rottenstone." It was filthy work, and "only females of not a very superior class like to come to it, so we would soon as not have the direct responsibility," explained the manufacturer William Hutton to an inspector in 1862.[45]

Flatware passed through many stages and premises. Barnards, the largest manufacturing business in Britain during the first half of the nineteenth century, supplied flatware to Rundell and Bridge and to Garrards, although the metal "blanks" had probably been supplied from Sheffield. In 1857, Barnards supplied Chawner and Adams with "German silver" blanks already stamped with Kings pattern, which

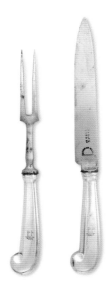

FIG 23. Fork and knife. England, early 19th century. Silver, steel.

Silver pistol-shaped handles such as those on this fork and knife were popular for many years and made by many makers.

FIG 24. Detail of blade mark from knife in fig 23. Blade stamped 'THORN-HILL / (N)EW BOND ST' and 'LONDON MADE' (in semicircle). England, early 19th century. Silver, steel.

The blades have the stamp of the retailer.

(NEXT SPREAD)
FIG 25. The Christofle silver-plating workshop in *Les grandes usines de France* (The Great Factories of France) by Turgan. Engraving by H. Linton. Paris, France, 1860.

The vitrines of the Christofle workshop show large amounts of flatware suspended from wires for the electrolysis plating process.

they then shaped and sent back for electroplating. So who was the manufacturer? The finished product almost certainly bore the stamp of the retailer.[46] (figs. 23, 24)

In the 1840s, Elkington, an entrepreneurial Birmingham firm, and Christofle, outside Paris, almost simultaneously established techniques of electroplating flatware, triggering a rush by other manufacturers to exploit this new means of satisfying the middle market. Nickel, first isolated in the 1740s, was being exploited by German flatware makers by the 1830s. In France, Christofle dominated production with its large factory at St. Denis. The subdivision, characteristic of the British industry, is no doubt why the firm emphasized total control of its production, issuing engravings and photographs of premises and processes and linking its innovations in production with a smart retail operation in Paris.[47] (fig. 25)

A huge variety of designs and up to twelve finishes — EPNS, "Albata," "Alfenide," and other inventive terms for variants on white metal or German (nickel) silver and so on — of flatware at different prices, with text in ten languages, were offered by Christofle, George Walker (1849), and David Cope of Birmingham (1865). The latter's brochure claimed that it had "three thousand five hundred designs for flatware suitable for all the various markets of the world...Collected since 1790," a marketing angle emphasizing history, which was typical of advertising by the Sheffield firms, too. Its Oriental pattern was impressed with a crescent moon and star in six variants for the Ottoman market, for example, and Texas Fiddle pattern with a spread eagle on the handle cost from £1.13 a dozen wholesale to the cheapest version in "yellow metal, brass, silver, or gold colour" at nine shillings a dozen. The range of prices, patterns, and finishes of metal was astonishing, as was the volume of production.[48] Christofle's St. Denis factory produced eighty thousand dozen sets of flatware a year, and maintained fifty-five foreign agencies.[49]

The export trade remained important for British manufacturers. In 1854, a Bristol manufacturer named James Williams sent thirty-two thousand ounces of flatware for hallmarking to Exeter, reporting to an inquiry that he exported most to the Americas, India, and the Cape of Good Hope.[50] This large volume compares with the New York manufacturer Albert Coles, who in 1850 used twelve thousand ounces of silver to make 780 dozen knives and forks, valued at $30,000; he employed fifteen workmen as well as steam power.[51]

Stimulating demand for large-scale orders required novelties and small variations in design, which the mass manufacturers could provide; Elkington's drawing books from the 1840s show, for example, over two hundred versions of fish carvers.[52] (figs. 26, 27)

Lias and Sons of Fleet Street, London, registered six designs for pierced spoons in 1851, part of a push to claim the superiority of British industry at the *Great Exhibition of the Industry of All Nations*, in 1851. A great variety of tableware was recommended in the 1845 U.S. edition of Thomas Webster's *Encyclopaedia of Domestic Economy*, including fish slices, asparagus tongs, cheese scoops, knife rests, nut crackers, grape scissors, etc., all items offered in Christofle's catalogue of 1862.[53] (fig. 28)

Invention did not lag. M. H. Wilkens of Bremen, founded in 1810, boasted by 1920 its two hundred-plus spoon designs developed since 1860, in qualities from six hundred to one thousand grams.

In 1904, the firm of Wolfers Frères in Brussels gave exclusive rights to certain designs, such as "Moderne no. 203," to the German court jeweler Friedlander in Berlin, who put together lavish canteens, including snail picks.[54]

By 1900, Solingen had overtaken Sheffield in volume of production, and at least from the 1870s, "Sheffield" was being stamped on German-made blades, to the fury of the Sheffield industry.

The discovery of stainless steel in 1913–14 gave Sheffield a new international lead in manufacturing high-volume flatware until as recently as forty years ago. Today, most of the mass production of cutlery has moved to the Far East, although in Britain a lively niche market in individual, specially designed, hand-finished services continues, often commissioned from an artist-craftsman. These pieces are inventive, well-balanced, and a pleasure to handle. In Britain, both the Goldsmiths Company and the Crafts Council actively sponsor new work through prizes, exhibitions, and electronic directories of makers (figs. 29, 30). Extreme expressions of this spirit are the Millennium Canteen, commissioned with flatware for salad, fish, soup, and so on from thirty-seven members of the Association of British Designer Craftsmen, to celebrate seven hundred years of cutlery-making in Sheffield; and the engaging fish slices by a hundred American and British artists and craftspersons commissioned by Seymour Rabinovitch and recently given to London's Victoria and Albert Museum.[55]

FIG 28. Twenty-six fruit and dessert knives and six dessert servers, including a cherry spear, cake server, and ice-cream server among others, in tray. F. Nicoud. Paris, France, ca. 1890. Silvered and gilt metal, mother-of-pearl, sueded fabric on wood core.

Plated and silver objects were sometimes featured together, depending on which material was more appropriate for specific functions, such as a sharp cutting edge or cherry pitter in plate.

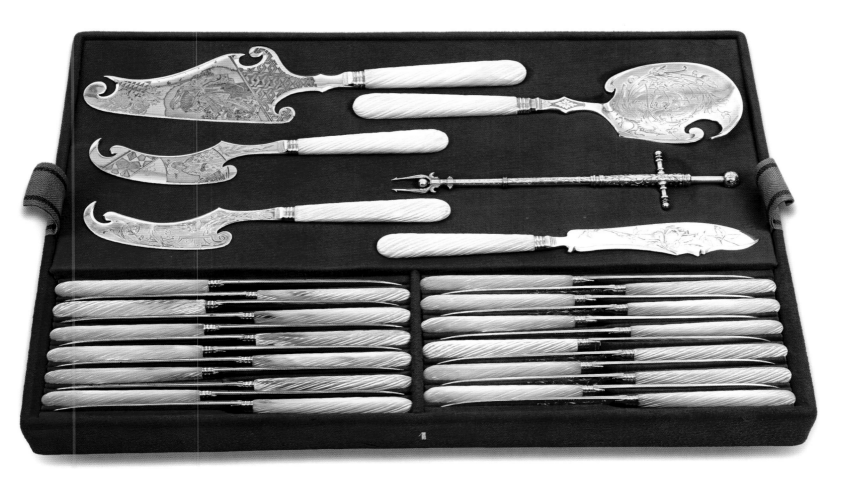

FIG 26. "Butter Knives"
(double-page spread),
Elkington Pattern Books,
Drawing Book 1, Folios
71/2. Birmingham,
England, 1840–73.

FIG 27. "Sardine Tongs,
Lobster Crackers,"
Elkington Pattern Books,
Drawing Book 3, Folios
44/5. Birmingham,
England, ca. 1870.

These books give a sam-
pling of the large variety
of pieces available to the
retail trade for purchase
from Elkington & Co.

FIG 29. Canteen Case
made for Millenium
Canteen commission
project. Andrew Skelton.
England, 1997. Wood,
stainless steel, fishing line.

FIG 30. Salad knife and
fork made for Millenium
Canteen commission
project. Chris Knight.
England, 1997. Silver,
stainless steel.

Examples of creative
activity in contemporary
British flatware design.

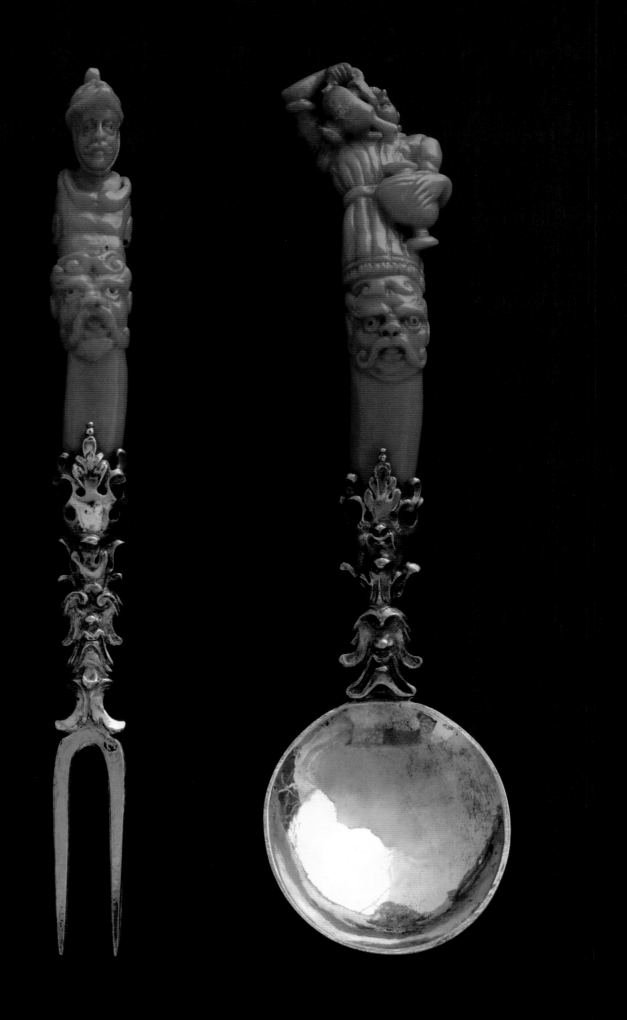

The Sexual Politics of Cutlery

CAROLIN C. YOUNG

I N THE WEST, CUTLERY TRANSFORMS THE ANIMAL ACT OF FEEDING INTO THE REFINED, HUMAN RITUAL OF DINING THAT BESPEAKS OUR CULTURE'S DEEPEST BELIEFS AND values. Adding meaning to our everyday lives, the fork, knife, and spoon fulfill symbolic needs that lie well beyond their practical uses. A silver spoon engraved "Willoughby de Eresby 1779," decorated with a monk presumably enlightening the "savage" beside him (fig. 2), articulates the fact that, particular styles and precious materials aside, to eat with even the dullest stainless steel flatware at a roadside diner is to participate in "Western civilization."

German sociologist Norbert Elias, writing in 1939, asserted that this elusive concept "expresses the self-consciousness of the West. One could even say the national consciousness. It sums up everything in which Western society of the last two or three centuries believes itself superior to earlier societies or 'more primitive' contemporary ones. By this term, Western society seeks to describe what constitutes its special character and what it is proud of."[1]

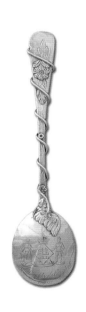

For Elias, the gradual adoption of dining cutlery, and refinements to its use, manifested the evolution of society's ideals from medieval *courtoisie* to early modern *civilité*, a sea change which, in his opinion, received its "specific stamp and function" from Erasmus of Rotterdam's *De civilitate morum puerilium* of 1530.[2] Elias noted, "What was lacking in this *courtois* world, or at least had not been developed to the same degree, was the invisible wall of affects which seems now to rise between one human body and another, repelling and separating."[3] Erasmus's text demarcated a shift, which later culminated in the widespread adoption of the fork and the laying of individual flatware — a result that only reached some isolated French villages and American pioneer towns after World War I.

To use cutlery is by no means obvious or natural—other cultures do not do so—and for many centuries, Europe and its former colonies did not. Claude Lévi-Strauss asserted that the use of forks (or any

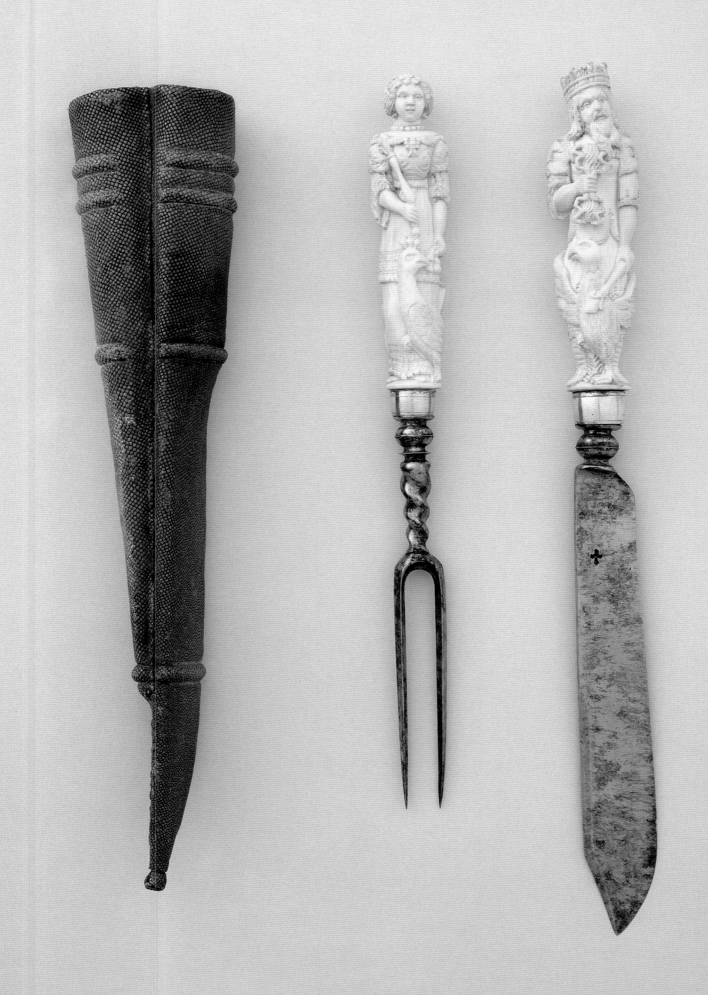

cutlery) was society's means of separating itself from the theoretical dangers of rawness and rottenness.[4] He further argued that Western society's primary goal was to protect *ourselves*, not others.

The Christian religion has been especially attuned to the dangers of "he that dippeth with me into the dish," the gesture by which Jesus identified his betrayer, Judas.[5] Cutlery renders the intimate act of sharing food physically and symbolically more distant. "Marry, he must have a long spoon that must eat with the Devil," wrote William Shakespeare.[6] He was merely transmuting Geoffrey Chaucer's earlier warning, "Therefor bihoveth him a ful long spoon That shal eat with a feend."[7]

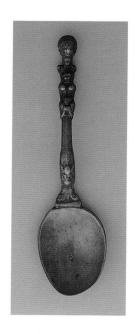

FIG 3. Spoon. Italy, ca. 1600. Bronze.

Nevertheless, even as cutlery separates its user from the exterior world, it paradoxically creates an especially potent bond between donor and recipient when offered as a gift. In the Old Testament, God commanded Moses to make golden spoons for the Tabernacle containing the Ark of the Covenant.[8] At its dedication, each of the twelve princes of Israel offered one filled with incense.[9] Thousands of years ago, Egyptian pharaohs were buried with exquisite ivory spoons in their tombs. Seventeenth- and eighteenth-century English and colonial pallbearers frequently received commemorative funeral spoons. Welsh and Dutch brides were often given a spoon at their betrothal— a custom which gave rise to the British colloquial term "spooning" for "making love." Christening spoons have existed since at least the sixteenth century. The antiquity, longevity, and multiplicity of such customs demonstrate that cutlery's emblematic significance cannot be explained solely by society's increased affects of repulsion.

In 1967, anthropologist E. A. Hammel analyzed the basic fork, knife, and spoon as sexual symbols. He concluded, "Their differentiation on these principles is thus basically male versus female, but the distinctions are not absolute."[10] In his estimation, spoons, sinuous and rounded, were female; knives, long and pointed, were male. Hammel admitted that the fork, "possessed of multiple sharp members," and "used to pierce," but also, "slightly cupped with respect to knives," and in some instances employed "to release and pour out," had both

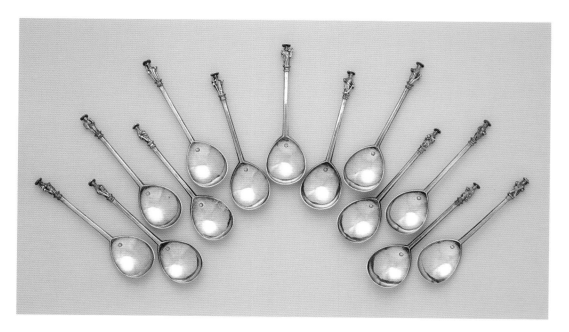

FIG 4. Set of 11 "Apostle" spoons and "Master" spoon made by William Cawdell, 1592. "St. Andrew" spoon made by Martin Hewitt, 1613. London, England. Silver, parcel gilt (Master).

FIG 5. "Brooklyn Bridge" souvenir spoon. Tiffany & Co. New York, New York, ca. 1883. Silver.

FIG 6. "Empire State Building" souvenir spoon. Tiffany & Co. New York, New York, ca. 1931. Silver.

male and female characteristics.[11] On balance, however, he decided that the fork was "more male" than the knife, and had an Oedipal relationship to the other utensils, which explains "why the British spoon mediates between the knife and fork, and why the American knife comes between the fork and spoon."[12] In Hammel's thinking, the three basic utensils thus existed as a family in which the fork was the son of mother spoon and father knife. Such a narrowly Freudian interpretation has its limitations, but is both borne out by and illuminates the historical uses and meanings of these objects.

Used to feed infants and invalids, the spoon (fig. 3) and its maternal characteristics transcend the voluptuous lines of its physical appearance. An instrument of comfort, rather than of threat, the spoon is, indeed, the mother of cutlery. It is the most collected and cherished of the three basic tools of the table and has long served as a sacred talisman through life's journey—and beyond. Spoons frequently denote membership within a community or commemorate a special person, place, or occasion. Dutch burghers and, eventually, their colonial counterparts in New Amsterdam gave spoons with fanciful cast knops in shapes such as monkeys, skeletons, milkmaids, and cupids as gifts in remembrance of christenings and funerals, friendships, and betrothals. Apostle spoons (fig. 4), offered singly or, by the very privileged, in sets of thirteen, with one representing each apostle and a "Master Spoon" showing Christ, made popular christening gifts in England and the Continent from the fifteenth through the seventeenth centuries. The Victorians revived this tradition amidst a sentimentalizing mania for collecting spoons for all sorts of occasions. Souvenir spoons, whose popularity peaked after the advent of automobiles, often served as mementos for special voyages and depicted state emblems and monuments among other playful themes. (figs. 5, 6)

Spoons also perform ritual pouring in religious ceremonies, as at the commemoration of the Tabernacle of the Ark of the Covenant. The pearl-encrusted English Coronation Spoon (fig. 7), purportedly dating to the twelfth century and listed among St. Edmond's Regalia in an inventory of 1359, has been used to anoint the monarch's head with sacred oil since at least James I's crowning in 1603. The spoon's original use is currently debated; however, its long handle and unusual double bowl argue that it has always had a ceremonial function.[13]

The knife's masculine connotations reach beyond its phallic shape (fig. 8), and back to the roots of European society, whose aristocrats are descended from tribes of hunters and warriors. Gaming perquisites made hunting their exclusive privilege; therefore, the distribution of its spoils at a banquet emphasized these rights by the bravura with which well-born carvers performed their tasks and by the elegance of their knives. Virile evocations of the hunt suffuse the dinner knife, which evolved from handsome personal knives that, in addition to performing all manner of everyday tasks, might be used to slice meat from a platter and also bring it to one's lips.

In the eleventh and twelfth centuries, property was transferred by "attestation by knife." In the sixteenth and seventeenth centuries, this evolved into a custom whereby English and Dutch grooms offered their brides pairs of "wedding knives" in a decorative sheath or bag that could be worn on a girdle. Knives imply such swarthy brutality that the practice of bestowing them on one's beloved seems almost

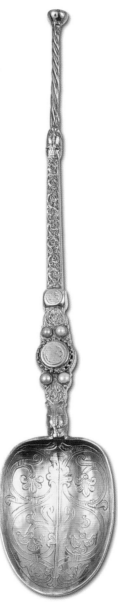

FIG 7. Coronation spoon. England, second half of 12th century. Silver, gilding, pearls.

shocking today. Indeed, French verses composed around 1460 super-stitiously cautioned, "He who gives his lover a knife as a New Year's gift knows that their love will cool."[14] Wedding knives, although daintily elegant, physically manifested the male claim upon the women to whom they were gifted. Their decoration aspired to be not only handsome but also instructive about the duties of the good wife. An exemplary pair (fig. 9), engraved, "* Johanna * Bouwens * 1618 *" along the handles, is also embellished with edifying scenes, including Suzannah and the Elders, and mythological figures such as Ceres and Bacchus, symbols of fertility and joy. A slightly later design (see Coffin, fig. 10) includes a Biblical exhortation for wives to submit to their husbands.

By contrast, the fork, a historically recent utensil, does not resound with the echoes of ancient ritual or gift-giving traditions (fig. 10). Symbolically considered the child of the spoon and knife, its chronological emergence parallels that of modern European culture. Homer's *Odyssey* described forks used for roasting ritually sacrificed meat.[15] Delicate ginger or sucket forks for eating preserved fruit frequently appeared in medieval royal inventories. Dinner forks, however, followed the path of Italian humanism, emigrating from Venice, Naples, Florence, and Rome northward to France, from which, in the late seventeenth and eighteenth centuries, they spread through the Continent, Britain, and eventually Europe's colonies.

Hammel's conclusion that the fork is more masculine than the knife locates him within the prejudices of the contemporary era, in which the fork is dominant. On the other hand, the interpretation of the fork as a sexually ambiguous object, with both feminine and masculine qualities, better explains its form, the obstinate historical resistance to its adoption, and why the most enduring legends about its introduction concern two immigrant brides and a cross-dressing king. These possibly apocryphal stories circulated to discredit their central characters, each of whom strayed from society's expectations of gender-appropriate behavior. Like all enduring myths and fairytales, they codified a wealth of meanings into simple form. They continued to be retold because they conveniently approximated the fork's chronological and geographical migration, even after their original subtexts were obscured.

The first concerns an eleventh-century Byzantine princess who married the Doge of Venice. St. Peter Damian (1007–1071) condemned her "excessive delicacy" of dining with a two-tined gold fork rather than with her God-given hands.[16] Two centuries later, St. Bonaventure (1221–1274) repeated Damian's parable, and called the

FIG 8. Knife. Probably Italian, 17th century. Steel, brass.

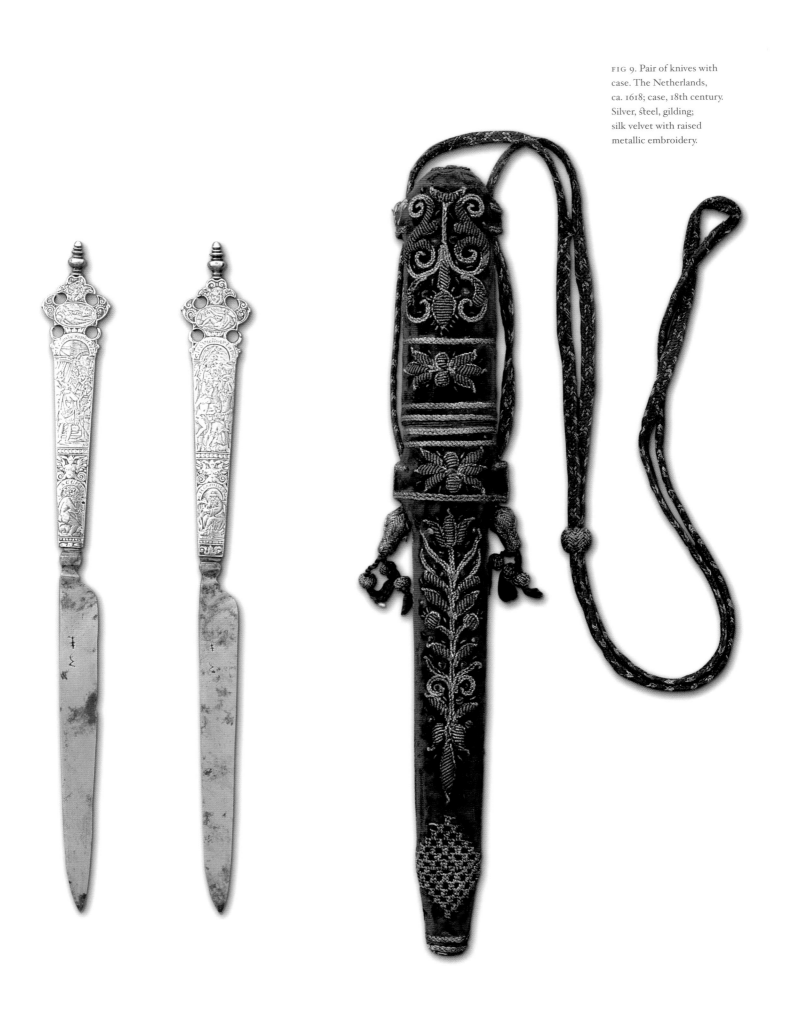

FIG 9. Pair of knives with case. The Netherlands, ca. 1618; case, 18th century. Silver, steel, gilding; silk velvet with raised metallic embroidery.

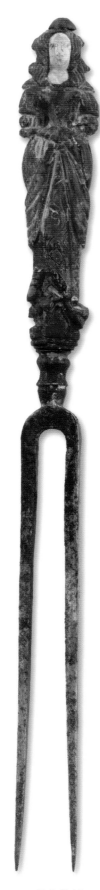

princess's premature death from plague "a just punishment from
God."[17] The church fathers regarded her as a witch-like cohort of the
most famous fork-wielder of all—the Devil. Some conjecture that
this ill-fated princess was Maria, sister to Emperor Romanus III Agyrus
(r. 1028–34), who married the eldest son of Doge Pietro II Orseolo
(r. 991–1009) and who died of plague in 1005, almost three-quarters of
a century before Damian wrote about her.[18] More commonly, she is
presumed to have been the Byzantine bride of Doge Domenico Selvo
(r. 1071–84).[19] Like Greek myths, the heroine is mutable, but the
essence of the legend remains the same—an exotic woman refused to
conform to local custom and instead flaunted her diabolical, vain
affectation. However, a manuscript illustration from the *Rabanus
Maurus Glossaria* of 1023 at Montecassino (fig. 11), which depicts two
men at table, each with fork and knife, demonstrates that Byzantine
ladies were not the only ones who protected their fingers with forks.

Strikingly similar is the oft-repeated legend which credits
Catherine de' Medici (1519–1589) with bringing the fork with her from
Italy to France when she married the future Henri II (r. 1547–59) in
1533. Recent scholars, including Barbara Ketcham Wheaton, have
disputed the idea that a teenage bride, married to the king's second
son (as Henri was when they wed), could have engineered such
a sweeping reform—especially since, when her husband finally did
inherit the throne, the arbiter of style was not Catherine but his
mistress, Diane de Poitiers (1499–1566).[20] Moreover, Catherine was
only one of innumerable Italian imports—including advisors, bankers,
artisans, artists, and crates of art and objects—of her father-in-law,
François I (r. 1515–47).

A 1589 inventory of Catherine's Parisian *hôtel particulier* documents
that she, indeed, owned a rock crystal-handled fork, *en suite* with
two nefs, a cup, two covered glasses and a vase; and two rock crystal
"estuys" filled with a matching set of coral-handled spoons, knives,
and forks.[21] The handles may have been as superbly carved as those
of a fashionable fork and spoon of similar date (see chapter opener).
Catherine probably owned many more forks. As was customary, she
traveled between properties with vast trunkloads of possessions.
Furthermore, the Bibliothèque Nationale de France possesses a first-
edition copy of Bartolomeo Scappi's *Opera* of 1570, which contains
the first engraving of a dinner fork, and which bears Catherine's royal
arms on its binding.[22]

Why, then, was Catherine credited with disseminating the dinner
fork through France? The first French text to describe a fork—C.
Calviac's *Civilité* of 1560—identifies it as Italian but does not mention
Catherine's name.[23] Significantly, the book's publication coincided
with Catherine's ascent to real power as Queen Mother and regent
to sons François II (r. 1559–60), Charles IX (r. 1560–74), and Henri III
(r. 1574–89). The civil wars and strife which followed redefined
Catherine's image as a manipulative, power-hungry "Machiavellian,"
and controlling Italian mother. Then, unhappy Protestants and
Catholics alike complained that "the Florentine" lavished riches on
Italian arrivistes, while the French paid the costs of war, famine,
and plague. They also blamed her for spreading decadent, Italianate
tastes, perhaps not to the whole court, but certainly to her favorite
child, Henri III.

FIG 11. Detail from *Glossaria*. Rabanus Maurus. Germany, 1023.

Whether he picked up the habit from his mother or in his travels to Venice, Henri III was famously implicated for fork-wielding in *L'Isle des hermaphrodites* by Thomas Artus. Published around 1605, during the reign of Henri IV (r. 1589–1610), the first Bourbon, who converted from Protestantism to Catholicism to solidify his throne, the text mocks the last of the Valois and his entourage of *mignons de couchette* (as many called the king's favorites) for their effeminate mannerisms and pretentious love of "everything that is new, unnecessary, or voluptuous." (In the period, "hermaphrodite" referred metaphorically to anyone with characteristics associated with the opposite sex.) The narrator expressed shock at witnessing the "hermaphrodites" dine with pronged forks, even though they awkwardly spilled more artichokes, asparagus, peas, and beans onto their plates than they put into their mouths.[24]

True or not, popular opinion regarded Henri III as a cross-dressing homosexual. That he and his pampered favorites used rarified, Italianate forks (fig. 12) was mentioned to reinforce that claim. Although Italy was not a nation, stereotypes of "Italian" character, including the widespread notion that all Italians were "effeminate sodomites," appeared regularly in contemporary pamphlets and travelogues.[25]

Such xenophobic prejudices influenced the regional use of cutlery. Eustachio Celebrino da Udine in Venice in 1526 specified, for the first time ever, that every place setting should include a fork and knife.[26] Spanish author Louis Vivès concurred around 1535.[27] By contrast, Calviac, in 1560, noted that the French might happily get through an entire meal sharing only two or three knives (and no forks) for the whole table.[28]

Protestants in particular resisted forks tenaciously. In 1518, Martin Luther (1483–1546) purportedly said, "God preserve me from forks."[29] Nationalistic anti-fork propaganda continued in Protestant strongholds through the Thirty Years War (1618–38). And, as late as 1835, in the Puritan culture of the United States, etiquette writer Eliza Ware eschewed forks as a fancied European affectation.[30]

Conversely, Vincenzo Cervio, in *Il trinciante*, published in Venice in 1581, explained that, although Italians occasionally employed talented commoners to carve, in France and Germany, where Teutonic

blood flowed thickest, only an aristocrat could do so.[31] Even today, particularly in English and American homes, the head of the family is still expected to carve the holiday roast with well-heeled dignity and grace, symbolically reenacting the rights of the lord of the manor.

In the second half of the seventeenth century, when the catchword of the era was *propreté*, which has the triplicate meanings "proper," "clean," and "one's own," the fork gained ground. Memories of Catherine and Henri III had faded, and France once again fell in love with the Italianate—from art, architecture, and music to fireworks, iced wines, and forks. French aristocrats began to offer guests individual forks, knives, and spoons, and serving implements appeared. Imitators throughout Europe, spellbound by the glamour of Versailles, soon followed suit.[32]

As the three basic utensils started to operate in tandem, their more potent gender connotations were subdued. Norbert Elias argued extensively that, as Western society became increasingly uncomfortable with feelings of suspicion and violence conjured by knives, their use became marginalized. Medieval injunctions against pointing them or cleaning one's teeth with them gradually evolved into Victorian etiquette's mandate that they be used only when absolutely necessary. However, society's need to mitigate the knife's implied brutality was only part of what occurred. The spoon's safely maternal associations made it seem progressively infantile and unsophisticated, and its use was equally restricted to the eating of soup or liquid foods, even as its popularity as a sentimental keepsake rose. The sexually ambiguous fork increasingly performed functions previously carried out by the more overtly male knife and female spoon. Not coincidentally, this process reached its nadir in the highly repressive Victorian era. Nevertheless, even when a menu does not require them, a well-laid table seems incomplete without a spoon and knife. This is because our desire for their symbolic evocations of nurture and of the hunt outweighs the demands of practical necessity.

Similarly, the fork's unsettlingly effeminate aura never vanished for some. Because they considered forks "unmanly," British sailors ate without them as surprisingly late as 1897.[33] And, in 1931, the French Surrealist poet René Crevel plumbed the psychosexual imagery of cutlery in *Mr. Knife Miss Fork* to describe the fantasies of a young girl who pretends that the knife is her father, and the fork the glamorous redheaded English adventuress who ran away with him. Attracted to grown-up words that no one will explain to her, the girl imagines that Mr. Knife tells Miss Fork, "You are like death, Cynthia, you are a whore like death, Cynthia, my darling, my little whore."[34] Nearly a millennium after St. Peter Damian decried the Byzantine princess and her fork, Crevel conjured her essence.

Whether or not we are conscious of the fact, cutlery's hidden social and sexual meanings continue to reverberate. We acknowledge these in the gifting of a silver spoon, the cutting of a wedding cake, and the solemn carving of a roast, but also unwittingly honor them merely by picking up a fork or by laying the table with each utensil in its proper place.

(OPPOSITE)
FIG 12. Fork. Italy or France, ca. 1550. Steel, bronze, gilding.

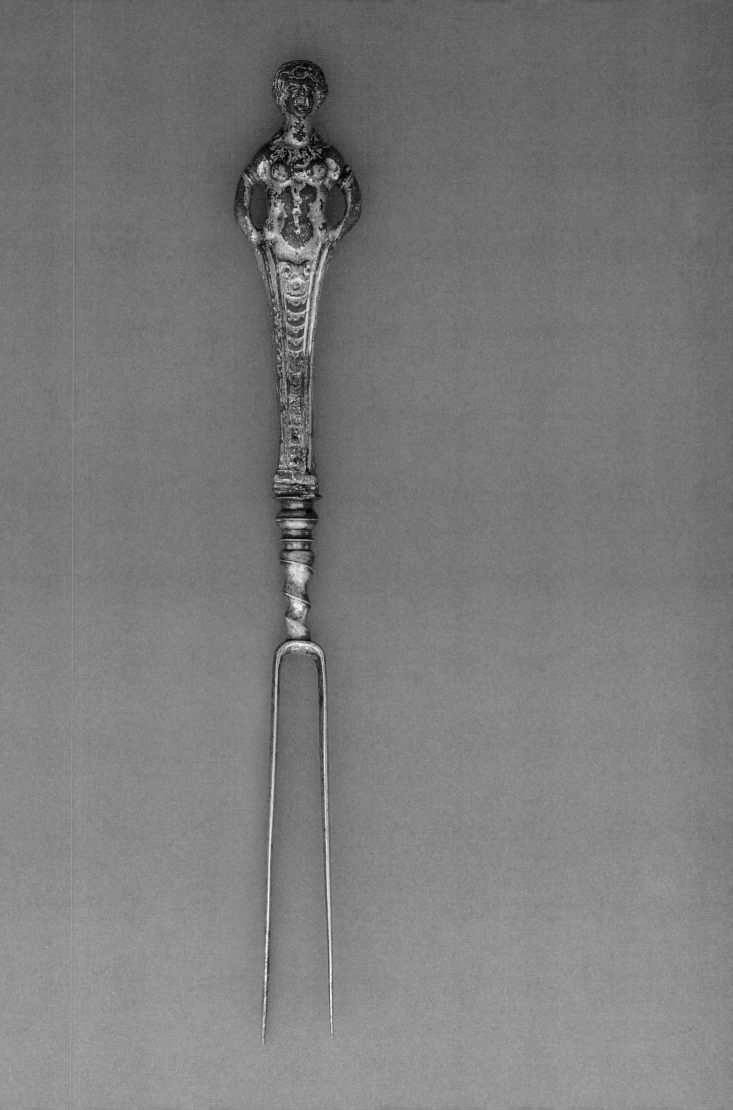

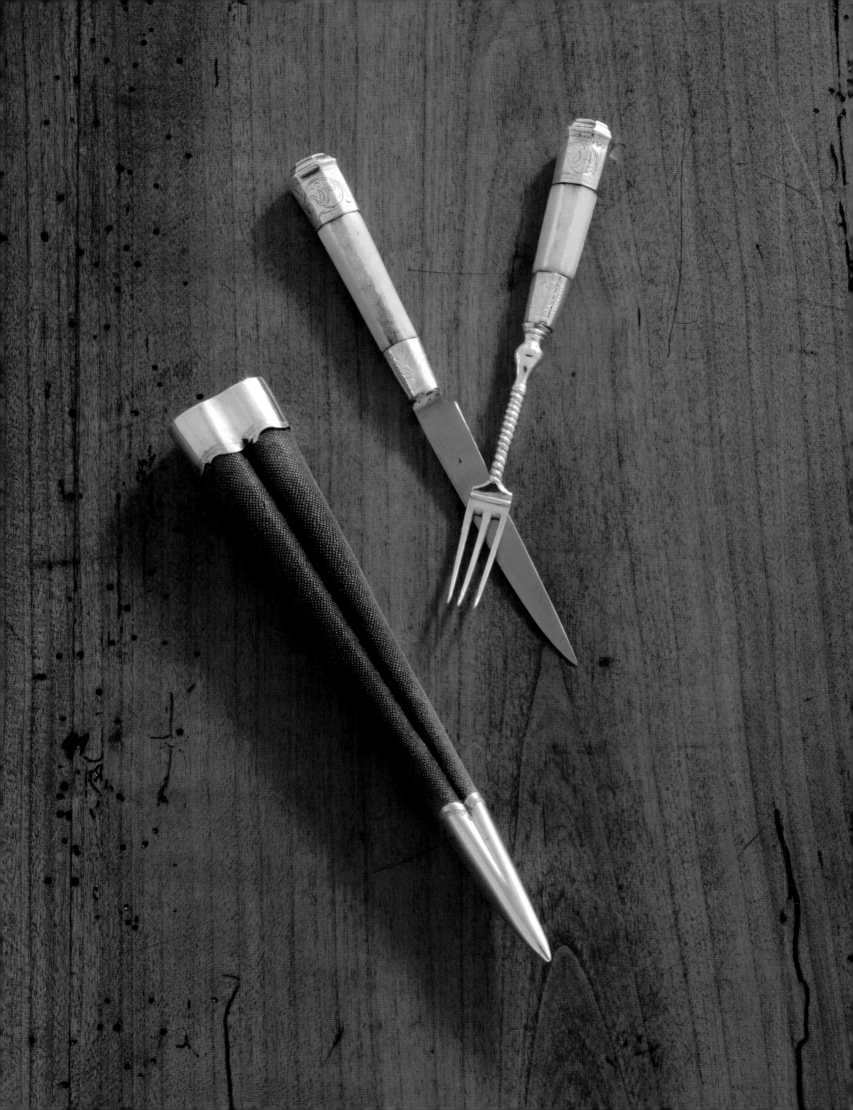

Implements of Eating

DARRA GOLDSTEIN

I am suited to snails
But am no less useful for eggs.
You don't know, do you,
Why I'd rather be called a cocleare?

—MARTIAL, *EPIGRAMS*, BOOK XIV, CXXI[1]

(OPENING SPREAD)
Traveling fork and knife
in case. Amsterdam, the
Netherlands, ca. 1700.
Bone, silver, steel, sharkskin.

(THIS PAGE)
FIG I. *Cochleare* spoon.
Romano-British,
ca. AD 300. Bronze.

(OPPOSITE)
FIG 2. Plate XCIV from
*Liber Chronicarum, Registrum
huius operis libri cronicarum
cu[m] figuris et ymagi[ni]bus ab
inicio mu[n]di*. Written by
Hartmann Schedel. Printed
by Anton Koberger.
Nuremberg, Germany, 1493.

In this image from the *Liber
Chronicarum*, there are no
forks on the table, only sharp
dagger-like knives and per-
haps a presentoir, a knife
with a broader blade for
serving—this one poised
rather nonchalantly on the
head of St. John the Baptist.

WITH APPETITE COMES DESIRE. BUT WHAT IS THE OBJECT OF THAT DESIRE? A HEARTY BOARD, OR AN ELEGANT REPAST?

A communal bowl to scrape with latten spoons, or a sumptuous display of silver utensils framing individual plates? The history of flatware, particu-larly the fork's slow ascent toward acceptance, is really an extended debate over what is couth or uncouth, or even *too* couth, at table. This history reveals a great social struggle between the convivial and the individual, between function and fashion, simplicity and pretension, gracelessness and savoir faire. The progress of the fork traces nothing less than the development of Western civilization.[2]

The earliest eating utensils consisted simply of sharpened sticks or pieces of flint for spearing, and shells from bivalves like oysters and clams that could be used as natural scoops. Because the heat of an open fire could easily burn the diner—who may have been eager to sample boiling soup from an early cauldron, perhaps an animal skull—it made sense to affix a stick to the shell to form a handle that would distance the hand from the heat and steam. In this way, the development of eating utensils reflected our relationship to nature: as we examined natural forms, we adapted them to our needs. As the centuries progressed, cutlery evolved in response to the diner's need to satisfy both appetite and desire—to get at that morsel and pop it into the mouth. By the late nineteenth century, however, eating uten-sils had moved beyond functionalism to artifice. So many different forms had been created for affluent Western tables that they actually became an impediment to the meal, rather than an aid, thereby beg-ging the question of cutlery's role in the civilizing process.

The ancient Romans feasted on snails and raw eggs, but both deli-cacies lie encased in shells, making hands ill-suited to the task of extri-cating them. So the Romans devised a special implement, the *cochleare*, to pry the delectable snail from its shell and release the golden yolk

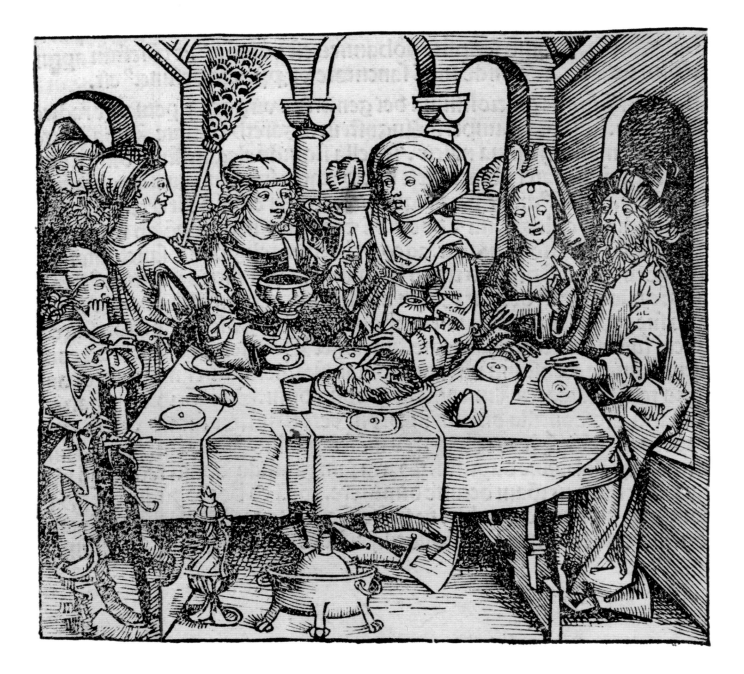

without mess. This spoon had a long handle with an awl-like tip that could be used to dig into snail shells or neatly pierce the ends of an egg so that the diner could suck out its contents (fig. 1). Although the tip could also be used to impale bits of food and transfer them to the mouth, the implement's name—derived from the Latin word for "snail," *coclea*—reflects its principal use, and the answer to Martial's rhetorical question. The *cochleare* differed from a second type of Roman spoon, the *ligula*, which had a round or oblong bowl and was used primarily for soups. Some *ligulae* had straight handles; the handles on others were ergonomically curved to allow the diner to hook a finger into them for ease of manipulation.[3]

Until the late fifteenth century, the knife and spoon sufficed for most purposes in Western table culture (fig. 2). The fork had been known in Roman times, but it was not considered a necessary piece of individual flatware like the spoon. Given their posture of reclining at

FIG 3. Fork from a traveling set. Hungary, ca. 1690. Steel, mother-of-pearl, horn.

table, the Romans would have had a difficult time manipulating the trinity of knife, fork, and spoon that we use today; the left hand could, at most, have balanced a plate for the right hand to pick morsels from. The use of forks as personal implements gained ground in Byzantium, where they were known from at least the sixth century, although they were not widespread until the tenth century.[4]

Nearly every history of cutlery repeats the same story of early resistance to the fork in the West (and Carolin Young mentions it briefly in her essay): When, in the eleventh century, the Princess of Byzantium married the Doge Domenice Silvie of Venice, she insisted on using a fork for her sweetmeats in order not to soil her lovely fingers. The princess was roundly castigated for this unseemly practice. After all, food was a gift from God, and to use an artificial means of conveying it to the mouth implied that this heavenly gift was unfit to be touched by human hands. The resemblance of the two-pronged fork to a pitchfork, an abstraction of the Devil's horns, aroused further suspicion.[5] Unfortunately, the princess fell ill soon after her arrival in Venice. She suffered a terrible death, which to opponents of the fork only confirmed their suspicions about her depravity and consorting with the Devil.[6]

A taste for sweetmeats gradually eased the fork's acceptance into Western courtly circles, however. In the eighth century, the Persians had improved ways to refine sugar, but until the early Middle Ages, this foodstuff was reserved largely for medicinal use. Increased trade with Arabia and North Africa brought greater availability, and gradually sugar began to replace honey in preserved fruits and candied nuts. Whole preserved fruits were a particular luxury because their preparation called for copious amounts of sugar. Such sweetmeats, also known as "suckets," were featured in a special "banquette" course that followed the main meal.[7] A small, two-pronged fork proved highly useful for eating these sticky treats. Etiquette manuals from the Italian Renaissance note the importance of the fork to seemly manners: using a fork signaled courteous behavior, itself a reflection of inner virtue (fig. 4). Along with other Italian fashions, the use of a small fork used for sweetmeats and fruits in fifteenth-century Italy eventually spread throughout Europe (fig. 3).

FIG 5. Pair of sucket forks. William Rouse. Boston, Massachusetts, 1677. Silver.

Its acceptance was hardly immediate. As Carolin Young notes in her essay, Thomas Artus's scandalous tract, *L'Isle des hermaphrodites* (1605), mocked Henri III for his "effeminate" use of the fork. Englishman Thomas Coryate encountered similar problems when he introduced the fork after a 1608 visit to Italy. Coryate earned the moniker of "Furcifer," or "fork-bearer," for his proselytizing; in England, as on the Continent, the fork was seen as unmanly. Whether a head of household or head of state, a man was judged by his ability to be effective, bold, and tough—all attributes that the fussy fork seemed to call into question. In fact, it wasn't until the end of the seventeenth century that use of the fork became generalized throughout Europe, and even then it was confined to the moneyed classes. Well into the nineteenth century, both in Europe and in America, regular folks continued to rely on the knife for cutting and spearing and the spoon for slurping liquids.

Still, those who could afford the luxury of sweetmeats found it hard to deny the suitability of the fork, especially for spearing sticky "dry" ones like glacéed fruits. Lovers of "wet" suckets—fruits preserved in sugar syrup—still had a difficult time: While the fork could successfully spear the fruit, it left the delicious syrup behind. And so the sucket fork (sometimes also known as a sucket spoon) was devised, a clever implement with a two- or three-pronged fork on one end and a spoon on the other for scooping up the syrup (fig. 5). These sucket forks, used almost 200 years before dinner forks came into common use in England during the Restoration, were favored for the green ginger preserves that the Elizabethans so loved (fig. 6). They continued to find favor across the ocean in seventeenth-century America, especially among women.[8] Silver was the metal of choice for those who could afford it: besides preventing contact with harmful base metals, it precluded the tainting of food with the tastes of these metals. Silver sucket forks were the length of a contemporary dessert fork.[9]

Despite the eventual acceptance of forks, most people, including the most refined, persisted in eating with their fingers (fig. 7). Queen Elizabeth used her fingers even though she owned forks; she considered spearing an uncouth action.[10] And we know that Geoffrey Chaucer's Prioress, a woman of good breeding, knew how to eat daintily with her fingers:

> *At meat her manners were well taught withal;*
> *No morsel from her lips did she let fall,*
> *Nor dipped her fingers in the sauce too deep;*
> *But she could carry a morsel up and keep*
> *The smallest drop from falling on her breast.*
> *For courtliness she had a special zest,*
> *And she would wipe her upper lip so clean*
> *That not a trace of grease was to be seen*
> *Upon the cup when she had drunk; to eat,*
> *She reached a hand sedately for the meat.*[11]

As late as the fifteenth century in England, the dipping of fingers into a common bowl was still standard practice. Even in cultured circles in France, the land of elegant style, fingers were long the implement of choice. The great essayist Michel de Montaigne rarely made

FIG 6. Sucket fork. Austria or France, ca. 1840–45. Silver, wood.

(NEXT SPREAD)
FIG 4. *The Wedding Feast.* Sandro Botticelli. Florence, Italy, 1483. Oil on canvas.

In Botticelli's *The Wedding Feast,* the women seated at the table on the left are using small two-pronged forks to eat sweetmeats.

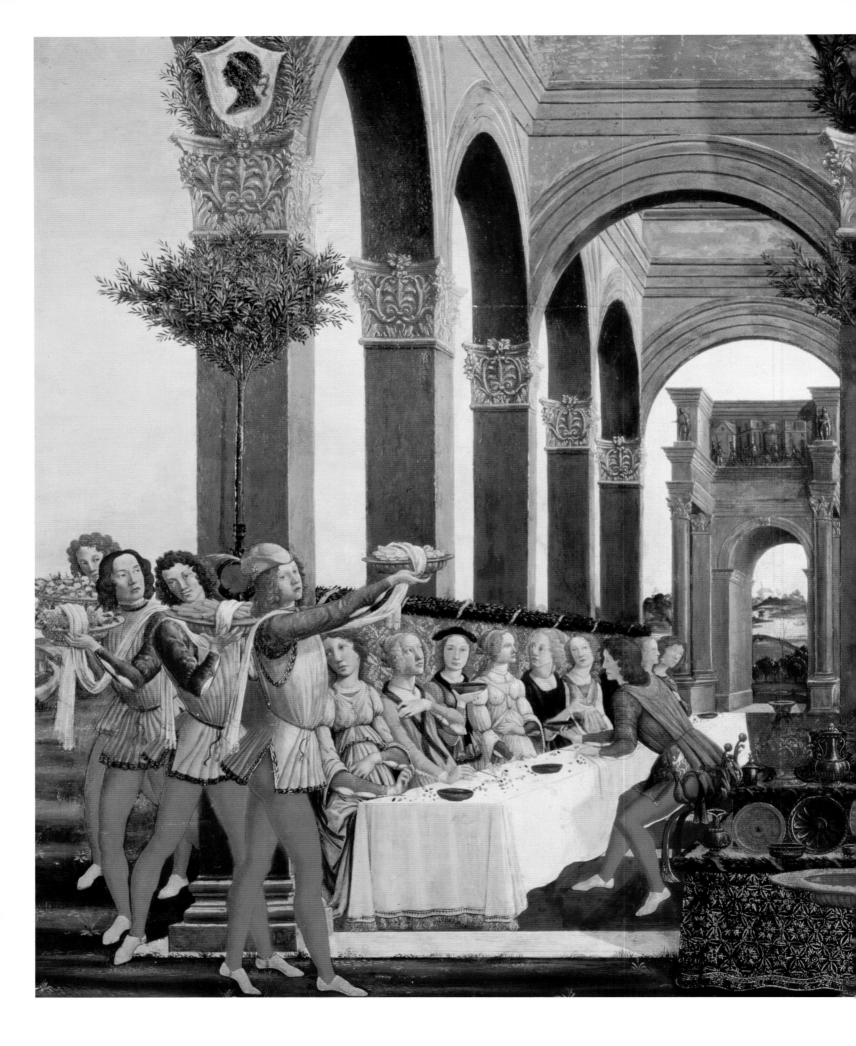

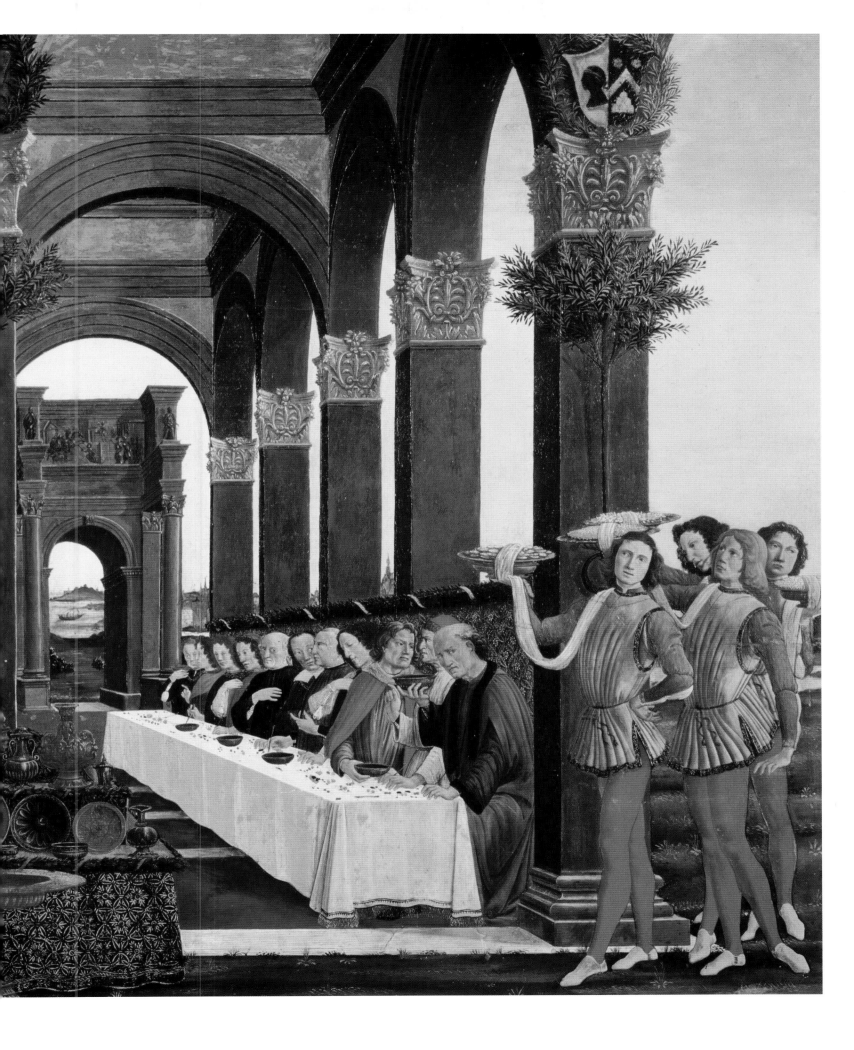

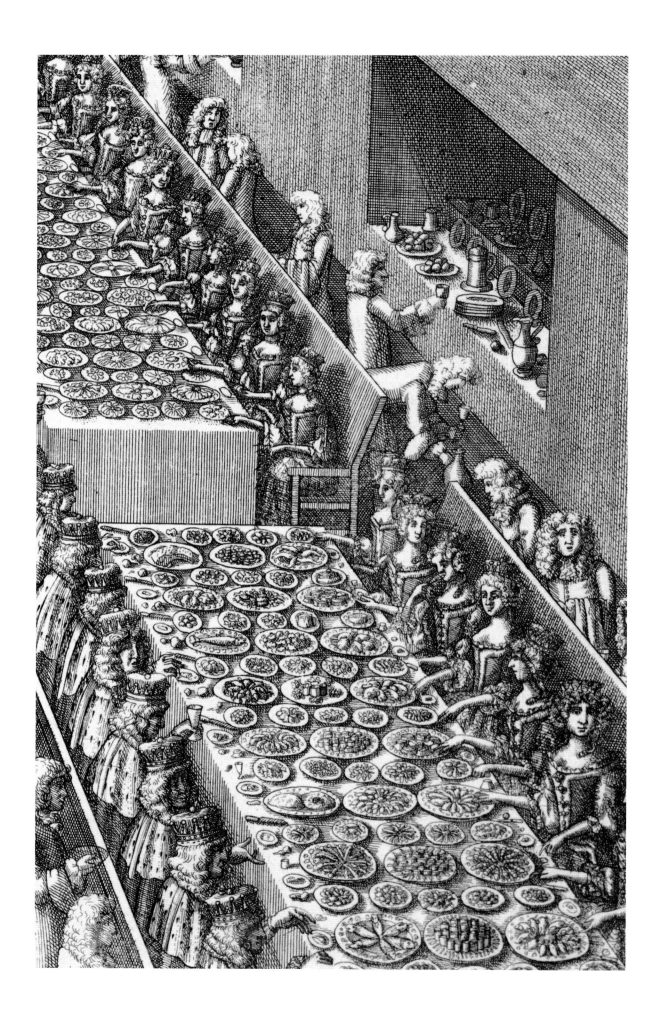

(OPPOSITE)

FIG 7. Detail from plate, "A Prospect of the Inside of Westminster Hall...," from *The History of the Coronation of...James II... King of England, Scotland, France and Ireland, and of Queen Mary...in... Westminster...the 23 of April 1685....* Written by Francis Sandford. Printed by T. Newcomb. London, England, 1687.

This festive table is set *à la française*, or in the French style, with all the foods for the course arrayed at once. Although there are no forks on the table, the knives have blunt tips, a peaceful modification that occurred after the introduction of the fork, which replaced the knife for spearing. However, the guests are still eating with their hands.

use of either spoon or fork, and acknowledged that he would often "bite my fingers in my haste."[12] King Louis XIV is said to have been the first host in Europe to provide his guests with a complete table setting so that they didn't have to bring their own[13]; yet, as mentioned in an earlier essay, for all the refinements he introduced to his court, he disliked forks and favored fingers for eating. In his account of life at Versailles, Saint-Simon reports that the king was dexterous enough to eat chicken stew by hand without spilling it.[14] Perhaps Louis took a cue from his mother, who "did not hesitate to plunge her lovely hands right into a stew in order to bring to her mouth many a savory bite, from meats to jams."[15]

But certain foods were too slippery to be easily handled by the fingers, and if we are to believe the Italian historian Giovanni Rebora, it was pasta that encouraged the development and spread of the fork, first in Italy and then beyond. In *Culture of the Fork*, Rebora states that "use of the fork accompanied the spread of pasta, and in fact seems limited, from the Middle Ages until at least the end of the second half of the sixteenth century, to those areas where pasta was eaten."[16] For ease in picking up slick noodles, the fork replaced the wooden *punteruolo*, a single-pronged utensil similar to a skewer or spike.

But not everyone dined on pasta, and too often the fork made early users feel either clumsy or effeminate. Many further complained that it distanced them from their food. Yet, as medieval patterns of communal life shifted toward increased sensitivity to the individual, the fork became ever more prominent. Diners grew increasingly aware of their tablemates and took pains not to offend anyone with coarse manners. At the same time, issues of hygiene came to the fore. Shared utensils meant shared germs; individual sets of cutlery and greater physical space between diners minimized the risk of contagion. In place of the medieval shared trencher, a separate plate was set before each diner, initially with only a spoon and knife, but eventually with a fork as well. Once the fork was adopted, hands no longer reached into the common serving bowl. The use of the fork was encouraged by a series of etiquette manuals, most famously Erasmus's 1530 *De civilitate morum puerilium*, which equated good manners with virtuous behavior. Thus the fork became a physical manifestation of a new code of politesse (figs. 8, 9).

The new table settings reflected the newly privileged individual, but they came with a certain loss of conviviality. Individual plates and eating utensils took up more space and, thus, increased the distance between seated diners. Meanwhile, the grand communal banquet halls gave way to increasingly private dining rooms, so that by the eighteenth century, not even servants were supposed to be seen at the most intimate meals—a practical accommodation taken care of by devices like the mechanical table, which enabled dishes to be replaced without visible human intervention.

Fine place settings demonstrated the status and wealth of their owners; they also represented a certain savoir faire in the implied mastery of their use. Still, what was one to do with newly fashionable *petits pois*, or peas, which were *une mode, une fureur,*[17] or all the rage, in late seventeenth-century Europe? Forks were not of much use in stabbing tiny peas. It was at around this time that the sharp, pointed blade of the table knife became both blunter and wider, to facilitate

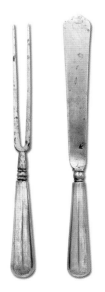

FIG 9. Fork and knife. England, ca. 1690. Brass, steel.

FIG 8. Fork and knife. The Netherlands, ca. 1660. Steel, enamel, silver.

scooping up foods like peas and conveying them to the mouth without risk of wounding oneself (fig. 10). The design of spoons changed, too. For centuries they had been made to be held in the fist, a practice that led to a good deal of slurping whenever soup was consumed (fig. 11). By the mid-1600s, however, the design had evolved so that the spoon could be held with two or three fingers[18] to facilitate more graceful maneuvering (fig. 12). But for reasons that remain unclear, the spoon was marginalized in favor of both the knife and the upstart fork, even for the consumption of foods that would seem naturally suited to it. As late as 1828, on a visit to the United States, the Englishwoman Mrs. Basil Hall wrote:

> *One and all, male and female, eat invariably and indefatigably with their knives. It goes rather against one's feelings to see a prettily dressed, nice-looking, young woman ladling rice pudding into her mouth with the point of a great knife, and yesterday to my great horror I saw a nursery maid feeding an infant of seventeen months in the same way. I must own the woman deserved credit for her dexterity in not cutting the child's mouth.[19]*

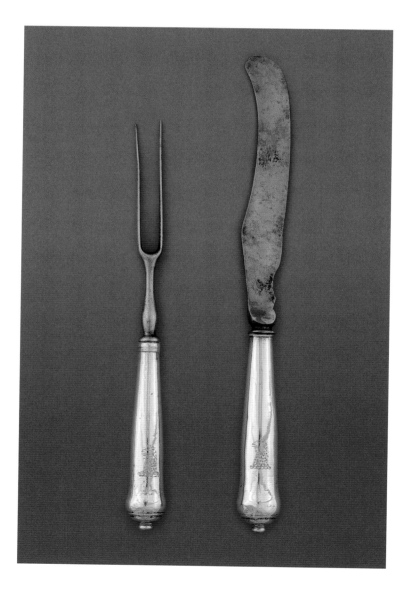

(LEFT)
FIG 10. Fork and knife. Europe, ca. 1700. Silver, steel.

(ABOVE)
FIG 11. Folding fork and spoon. The Netherlands, possibly Zeeland, early 17th century, with later inscription "R Brijsma Anno 1753." Silver.

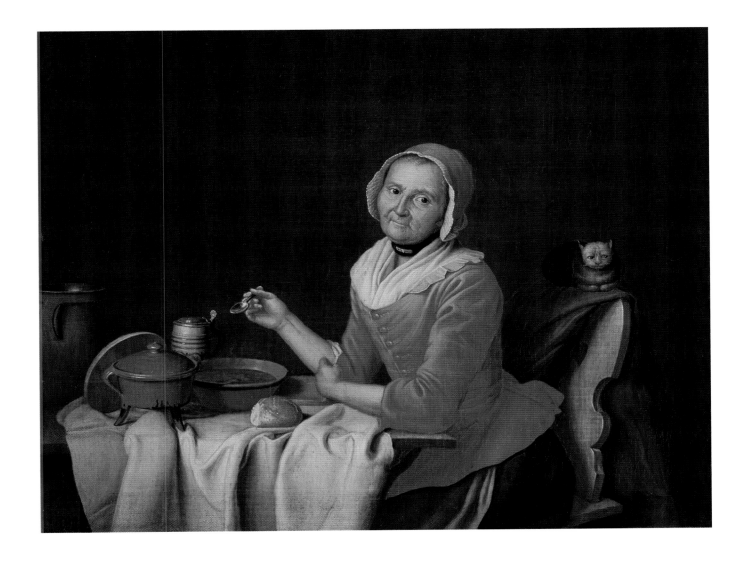

(ABOVE)

FIG 12. *The Soup Eater*.
Peter Jakob Horemans.
Flanders, 1764.
Oil on canvas.

By the mid-eighteenth
century, the shaft of
the spoon was narrow
enough to be held
gracefully with two or
three fingers.

(RIGHT)

FIG 13. Detail of *Manners
at Table, 1800*, vol. 1, p. 131.
Lewis Miller.U.S.A.,
1865. Watercolor.

Even though the table
is set with forks, this
uncouth American diner
continues to eat with
his knife.

Yet at least one American arbiter of taste railed against the imposition of European manners. In 1837, Eliza Farrar, the spirited wife of a Harvard professor, wrote:

If you wish to imitate the French or English, you will put every mouthful into your mouth with your fork; but if you think, as I do, that Americans have as good a right to their own fashions as the inhabitants of any other country, you may choose the convenience of feeding yourself with your right hand, armed with a steel blade; and provided you do it neatly, and do not put in large mouthfuls or close your lips tight over the blade, you ought not to be considered as eating ungenteelly.[20]

When Farrar published her book, the memory of the British colonial yoke was not all that distant; plenty of Americans remained proud of their independent, rough-hewn ways, and rejected any facile imitation of European trends (fig. 13). Still, such stalwarts could not hold out long against the latest mode. After the newly discovered process of electroplating and the discovery of Nevada's Comstock Lode made silver, or its look-alike, accessible to the American middle class in the mid-nineteenth century, the fork came into widespread use.[21] One opinionated editor at *Scribner's Monthly*, writing nearly forty years after Mrs. Farrar, concurred with her ideas about what constitutes genteel manners in the use of knife and fork:

We remember reading of three unfortunate ladies who were entertained one summer day at the house of a country friend, and whose consequent sufferings were so remarkable that they will serve to point a little moral. These ladies were very high-toned, so to speak. They were so very genteel and so extremely proper in their manners, that if society conferred degrees they would have been Mistresses of Social Arts and Doctresses of Social Laws.

So these three high-toned ladies sat down to dinner in the house of their country friend, and there were peas on the table. "Peas," wrote one of the immaculate trio, "such as we never see in town—fresh, green, plump, and luscious, and so delightfully hot and tempting! But as the forks had only two prongs, making it quite useless to try to eat peas with them, we were obliged to leave the delicious things on our plates. The family ate their peas with their knives, but of course we could not do that."

Now our opinion may be social heresy, but we certainly believe that a true lady would have eaten those peas with her knife, simply because she would have known that the laws of true politeness made it imperative upon her to use her knife in such a case. But this genteel trio did not appear to understand that politeness requires a greater attention to the feelings of others than to mere forms; that what is very genteel in one place is often quite boorish in another, and that there is a hyper-gentility and a plu-propriety which is offensive to the nostrils of a true gentleman or lady.[22]

By this time, the fork was such an object of fashion that diners were admonished to use it for all sorts of foods, even for those to which it was not perfectly suited. Until 1922, for instance, proper etiquette demanded that specialized forks be used for eating ice cream.[23] Not everyone was happy with this fad. As Florence Howe Hall, the grand-daughter of Julia Ward Howe, complained in 1887:

> *The fork has now become the favorite and fashionable*
> *utensil for conveying food to the mouth. First it crowded out*
> *the knife, and now in its pride it has invaded the domain of the*
> *once powerful spoon. The spoon is now pretty well subdued*
> *also, and the fork, insolent and triumphant, has become a sump-*
> *tuary tyrant. The true devotee of fashion does not dare to use*
> *a spoon except to stir his tea or to eat his soup with, and meekly*
> *eats his ice cream with a fork and pretends to like it.*[24]

The more diners resorted to the fork, the more they noticed its limitations. A two-tined fork may be useful for spearing, but it is not a good tool for eating delicate foods like flaky fish or pastry. To meet this need and other presumed ones, flatware manufacturers stepped into the breach, paying greater attention to the shape of the utensils as they related to food. Although multi-tined forks had periodically been manufactured for centuries, dinner forks were now regularly made with several tines (usually three or four, but on occasion up to five or six) rather than with two long, widely spaced straight ones. In this way, the diner could spear food without having to twist the fork and risk damaging a delicate morsel or, worse yet, having the food fall off the tines or slip through the space between them. The additional tines, now molded in a slightly curved fashion, helped to scoop up food like a spoon, and the curve allowed for a clearer view of the food being cut.[25] Fish forks were designed with four tines, of which the outer two curved slightly for ease in picking up flaked pieces of fish. A special pastry fork, or "cutting fork," was patented in 1869 by Reed & Barton, with one thick outer tine sharp enough to cut the pastry.[26] Its remaining tines functioned like those on a regular fork to bring the food to the mouth.

American silver manufacturers were extraordinarily inventive when it came to flatware design for the moneyed classes. Like the perfect household servant, the manufacturers not only responded to, but even anticipated, the whims and requests of their clients. This attentiveness, reinforced by attractive advertising in jewelers' books and illustrated volumes of silver patterns, helped to spawn the vigorous consumer culture that characterized the last decades of the nineteenth century. One of the first implements the silver manufacturers toyed with was the spoon. In the 1860s, a new style was devised with a round bowl which enabled diners to eat soup from the *side* of the bowl rather than from the front—an innovation that entailed less slurping.[27] As the author of *True Politeness*, a late nineteenth-century etiquette manual, admonished, "Soup must be eaten from the side, not the point of the spoon; and, in eating it, be careful not to make a noise, by strongly inhaling the breath: this habit is excessively vulgar. You cannot eat too quietly."[28] A further innovation had to do with the curvature of the back of the spoon, which, in contrast to English design practice, was

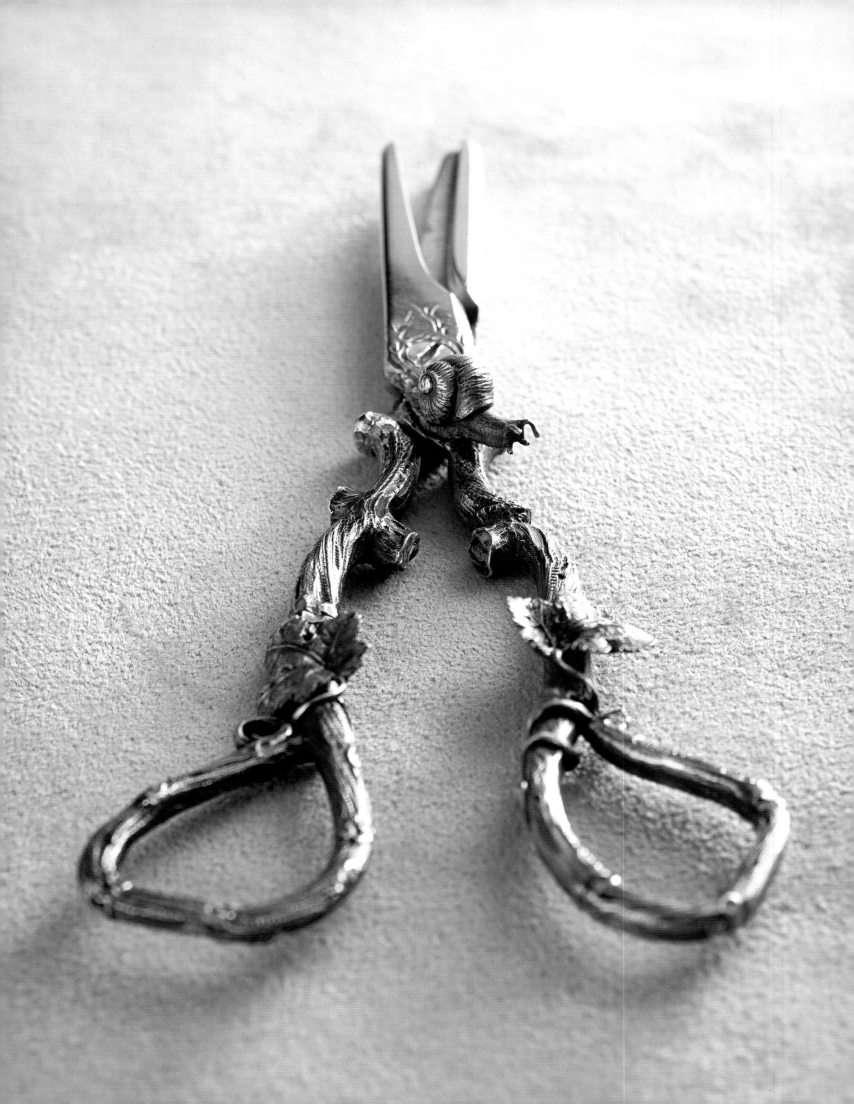

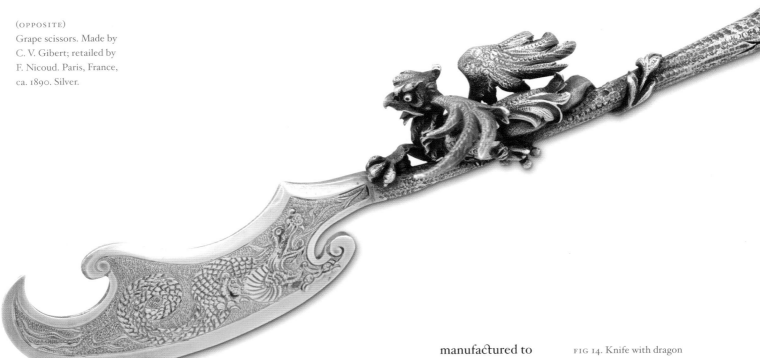

(OPPOSITE)
Grape scissors. Made by
C. V. Gibert; retailed by
F. Nicoud. Paris, France,
ca. 1890. Silver.

manufactured to
catch on the rim of the soup
plate so that it would not slip in—
a problem with porcelain's slick surface. These
newfangled soup spoons were the size of present-day
serving spoons. Their large size prompted the development of
yet another type of soup spoon, this one for the stylish bouillon often
served in small cups at the beginning of meals . The bouillon spoon was
designed to be smaller and less unwieldy than the cream soup spoon,
though it still had a circular bowl rather than an ovoid one. By contrast,
the dessert spoon had an oval bowl that allowed for "a nice, clean frontal
entry into mouth."[29] Dessert eaters faced another problem, however.
Acidic fruits can discolor silver and leave an off taste, so dessert spoons
(and fruit knives) were often gilded to avoid corrosion, a practice begun
in the sixteenth century (fig. 14). As is obvious from such refinements
in design, by the late nineteenth century, the use of cutlery reflected an
abundant table even among the middle classes, in contrast to the early
modern period in Europe, when for most people the issue had been
subsistence. Now the focus was pleasure, not sustenance, and showy
displays of vast quantities of food gave way to an appreciation of quality
and taste.

Beginning in the fifteenth century, increased global trade had
put on the table a greater variety of foodstuffs, many of which took
Europe by storm. Newly introduced beverages like chocolate (six-
teenth century), tea (late sixteenth to early seventeenth century), and
coffee (seventeenth century) called for new implements, which led
to the development of chocolate spoons, teaspoons, and coffee spoons,
as well as other accoutrements for the tea table, such as caddy spoons,
cream ladles, and sifter spoons. By the first decade of the eighteenth
century, afternoon tea had become an important social function in
England, and the size of ladies' teacups brought about a shortening of
the spoon handles to better accommodate them. The size of caddy
spoons was directly proportional to the cost of the tea itself. Initially
quite small when tea was new and expensive, these spoons grew

FIG 14. Knife with dragon
on handle from Gibert-
Nicoud dessert service.

(NEXT SPREADS)
Detail of bon bon spade
from Gibert-Nicoud
dessert service.

Sugar sifter (top) and
berry spoon (bottom)
from Gibert-Nicoud
dessert service.

Group of teaspoons
from Gibert-Nicoud
dessert service.

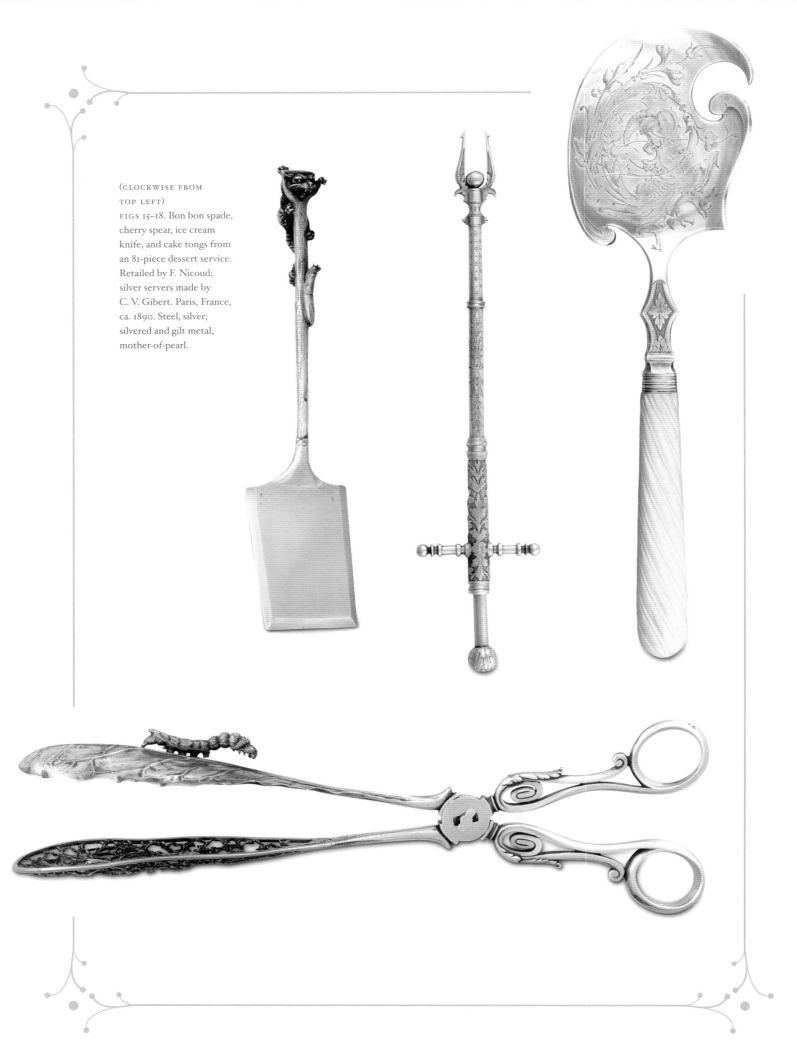

(CLOCKWISE FROM TOP LEFT)

FIGS 15–18. Bon bon spade, cherry spear, ice cream knife, and cake tongs from an 81-piece dessert service. Retailed by F. Nicoud; silver servers made by C. V. Gibert. Paris, France, ca. 1890. Steel, silver; silvered and gilt metal, mother-of-pearl.

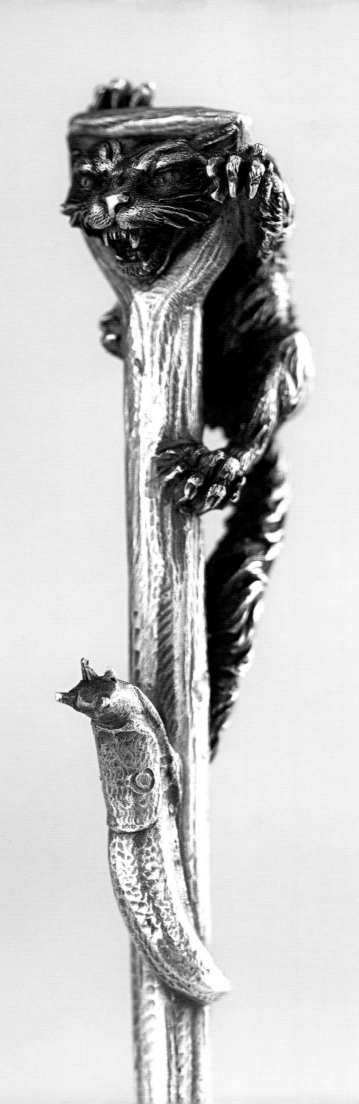

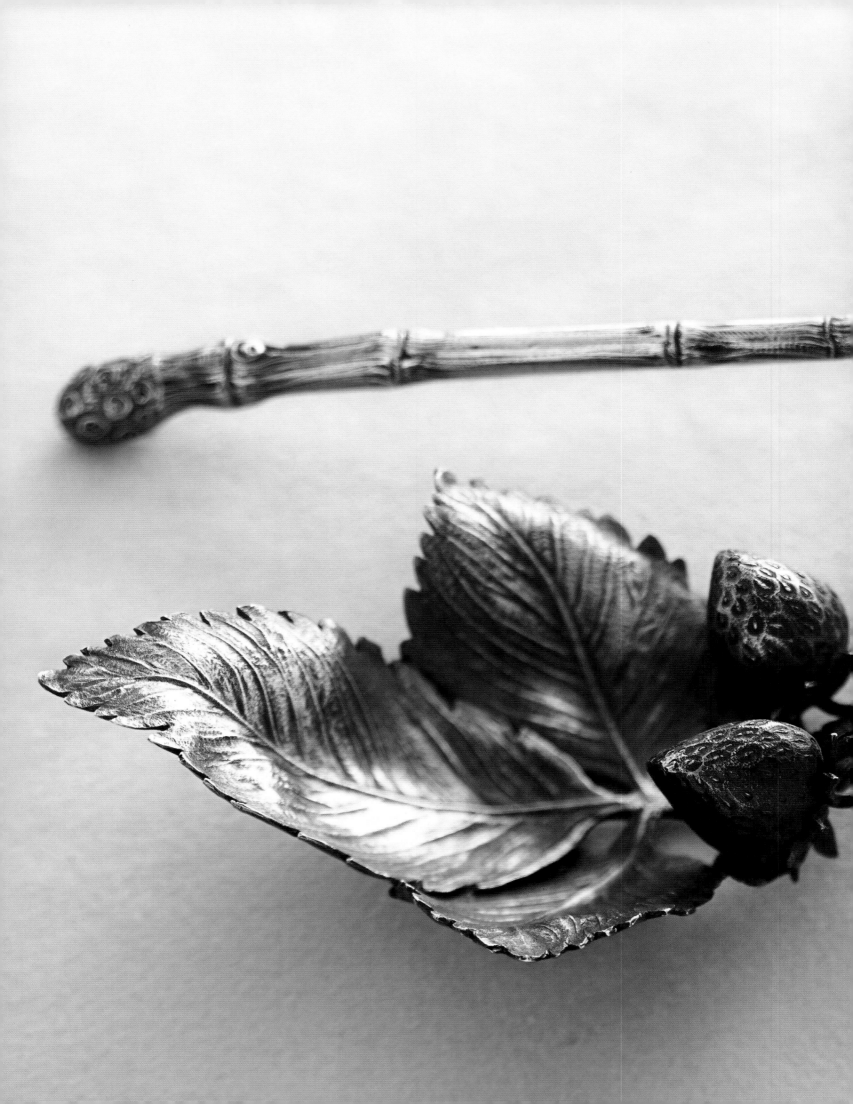

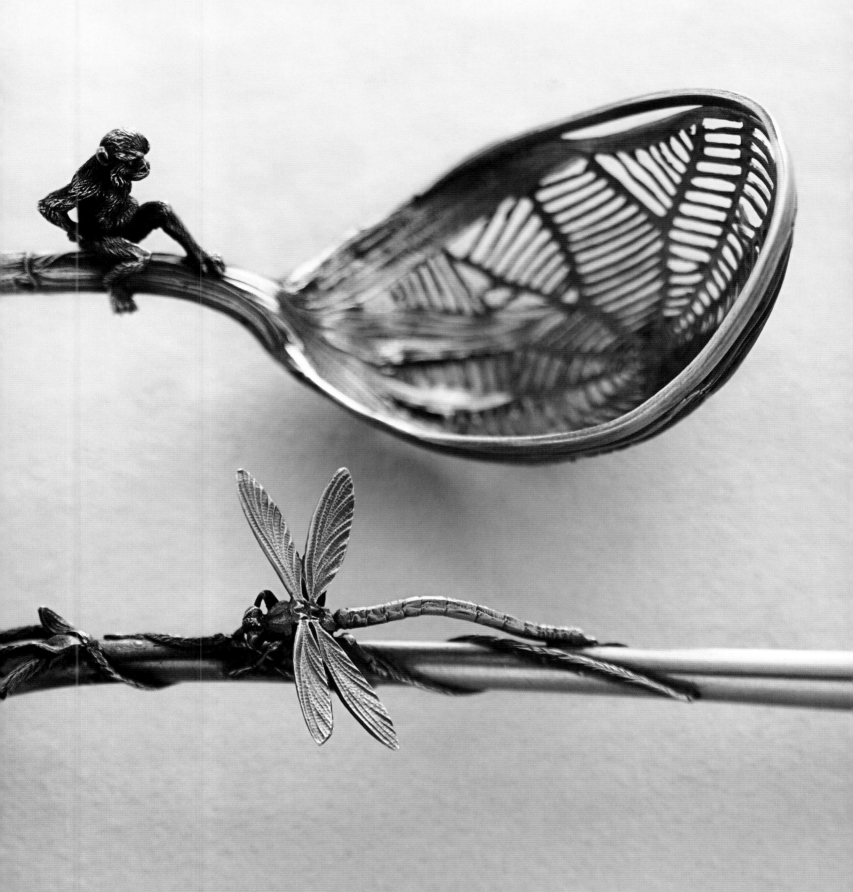

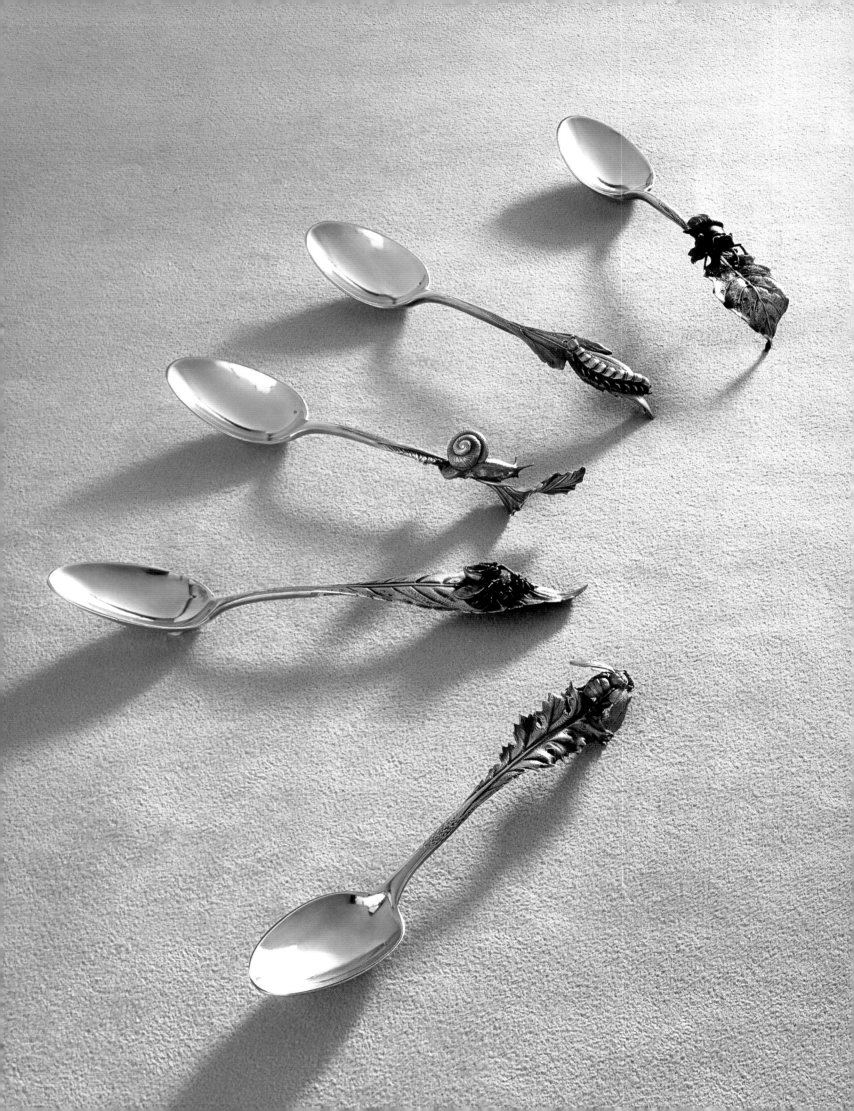

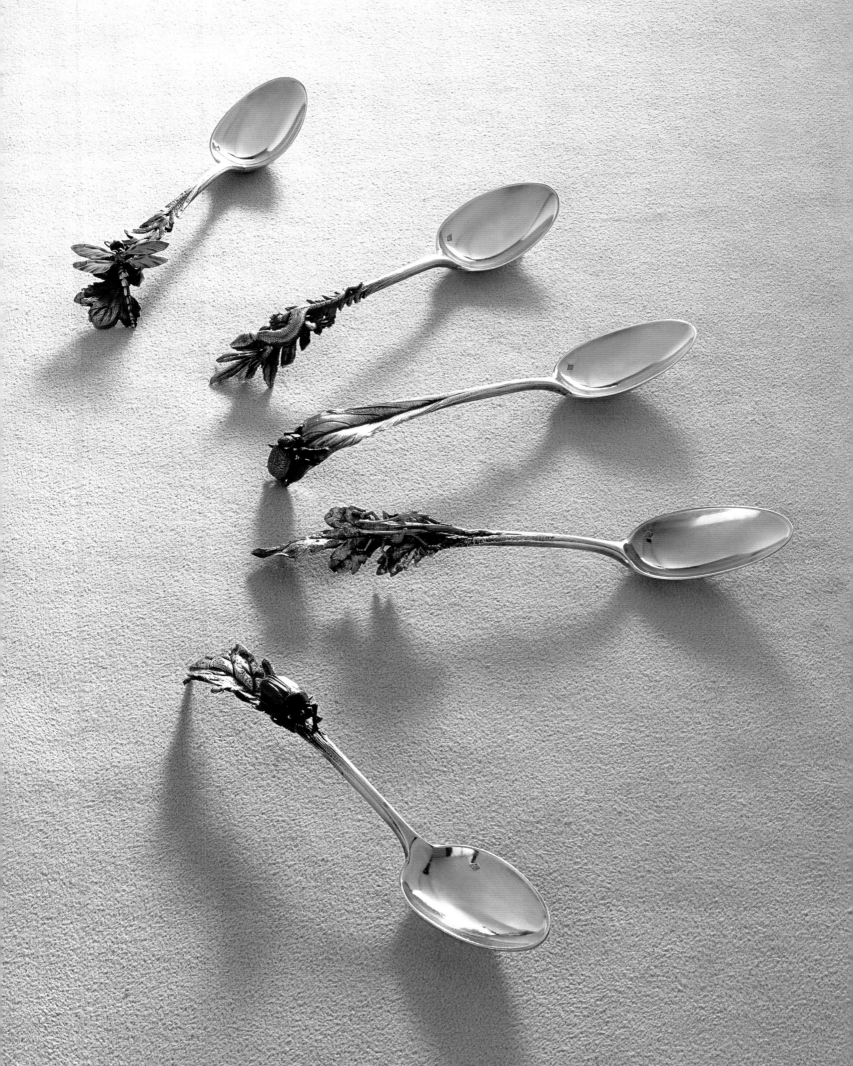

progressively larger as tea declined in cost (figs. 19, 20). Similar changes can be traced in the availability of sugar, whose implements also reflected the march of industrialization. Refined sugar was introduced to Europe in the thirteenth century in the form of loaf sugar—large, solid cones—for which sturdy sugar nips were required to break off chunks. Sugar tongs were introduced in the eighteenth century to facilitate picking up lumps of sugar. As sugar was an expensive luxury, only the finest utensils were deemed appropriate to serve it. When the refining process was perfected and uniform sugar cubes became available in the late nineteenth century, a wide variety of elegant tongs was

FIG 19. Tea scoop. Samuel Pemberton. Birmingham, England, 1809. Silver, mother-of-pearl.

FIG 20. Tea scoop. The Netherlands, 1833. Silver.

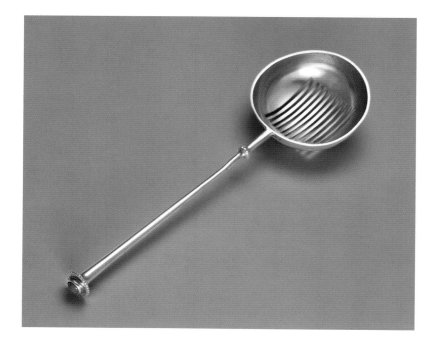

marketed, some with narrow claw feet (fig. 22), others with broader, spatula-like ends. Granulated sugar was sifted into beverages or over desserts by means of castors or elegantly pierced spoons (fig. 21).

The upper-middle classes in eighteenth-century England and America evinced a passion for punch and other elaborate drinks such as toddies and syllabubs served from large bowls. These beverages called for special serving utensils, which prompted the development of long-handled punch and toddy ladles, often with a crooked or curved shaft which enabled them to hang on the rim of the punch-bowl without falling in. (The handle of the toddy ladle was somewhat shorter than that of the punch ladle.) (fig. 23) Silver nutmeg graters facilitated the addition of fresh nutmeg, while pierced strainers kept lemon and orange pulp from marring the drinks. Other specialized utensils embellished the highly developed table culture of eighteenth-century Europe, perhaps the oddest being "masticating knives" that could easily mince food, presumably for toothless old diners.[30] Less curious were the special tongs introduced in the mid-eighteenth century to serve the newly chic asparagus without damaging the spears. For the next century and a half, different designs were tried out for asparagus, from various styles of tongs to shovels and spatula-like forks.[31] (figs. 24–26)

(LEFT)
FIG 21. Sugar spoon. Designed by Josef Hoffmann. Produced by Alexander Sturm & Company. Vienna, ca. 1902. Silver, turquoise.

(RIGHT)
FIG 22. "Assyrian Head" sugar tongs. Meriden Britannia Company. Meriden, Connecticut, 1885–86. Silver-plated metal.

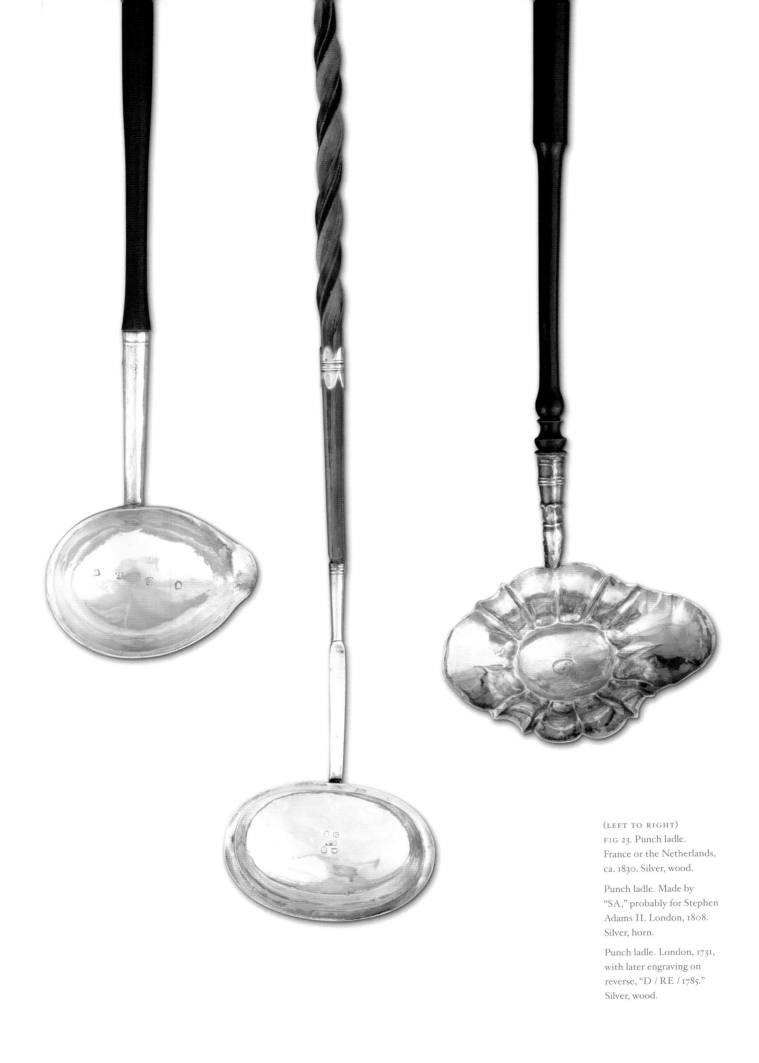

(LEFT TO RIGHT)
FIG 23. Punch ladle.
France or the Netherlands,
ca. 1830. Silver, wood.

Punch ladle. Made by
"SA," probably for Stephen
Adams II. London, 1808.
Silver, horn.

Punch ladle. London, 1731,
with later engraving on
reverse, "D / RE / 1785."
Silver, wood.

But newly introduced and luxury foods were not the only reason for the proliferation of serving and eating utensils. Other factors must also be taken into account, particularly the ways in which meals were served. To understand the relationship of flatware to table service we must first step back a few centuries. From the late sixteenth to eighteenth centuries in Europe, the predominant mode of service was known as *à la française*, or "in the French style." This fashion entailed a series of grand courses—*mets* or *services*—in which all of the dishes for a given course (often numbering in the dozens) were placed on the table simultaneously, as in a series of buffets. The first course typically included soup, appetizers, and savory sauces; the second comprised a roast with salads and side dishes; and an optional third course elaborated on the second, followed by a final course of sweets or fruits.[32] Each course was removed when guests had had their fill. Guests served themselves freely, according to appetite, but unless a kind neighbor agreed to help by serving from a more distant dish, they had to make do with the foods within reach. Only in the eighteenth century, with the rise of more intimate dining, did table service begin to change. For one thing, carving as an art form demanding great knowledge and dexterity declined, and was no longer the essential tableside spectacle. An even greater change occurred in the early nineteenth century with the introduction to Europe of so-called *service à la russe*, or "Russian-style dining." The precise date of its arrival in France is unclear, but despite initial resistance, by midcentury, this style of service had come into vogue in England, whence it made its way to America.[33] In *service à la russe*, the dishes were not all set on the table at once, but offered instead in succession; individual portions were presliced and passed around by servants. To diners used to the French style, the seemingly endless succession of plates made the Russian style seem unrestrained, even oppressive. Considerate hosts provided individual menus, so that their guests would know how many different dishes were coming and be able to pace themselves throughout the meal. Russian-style service also required many more servants and place settings for a meal, leading to considerable additional expense: enough silverware was needed for each successive round of dishes (fig. 27).

By the end of the nineteenth century, the move from convivial feasting to individualistic dining was complete—a development paralleled in the dining space itself, which over the course of three hundred years had evolved from the grand communal banquet hall to ever more intimate dining rooms. The artistic visions of such late nineteenth-century architects as Charles Rennie Mackintosh and Josef Maria Olbrich merged furniture, wallpaper, table settings, and silverware into a single, harmonious whole. The bourgeoisie clamored to set up fashionable dining rooms in their homes. In America, where power was based not on heredity but on how one spent one's money, a new kind of elitism took hold. America's "royal" families—the Carnegies, Morgans, Vanderbilts, Rockefellers, and Mellons—had acquired

FIG 25. "English King" asparagus server. Patent to Charles Grosjean, 1885. Manufactured by Tiffany & Co. New York, New York, ca. 1885–91. Silver.

FIG 24. "Wave Edge" asparagus tongs. Patent to Charles Grosjean, 1884. Manufactured by Tiffany & Co. New York, New York, ca. 1891–1902. Silver.

FIG 26. *Still Life with Asparagus*. Philippe Rousseau. France, after 1880. Oil on fabric.

their wealth in industry and banking. The middle class sought to emulate them (albeit on a vastly reduced scale) by aping their fashions in dining. Seemingly unrestrained consumption led to the advent of what Mark Twain termed the "Gilded Age," with its celebration of excess, when anxious hostesses went to great lengths not only to keep up with the Joneses, but to surpass them. An extensive collection of individual flatware and serving pieces demonstrated both taste and presumed wealth, but unfortunately, the ante was constantly being upped (fig. 28). Once everyone began to use forks, for instance, this utensil no longer represented status, even if knowing its proper usage did. Flatware manufacturers played on Americans' social anxiety and inherent insecurity about their relative lack of sophistication vis-à-vis the Europeans by introducing new forms, which led to the unprecedented proliferation of silverware during the second half of the nineteenth century.

Simply owning these new pieces was not enough for the cognoscenti, however. The savvy diner needed to demonstrate finesse by immediately knowing which fork was to be used for salad, which for fish, and which for meat. Although at some tables where Russian-style dining was the norm, the cutlery was replaced along with the dishes for each course, at other, less affluent ones, it was laid out all at once, leading to considerable anxiety and confusion. Choosing the proper serving utensils was not much easier: Which was the properly shaped server for tomatoes, which for cucumbers? Could the fish knife ever double as an ice-cream slice, even though its blade is slightly wider?[34]

FIG 27. Frontispiece from *The Book of Household Management.* Written by Isabella Beeton. Published by Ward, Lock, & Co. New York and London, England, 1888.

This illustration shows a dining table set *à la russe*, with the center of the table freed for floral displays and other decorations.

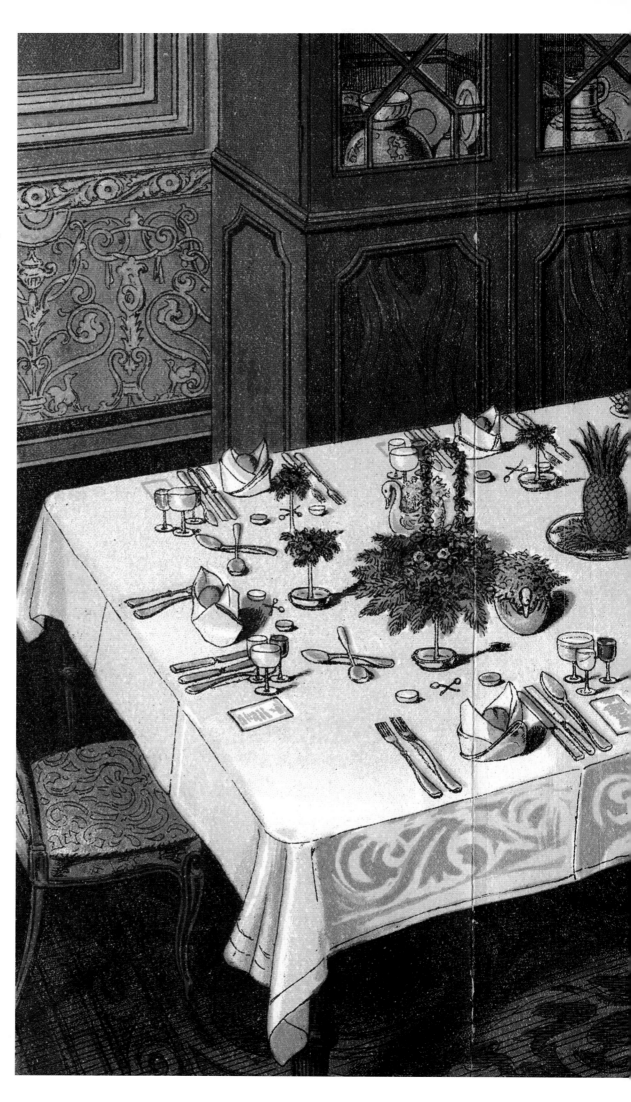

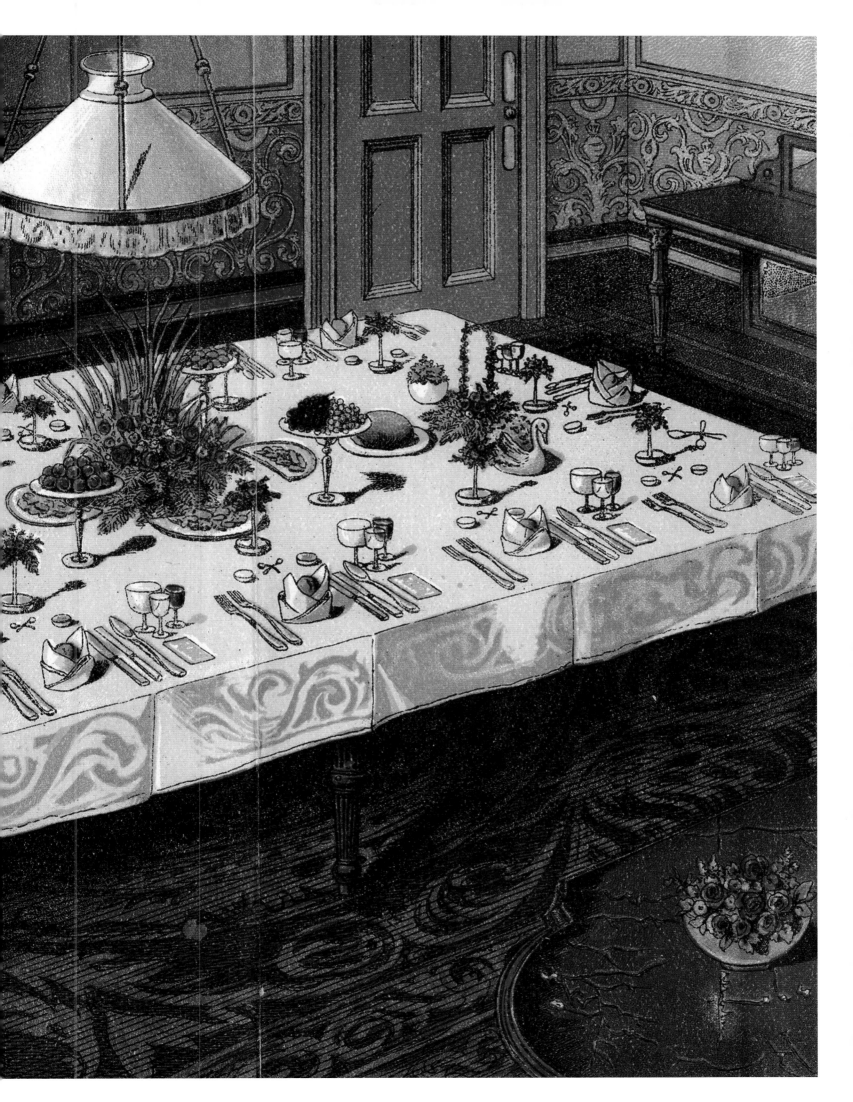

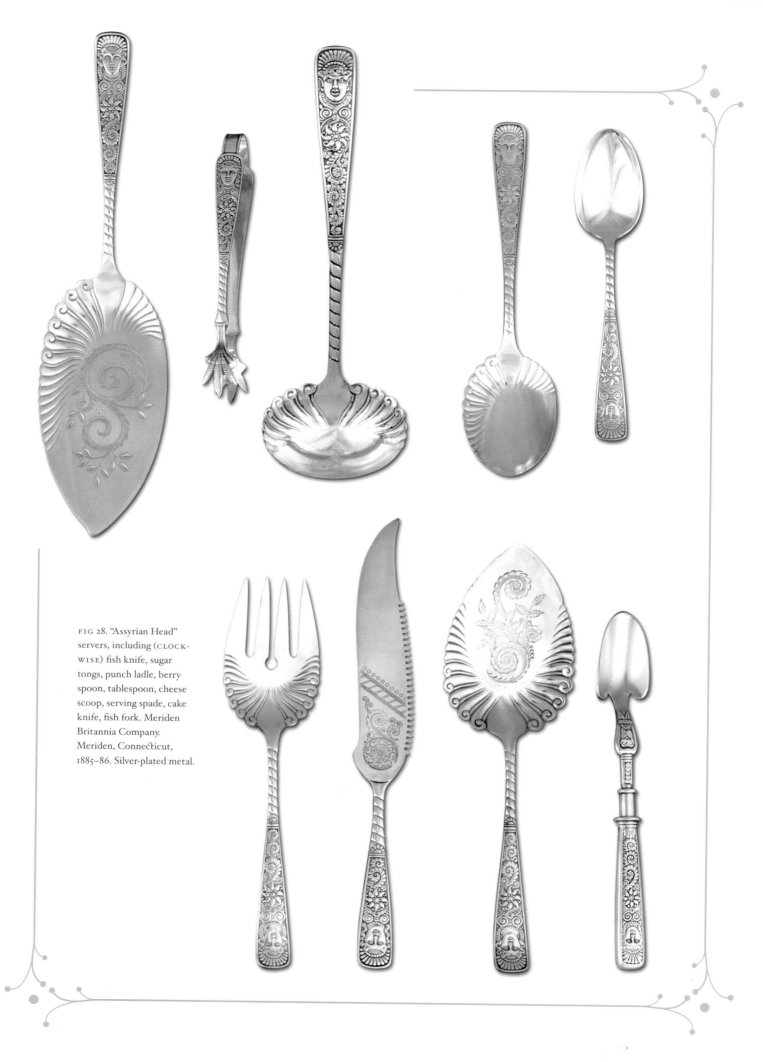

FIG 28. "Assyrian Head" servers, including (CLOCK-WISE) fish knife, sugar tongs, punch ladle, berry spoon, tablespoon, cheese scoop, serving spade, cake knife, fish fork. Meriden Britannia Company. Meriden, Connecticut, 1885–86. Silver-plated metal.

Perhaps because of their well-defined social classes, the English exhibited far less anxiety about their tables. Late nineteenth-century silver place settings of English manufacture did not come close to matching the number of pieces in American sets, which, at their most excessive, contained 146 pieces in a single pattern.[35] Even if one settled for the 131 pieces in the Towle Company's "Georgian" pattern, having a complete service for twelve required the purchase of 1,888 pieces. This pattern included nineteen different types of individual spoons and seventeen different spoons for serving.[36] Such a collection enabled what Fernand Braudel has termed the "unending social drama of luxury,"[37] in which the attainment of the superfluous causes greater joy than the attainment of basic necessities. The American upper classes took great pleasure in amassing brilliant displays of silver and gilt flatware of dubious practical use. The more esoteric the piece, the greater its value; and enjoyment was often proportional to whimsy.

And whimsy there was. Implements included special servers for macaroni, ice cream, aspic, fried oysters, fried chicken (fig. 29), chipped beef, horseradish, chow chow, and pickles, as well as for the newly popularized potato chip. Today, we wouldn't dream of reaching for potato chips with anything but our hands, but after they were served to customers at a restaurant in Saratoga Springs, New York, and became all the rage,[38] Tiffany developed a Saratoga chip server to present them in style (fig. 30). Another American innovation was the individual butter knife, which, like the round soup spoon, had no European precedent. An advertisement in the ladies' magazine *The Modern Priscilla* included a tempting offer for these knives:

> *Don't Buy Silver Butter-Spreaders. Let us give you a full set free—a set that would cost you $3.00 in the jewelry stores. These butter-spreaders are Wm. Rogers & Sons' famous AA triple plate. Nothing on any table to-day is more dainty—more refined…Sooner or later you'll want Butter-Spreaders. Why not get them now? Simply send us one top from a small jar of Armour's Extract of Beef, or send the paper certificate underneath. Send it with 10¢ to cover the cost of packing and carriage…For six tops or certificates and 10¢ for each, we'll send you a full half dozen spreaders.*[39]

There were individual forks for eating the likes of raw oysters, terrapin, strawberries, and grapefruit, as well as utensils for serving caviar (made of mother-of-pearl or horn to avoid contact between the roe and metal), lemon slices, ice, cucumbers, tomatoes, poached eggs, toast, sandwiches, nuts, jelly, bonbons, berries, cakes, pastries, pie, and buckwheat griddle cakes, among other foods. Rogers Bros. featured a "sandwich or baked potato fork" in the Old Colony pattern, as well as a ladle specifically made for mayonnaise. Even though asparagus serving tongs had been known since the mid-eighteenth century,[40] individual tongs for conveying a single spear to the mouth were developed in the late nineteenth century so that the asparagus would not be blackened, and its taste corrupted, by a steel-bladed knife. Also manufactured were long, narrow spoons and scoops for extracting rich marrow from bones. In some cases, these singular implements served a real purpose, as in the case of marrow scoops and lobster picks,

Tafelservice aus Hummerschalen.

1883

FIG 32. "Tafelservice und Hummerschalen" depicting seafood service of lobster-claw implements, tureen, and condiment and toothpick holders. Germany, 1883. Engraving.

whose splayed tines helped ease the meat from the shells (figs. 31, 32). Grape scissors enabled guests to eat graciously and not contaminate an entire bunch of grapes with their fingers. And for all the men with fashionably large moustaches, special spoons were necessary to keep their bristles clean during a meal. For the most part, however, specialized utensils were a ploy on the part of the flatware industry to sell more goods in response to the latest food fashions (fig. 33). A closer look at a few of these implements will reveal their relationship to American food fads of the past.

Two of the nineteenth century's most fashionable foods were originally popularized in the United States by Thomas Jefferson. He served as minister plenipotentiary to the Court of Louis XVI, and the four years he spent in Paris gave him a taste for things French. Although ice cream had been known in the colonies and in the early republic—it was served by the governors of Virginia, in 1770, and of Maryland; Martha Washington is known to have served ice cream at levees; and Abigail Adams to have eaten it[41]—the first ice-cream freezer on record belonged to Jefferson, and the first written American recipe for ice cream (French style, with egg yolks) is in his own handwriting.[42] Ice cream could be bought from French émigré confectioners in Philadelphia and New York City,[43] but as more people wanted to eat it at home, too, servers were devised for the formal table, from the now-familiar ice-cream scoop to

FIG 33. "Catlin" pattern serving spoon. Patent to Charles Grosjean. Manufactured by Tiffany & Co. New York, New York, ca. 1884–91. Silver.

FIG 31. Lobster fork. Made by John Polhamus. Retailed by Tiffany & Co. New York, New York, ca. 1855. Silver.

ice-cream slices, spoons, forks, saws, and shovels (figs. 34, 35). Yet, as noted above, despite the proliferation of ice-cream serving utensils, the frozen cream itself was supposed to be eaten with a fork.

Jefferson also introduced the American public to macaroni and cheese. It may be difficult to imagine today's ubiquitous casserole as anything more than comfort food, but in the mid-nineteenth century, *nouilly à macaroni* became the height of chic. Jefferson had encountered macaroni in Paris, and while touring Italy in 1787 he drew plans for a "maccaroni" machine for making homemade pasta.[44] Ornate macaroni servers, sort of a cross between a serving fork and spoon, were offered in response to the great popularity of this dish. The most common design had spiked edges along one side rather than at the tip so that the macaroni could be simultaneously cut and scooped without compressing the noodles (figs. 36, 37).

With the spread of railroads and the advent of the refrigerated railway car, previously unavailable foodstuffs became more commonplace. Future archaeologists might possibly date the completion of the continental railroad by the appearance of a new type of spoon with a narrow bowl tapering to a sharp tip. This was an orange spoon, designed for eating the fruit in style; gilding prevented adverse

(OPPOSITE)
FIG 35. Ice-cream saw. Dominick and Haff. New York, New York, ca. 1880. Silver, silver-gilt.

Ice-cream hatchet. Gorham Manufacturing Company. Providence, Rhode Island, ca. 1870–80. Silver.

FIG 34. "Wave Edge" ice cream server. Patent to Charles Grosjean, 1884. Manufactured by Tiffany & Co. New York, New York, ca. 1884–91. Silver.

REED & BARTON
SILVER AND GOLD PLATE.

Venetian Macaroni Spoon.

Russian Sugar Shell, Silver
Engraved Bowl.

FIG 37. Macaroni server.
U.S.A., ca. 1865. Silver,
parcel-gilding.

chemical reaction with the acidic fruit. After 1866, when the first oranges were transported by rail from Los Angeles to the East Coast,[45] oranges, presented either whole or in halves, regularly graced fancy dessert tables. The new mode of transport led to the expansion of the citrus industry and the movement of perishable produce throughout the country. In addition to orange spoons, melon knives and forks, delicate strawberry forks (fig. 38), and, somewhat later, grapefruit spoons appeared on fashionable tables.

The development of these specialized servers mirrored the rise of other industries. For instance, cheese scoops became popular as the commercial cheese industry developed in New England in the second half of the nineteenth century. Cheese knives, used for hard cheeses like cheddars, had spikes on the tip of the blade for spearing the piece sliced from the wheel of cheese by the blade.

The ice industry also grew throughout the 1800s; by the end of the century, a home icebox or ice chest was commonplace in the United States, and iced beverages became chic. Long-handled spoons, often with hollow handles that doubled as straws, were sold specifically for drinking lemonade or iced tea. Other spoons with elongated handles were marketed for parfaits. They enjoyed particular cachet in the early twentieth century when ice-cream socials were a favorite form of entertainment, and remained popular through the great American soda-fountain era of the 1950s and 1960s.

FIG 36. Venetian macaroni spoon from *Reed & Barton, artistic workers in silver & gold plate*, p. 315. Published by Reed & Barton. Taunton, Massachusetts, ca. 1884.

(OPPOSITE)
FIG 38. Design for a Strawberry fork, 1093. Tiffany & Co. New York, New York.

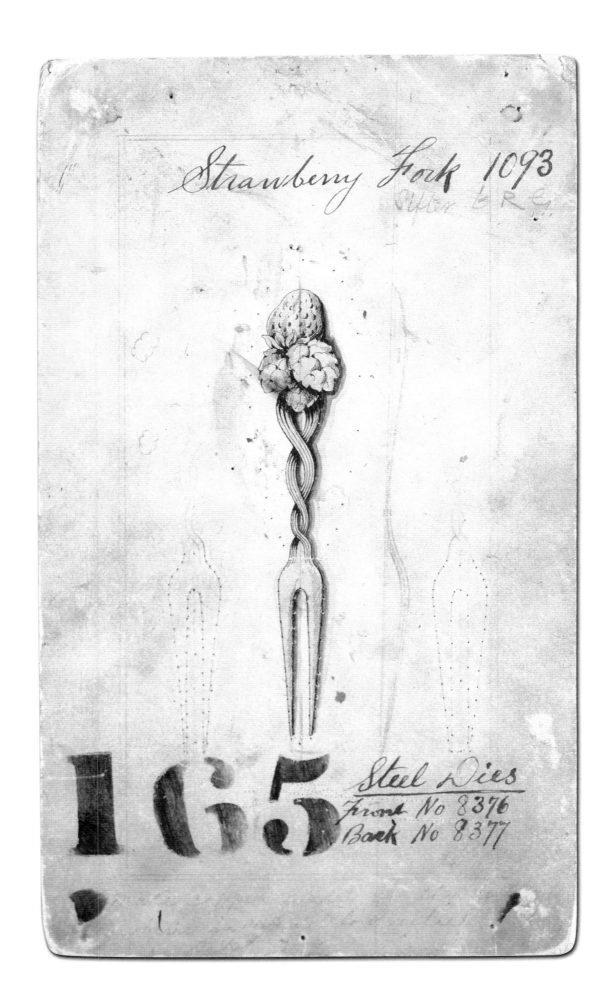

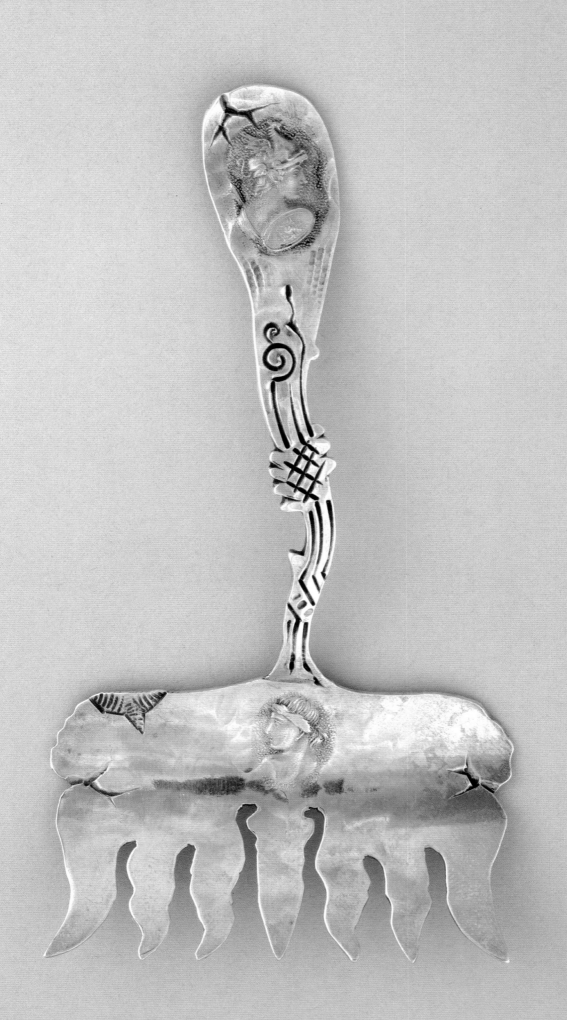

On the savory side, sardine forks and tongs were produced in response to demand for the excellent French sardines, packed in oil, imported to the United States in increasing numbers. Thanks to improved preserving techniques, by the 1880s, Brittany, France, was producing nearly fifty million cans of sardines annually for export.[46] Sardine forks differed from regular forks in their widely spaced multiple tines and shallow, scooped bowl, which served to lift the sardines without breaking them (fig. 39). Oyster forks were not a new invention, as variations on small two- or three-tined forks had been used since ancient times; but the more modern iteration had slightly curved outer blades to help release the oyster from its shell (figs. 40, 41). Nineteenth-century American olive servers came in the form of both forks and spoons, and there were even some sucket fork–like servers with a spoon on one end and a fork on the other (figs. 42, 43). As for fish servers, they had been produced in Europe beginning in the latter part of the eighteenth century (fig. 42). By the second half of the nineteenth century, both individual fish knives and forks were provided at formal dinners. Fish forks, somewhat more rounded than standard dinner forks, were less likely to tear the fish apart. Fish knives were blunt, or, in the late nineteenth century, scimitar-shaped—unlike the

FIG 40. "Vine" oyster fork. Design attributed to Edward C. Moore, ca. 1872. Manufactured by Tiffany & Co. New York, New York, ca. 1872–91. Silver, gilding.

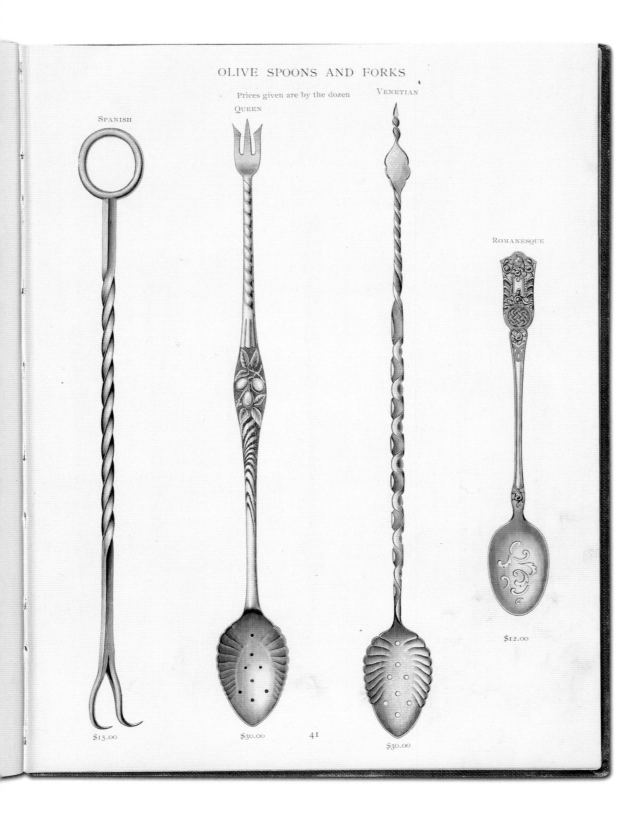

OLIVE SPOONS AND FORKS

Prices given are by the dozen

SPANISH

QUEEN

VENETIAN

ROMANESQUE

$15.00

$30.00

41

$30.00

$12.00

FIG 42. Olive spoons and
forks from *Spoons, forks,
knives, etc. made by the Meriden
Britannia Co....*, catalogue
no. 43, p. 41. Published by
Meriden Britannia Company.
Meriden, Connecticut,
ca. 1890.

(ABOVE)
FIG 43. Olive fork/spoon.
Tiffany & Co. New York,
New York, ca. 1880–91. Silver.

(OPPOSITE)
FIG 44. *Designs for Cutlery*.
Pietro Belli. Italy, 1815–30.
Pen and brush and brown ink,
graphite on light blue paper.

As indicated by the fish
that adorns it, the server in
the middle of the drawing is
intended for use as a fish slice.
The server to its left could
likewise be used for fish.

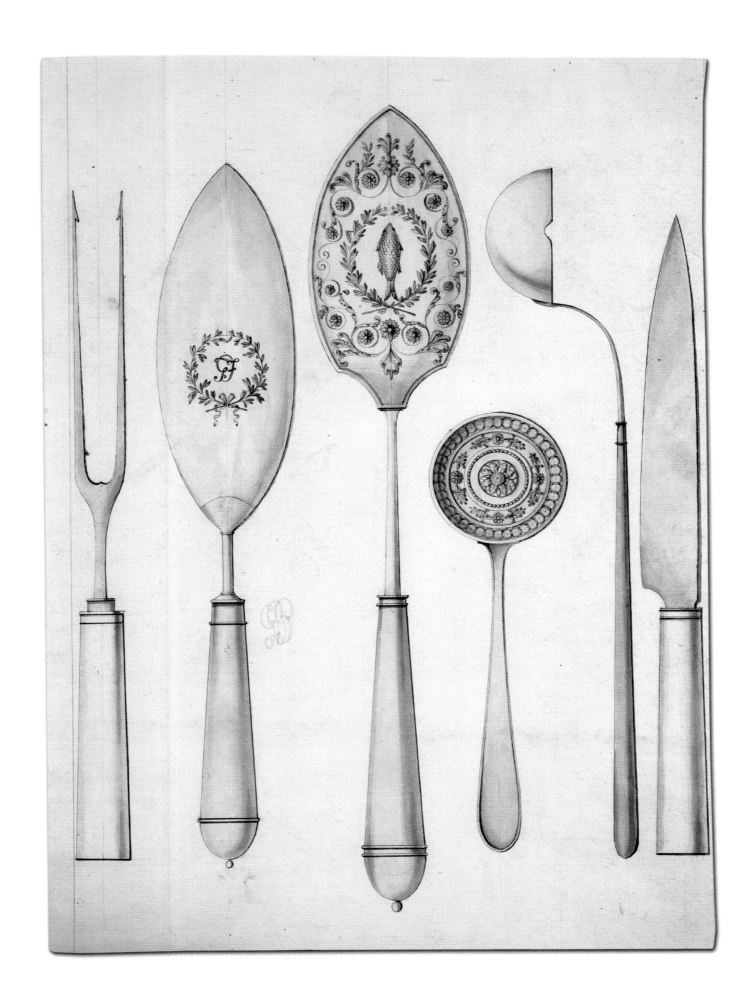

IMPLEMENTS OF EATING

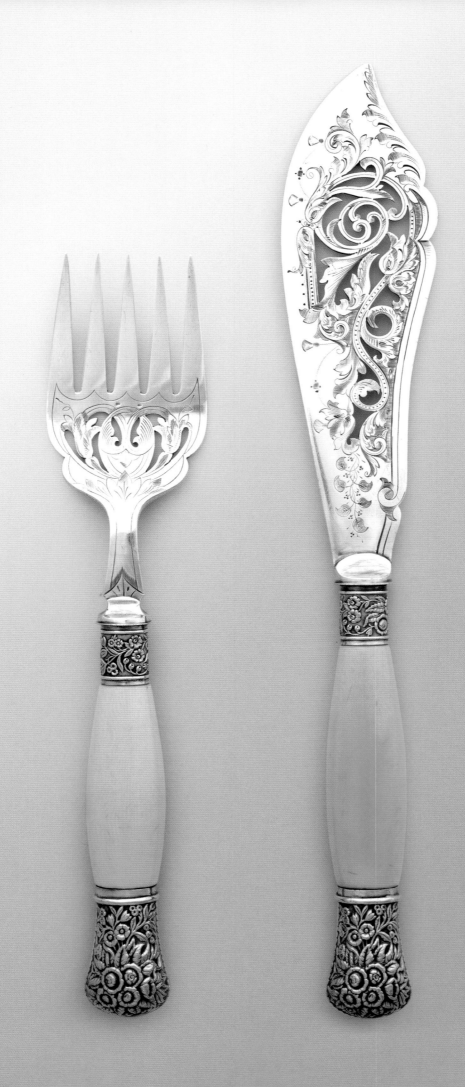

(OPPOSITE)
FIG 45. Fish servers, fork,
and knife. England or
U.S.A., ca. 1880. Silver-
plated metal, ivorine.

standard steel-bladed dinner knives that could hold a sharp edge—
because they needed to lift the fish rather than slice through it. They
were fashioned of silver, including the blades, to avoid transferring a
metallic taste (figs. 45, 46).

The elegance of the late nineteenth-century table was enhanced
by the use of skewers, which could make even mundane dishes look
grand (fig. 47). The French chef Urbain Dubois promoted the fashion
for these attelettes (from the French *hâtelets*) in his *Artistic Cookery*,
published in London in 1870 (fig. 48). Silver skewers holding intricately
carved vegetables, fruits, or often crayfish surmounted desserts and
roasts alike, and turned horizontal presentations into architectural
fantasies. Ornate finials with figures from mythology and nature added
to their appeal. For additional drama, the attelettes could be threaded
with cubes of aspic, which shimmered in the candlelight, making them
a desirable addition to the late Victorian table.

By 1925, the proliferation of specialized pieces of flatware had
grown to such an extent in America that the federal government
had to step in (fig. 46). Herbert Hoover, in his capacity as Secretary
of Commerce under President Calvin Coolidge, set a limit of fifty-
five on the number of flatware pieces that could be contained in a
single pattern. This regulation was subsequently adopted by the
Bureau of Standards and accepted by the Sterling Silver Manufacturers
Association;[47] shortly thereafter, no less a social arbiter than Emily
Post agreed that dozens of flatware pieces were unnecessary
and that a single fork could serve several purposes. Her pro-
nouncement was a long time in coming, but welcome
nonetheless: "No rule of etiquette is of less impor-
tance than which fork we use."[48]

The twentieth century saw an easing of
the strict rules of flatware etiquette that
had governed nineteenth-century soci-
ety. Most of the specialized servers
and individual pieces of cutlery

FIG 46. Fish slice.
Germany or U.S.A.,
ca. 1940. Bakelite,
chromed metal.

(NEXT SPREAD)
FIG 47. Skewers. France
and Italy, mid- to late 19th
century. Silver.

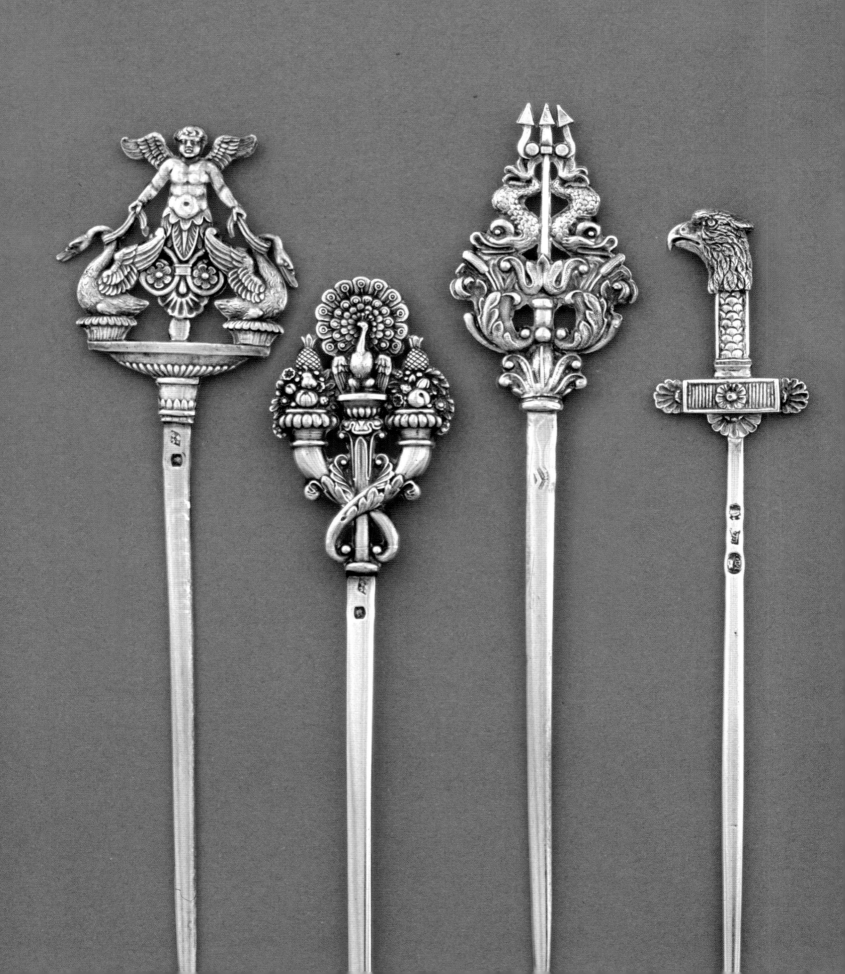

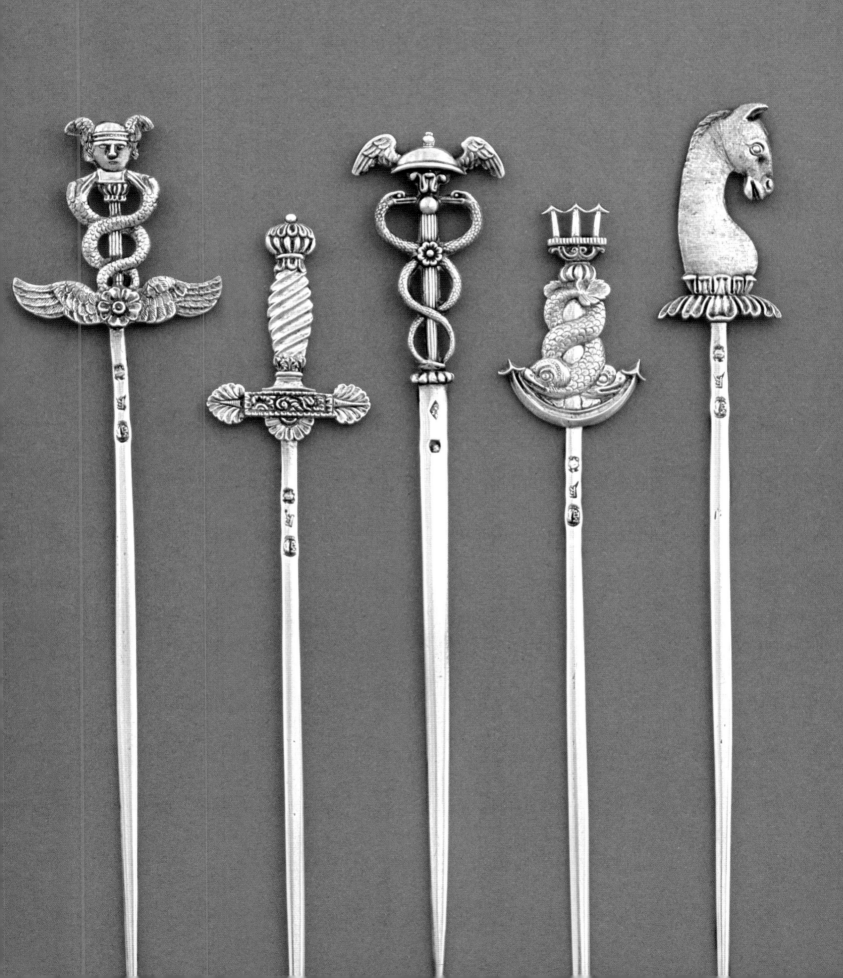

PL. 5.

Hâtelets pour ornement de mets chauds et froids.

FIG 48. "Hâtelets pour ornement de mets chauds et froids" (Skewers to decorate hot and cold foods), plate 5 from *Artistic Cookery*, opposite p. 8. Written by Urbain Dubois. Published by Longmans, Green & Co. London, England, 1870.

(OPPOSITE)
FIG 49. "Community Plate Adam," from *Illustrated catalogue and price list, 1918, A.C. Becken Company, wholesale jewelers*. Published by A. C. Becken Company. Chicago, Illinois, 1918.

COMMUNITY PLATE

ADAM

SOUP SPOON
SIX IN PLAIN BOX
Soup Spoon, length 7½ in., wt. of pkg. 12¼ oz., per doz. $15.68

BOUILLON SPOON
SIX IN LINED BOX
Bouillon Spoon, length
4⅞ in., wt. 10 oz., per set $6.78

INDIVIDUAL SALAD FORK
SIX IN LINED BOX
Ind. Salad Fork, length 6⅛ in., weight 11½ oz., per set $7.06

HOLLOW HANDLE FRUIT KNIFE
SIX IN LINED BOX
H. H. Fruit Knife, length 6⅝ in., weight 1 lb., per set $11.26

HOLLOW HANDLE ORANGE KNIFE
SIX IN LINED BOX
H. H. Orange Knife, length 7⅞ in., weight 1 lb. 1 oz., per set $11.68

OLIVE SPOON
ONE IN LINED BOX
Olive Spoon, length 5¾ in., weight 3¾ oz., ea. $1.63

OYSTER FORK
SIX IN LINED BOX
Oyster Fork, length 6½ in., weight 8¼ oz., per set $4.84

PICKLE FORK
ONE IN LINED BOX
Pickle Fork, length 6⅛ in., weight 3 oz., each $1.52

HOLLOW HANDLE CHEESE SERVER
ONE IN LINED BOX
H. H. Cheese Server, length
6½ in., weight 5½ oz., each $2.50

ICE CREAM FORK
SIX IN LINED BOX
Ice Cream Fork, length 5⅝ in.,
weight 9½ oz., per set $5.46

ICED TEA SPOON
SIX IN PLAIN BOX
Iced Tea Spoon, length 7½ in., wt. of pkg. 8 oz., per doz. $11.00

JELLY SERVER
ONE IN LINED BOX
Jelly Server, length 6¼ in.,
weight 4 oz., each $1.63

BUTTER SPREADERS
SIX IN LINED BOX
Flat Handle Butter Spreader, length
6½ in., weight 15 oz., per set $5.76
Hollow Handle Butter Spreader, length
6½ in., weight 1 lb. 1 oz., per set 11.26

ORANGE SPOON
SIX IN LINED BOX
Orange Spoon, length 5⅝ in., weight 10 oz., per set $5.50

TOMATO SERVER
ONE IN LINED BOX
Tomato Server, length 7⅝ in.,
weight 5 oz., each $3.32

BABY SPOON, BENT HANDLE
ONE IN LINED BOX
Baby Spoon, Bent Handle, length 3¾ in., weight 1¾ oz., each $1.11

SUGAR TONGS
ONE IN LINED BOX
Sugar Tongs, Small, length
4 in., weight 2 oz., each $1.50
Sugar Tongs, Large, length
4½ in., weight 2¼ oz., each 2.07

HOLLOW HANDLE PIE SERVER
ONE IN LINED BOX
H. H. Pie Server, length 10¼ in., weight 8 oz., each $4.26

ADAM DESIGN

fell by the wayside as entertaining grew more casual (see Lupton, fig. 25). No longer could households afford servants to hand around the numerous plates called for in the strict Russian style, or to clean and keep the silver well polished—a task that most housewives found onerous. The abandonment of the great houses in England and the stylish "cottages" in the United States meant a reduction in space for the storage and display of silver. With the advent of affordable stainless-steel flatware, the romance of silver began to fade, and consumers began to look for practicality in tableware (fig. 50).

Sporadic attempts to invent new cutlery forms for the modern era never caught on entirely (fig. 51). The so-called "spork," a combination of spoon and fork, is today found only in plastic versions at fast-food establishments. (The "splayde," a knife, fork, and spoon combo, has passionate advocates in Australia.)[49] Another spoon/fork combination, this one made of biodegradable starches from corn, wheat, and potatoes, was designed to be tossed out with the meal.[50] (fig. 52) Other twentieth-century dining trends found expression in such flatware lines as "Edo," produced by the German silver manufacturers Robbe & Berking in response to the minimalist dining style of nouvelle cuisine. The "Edo" fork resembles a cross between a Western-style implement and chopsticks, with a tong-like design for easy manipulation. This pattern was promoted specifically in terms of its relationship to food and a sparer style of dining.[51] (fig. 53)

Such new forms are intended to bring us closer to our food rather than distance us from it—an approach quite opposite to the progression of cutlery design up until now (fig. 54). If the use of the fork reflects the process of civilization, we can now, perhaps, detect a humanizing effect in our return to a simpler mode of existence in which fancy implements are eschewed. Having the right tools for

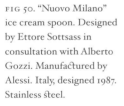

FIG 50. "Nuovo Milano" ice cream spoon. Designed by Ettore Sottsass in consultation with Alberto Gozzi. Manufactured by Alessi. Italy, designed 1987. Stainless steel.

FIG 51. Spaghetti-twirling fork. Kristen Alexandra Milano. U.S.A., 1999. Silver.

FIG 52. Moscardino disposable sporks. Designed by Giulio Iacchetti and Matteo Ragni. Produced by Pandora Design. Milan, Italy, 2000. Mater-Bi™.

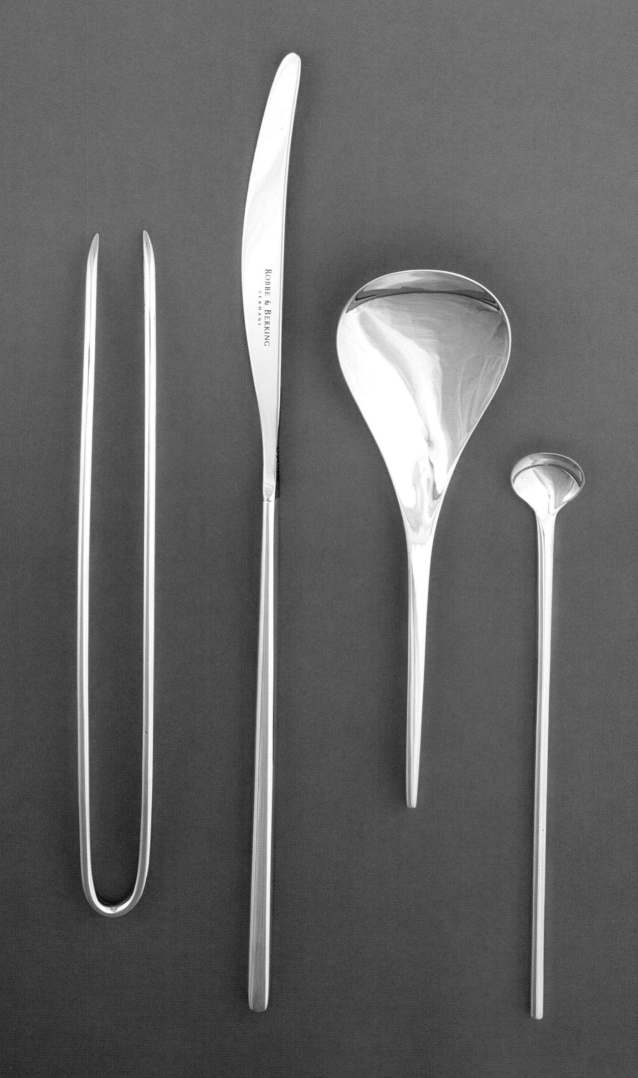

(OPPOSITE)

FIG 53. "Edo" chopstick
or fork, knife, and spoons.
Designed by Bibs Hosak-
Robb. Manufactured
by Robbe & Berking.
Germany, 1985. Silver-
plated metal.

eating has always been both a practical mandate and a societal one.
Though cutlery was designed for the table, its meanings extended far
beyond the dining room to embrace power, wealth, and social savvy. The
contemporary trend toward more natural dining explains, in part, the
disappearance of so many of the implements once touted as must-haves,
not only from our tables but also from our consciousness. Instead of
creating new implements to mediate between our food and our mouths,
twenty-first-century Americans and Europeans are again recognizing
the efficacy of the hands. People desire to experience their food on a
more sensual level. As we convey food by hand to our mouths, we redis-
cover tactile pleasures.[52]

Even so, gazing back at what the civilizing process has wrought,
we can enjoy five hundred years of beautiful objects, even if they have
sometimes been absurd. Today, we can enjoy asparagus without using
special serving tongs, and we eagerly scoop up macaroni and cheese with
just about any sturdy spoon. Yet even if our full enjoyment of food is no
longer predicated on possessing the perfect implement, there is undeni-
able pleasure to be found in using whimsically decorated sugar tongs
or in handling a well-balanced spoon. And how could we possibly extract
the sweet morsels of snails without a specially designed fork? Some
things have not changed, not in a thousand years.

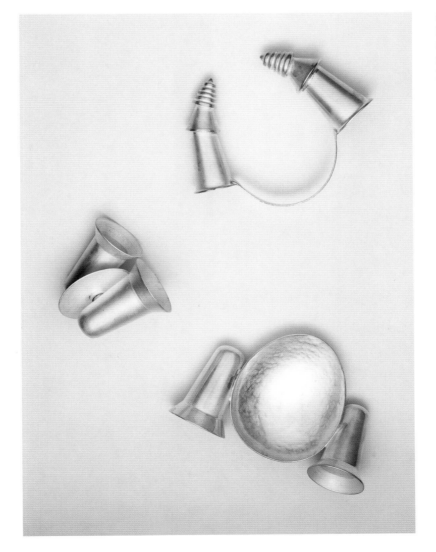

FIG 54. "Eat Alien" tools.
Designed by Titti
Cusartelli. From *Cutlery*.
Published by Giorgetti.
Italy, 1997.

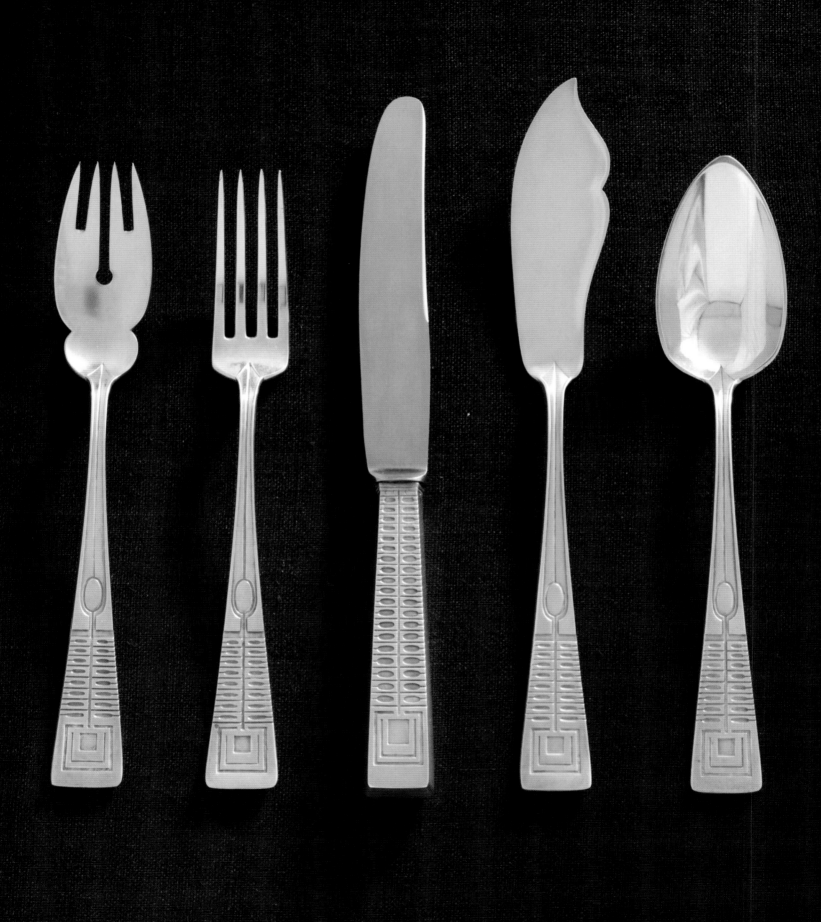

The Design of Table Tools
and the Effect of Form
on Etiquette and Table Setting

———

SUZANNE VON DRACHENFELS

(OPENING SPREAD)
Five-piece place setting designed for the Wertheim Department Store Dining Room display. Designed by Peter Behrens. Manufactured by Martin Josef Rückert. Berlin, Germany, 1902. Silver, parcel gilding.

(OPPOSITE)
FIG 1. Fork and knife. England, ca. 1720–40. Brass, steel.

THE TOOLS OF THE TABLE—KNIVES, SPOONS, AND FORKS—ARE THE PROPS OF A CIVILIZED SOCIETY. LIKE THEATER PROPS THAT SET THE MOOD OF a scene, the design of these tools, often called flatware, greatly affects the drama of a table setting. The way these tools are used is governed by the standards of etiquette, a word derived from the French term for "label" or "ticket." In the seventeenth century, *etiquettes* were required for admittance to the French court. In the Court of Louis XIV, manners were so overly elaborate, strict codes of conduct and behavior were printed on both sides of the etiquettes. Eventually, etiquette came to mean the appropriate conduct for all social situations, including the right way to handle table tools.

The etiquette of flatware is rooted in designs based on need. Form follows function, and the etiquette followed the form. According to Margaret Visser, author of *The Rituals of Dinner*, "neatness, noiselessness, and cleanliness" are three attributes of Western table manners.¹ With these tenets in mind, and to allow for an overlap in the time sequence of development, the design and etiquette of the knife, spoon, and fork are addressed separately.

FIG 2. Fruit knife. France, late 19th century. Silver, mother-of-pearl.

Dessert knife. Paris, France, 1819–38. Silver, mother-of-pearl.

The Knife

The knife was man's first implement, a utensil used to cut and spear that offered a neater way to eat than with one's fingers. The way a knife is laid on the table has its roots in the Middle Ages: A blade laid facing the plate indicated a position of trust, as opposed to a blade laid away from the plate, ready for swift retaliation against the enemy. The etiquette of the inward placement continues in table setting today.

As people ate from the blade of a knife, there was little etiquette other than to eat as safely as possible. Many knives were wrought with a double edge, a design that changed around 1669, when France's Cardinal Richelieu, leading minister to King Louis XIII, witnessed

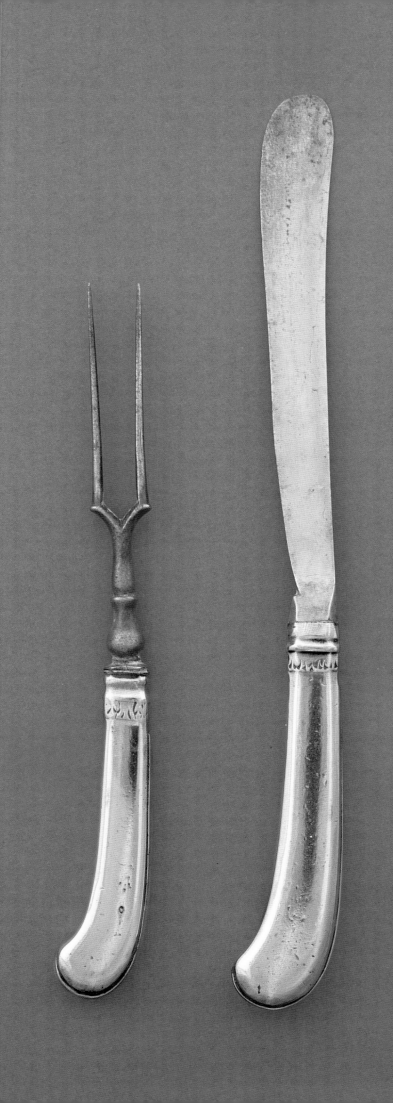

a dinner guest pick his teeth from the pointed tip of a double-edge blade. Thereafter, the Cardinal forbade innkeepers to lay double-edge knives on tavern tables and mandated new knives wrought with a single cutting edge and a rounded tip (figs. 1, 2). However, etiquette sanctioned the provision of toothpicks on a side table.[2] The single-edge blade also made it easier to eat foods, such as peas, rice, and gravy, from the slightly-raised border of the blunt side.

> *"I eat my peas with honey I've done it all my life.*
> *It makes the peas taste funny*
> *But it keeps them on the knife."*[3]
> —ANONYMOUS

The mandate of the single-edge blade changed the way the knife handle was held. Rather than gripping it with all five fingers, as if to stab a morsel of meat, the user folded the palm of the hand around the handle, with the index finger extended along the top of the blade. The new grasp allowed better leverage to cut food, and is the way a knife handle is held today (figs. 3, 4).

The use of the knife for placing food in the mouth fell from favor in seventeenth-century France, when aristocrats adopted the fork as a table tool of refinement. By reason of geography, the change in etiquette was slow to reach North America, and, once there, to gain acceptance; many Americans ate from the blade of a knife well into the nineteenth century. The English writer Frances Trollope, author of the 1832 work *Domestic Manners of the Americans*, observed among them "the frightful manner of feeding with their knives, till the whole blade seemed to enter into the mouth; and the still more frightful manner of cleaning the teeth afterwards with a pocket-knife."[4]

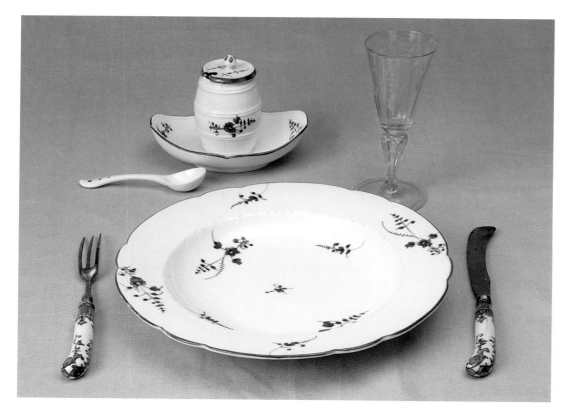

FIG 7. A table setting comprised of mid-eighteenth-century French ceramics, including St. Cloud porcelain-handled fork and knife (ca. 1740); Chantilly plate and mustard pot with spoon (ca. 1750); and a Swiss wine glass (late 18th century). Porcelain, silver, steel (flatware); porcelain (plate, mustard pot); glass.

By the nineteenth century, the advances of the Industrial Revolution led to a wider variety of foods available to a larger public, creating a market for specialized machine-made utensils designed to eat particular foods, such as fish. The fish knife featured a dull blade and pointed tip, a table tool designed to divide the soft tissue of cooked fish and separate it from the bone, rather than to cut the meat with the side of the blade (fig. 5). Today, this practice continues, and the handle of a fish knife is held toward the end, between the thumb and first two fingers, rather than folded in the palm of the hand like a dinner knife.

The Spoon

The spoon was the second tool of the table, a utensil which fostered a less noisy way to sip and sup. For soft foods, such as soups, stews, and puddings, early spoons differed little in appearance; in the eighteenth century, when etiquette started to dictate specific sizes and shapes for each function, forms began to vary greatly. An essential utensil, the spoon was a personal object carried throughout life, given as a gift at births, christenings, weddings, and even as a prize in lotteries. In North America, for instance, a spoon was given at funerals, engraved with the deceased's name and pertinent dates.[5]

Initially, spoon handles were wrought with a straight stem, a flat profile that changed to an arched form in the eighteenth century (fig. 6). The new design brought about an innovative way to hold a spoon. Whereas the seventeenth-century stem was grasped with all five fingers and held in the palm of the hand like a scoop, the curved handle was held between the thumb and index finger. The adjacent three digits extended outward to keep them free of grease, a practice carried over from the Middle Ages, when foods were still grasped with the fingers. People now eat primarily with utensils, and the extension of fingers is no longer necessary and, in fact, is considered affected. A spoon handle is now grasped between the thumb and index finger; the third finger rests under the stem, and the fourth and fifth fingers curve inward, cupped in the palm of the hand.

The loosening of spoon etiquette coincided with the relaxation of strict court etiquette after the death of Louis XIV (r. 1715–74). To escape the perfunctory, ritualistic decorum associated with the Sun King, many aristocrats, following his demise, moved from the confinement of the cold apartments at Versailles to the freedom of smaller, more independent quarters in Paris, some with a room made solely for dining. Compared to the grandeur of Versailles, the intimacy of small dining rooms encouraged richly appointed table settings, including flatware, and led to elegant entertaining by mid-eighteenth century (fig. 7). At this time, the accoutrements of the table assumed importance over a display of silver on a sideboard, a fashion more popular at both earlier and later dates. Fashionable table settings included spoons designed as sets for the table rather than as personal objects, hence the term "table" spoon.[6]

Prior to the seventeenth century, spoon handles had been designed with round or polygonal stems, a shape that tended to turn over on the table. For balance, mid-seventeenth-century handles were designed with a wider, flatter stem, and with ends that curved upward. The wider

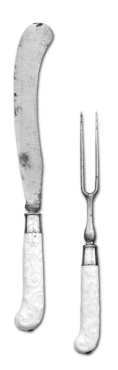

FIG 4. Table fork and knife. Bow Factory. England, ca. 1750. Glazed porcelain, silver, steel.

The pistol grip encourages the most effective knife-grasp position. The raised decoration of this example may have helped keep the porcelain from slipping.

FIG 3. Knife grasp appropriate for cutting from late seventeenth century up to present.

FIG 5. Standard grip for fish knife to enable boning and skinning without tearing the flesh.

FIG 6. This spoon grip, which came about in the second half of the eighteenth century, was encouraged by the arched form of the handle's stem. It is still in use today.

handle provided room on the back for engraved ornamentation, such as a monogram or a crest. To display the ornamentation, French aristocrats laid the spoon facedown on the table. Because the handle of the fork emulated that of the spoon,[7] it too was ornamented on the back and laid on the table face down. The etiquette of the downward placement continues, mainly in formal table settings.

The French table-setting practice carried over to England, notably after Charles II returned from exile in France in 1660, having been influenced by things French. Although handles with upward-turned ends continued to be in vogue, from the mid-eighteenth century into the beginning of the twentieth century, most spoon handles were designed to turn under. To balance the downward curve on the table, fashionable English hosts laid the spoon and fork face up and displayed a monogram or crest on the front of the handle.[8] Today, placement, up or down, is a matter of personal preference, although the upward placement of a spoon and fork is more often associated with informal table settings, elegant or otherwise.

Originally, spoon bowls were designed to accommodate soft foods with a thick texture, such as custard, porridge, and hearty soups. By the nineteenth century, elegant entertaining called for soup spoons designed with bowls formed in specialized shapes to accommodate the texture of thick or thin soup, namely an oval-bowl soup spoon and a round-bowl soup spoon, in large and small sizes. Compared to the shallow spoon bowls wrought to eat soft foods—thin soup was generally drunk from a bowl—the new spoon shapes featured deep bowls designed especially for soup.

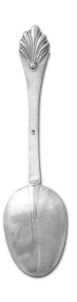

FIG 8. Spoon, engraved on handle "A.M.S. G.S. / .1.7.2.2." Prussia, ca. 1722. Silver.

"Never raise your plate to your lips,
but eat with your spoon."[9]
—THE GENTLEMEN'S BOOK OF ETIQUETTE, C. B. HARTLEY, 1875

As with all flatware, the new designs in spoon bowls increased the range of table-tool etiquette. The oval-shaped bowl, now called as an "oval soup spoon," was designed first with an elliptical shape and later with an egg shape, made with a somewhat rounded and slightly pointed end that fit into the mouth, to eat soup made with pieces of solid food, such as vegetable or beef soup (fig. 8). The larger round-shaped bowl soup spoon, known today as a "cream soup spoon," featured a curved rim which followed the shape of the mouth, a design made to sip puréed soup, such as cream-of-tomato soup, laterally from the side of the spoon bowl. The smaller, round-bowl spoon, or bouillon spoon, was also designed to sip thin soup, such as bouillon or consommé, from the side of the spoon bowl. These practices continue today.

The Fork

The fork is the newest utensil of the table, designed to spear and lift morsels to the mouth. According to Thomas Coryate, a seventeenth-century traveler and son of the Rector of Oldcome, "All men's fingers are not alike cleane." The fork afforded a cleaner way to eat.

Although the Romans used forks only for serving—aristocrats ate with three fingers and slaves with five—they practiced cleanliness at

the public baths. An attempt to reintroduce the fork in Italy, after its fall from use in Roman times, took place in the eleventh century. After the barbarian invasions of Europe in the Middle Ages, water was badly polluted, and bathing was a luxury. The fork fostered cleanliness, and in the late sixteenth century, when upper-class Italians expressed renewed interest in hygiene, the fork began its journey toward acceptance in Europe.

Approval of the fork occurred in France in the seventeenth century when the French court deemed it uncivilized to eat meat with both hands. Acceptance was not readily granted by the aristocracy of England, however, who initially judged the utensil effeminate. In the words of Nicholas Breton in *The Courtier and the Countryman*, "We need no little forks to make hay with our mouths, to throw our meat into them."[10] But this attitude began to change when Thomas Coryate chronicled the Italian custom of eating with a fork in his 1611 narrative, *Coryate's Crudities*. According to Coryate, "The Italians do always at

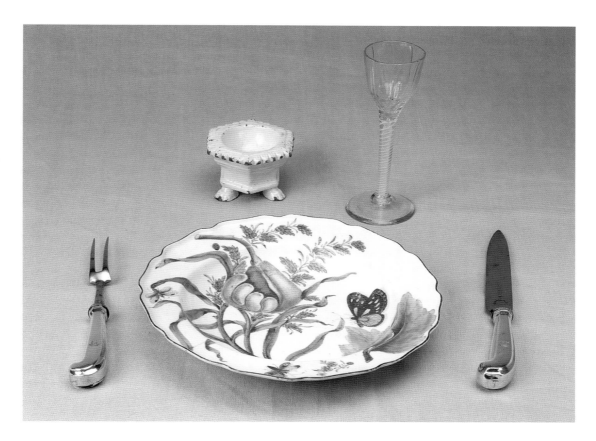

FIG 9. A table setting with typical English pistol-gripped silver knife and fork of a style popular starting in the mid-18th century, seen here with a Chelsea botanical plate, ca. 1753–56 (porcelain); a salt cellar, ca. 1760 (creamware); and an Anglo-Irish drinking glass, late 18th century (glass).

their meals, use a little fork, when they cut their meat. For while with their knife, which they hold in one hand, they cut the meat out of the dish, they fasten their fork, which they hold in their other hand upon the same dish."[11] As mentioned in Darra Goldstein's essay, although Coryate was ridiculed by some as effeminate, official acceptance came following the Restoration when Charles II granted approval. By the eighteenth century, the fork was accepted by the upper ranks of English society as well as among some of its commoners (fig. 9).

Not everyone owned a fork, and in the seventeenth century, etiquette sanctioned sharing the utensil and wiping the tines clean

before passing it to another person. But, in general, proper use of
the fork was uncertain; many were unsure how to hold it, and others
considered the table tool awkward, even dangerous, to use. From roy-
alty to aristocrats to commoners, the etiquette of the fork differed
on both sides of the Atlantic. As the majority of people are right-
handed, initial etiquette followed the kitchen custom of holding a
fork in the left hand to steady a slab of meat for carving. At the table,
the fork was held in the left hand to take a bite, aided by a knife held
in the right hand to cut and assist, low to the plate when not in use.
Because the fork was first accepted in Italy in the sixteenth century
and adopted in France in the seventeenth century, the left-hand style
of eating is often called "Continental."[12]

Today, eating from a fork held in the left hand and a knife held
in the right hand to assist is accepted etiquette for all meals, formal
and informal. This style provides economy of movement that does
not disrupt conversation at a meal where there is continual service.
The method promotes a relaxed ambience associated with gracious
dining, especially at a formal dinner, where a minimum of five courses
is served, such as two appetizers, main course, salad, and dessert—a
meal continually disrupted by the laying of plates, the presentation of
courses on platters, the clearance of soiled plates, the pouring of wine,
and the replenishment of water goblets.

From the late seventeenth century into the second half of the
eighteenth century, the design of the fork changed, and so did its
usage. The tines were shortened and moved closer together, and their
number increased from two to three around 1680, and to four around
1760. Moreover, the tines were designed with a more pronounced
upward curve, making it easier to take bites from the front of the
utensil.[13] (fig. 10) After a morsel was cut, the knife was laid on the right
rim of the plate, with the blade facing the center, in the position of
trust after our medieval ancestors. To convey a bite to the mouth, the
fork was transferred to the right hand and the tines were turned up.
The transfer style caught on in France, and was practiced by the bour-
geoisie as well as the aristocracy well into the nineteenth century.[14]

In England, the etiquette of the fork further evolved in the nine-
teenth century, but this time, it was not as a result of a change in
design. The English simply chose to use the knife as little as possible,
eschewing the transfer method. According to *The Habits of Good
Society*, published anonymously in 1859 and 1889, "Everything that
can be cut without a knife, should be cut with a fork."[15] When feasi-
ble, an entire meal was eaten from a fork held in the left hand, partic-
ularly after Charles Day in *Etiquette and the Usages of Society* declared
the transfer method "vulgar." All the while, the knife, as before, was
held in the right hand while eating low to the plate.

Nineteenth-century Americans who did eat with a fork employed
the transfer method adopted by the French, a practice labeled "zigzag"
in the twentieth century by Emily Post, doyenne of American eti-
quette. Because the transfer style shifts the fork to the right hand, the
hand over which most people have the greatest control, the method
was fully accepted in America, and is sometimes called "American."[16]

Currently, at an informal meal—a meal of four courses or fewer,
such as soup, salad, main course, and dessert—the American style is
accepted because the shift of fork from one hand to the other does

not disrupt the conversation and easy atmosphere of a meal with minimal service. Of the two ways to handle a fork, however, the Continental style is the acknowledged practice for all dining situations, formal and informal, and the American style is reserved for informal meals only.

During the nineteenth century, the basic etiquette for using table knives, forks, and spoons was understood by a wide audience. However, as the century progressed, the addition of numerous specialized implements, especially in the United States, created new and elaborate forms of etiquette. The anxiety and greater social stratification which ensued was, in part, based on the knowledge of the correct placement and usage of these utensils. The basic principle of "working from the outside in," which still prevails, became codified during this time.

In the twentieth century, the design of each form achieved greater standardization, much as it had in the eighteenth century. During World War I, the production of silverware was curtailed for several years. As job opportunities increased for women in defense plants, many left domestic service and found work in factories and offices that offered better pay and shorter hours. Good "help" was hard to find. For the average housewife, the multicourse meal laid with an array of specialized table tools began its journey toward simplification. Moreover, by the first half of the twentieth century (ca. 1926), silver manufacturers began to reduce the number of specialized table tools available in an average set.[7] The designs of specialized table tools continue to charm and intrigue, but the availability is more or less relegated to a few manufacturers, antique shops, estate sales, auctions, and family pieces.

Over the course of the past few decades, our society's dining habits have become much simpler. Life is fast-paced, and many households are dual-income. Women who work outside the home have little time to prepare multicourse menus, served at elaborate table settings laid with an array of table tools. Simple, informal meals are the norm, and basic utilitarian utensils are designed for multipurpose use, such as an oval spoon to eat soup, cereal, and soft desserts, and notched forks to eat salad, fish, and firm desserts.

Still, confusion occasionally arises over the etiquette of which utensil to use, a spoon or fork, in certain situations. When a dish is served in which both utensils seem appropriate, such as cheese soufflé topped with bacon, and served in a deep bowl, remember that form follows function, and that the etiquette which follows form is based on common sense. A flat table tool, namely a fork, is designed to spear and lift food served on a flat surface, such as a plate. A bowl-shaped utensil, specifically a spoon, is designed to sip or eat food served in a concave form, namely a bowl. When common sense is brought to the table, the design of table tools seems logical and the etiquette is natural. Sound simple? It really is.

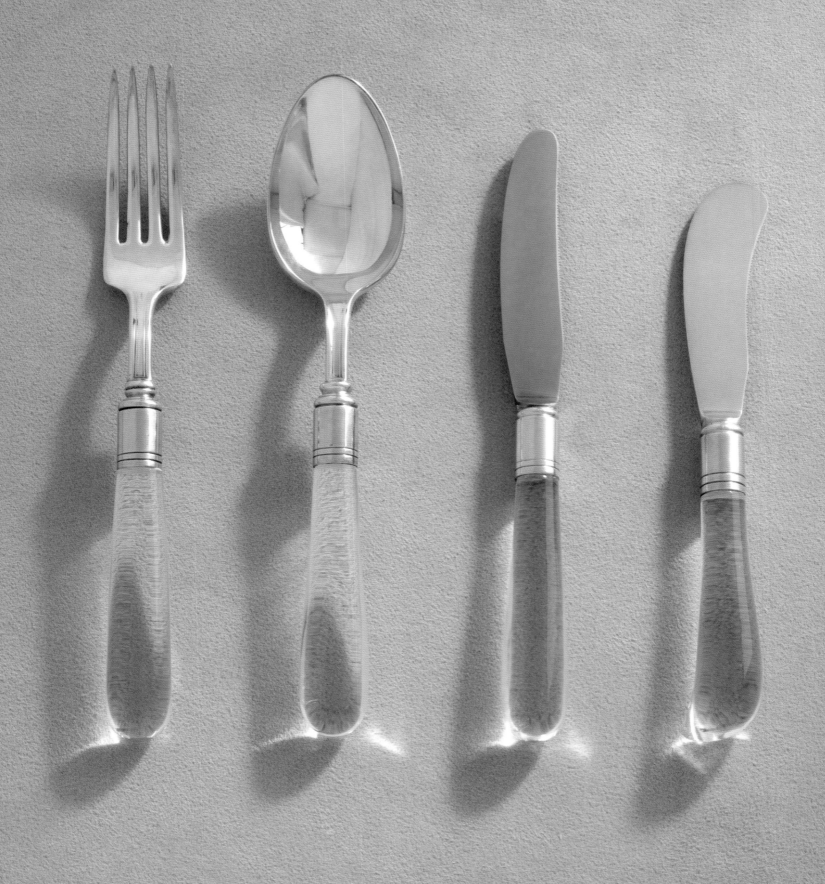

From "Fiddle" to Fatuous: The Proliferation of Cutlery and Flatware Designs in Nineteenth-century America

JENNIFER F. GOLDSBOROUGH

I N 1800, PROBABLY LESS THAN 1 PERCENT OF AMERICAN HOUSEHOLDS COULD CLAIM TO OWN EVEN A SINGLE SILVER SPOON. A HUNDRED YEARS LATER, MORE THAN A hundred different forms for knives, forks, and spoons in thousands of distinct handle patterns, made in solid silver or of silver electroplated onto base metal, were being produced. This abundance of serving and eating utensils was widely available and accessible not only to the elite, but the entire American middle class. One wonders how many brides in Nebraska really needed a dozen individual mango forks to match their dinner forks, especially if they already had matching berry forks, orange spoons, melon knives, etc. (fig. 1). For that matter, how many proper Bostonians actually would have used oyster forks, lobster forks, crab forks, sardine forks, terrapin forks, or even snail forks, each of which differed slightly in the shape of the tines, but whose handles matched the dinner forks and spoons (figs. 2, 3)? Did even the most gracious hostess require a lettuce-serving fork, a salad-serving fork, and a slightly different chicken salad-serving fork? Would Christmas dessert have tasted different if served from a blancmange spoon or a berry spoon instead of a pudding spoon?

Historical wisdom and decorative-arts tradition send us to France for the origin of household objects and customs; but the French, whose cuisine has always been recognized as superior and more refined than those of English-speaking nations, were getting along fine during the nineteenth century with just their standard knives, forks, spoons, slightly smaller dessert spoons and forks, fish sets, and an occasional asparagus server—much as they had used since the time of Louis XIV. The proliferation of distinct patterns and forms of table cutlery and flatware is almost entirely an American idiosyncrasy from the last third of the nineteenth century.[1]

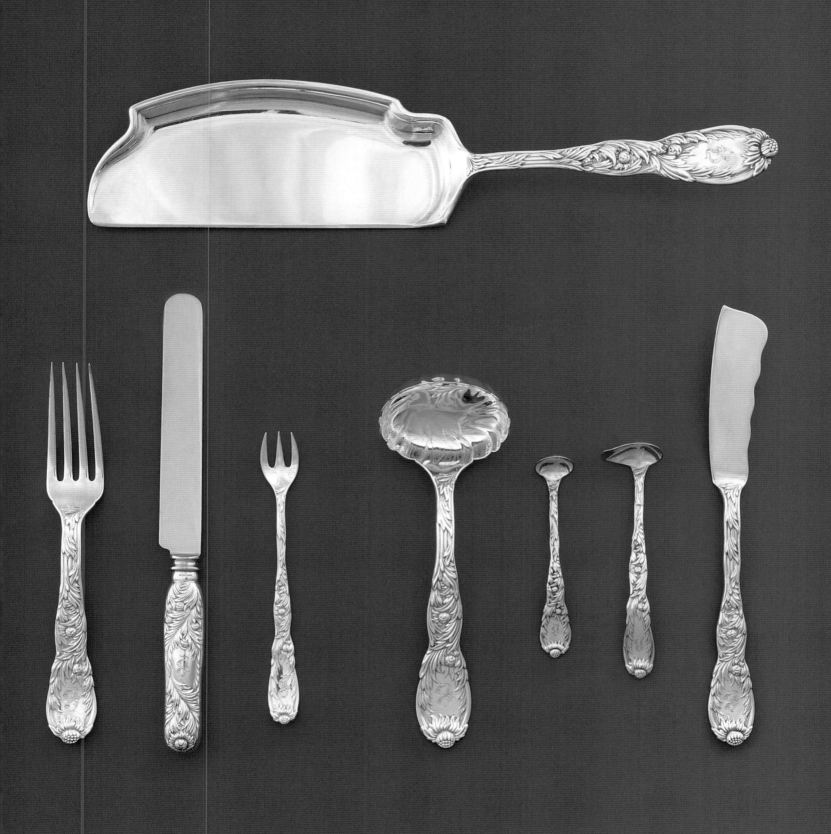

Certainly, mechanization and industrialization played roles in the proliferation of table silver in America. Throughout the first half of the century, craftsmen up and down the East Coast invented rollers, hand-powered stamping machines, and other devices in a fairly futile attempt to quickly and cheaply fabricate silver spoons from metal sheets made of melted coins. The first mechanically produced spoons were thin and flimsy, with little or no strength in their shaping, and with shallow, pressed-out bowls that were brittle and readily broken (fig. 4). Casting required too much special equipment and metal to be feasible for making most flatware or cutlery.[2]

Decorative techniques such as engraving or chasing required intensive skilled labor. It was not until 1852 that John Gorham of Providence, Rhode Island, convinced an English toolmaker to provide a steam-powered press that could successfully machine-stamp spoons.[3] With hardened steel dies, powered drop-presses could shape and partially decorate spoons, forks, and knife handles with a single blow; however, the dies themselves were expensive and required even more skill to cut than that to make an old-fashioned silver spoon. A die-struck piece of silver still required considerable hand-finishing, engraving, or chasing before it was ready for sale. Nineteenth-century die-stamping machines may have made it possible for companies to make more silver, but they did not really cut down on the skilled labor involved in the total creation of a fine product.

The advent of die-stamping machines for flatware certainly helped popularize the new electroplating process. By the early 1840s, workers were mastering the process of depositing a silver coating on a finished base-metal object through electrolysis. While earlier methods of applying a thin, cosmetic covering of precious metal on a less expensive substrate had been tedious and problematic, electroplating almost magically provided the appearance of silver with far less skill and expense. (An object made of fused or Sheffield plate, invented in England in the mid-eighteenth century, had cost an average one-third of the same object in solid silver; but fused plate was eminently unsuited for flatware (fig. 5).) An electroplated object was often only one-tenth the cost of the same object of solid silver, and the material was particularly appropriate for eating utensils. Many of the base metals were considerably harder than solid silver and could be decorated effectively only by using the new die-stamping machines; most early electroplated flatware patterns were thus simpler and more shallowly defined than solid-silver patterns of the same period. But they were stronger and heftier than "cookie-cutter," hand-pressed coin silver spoons, and they offered ample opportunity and options for new designs to appeal to the public at reasonable cost.[4]

A third factor in the proliferation of silver was the enormous increase in availability of the raw material itself. The commercial exploitation of vast silver mines in the western United States following the Civil War resulted in a drop in the price of raw silver from $1.32 per ounce in 1850 to $0.62 per ounce in 1900.[5] This decline of more than 50 percent in the cost of silver, the accessibility of cheaper electroplate, and the increased prosperity of a larger group of Americans put silver or silver-like utensils on virtually every table.

Nineteenth-century America was known worldwide as the land of opportunity, and there is no question that the rising middle class rose

FIG 4. Spoon. Frederick J. Posey. Hagerstown, Maryland, 1820–42. Silver.

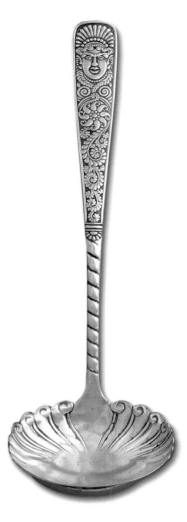

FIG 5. "Assyrian Head" ladle. Meriden Britannia Company. Meriden, Connecticut, 1885–86. Silver-plated metal.

faster and further here than anywhere else. This was reflected in the general standard of living, and especially in the expectations, pretensions, and aspirations of the bourgeoisie. This era also witnessed the widespread emergence of modern consumer culture, and this was most visible among the American middle class.

As others have for centuries, the American middle class tried to "better themselves" by changing their accents and vocabularies, by imitating the way those with more money, power, or education dressed and furnished their homes, and by copying the customs and manners of those perceived as socially superior. Without a doubt, their fears of inferiority and social naiveté—combined with manufacturers' efforts to capitalize on those feelings—account, in large part, for the invention of so many different silver forms. Newly prosperous Americans, afraid of doing the wrong thing, were easily maneuvered into purchasing specialized utensils for every possible food (fig. 6).

Silver objects took on enhanced, near-mythic desirability as they became accessible to most people for the first time, but the urge to acquire silver also related to other improvements in the middle-class lifestyle. Advancements in transportation and in the preservation and preparation of food made hitherto luxury or unattainable foods available to a much larger segment of the population. Specific objects for serving and eating such foods gave the newly prosperous a triple reward in status: having a previously rare food such as lobsters; the specific silver utensil with which to eat it; and being socially sophisticated enough to show off both luxuries by entertaining guests according to proper etiquette. Entertaining at dinner was itself an elite activity previously indulged only by the truly rich.

Only the most exotic or fashionable fruits and vegetables of the time had specific forms "designed" and named for them: there were pea spoons and asparagus servers, but no carrot forks or cabbage servers; mango forks and cantaloupe knives, but no apple forks or watermelon knives (fig. 7). The multiplicity of silver patterns, and of the forms of knives, spoons, and forks within those patterns, in American silver and electroplate reached its zenith between approximately 1885 and 1910. And during those years, the hopes, dreams, and desires of almost all American women were held within the bowls of those very silver spoons! Men might dream of a motorcar, families might hope for a house of their own, but a silver spoon had become an attainable talisman of success for everyone.[6]

Silversmiths, such as Samuel Kirk of Baltimore, who had started their businesses at a time when silver was purchased only by the very wealthy and educated, or by those who catered exclusively to the elite, such as Tiffany & Company, tended to make relatively few patterns, and adhered mainly to the European custom of silver forks, spoons, and knives of large scale with few additional forms. It was the manufacturers such as Gorham, Reed & Barton, and Towle, who were targeting a more general, albeit affluent, market, and who were responsible for creating excessive numbers of forms and almost ludicrously specialized designs for serving and eating utensils. Since most Americans were still eating with only a knife and spoon in the 1880s, it is hardly surprising that the etiquette of the day ruled that the fork should be used whenever possible to cut and eat. Hence, such outlandish implements as pastry forks whose outer tines were sharpened

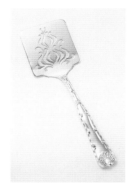

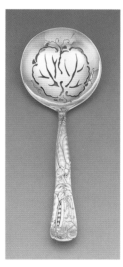

FIG 6. "Wave Edge" griddle cake server. Patent to Charles Grosjean, 1884. Manufactured by Tiffany & Co. New York, New York, ca. 1884–91. Silver.

FIG 7. "Vine" pea server. Attributed to Edward C. Moore, 1872. Manufactured by Tiffany & Co. New York, New York, ca. 1872–91. Silver.

to cutting blades or ice-cream forks appeared on the market—notwithstanding the fact that a fork is an ineffectual tool for eating ice cream. A silver fork became the most ubiquitous symbol of affluence in a democratic society. In a nation that claimed to be a classless society, quotidian flatware had become the most significant and exquisitely calibrated marker of one's status.

During the last quarter of the nineteenth century, American silver and electroplated flatwares were among the first truly design-driven consumer products. For thousands of years, the acquisition of silver spoons and forks had been encouraged by the high status value of the metal itself. Once the price of silver flatware became widely afford-

FIG 8. Patent application for Tiffany & Co.'s "Wave Edge" spoon or fork handle and design drawing of "Wave Edge" spoon handle. Submitted by Charles Grosjean, 1884.

able, manufacturers focused on varied and fashionable designs to increase demand. Silver manufacturers were among the first American industrialists to recruit, hire, and encourage professional designers. Silver flatware was often the first "designed" product to enter many American homes. Foreign artists were perceived to be better trained than their American peers; after all, American-born painters and sculptors continued going to Europe for education and experience even through much of the twentieth century. In addition, all things European held enormous cachet for Americans, who tended to feel inept and isolated in terms of the arts and culture. Most of the senior officers of American silversmithing firms traveled abroad to see the latest fashions, study the arts of the past, search for new machinery and tools, collect design books and models, and hire skilled employees. As early as 1841, John B. Young, partner in Tiffany & Young, made his first business trip to Europe. John Gorham made a trip to England

and Europe in 1852, during which he toured "the competition," arranged for and helped design the first powered die-stamping machine in the world for spoons, interviewed possible employees, and soaked up every bit of design inspiration he could see. Henry Child Kirk of the Samuel Kirk firm made extensive trips to Europe and Russia to explore potential markets and absorb new ideas.

Silver manufacturers also developed design departments, complete with extensive art research facilities and libraries filled with such volumes as Owen Jones's *The Grammar of Ornament*, first published in 1856, and Albert Racinet's *L'Ornement Polychrome* of 1869. Gorham's first foreign-born designer was George Wilkinson; trained as a die-cutter in Birmingham, England, Wilkinson first worked for the Ames Company in Chicopee, Massachusetts, between 1854 and 1857, then joined Gorham. With the exception of a few months in 1860, Wilkinson continued at Gorham, taking on more and more design responsibilities, until his death in 1894. Two more English designers joined the firm in 1868: Thomas Pairpoint, formerly of Lambert & Rawlings, and A. J. Barrett, previously with Hunt & Roskell. In 1881, the French designer Antoine Heller came to Gorham from a brief stint at Tiffany's, and, in 1891, the renowned English designer William C. Codman began his contribution as chief designer with Gorham until his retirement in 1914, replaced by his son William.[7]

In 1851, Tiffany hired John C. Moore to operate a silver shop producing wares exclusively for Tiffany; the operation soon was taken over by his son Edward C. Moore.[8] Edward Moore was not only a talented designer who had his fingers on the pulse of the most fashionable clientele in America and Europe, but also a world-class art enthusiast whose collections of exotic and ancient ceramics, glass, metalwork, and textiles still fill exhibition cases at New York's Metropolitan Museum of Art. Moore employed "scouts" all over the world (including the great English designer Christopher Dresser) to locate and purchase objects for his collection, which was originally intended as a "library" of design inspiration.[9] Although Moore was American-born, he was extremely cosmopolitan. Before his death in 1891, he trained several design masters, including Paulding Farnham, who designed some of Tiffany's most opulent turn-of-the-century silver and also had a successful career as a sculptor.[10] During the 1880s, Tiffany's most innovative flatware designer was Charles T. Grosjean.[11] (figs. 8, 9)

Reed & Barton in Providence, which originated as a Britannia metal shop, began to make electroplated flatware in the 1860s and expanded to solid-silver flatware production at the end of the 1880s. Henry Reed himself patented early flatware designs.[12] But as early as 1854, William Parkin was brought from England to cut dies and develop designs in a special design room.[13] Just as at Gorham, Meriden Britannia, and most silver and electroplating companies, foreign designers played major roles at Reed & Barton: W. C. Beattie came from England in 1874 as full-time designer; he was succeeded in 1889 by another English artist, A. F. Jackson.[14] By that year, Reed & Barton employed twenty-four men in the design department, half of whom were foreign-born, including the important French designer Ernest Meyers.[15] All of these late nineteenth-century silver designers were considered artists rather than craftsmen.

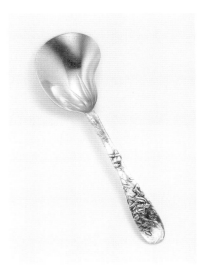

FIG 9. "Lap Over Edge" berry scoop. Patent to Charles Grosjean, 1880. Manufactured by Tiffany & Co. New York, New York, ca. 1891–1902. Silver, gold.

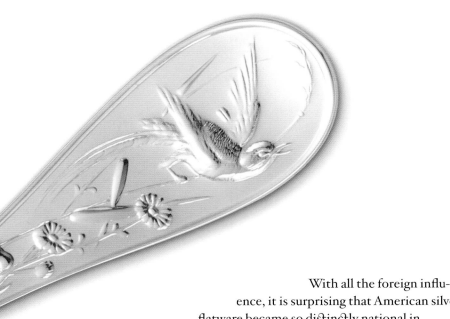

FIG 10. "Audubon"
place setting. Original
patent to Edward C.
Moore as "Japanese," 1871.
Manufactured by Tiffany
& Co. Rhode Island,
2001. Silver.

With all the foreign influence, it is surprising that American silver flatware became so distinctly national in character during the last decades of the Victorian era. Although most flatware patterns followed such traditional art-historical designations as Renaissance, Baroque, Rococo, or classical, the motifs on which those designations were based were rarely taken from the silverwares of a former period, but rather from architecture, textiles, furniture, and other arts. Thus, American nineteenth-century silver is clearly part of the Anglo-European tradition, but at the same time, it is distinctly different from British or Continental wares, of its own or any previous time. Conceivably, the heavy reliance on published design books and other artistic models, such as textiles, ceramics, and prints, could account for the distinctly American style of silver design. Nationalistic historical references appeared in American silver designs decades before the centennial of 1876, and "Colonial" became a design grab bag, including almost anything an artist wanted to employ. These so-called "Colonial" patterns bore little relationship to the spoons of the pre–Revolutionary War era, but nevertheless were imbued with historical and patriotic significance.

In 1800, almost all silver spoons made in America looked alike, with only the most minor decorative differences; by 1850, there were about a dozen simple patterns available for spoon and fork handles made by various companies in either solid silver or electroplate. The whole idea of matching patterns was still embryonic. For the most part, silver was acquired gradually as a family could afford the investment in a dozen or half-a-dozen implements and as customs in eating and setting a table evolved. The idea that everything would match simply did not occur to our eighteenth-century forebears, as there was no tradition of large matching services. By the mid-nineteenth century, if a family's accumulation of spoons and forks looked similar, it was most likely because styles changed slowly and the consumer had few, if any, choices.

With the advent of powered die-stamping machines, successful electroplating, professional designers, the drop in the price of raw silver, and a vastly expanded body of potential customers after the Civil War, manufacturers exulted in developing ever larger services in ever greater numbers of patterns. During the 1870s through the 1890s, some extraordinary designs were created to appeal to every imaginable taste; and many of the patterns designed in these decades still

define silver flatware in the minds of many Americans. By the beginning of World War I, over three thousand patterns for solid-silver or electroplated flatware had been devised and put into production by American manufacturers. Some of these patterns were available only briefly; others have been made continuously since they were first designed. By the early twentieth century, clever manufacturers capitalized on the popularity of some of their flatware patterns by naming and decorating tea services and other hollowware lines after them.

As trained designers got into the act, designing a silver spoon entailed far more than selecting a motif to stamp on the end of a standard handle. The usual eating utensils such as dinner forks, knives, and soup spoons might have been somewhat limited by their immutable functions, but even the smallest serving implements or specialized pieces became elegant works of art. During the 1870s, many designs were rather flat and pictorial, especially those based on classical, Near Eastern (then usually called "Oriental"), or "Japanese" designs.[16] The shallow relief of these patterns was due in part to the makers' lack of familiarity with the potential of powered drop-presses and the hardness of the base metal alloys used for electroplating, and also to the inherently flat nature of design book illustrations, Japanese woodcut prints, and textiles used as inspiration. Moreover, both Japanese and Islamic metalwork featured surface pattern and ornamentation which could be replicated with new methods (fig. 10).

More deeply sculpted forms became possible as drop-press technology advanced and designers rose to the occasion, especially during the period between 1885 and 1905. Handles became high-relief renditions of flowers, fruits, masks, figures, and other decorative motifs. Most of these effects could be achieved with the drop-press, but they required extensive handwork for finishing—undercutting and chiseling of the edges, chasing, engraving, and hammering. On many of the finest commercially produced wares, the handle of each form (or at least of each different size of utensil) had a different but related design. This meant that dozens, or even hundreds, of additional dies were required to complete a service, but the result was a far more interesting and artistic table setting. Included among Tiffany's full-line patterns, with variations in their handle designs produced under the direction of Edward C. Moore, were "Japanese," "Vine," and "Olympian," introduced at the *Exposition Universelle* in Paris, in 1878.[17]

F. Antoine Heller left Tiffany in 1880 and returned to Paris before being successfully wooed back to America by Gorham.[18] His Gorham patterns with varied handle designs were particularly innovative, notably "Fontainebleau" of 1882, "Old Masters" of 1887, "Medici," "Nuremburg," and "Mythologique." All of Heller's finest and most famous flatware patterns employed figural sculpture, and were conceived as miniature bas-reliefs. Perhaps the only pattern with different handle dies to remain in continuous production throughout the twentieth century is Reed & Barton's "Francis I," an Ernest Meyers design of 1908 with dies originally cut by Max Boewe, a German-born craftsman.[19] Most handle shapes were loosely based on those which had evolved during the eighteenth century, resulting in well-balanced, functional tools. Occasionally, innovative design took precedent over purpose, and the user was provided with little to grip or use as leverage. Although exquisite, patterns such as Gorham's

FIG 11. "Bird's Nest" ice spoon. Gorham Manufacturing Company. Providence, Rhode Island, ca. 1870. Silver, parcel gilding.

"Lady's" and "Bird's Nest" or Towle's "Ball Twist," with their slender, rod-like handles, were not always utilitarian (fig. 11).

By the late nineteenth century, it is evident that much of the role of the silver designer was to create as many different forms as he could imagine and then put names and purposes to them. An example would be servers for macaroni, a luxury food popularized in America, as mentioned earlier, by Thomas Jefferson. The elite had managed to serve pasta with a large spoon or fork for several generations before their appearance, but during this period, macaroni servers developed as flamboyant, miniature abstract sculptures (see Goldstein, fig. 34). The shaped bowls, blades, and tines of the serving pieces were often as beautifully designed and decorated as the handles, turning such impressive objects as crumb knives, asparagus servers, croquette servers, and punch ladles into constructions which presaged the work of Jean Arp, Constantin Brancusi, and Alexander Calder decades later (figs. 12, 13). The "working" part of the design was related either to the handle style or the food to be served. These areas also offered opportunities for customization of an otherwise standard pattern; for example, at least two very different bowl and tine designs were used for the same forms in Tiffany's Japanese pattern.[20]

Among the very wealthy, whose families had owned silver for several generations, the tendency was simply to expand their old, "standard" patterns to serve an increased number of people. Such owners were often sophisticatedly blasé about whether each item "matched" all the others on the table. Other elite customers traded in their old family silver and acquired services for twenty-four or more in the forms with which they were already familiar. A few exceedingly wealthy customers had extraordinary services custom-designed and made to their order. The most expensive aspect of such an indulgence was not the cost of the silver, or even of the design and actual crafting and finishing of the silver, but the cutting of the hundreds or thousands of dies required. The dies alone for the famous flatware service made by Tiffany for J. W. McKay cost $9,000, and those for the W. K. Vanderbilt service were reputed to have cost over $10,000.[21] (fig. 14)

In contrast, middle-class customers acquiring silver or electro-plated dinner services for the first time tended to buy a greater variety of pieces, but for fewer people. Middle-class hosts and hostesses might put out just as many courses as the elite, but they typically had fewer seats in their new dining rooms. Thus, it is in services for a dozen that we most often find the greatest variety of forms. By 1880, Reed & Barton offered twenty different spoons, twelve different forks, and ten different knives, in four different grades or qualities of electroplate, and more than a dozen patterns.[22] When we go through the list of solid-silver items made in some of the most extensive patterns like Gorham's "Chantilly" or Reed & Barton's "Francis I," we find as many as fifty-five different spoons or ladles, fifty different forks, and thirty-two knives, plus various tongs, servers, and related pieces.

No one purchased every possible form, especially not all at one time, but the opportunities to augment services with new or different specialized forms were encouraged by manufacturers. Since silver flatware almost never wore out or became truly obsolete, the industry had to find other ways to maintain growth. To adequately distinguish a preserve spoon from a jelly spoon, salad spoon, or berry spoon, or

FIG 12. "Olympian" crumber. Tiffany & Co. New York, New York, 1878. Silver.

FIG 13. "Persian" ice-cream knife. Designed by Edward C. Moore, 1872. Manufactured by Tiffany & Co. New York, New York, 1872–1904. Silver, parcel gilding.

FIG 14. Serving spoon custom-designed for William K. Vanderbilt. Patent to Charles Grosjean, ca. 1885. Manufactured by Tiffany & Co. New York, New York, 1885. Silver.

between a pea spoon and ice spoon, or a strawberry fork and lemon fork, one must consult a period catalogue for each particular pattern. Sometimes the only difference between two forms with different names was a slight variation in the shape of the bowl or tines, in overall size, or in the piercing. Often what was given one name in one pattern was given a different name in another pattern, even by the same manufacturer (fig. 15).

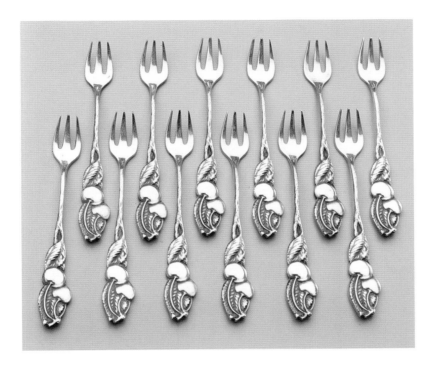

FIG 15. Cherry forks. Tiffany & Co. New York, New York, ca. 1908. Silver.

These Tiffany & Co. forks were listed specifically as "cherry forks" in this pattern, but virtually the same form was called an "oyster fork" in the "Chrysanthemum" pattern; see fig. 3.

To compound the confusion—and what must have created chaos for the manufacturer and distributors of these wares—the basic eating utensils usually were made in each pattern in three different weights and costs of solid silver. Teaspoons were available in four weights and at least two sizes in most patterns. As Darra Goldstein notes in her essay, some of this disorder was finally brought under control in 1926 at the forceful encouragement of then–Secretary of Commerce Herbert Hoover; members of the Sterling Silverware Manufacturers Association agreed on a "simplified" list of a maximum fifty-five different forms which could be made in any pattern introduced after that time.

A number of patterns were never available in complete services. Prepackaged gift sets were especially popular in the late nineteenth century and were the way many middle-class families began to acquire silver flatware. Gift sets were often designed around the service of a particular food or course. The extraordinary prevalence of pickle sets, which comprised a matching knife and fork, reinforces our understanding of the essentially middle-class nature of the market for electroplate and solid-silver gift sets. Victorian cupboards were replete with pickle knives, pickle forks, chowchow forks, relish servers, and electroplated frames for fancy glass pickle jars. Olive forks and spoons represented a step up to more exotic and luxurious fare for the bourgeois family. Sets for serving or eating fruit, preserves and jelly, game, fish, ice cream,

(OPPOSITE)

FIG 17. "Squirrel" child's
set. Tiffany & Co.
New York, New York,
ca. 1915. Silver.

and many other delicacies enjoyed enormous popularity, especially as wedding and anniversary gifts (fig. 16). Gift sets were made in patterns which were also available in a complete service of flatware, or a pattern might be devised that was very specific to a particular purpose — for instance, oranges blossoms might appear on the handles of a set of orange spoons with an orange peeler or orange knife.

Children's sets also became inordinately popular. A silver spoon had been a traditional gift to an affluent baby for centuries; in the past, it might have been the only silver spoon a person would own during his or her lifetime, and would serve a multitude of purposes in addition to being a somewhat liquid investment. In the second half of the nineteenth century, matched forks and spoons were made with very short handles for the use of infants and toddlers, and "youth sets" of miniature adult-shape knives, forks, and spoons were made or imported for children (fig. 17). Such sets were not frivolous indulgences, but rather were considered an important part of education and acculturation. They were the necessary tools by which a child learned manners and appropriate behavior so that he could join the proper adult world to which the possession of silver entitled him.

The increasingly powerful role of women during the nineteenth century was inextricably related to the design of American flatware, resulting in the feminization of silver. The rituals of dining and all of its accoutrements had been essentially masculine through the eighteenth century. With the "cult of domesticity" that ran rampant in Eastern American cities in the 1830s and 1840s, and with the rise of consumerism during subsequent decades, women wrested firm control of all aspects of household operations and embellishment by the post–Civil War period. In addition, women were perceived as the guardians of respectability and culture. George Washington had copied and kept his own book of "civility," but a plethora of etiquette books published in the nineteenth century were written by women. As silver forms and patterns proliferated, manufacturers began to direct their attentions specifically to the "lady of the house."

Perhaps the most enduring impact of women on American flatware was the reduction in size of the primary knives, forks, and spoons used for dinner service. While this resulted in a small savings in the cost of the metal itself, it also shifted American expectations toward less heavy and virile silver designs. This American acceptance of smaller implements extended through the twentieth century. During World War II, solid-silver flatware production was limited to six-piece place settings, and sale of only the luncheon or dessert size was enforced.[23] After the war, several major manufacturers introduced "place" knives, forks, and spoons, which were midway in size between dinner and luncheon items, in the hopes of expanding their market; but throughout the 1950s and 1960s, many brides continued to opt for only the luncheon size in their sterling-silver flatware. By the middle of the twentieth century, the smaller size was perceived to be easier to balance on a plate in the ubiquitous buffet entertaining style of that era. It was not until the very end of the twentieth century, after decades of mass travel and the importation of European-style electroplate and

FIG 16. "Daisy" soup ladle
with turtles. Tiffany & Co.
New York, New York,
ca. 1870–80. Silver.

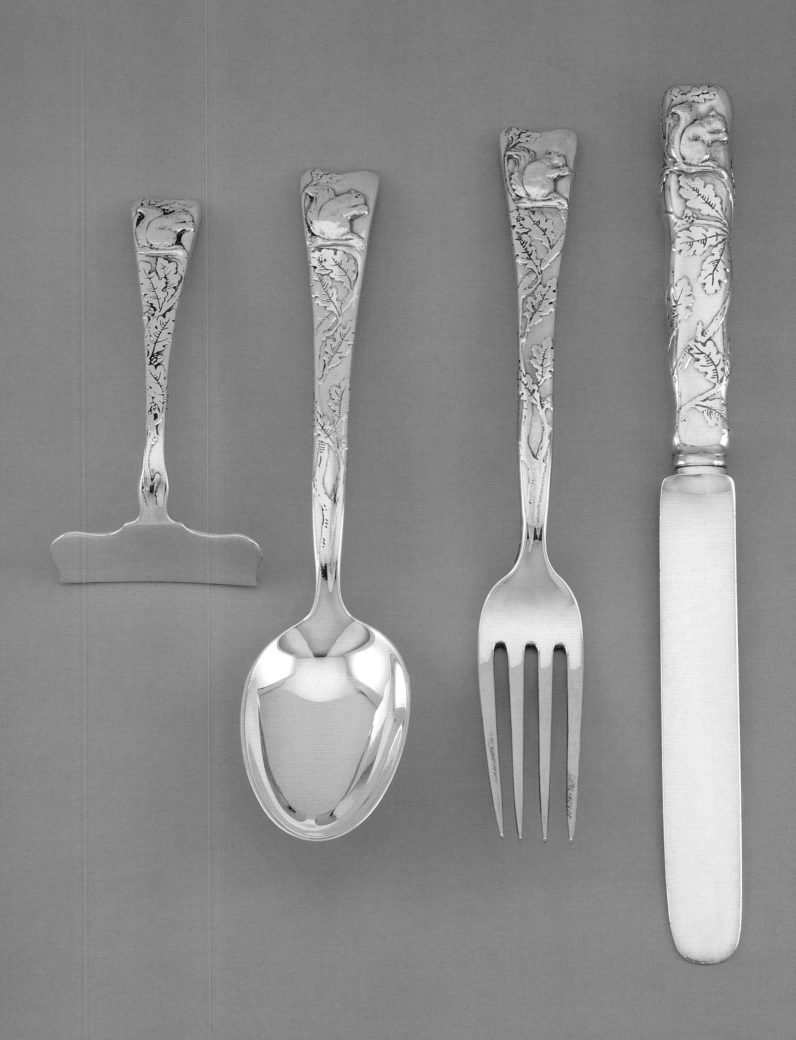

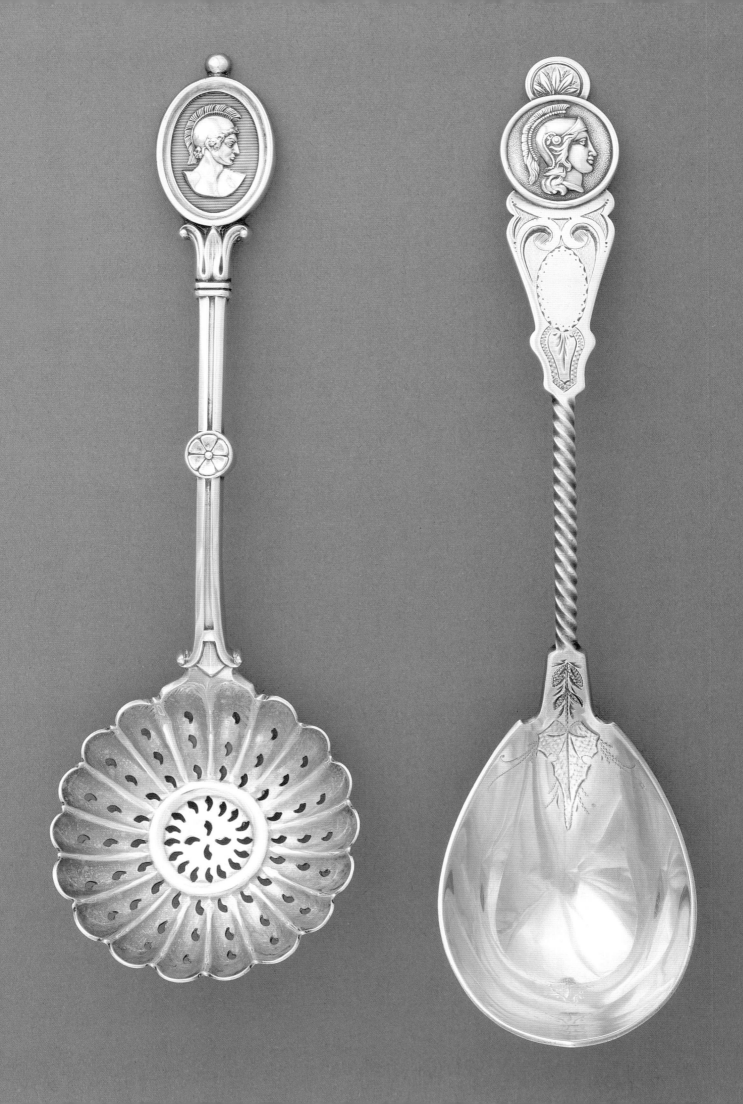

stainless-steel flatware, that more cosmopolitan Americans began to
select large-scale eating utensils for "sit-down" dining again.

Many patterns were unquestionably designed to appeal to femi-
nine tastes. Floral designs were always available; and the militaristic
"Medallion" patterns of the Civil War era and the intellectual, exotic
Japanese and Near-Eastern patterns, which had dominated the 1870s,
were quickly superceded by Rococo revival or derivative traditional
designs, whose curving lines were associated with femininity (fig. 18).
Even racy Art Nouveau patterns, such as the Alvin Manufacturing
Company's "Raphael," Gorham's "Mythologique," and especially
Reed & Barton's "Love Disarmed," evidently appealed to sophisti-
cated women who were willing to put the latest fashion above lady-
like modesty as a new century dawned. An early twentieth-century
mail-order course in how to sell silver, produced by the Sterling
Silversmiths Guild of America, acknowledges the conflicting points
of view between the then-entirely male silver sales force in the United
States and the almost exclusively female purchasers of silver.[24] Rarely
was masculine taste considered or consulted (fig. 19).

Table silver, especially a service of flatware, became an American
woman's most important possession, whose social and sentimental
significance often far exceeded its monetary value. Flatware was
passed from mother to daughter, went with the woman in cases of
separation or divorce, and defined a woman's breeding, education,
taste, and culture. Today, there are still women whose silver flatware
provided a financial "cushion" when they became widows. The selec-
tion of a woman's silver pattern became a rite of passage, and the
public statement of her identity and self-image. By the turn of the
twentieth century, the possession of silver flatware had become so
important to a woman's position that those families who could afford
to do so started collecting silver for a girl at the time of her birth, in
which case, an already extant family pattern was augmented, or the
girl's mother, grandmother, godmother, or aunt made the choice of
pattern on her behalf, and she was brought up to "match" her silver.
This upper-middle-class custom offered family and friends the oppor-
tunity to give a girl silver for birthdays, holidays, and other occasions
throughout her childhood so that when she reached marriageable age
she already possessed much of her service.

Among the wealthy, a bride-to-be decided on her pattern, and
her father presented the entire service as a wedding gift. Well into the
twentieth century, it was considered "correct" for silver flatware to
carry a bride's maiden initials rather than her married initials. As more
American women were offered educational and career opportunities,
it became customary for middle-class girls, for whom a pattern had
not already been selected, to choose their silver patterns at the time
of their high-school graduation and to build their silver services
through gifts and with their own savings. During the years between
the end of World War I and the 1970s, when stainless steel supplanted
silver as the dominant flatware material, many young "working girls"
spent money to acquire one silver spoon or fork at a time rather than
going to the movies or indulging in a new blouse. As such, a silver
spoon remained, until well after World War II, the most ubiquitous
symbol of the American dream.

FIG 19. Advertisement
for "1847 Rogers Bros."
(line of Meridien Britannia
Company, a division
of International Silver
Company, Meridien,
Connecticut), in *The Modern
Priscilla*, p. 23. Published by
The Priscilla Publishing
Co. Boston, Massachusetts,
November 1909.

Modern Flatware
and the Design of Lifestyle

———

ELLEN LUPTON

FROM A BAG OF DRIVE-THROUGH BURGERS
TO A HOLIDAY FEAST SERVED WITH A
FAMILY'S FINEST TABLEWARE, PEOPLE USE
THE TOOLS AND ENVIRONMENTS OF

dining to express their personal style and social
status, as well as the meaning of a particular meal.
One's choice of cutlery is an expression of taste.
Taste may begin with the mouth or be felt in the
gut, but it is articulated through what we do in
front of other people—what we say, what we buy,
what we serve, and how we serve it. Like good manners, "good taste"
is a mark of cultivation, a product of social training.

The history of modern taste, both popular and elite, can be wit-
nessed in the design of flatware. These modestly scaled, yet design-
intensive objects connect the intimate act of eating with the commu-
nal act of dining. The knife, fork, and spoon are a cast of characters
who persistently make their way across the stage of twentieth- and
twenty-first-century design. From their place in the background of
design's larger dramas, these objects reveal how designers approached
the basic activities of eating and socializing, and how marketers,
manufacturers, and consumers came to equate the expression of
one's self with the use and display of one's things.

The German sociologist Max Weber began using the phrase
"life style" at the turn of the twentieth century to describe status
groups within society. He saw that education and occupation
connected people as strongly as their economic means. In the 1920s,
the Viennese psychotherapist Alfred Adler talked about "life style"
as a human being's unique, self-directed personality; he viewed
lifestyle in individual, rather than social, terms. In the 1950s and
1960s, sociologists and market researchers defined "life style" as
the way people shape their social identities through products and
purchases. In an upwardly mobile society, professional status, educa-
tional levels, and one's choices of neighborhood and housing had
become powerful sources of identity. A whole new generation, for

example, was college-educated, equalizing people whose parents had diverse origins.[1]

"Life style" was digested from a semiotic point of view by the French sociologist Pierre Bourdieu in a famous study conducted in the 1970s. Comparing the everyday practices of bourgeois and working-class families, Bourdieu saw the measured customs of middle-class dining as a stylization of daily life: form, appearance, and manners were valued over—and, indeed, suppressed—expressions of bodily enjoyment. He reported that working-class families would reuse plates from course to course, cleaning them up with a wipe of bread; improvise dessert plates from the baker's cardboard box; and pass around a single spoon for stirring coffee. For the working-class family, the food was more important than how it was served: "No matter that the tableware is ordinary, so long as the food is 'extra-ordinary.'" In contrast, bourgeois custom relied on a precise and measured sequence of events, including waiting for people to be served, separating foods and courses, and observing proper etiquette and place settings.[2]

In common parlance today, lifestyle (compounded into a single word) incorporates a range of attitudes toward consumption, status, and the human body. "Lifestyle marketing" presents housewares,

FIG 1. "A Light's Drawing" cup, dishes, placemat and napkin. Designed by Sandra Bautista. Produced by BOSA. Italy, 2005. Stoneware, textile (cotton, linen).

FIG 2. Dinner fork, knife, spoon. Designed by Joseph Maria Olbrich, Darmstadt, Germany. Manufactured by Christofle. Paris, France, 1901. Silver-plated metal, steel.

furniture, paint colors, and other domestic goods in relation to carefully constructed environments that suggest the broader habits and personal character of the consumer. From magazines like *Martha Stewart Living* to catalogues for Pottery Barn or Williams-Sonoma, products appear within lavishly art-directed settings.

Lifestyle also serves to describe how people maintain and use their bodies, from regimens of diet and exercise to sexual orientation. Health clubs bill themselves as "lifestyle centers," and breweries advertise their low-carbohydrate beers as "lifestyle" beverages. Like taste, lifestyle connects the private, individual body with public, outward behavior.

From the early twentieth century to the present, modern designers have helped invent the notion of lifestyle. A recurring theme within modernism is the desire to unify art and life, breaking down the barrier between the fine and applied arts to integrate visual practices with everyday experience. Modern designers have proclaimed a new interest in creating objects that affect the way we live, and have made goods that are desirable to broad swaths of the public. Whereas aristocratic taste had set the highest standard of decoration in previous centuries, modern designers have turned attention to life at the middle. Mass markets have provided not only the economic promise of wider sales, but also a chance to broadly affect society. Elitism was narrow; populism is powerful. Products such as flatware are conceived as part of an overall lifestyle, addressing ideas about personal comfort and hygiene, the nature of entertaining, and the desire for simplified domestic routines. Designers have shaped new styles—and stylizations—of living as they craft tools for changing modes of dining, dwelling, and entertaining (fig. 1).

The Gesamtkunstwerk *and the* Art of Life

The Vienna Secession was founded in 1897 by a progressive circle of artists and designers who sought to stylize life through the spectacular idea of the *Gesamtkunstwerk*, the total work of art. They abandoned the official academic salon (*Künstlerhaus*) in order to integrate artistic practice with useful objects and environments. From the decorative eroticism of Gustav Klimt's paintings to the luxurious geometries of Josef Hoffmann's furniture and utensils, the objects of the Vienna Secession envisioned a mode of living touched by beauty and originality in every facet, from the hardware on the doors to the gowns on the women. The domestic realm offered a stage upon which to set a drama of aesthetic renewal.

And a stage, indeed, it was, for the ideal of the *Gesamtkunstwerk* was realized more fully in the context of public exhibitions than in private homes.[3] Josef Maria Olbrich, the architect of the 1898 Secession exhibition building in Vienna, orchestrated many of the group's public presentations. His own home at the Darmstadt Artists Colony, built in 1901, was open as an exhibition before Olbrich moved in to live there. In the dining room, visitors could view a table set with Olbrich's own flatware, and they could use the pieces themselves in the four hundred-seat exhibition restaurant.[4] (fig. 2)

FIG 4. Chair for the dining room of the Purkersdorf Sanatorium. Designed by Josef Hoffmann. Manufactured by Thonet Brothers. Austria, 1904–06. Beechwood, leather, metal.

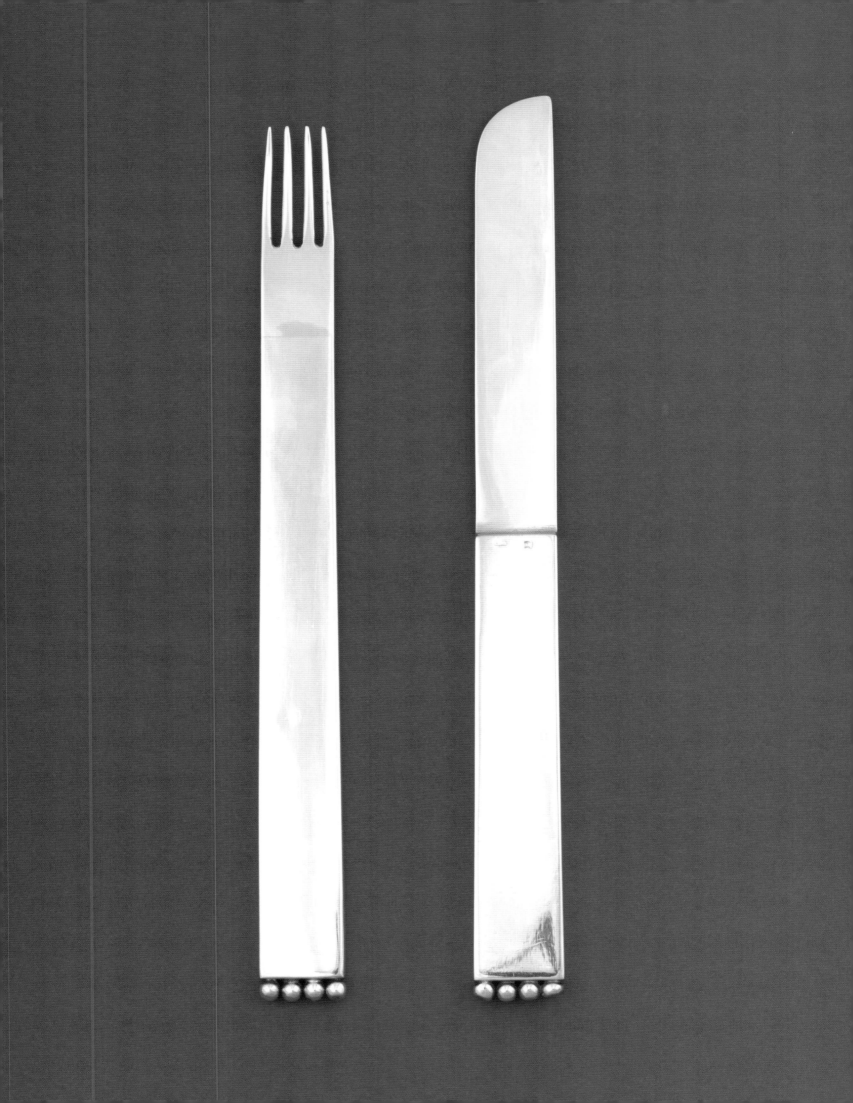

Josef Hoffmann and Koloman Moser, leading designers within the Secession group, founded the Wiener Werkstätte (Vienna Workshop) in 1903, seeking to link designers with craftsmen and manufacturers who could make their products available to a wider public. Hoffmann created several flatware patterns through the Wiener Werkstätte, including the "Flaches Modell" (Flat Model) of 1903, whose vocabulary of dramatically straight lines with ball shapes also occurs in Hoffmann's Purkersdorf dining chair (1904–06). While the spheres on the chair reinforce the joints at the leg and seat, the balls on the silverware appear to have a wholly decorative function.[5] (figs. 3, 4)

The "Flaches Modell" flatware was presented to the public in a 1906 exhibition at the Wiener Werkstätte called *The Set Table*. Critics at the time reacted against the severity of the design. One reviewer commented, "It reminds one of anatomical utensils and surely would spoil for many the appetite by reminding one of the dissecting hall…[The result is] disobliging for the eye, the hand, and even for the mouth." Another critic attacked Hoffmann's "purposeless ornamentation" and his use of shapes whose break with tradition would cause discomfort to the hand.[6]

Other movements around the world were creating unified domestic environments. In 1912, architect George Washington Maher conceived the Rockledge Estate, in Minnesota, an elaborate summer residence in which a system of design motifs connected the architecture and the landscape with the interior furnishings, from silverware and tea services to sconces, rugs, and draperies. The architect's naturalistic ornament and color palette were inspired by the coral lilies growing wild around the property; a structural language of segmental arches reverberated throughout the building, and gave the flatware its distinctive profile.[7] (fig. 5)

Functionalism and the Reform of Life

In the early twentieth century, people of even modest economic means in developed nations had access to a great number of consumer goods, including matched sets of mass-produced flatware. Progressive designers in the 1920s and 1930s celebrated the idea that well-designed industrial objects could be of equal value to people across the strata of society: a well-balanced fork or knife was as necessary to a factory worker as to a diplomat. If the processes of daily life—cooking, eating, bathing, sleeping, working—were universal, so, too, could the objects put in their service.

Proclaiming the house as a "machine for living," the Swiss architect Le Corbusier exchanged decorative forms and surfaces for a severe, purified functionality. Manufactured objects, he argued, should be neutral tools serving the needs of habitation. Railing against the clash between modern life and historical styles, he exclaimed, "The dining car (room for eighty diners) and elaborate place settings in the style of Louis XIV?"[8] Advancing a new program for the decorative arts, he pointed to the anonymous, industrially produced dishes and glassware of the Paris café as models for a domesticity stripped of ornament. Modern flatware reflecting this sentiment include a pattern

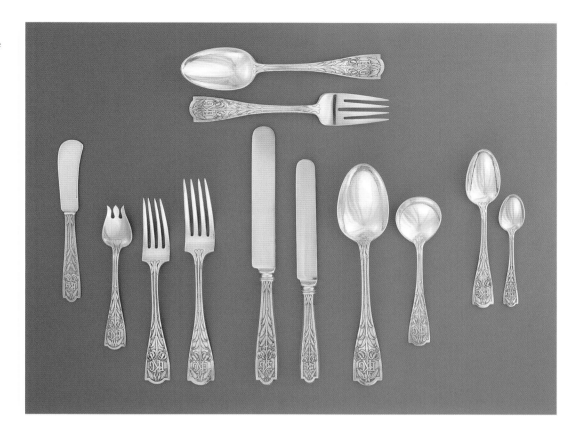

designed by Fritz August Breuhaus de Groot in Germany in 1931 (figs. 6, 7). Working in Denmark, Kay Bojesen presented a flatware pattern at the 1938 Milan *Triennale*, whose severe, nondescript appearance resulted from a functional analysis of basic forms.[9] (fig. 8)

In the 1920s, many modern architects addressed the problem of worker housing, particularly the need to transform traditional spaces for cooking, eating, and socializing into a more efficient ensemble. The Weissenhof settlement, built in Frankfurt, Germany, in 1927, featured experimental prototypes for worker housing conceived by progressive designers from across Europe. In several Weissenhof projects, the conventional dining room disappeared into the open space of the living room, while the kitchen became a modular, mechanized workshop.[10] The idea of constructing open, multiuse spaces for living and dining was also seen in dwellings created for sophisticated patrons of modernism, such as Le Corbusier's villa at Garches, built in 1927.[11]

Jean Elysée Puiforcat's designs for silver, created from the 1920s through the 1940s in France and Mexico, interpreted the modernist design vocabulary through the intensifying lens of luxury and precision. Puiforcat transformed the search for functional, industrial equipment into the production of exquisitely crafted, aesthetically refined objects. His silverware patterns used both functional and geometric analysis to question traditional forms and invent new ones. Puiforcat rejected the way the handle of a fork or spoon becomes thinner at its "branch," preferring instead to create a continuous shaft where the handle meets the tool. Puiforcat's fascination with the pure geometry of the circle can be seen across his oeuvre: the bowl of a cocktail spoon is sliced from a perfect sphere, while the handles of a coffee set have circular openings to match their circular footprints.[12] (figs. 9–11)

(ABOVE)

FIG 6. Dinner fork and
knife. Designed by Fritz
August Breuhaus de Groot.
Manufactured by Henckels.
Germany, 1931. Silver-plated
metal, stainless steel.

(RIGHT)

FIG 7. Poster: *Couverts
Deetjen*. Jean Adrien
Mercier. France, 1930.
Lithograph on paper,
backed on linen.

(OPPOSITE)

FIG 9. Illustration of fork,
knife, and spoon, from *Jean
Puiforcat, orfèvre sculpteur*.
Published by Flammarion.
Paris, France, 1951.

(BELOW)

FIG 8. "Grand Prix"
flatware service.
Designed by Kay Bojesen.
Manufactured by
Rosendahl. Denmark,
designed 1932, produced
1980. Stainless steel.

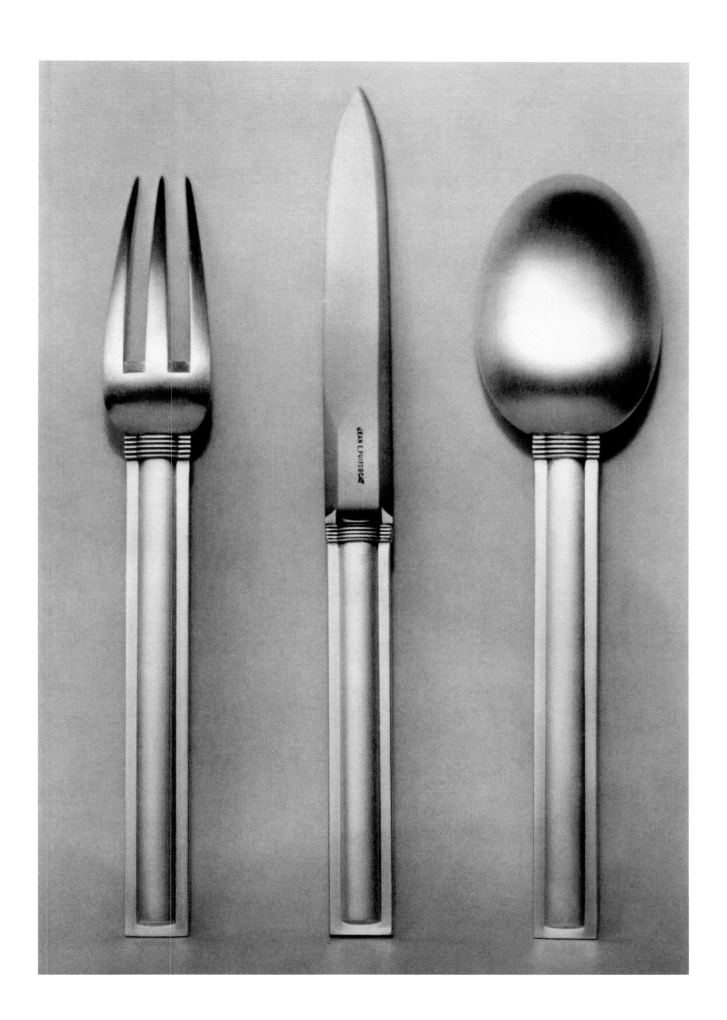

MODERN FLATWARE
AND THE DESIGN OF LIFESTYLE

(ABOVE)

FIG 10. Drawing: *Design for a Punch Ladle*. Jean Elysée Puiforcat. Mexico, 1943. Pen and black ink, graphite on cream tracing paper.

(RIGHT)

FIG 11. Drawing: *Design for a Coffeepot, Sugar Bowl, and Creamer*. Jean Elysée Puiforcat. Mexico, 1942. Pen and black ink, brown ink, brown pastel (verso), graphite on cream tracing paper.

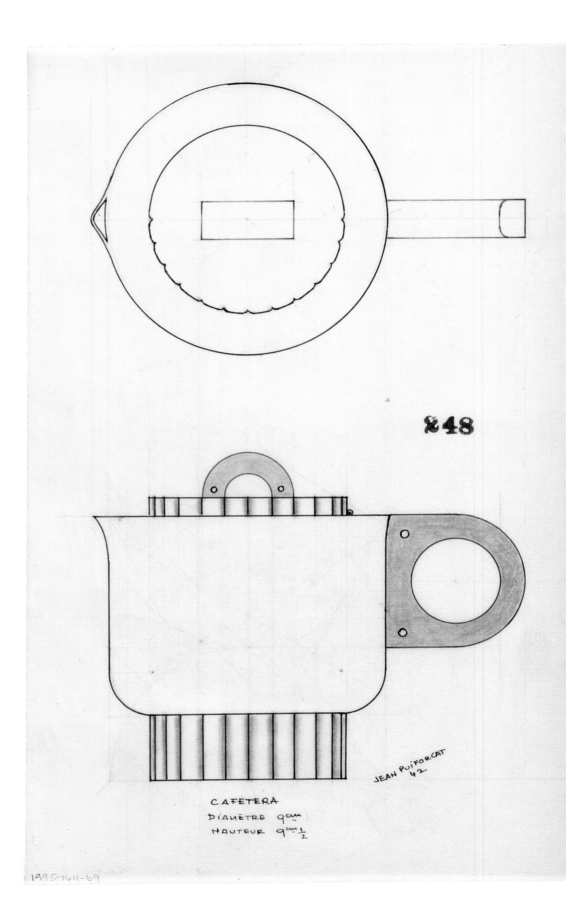

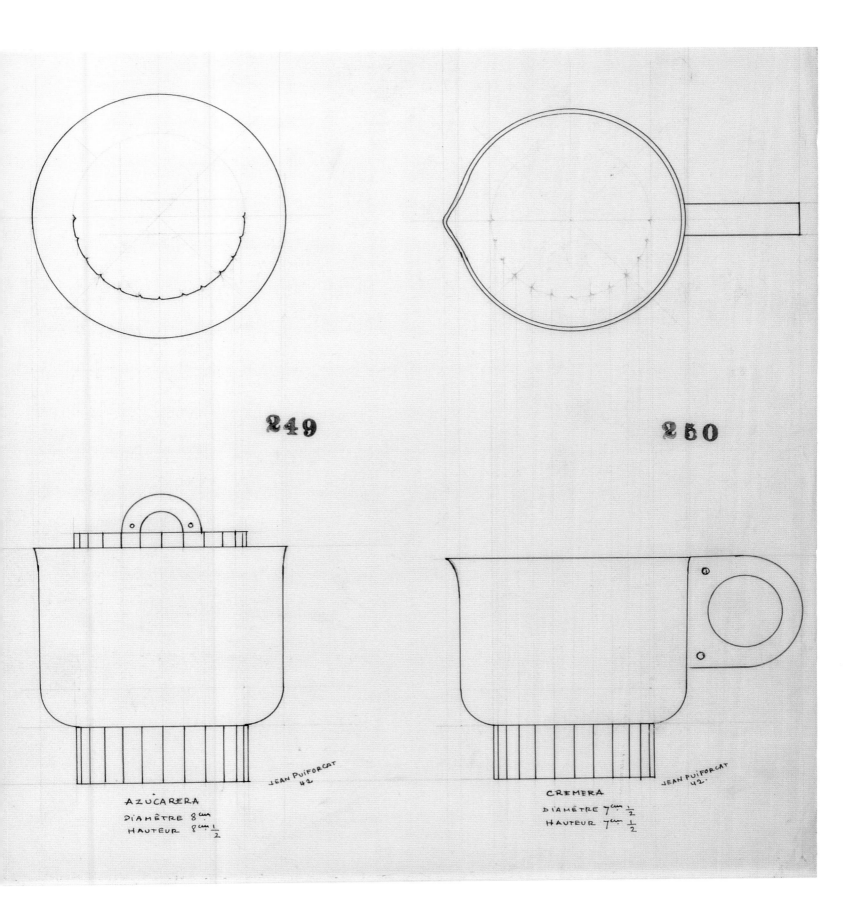

249

250

AZUCARERA

DIAMÈTRE 8cm

HAUTEUR 8cm $\frac{1}{2}$

JEAN PUIFORCAT
42

CREMERA

DIAMÈTRE 7cm $\frac{1}{2}$

HAUTEUR 7cm $\frac{1}{2}$

JEAN PUIFORCAT
42.

Scandinavian Modern and the Return to Nature

Designers working in the countries of Scandinavia formed a regional approach to modernism that eventually came to have a global impact. Drawing on the traditions of craft, practicality, democracy, and simple living which had long characterized the cultures of northern Europe, progressive designers embraced natural forms and materials and sought to make well-designed, industrially produced objects available across society.[13]

In the early twentieth century, the Danish silversmith Georg Jensen pioneered an abstracted, yet naturalistic, vocabulary which helped set the course for Scandinavian modernism, as seen in patterns such as "Acorn," designed in 1915 (figs. 12–14). In the 1920s, Jensen began commissioning work from other progressive designers from Denmark and beyond. The company continued to flourish after Jensen's death in 1935.

A pattern created by Arne Jacobsen for Georg Jensen in 1957 became an emblem of futuristic living, appearing in the 1968 Stanley Kubrick film *2001: A Space Odyssey*. Jacobsen reconceived the knife, fork, and spoon as continuous, flowing objects rather than assemblies of functional and decorative components (fig. 15). Similar ideas were explored in designs by Jens Quistgaard, Svend Siune, Tias Eckhoff, and others throughout the 1960s (figs. 16–18). Affordable stainless-steel flatware patterns like these were made to appeal to both the hand and the eye. Hundreds of original designs were created in Denmark, Norway, and Sweden, and many found a ready market among forward-looking consumers in the United States in the 1950s and 1960s, who warmed to this humane and inventive mode of modernism, one which matched their generation's relaxed patterns of dining and entertaining.

American Modern

Modernism in America took cues from European design—both the Bauhaus and Scandinavian varieties—but infused it with its own energy and imagery. Shimmering across the Art Deco film sets of the 1920s, American modernism conjoined glamour and spectacle. In the 1930s, streamlining emerged as an aesthetic of sales, a sculptural rhetoric which rekindled desire in a period of economic hardship. If modernism in the Bauhaus vein sometimes took a stern view toward efficiency in the home, American designers appealed to the appetite for leisure and entertainment.

The Joy of Cooking, published in 1931, put pleasure at the center of American dining, while Dorothy Draper's 1939 classic work *Decorating Is Fun!* took an eclectic and forgiving view of interior design. One's choice of environment, wrote Draper, should reflect one's life: "Decorative styles are, after all, simply indications of a manner of living...Your home is the backdrop of your life, whether it is a palace or a one-room apartment. It should be honestly your own—an expression of your personality."[14] She advised consumers to follow their own taste when setting the table, choosing flatware patterns from among

FIG 12. "Acorn" carving knife and fork. Designed by Johan Rohde. Manufactured by Georg Jensen Sølvsmedie. Copenhagen, Denmark, 1915. Silver, stainless steel.

(TOP AND LEFT)
FIG 14. Serving fork and spoon, model number 38. Design attributed to Arthur Georg Jensen (1866–1935). Manufactured by Georg Jensen Sølvsmedie. Copenhagen, Denmark, designed ca. 1915–20, produced ca. 1955–60. Silver.

Serving fork and spoon, model number 83. Design attributed to Arthur Georg Jensen (1866–1935). Manufactured by Georg Jensen Sølvsmedie. Copenhagen, Denmark, designed ca. 1915–20, produced ca. 1955–60. Silver.

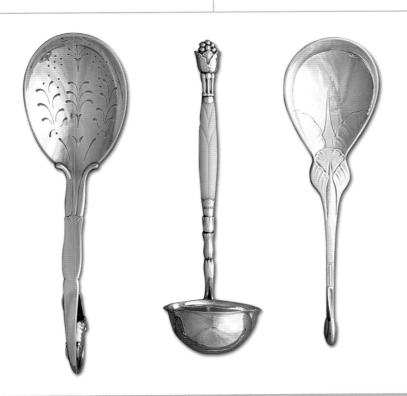

(LEFT TO RIGHT)
FIG 13. "Blossom" pierced spoon or sugar sifter. Georg Jensen Sølvsmedie. Copenhagen, Denmark, designed 1912, produced after 1944. Silver.

Sauce ladle, model number 93. Georg Jensen Sølvsmedie. Copenhagen, Denmark, designed 1910, produced ca. 1915–32. Silver, ivory.

"Snail" serving spoon. Georg Jensen Sølvsmedie. Copenhagen, Denmark, designed 1908, produced ca. 1915–27. Silver.

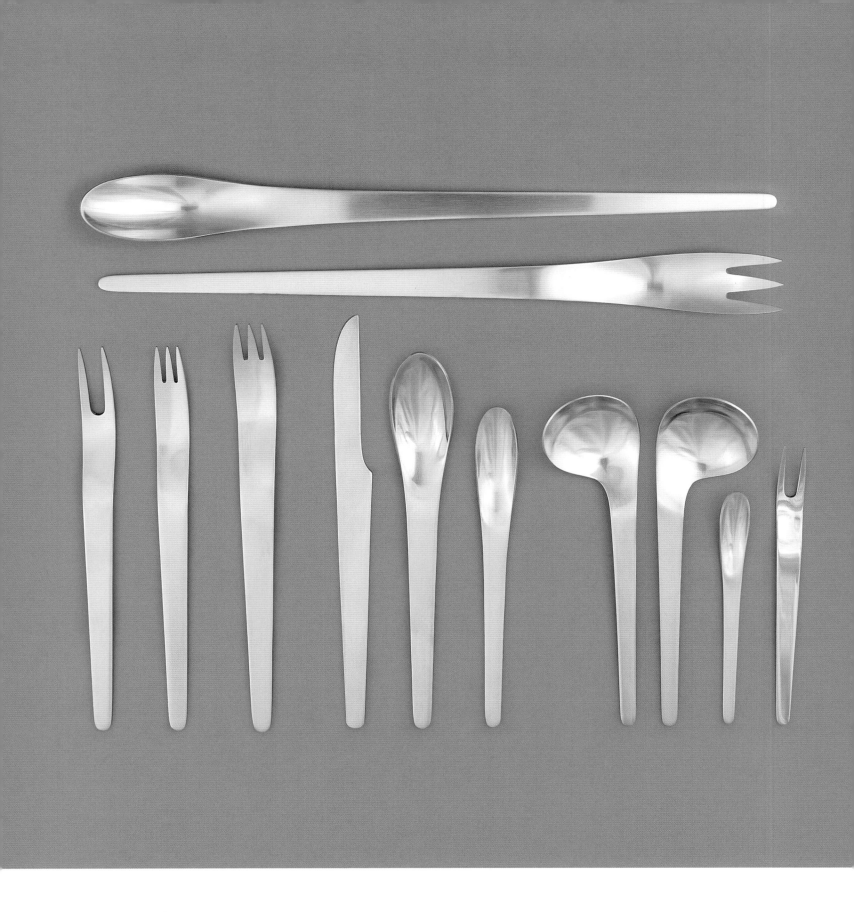

FIG 15. "AJ" flatware.
Designed by Arne Jacobsen.
Manufactured by Georg
Jensen Sølvsmedie.
Copenhagen, Denmark,
designed 1957, produced
ca. 1990. Stainless steel.

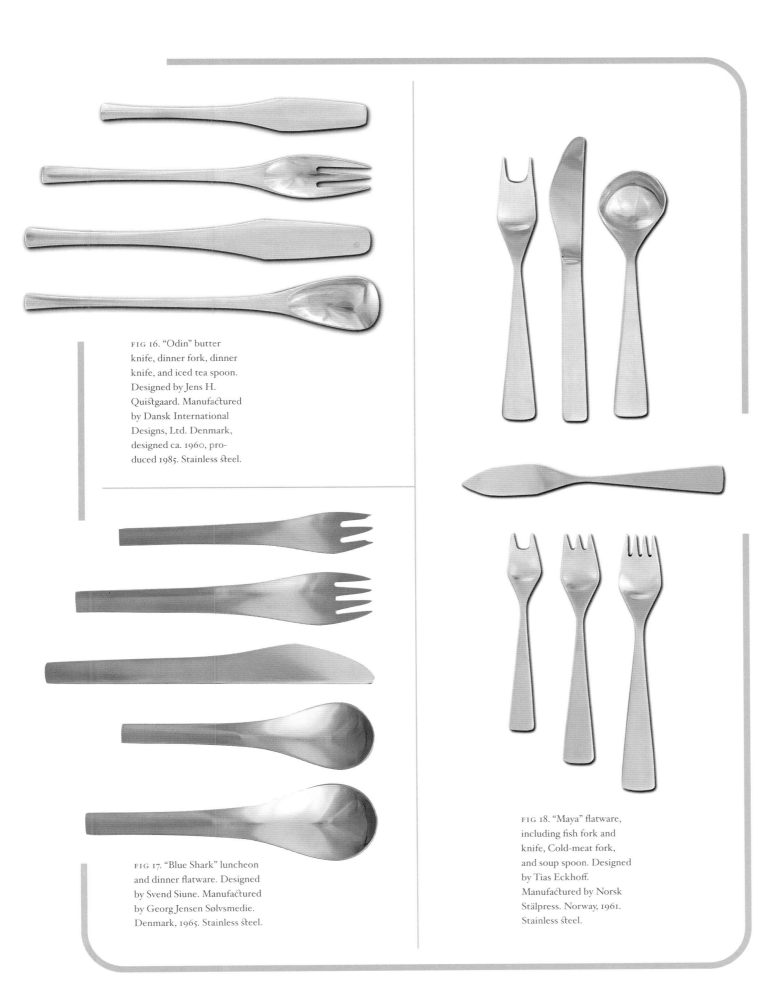

FIG 16. "Odin" butter knife, dinner fork, dinner knife, and iced tea spoon. Designed by Jens H. Quistgaard. Manufactured by Dansk International Designs, Ltd. Denmark, designed ca. 1960, produced 1985. Stainless steel.

FIG 17. "Blue Shark" luncheon and dinner flatware. Designed by Svend Siune. Manufactured by Georg Jensen Sølvsmedie. Denmark, 1965. Stainless steel.

FIG 18. "Maya" flatware, including fish fork and knife, Cold-meat fork, and soup spoon. Designed by Tias Eckhoff. Manufactured by Norsk Stälpress. Norway, 1961. Stainless steel.

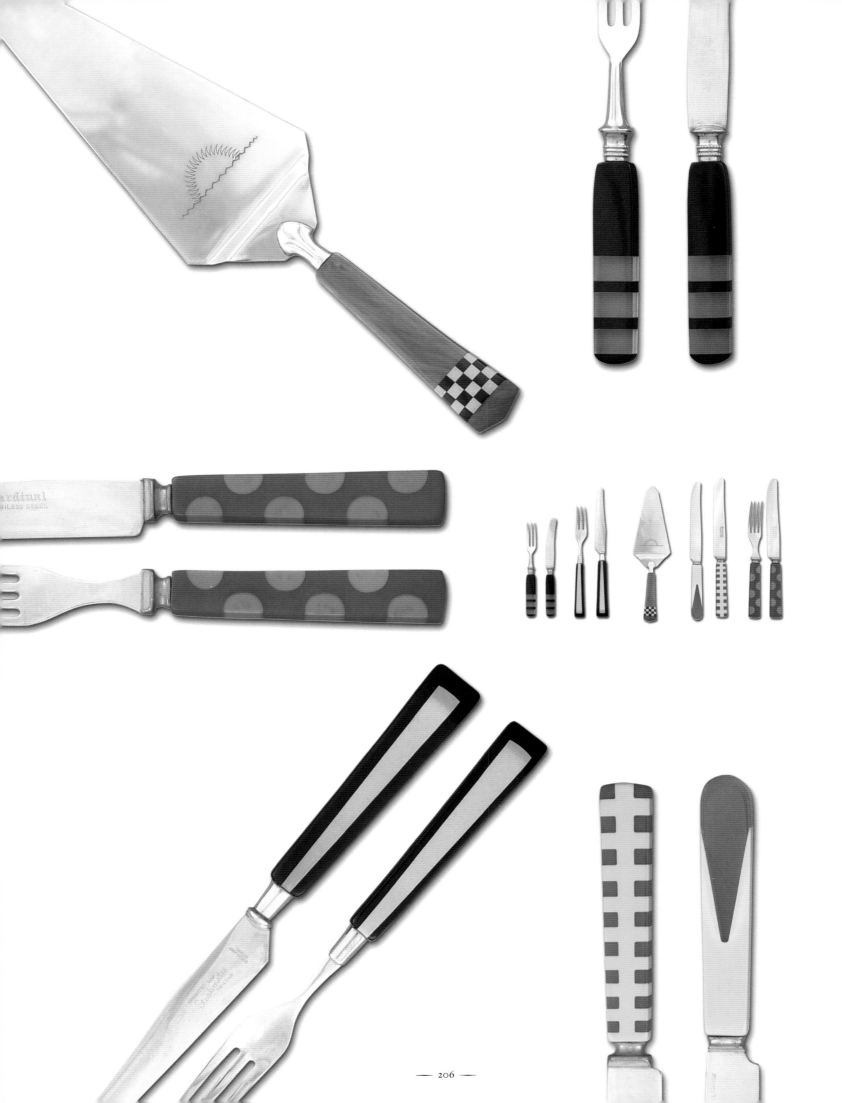

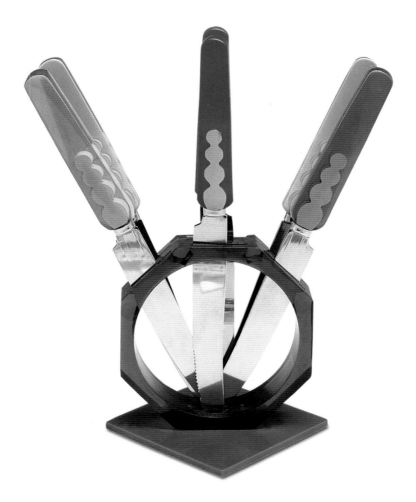

Georgian and Colonial copies as well as from among the "more simple, modern silver that is being made in Denmark, Sweden, and America." Draper decreed that flatware need not match the room's furnishings, and that acquiring a vast range of specialized eating utensils was unnecessary.

Designed with an eye for originality, flatware with glass handles introduced by the Steuben Glass Works around 1932 used familiar tabletop materials in an unfamiliar way; the clear glass handles infused these pieces with subtle and refined glamour.[15] (see Goldsborough, opening spread) Stainless-steel flatware fitted with Bakelite handles from the 1930s and 1940s combined crisp, geometric ornament with flamboyant color, demonstrating a more relaxed, festive spirit. Such objects celebrated newness and abundance rather than tradition, permanence, or the universality of function (figs. 19, 20).

By the close of World War II, sociologists and cultural commentators were observing a world transformed by consumption. David Reisman's *The Lonely Crowd*, published in 1950, argued that social distinctions in the United States now hinged on individual taste and consumer choices rather than on the old divisions of class and income. Reisman contended, "No walls of privacy, status, or asceticism remain to protect or prevent one from displaying personalized taste in food and décor as an element of one's competition with others." He observed that middle-class consumers were now embracing "immigrant" cooking along with casual and ethnic tableware—"Mexican casseroles and copper kettles"—and the pressure to observe strict etiquette and convention had given way to the desire for originality and self-expression.[16] (fig. 21) As old

FIG 21. Illustration:
Mexican-themed "Patio
Supper for Unexpected
Guests," from *How to
Take a Trick a Day with
Bisquick, as Told to Betty
Crocker by Screen Stars,
Society Stars, Home Stars,
and Homemaking Editors*.
Published by General
Mills, Inc. U.S.A., 1935.

standards of etiquette were breaking down, a new hierarchy of taste and opinion-making was emerging, as laid out in Russell Lynes's cutting diatribe of 1949, "Highbrow, Lowbrow, Middlebrow."[17] In the absence of clear and obvious rules, consumers were now struck with anxiety about whether their taste was sufficiently informed and up-to-date.

Betty Friedan's 1963 bestseller *The Feminine Mystique* laid bare the lifestyles of educated, affluent women in the 1950s, who had come to accept suburban domesticity and full-time mothering as the limits imposed around their privileged existence.[18] Looking back at her own life, Friedan later recalled 1949 as a turning point for herself and other young Smith College graduates in New York City. She remembers suddenly deciding that she did, indeed, want her mother's sterling silver, a possession previously deemed "too bourgeois." Her mother's silver, a traditional emblem of status, took its place alongside progressively designed furniture and objects: "Suddenly, we were very interested in houses and things: chairs, tables, silverware. We went to the Museum of Modern Art to study furniture and displays of modern architecture, and we bought our first possessions—Eames chairs, a blond free-form sculptured Noguchi dining table, and a Herman Miller couch-day bed."[19]

Responding to the post-war embrace of suburban domesticity, Russel and Mary Wright's 1950 *Guide to Easier Living* emphasized comfort and enjoyment as well as contemporary style.[20] The Wrights encouraged readers to experiment with new ways to serve and enter-

tain, from the "Kitchen Buffet" to the "Cooperative Meal," concepts in which guests and family participated in the making and serving of a meal. Russel Wright's "Highlight" or "Pinch" cutlery, manufactured in 1953, was designed to fit comfortably in the hand and coordinate with his organically shaped, richly colored dinnerware of the same period.[21] (fig. 22)

(ABOVE)

FIG 22. Drawing: Design for "Highlight" or "Pinch" flatware for John Hull Cutlers Corporation. Russel Wright. U.S.A., 1948. Brush and green and white gouache, black ink and wash, black chalk over graphite on chartreuse paper mounted on board.

(RIGHT)

FIG 23. "The all-in-one room," from *Guide to Easier Living*. Russel and Mary Wright. Published by Simon and Schuster. New York, 1951.

This casual approach to dining inspired architectural changes as well. Open-plan spaces for cooking, eating, and relaxing facilitated the "easier living" championed by the Wrights, who advocated connecting the kitchen and dining areas with a freestanding storage unit containing a pass-through opening. The goal was to integrate housekeeping functions into the life of the family, allowing a mother, for example, to prepare dinner or wash dishes while watching her children play (fig. 23). Earlier examples of open-plan kitchen/living/dining spaces include a 1934 house by Frank Lloyd Wright and a "living kitchen" designed by Richard Fordyce in 1945.[22] Such open domestic architecture dismantled the barriers between work and play, ritual and routine.

In the 1950s, industrial designer Don Wallance based his "Design 1" stainless-steel tableware on studies of the human hand as it physically manipulates the tools of eating. Revising the modernist dictum, "Form follows function" to "Form follows functions,"[23] Wallance sought to create objects suitable for mass production as well as pleasing to the hand and eye. His team created numerous three-dimensional prototypes before making detailed drawings for final production. The result was affordable, comfortable, machine-made flatware that did not feel cheap or institutional (fig. 24).

Of course, not all consumers embraced modern design, but they were more likely to do so in the context of everyday flatware than in sets reserved for special occasions. Comfortable-to-hold, easy-to-maintain designs were deemed suitable for daily use. Flatware patterns

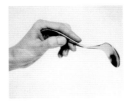

FIG 24. Photograph of grip and form studies for "Design 1" flatware designed by Don Wallance, ca. 1953–54.

employing a modified modernism appeared in advertisements and catalogues throughout the twentieth century (fig. 25). Marion Weeber Welsh's "Classic Column" pattern of 1967 combined neoclassical imagery with a modern taste for clean, geometric lines (fig. 26). Today, simple, familiar designs make up the bulk of cutlery selections on offer by such mainstream retailers as Williams-Sonoma, Crate & Barrel, and Target. Plain and shapely patterns based on Colonial American precedents appeal to contemporary consumers who crave historical references alongside modern comfort and practicality.

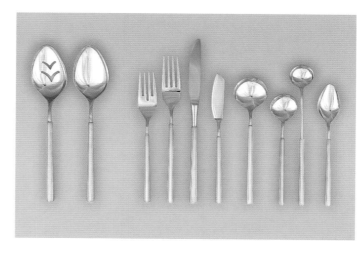

From a Spoon to a City: Italian Modern

Italian product design emerged as a global force after World War II, influenced by the flexible, humanistic modernism expressed in American and Scandinavian products and by the depictions of technologically enhanced living celebrated in Hollywood movies. As its cities were rebuilt after the war, Italy reached new levels of industrialization, with broader access to everything from refrigerators and televisions to portable typewriters. Members of the urban middle class were eager to embrace the future, and progressive designers worked with new forms, materials, and technologies to create products of daring originality.[24]

The Italians viewed design as a continuum extending from the urban environment down to the cup, spoon, and saucer. A towering figure was Gio Ponti, who designed skyscrapers and city squares as well as some of the century's most ingenious flatware. Ponti was at the forefront of a movement to create functional objects for use in everyday urban life. These objects were not anonymous servants to bodily functions, but exuberant witnesses to the ceremonies of modern existence. Whereas a 1933 flatware set by Ponti had sought stability in the perfect circle (fig. 27), his postwar table settings were infused with dynamism. The asymmetrical implements featured in the 1951 "Conca" pattern are objects in motion, conceived for the unfolding narrative of the meal (figs. 28, 29). A contemporary advertisement explained, "This is the cutlery of the modern party, for the snack after the show, for the holiday home. Its aim is not to replace traditional services,

FIG 27. Prototype cutlery
for Krupp Bendorf.
Designed by Gio Ponti.
Italy, 1933. Stainless steel.

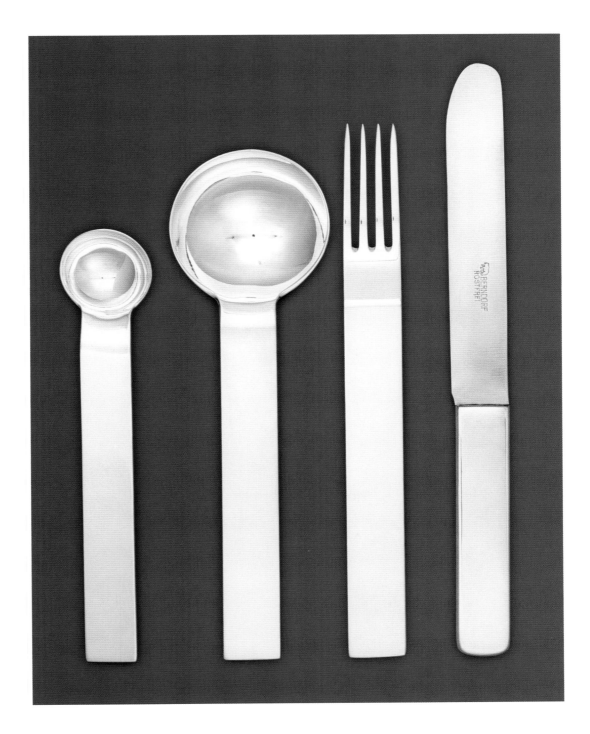

but to bring design to the table."[25] Ponti's 1956 "Hollow Handle" proto-
type for Krupp featured the restless, unstable diamond motif which ani-
mated Ponti's architecture; the pieces were meant to fit together on the
table in a novel fashion, revealing his view of flatware as part of a larger
environment (fig. 30). Ponti elaborated this concern in his prototype for
"Positive-Negative" plates and table linens, which played dynamically
against each other, and in new prototypes for Christofle (figs. 31, 32).

Carlo Scarpa was another Italian architect who brought his love
of form, detail, and atmosphere to projects of every scale. The short-
ened knife blade in his elegant 1981 Cleto Munari flatware reflected
his observation that only the end of the knife is an active cutting
tool, and the rest given over to the handle."[26] (fig. 33)

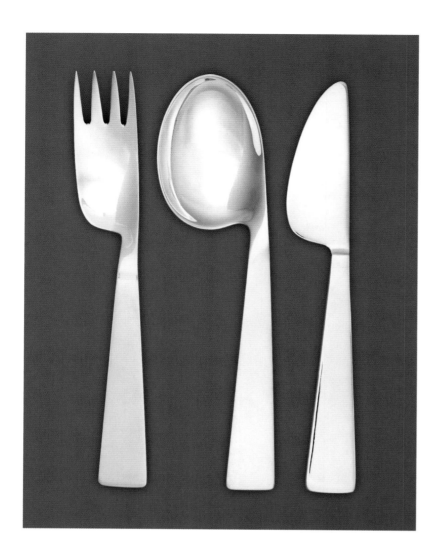

FIG 29. Design drawing: "Conca" cutlery for Krupp Italia. Gio Ponti. Italy, 1951.

FIG 28. "Conca" cutlery for Krupp Italia. Gio Ponti. Italy, 1951. Stainless steel.

"Conca," presented at the 9th Milan *Triennale*, was made in several versions, having either axial or asymmetrical handles, in silverplated alpaca (an alloy of brass and nickel), or with vermeil handles. The pattern was also produced by Fraser of New York.

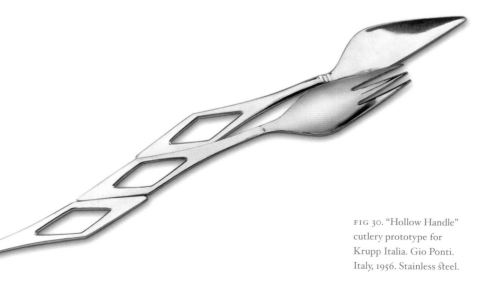

FIG 30. "Hollow Handle" cutlery prototype for Krupp Italia. Gio Ponti. Italy, 1956. Stainless steel.

(RIGHT)

FIG 32. Protype "Arched cutlery" for Christofle. Designed by Gio Ponti. Made by Lino Sabatini. Italy, 1955. Silver.

(BELOW)

FIG 31. Prototype "Positive-Negative" plate with "Positive-Negative" tablecloth. Gio Ponti. Italy, 1953.

(NEXT SPREAD)

FIG 35. "Bambino" children's place setting. Designed by Lorenza Bozzoli and Massimo Giacon. Manufactured by Alessi. Italy, designed 2003, this example produced 2005. Plastic (PMMA, PP).

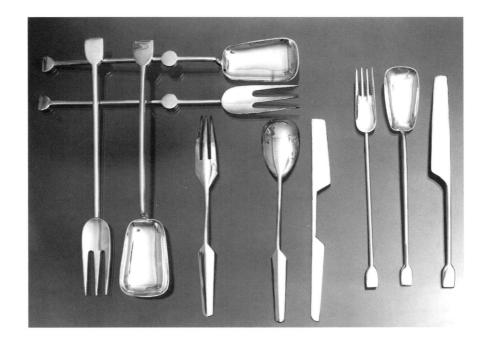

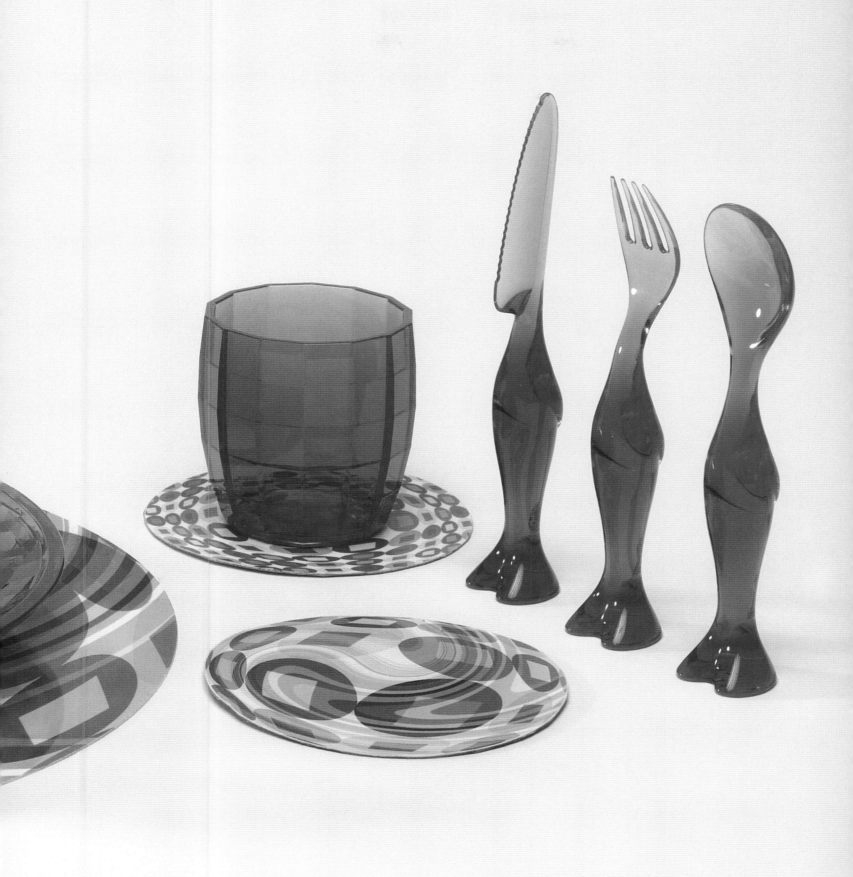

FIG 33. Place setting and fitted roll. Designed by Carlo Scarpa. Manufactured by Cleto Munari. Vicenza, Italy, designed 1977, produced ca. 1986. Silver, stainless steel, felt (roll).

Seeking radical simplicity over sculptural refinement, Sergio Asti's 1976 Boca flatware consisted of minimal ribbons of steel folded and curved into the shapes of eating instruments (fig. 34). In the 1980s, the Alessi company brought a flamboyant marketing ethos to Italian design, creating tableware and kitchen implements that were both humorous and functional. Today, the shelves of museum gift shops around the world are stocked with Alessi's brightly colored plastic gadgets as well as its high-end limited editions (fig. 35).

(OPPOSITE)
FIG 34. "Boca" flatware. Designed by Sergio Asti. Manufactured by H. E. Lauffer. Italy, 1976. Stainless steel.

Life on the Move: From Fastfood to the Jet Set

The advent of trains, planes, ships, and automobiles opened the way to dining on the move. Nineteenth-century passenger trains provided first-class passengers with full meal service in elaborately outfitted cars, a tradition that continued into the next century (fig. 36). The passenger trains designed by Henry Dreyfuss in the 1930s and 1940s were conceived as a total design experience. Everything from the light fixtures to the tableware was designed to make travel by rail a public experience combining sophistication and adventure.[27] (figs. 37, 38) The dining rooms aboard ocean liners such as the French *Normandie* and

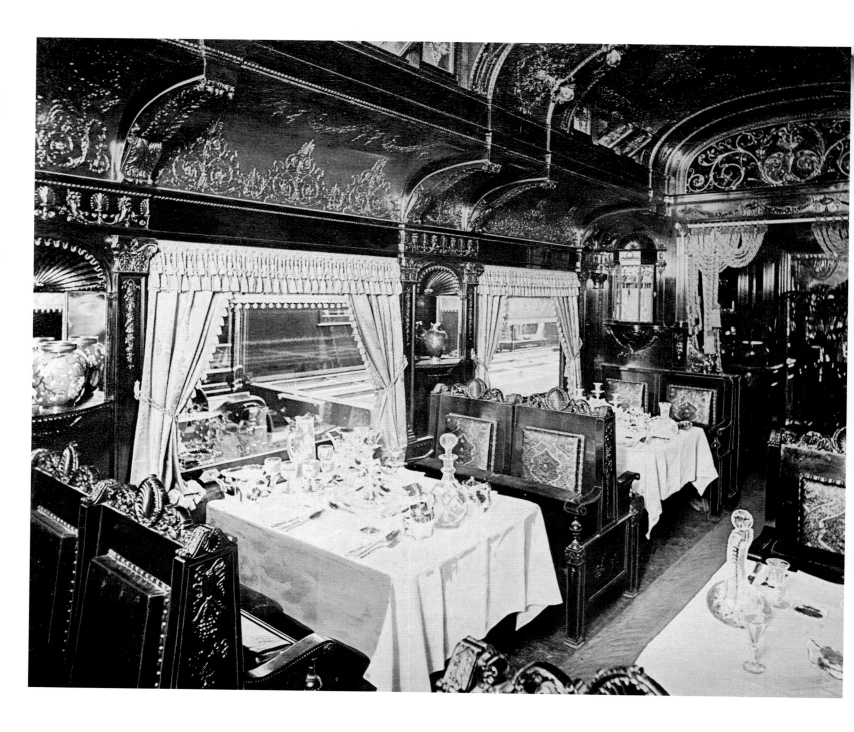

FIG 36. Photograph:
Dining Car, Vestibule Train
("La Rabida"), from *The
book of the fair; an historical
and descriptive presentation
of the world's science, art, and
industry, as viewed through
the Columbian Exposition at
Chicago in 1893*, chapter
XVIII—Transportation,
p. 553. Hubert Howe
Bancroft. Published by
The Bancroft Co., Chicago
and San Francisco, 1893.

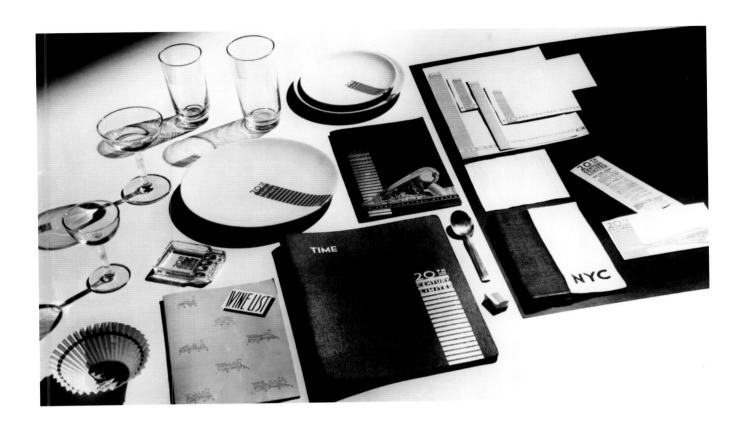

(ABOVE)

FIG 37. Publicity photo-
graph: Dining car
appointments for the
20th Century Limited train
designed by Henry
Dreyfuss for the New York
Central System, 1938.

(LEFT)

FIG 38. Illustration: *20th
Century Limited* train "King
Size Diner" car designed
by Henry Dreyfuss for
the New York Central
System, 1948, from *Book
of the Century, Flagship of
New York Central's Great
Steel Fleet.*

(OPPOSITE)

FIG 39. Illustration: "L'heure du dîner dans la grande salle à manger" (Dinner in the grand dining room of the ocean liner *Normandie*), in *Le paquebot "Normandie."* J. Simont. Published by L'illustration. Paris, 1935.

FIG 40. Illustration: "Les couverts de table 'Orfèvrerie Christofle' de *Normandie*" (Flatware produced by Christofle for the ocean liner *Normandie)* in *Le paquebot "Normandie."* Published by L'illustration. Paris, 1935.

FIG 41. Place setting from the ocean liner SS *United States*. U.S.A., designed ca. 1952. Silver-plated metal, glazed stoneware, glass.

the American SS *United States* offered their passengers even more luxury and spectacle. As on the trains, the flatware and other table items emulated fine dining on land, and signature pieces underscored the corporate identity of the carrier (figs. 39–41).

In the 1950s and 1960s, the members of the "jet set" were glamorous folk endowed with the leisure time and resources for transcontinental flights. Meals were served with dishes and flatware that affirmed the prestige of the voyage. By the 1950s, airlines were using modern design principles to create table settings mindful of the cramped conditions of air travel. Dishes were designed to nest together within a tray, allowing a multicourse meal to be served with safety and grace. While airlines such as Scandinavian Airlines have continued to introduce new tableware services for business- and first-class passengers, such refinements have all but disappeared from the tray tables of the global economy class on most airlines (figs. 42–48).

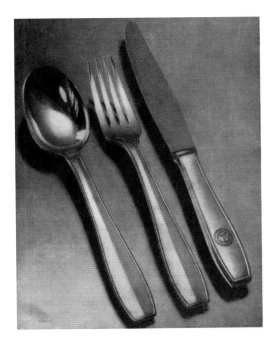 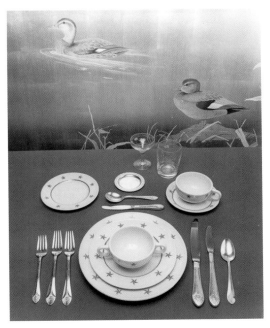

Mobility—economic and geographic—was central to the malleable social structure of mid-century America. The Servicemen's Readjustment Act of 1944, better known as the GI Bill, gave soldiers returning from World War II a chance to enter the new white-collar society. Young families moved away from their parents' neighborhoods to the suburbs, transported by their cars. Fast-food restaurants served the expanding culture of the automobile, while homemade picnics, equipped with lavish picnic kits or with disposable plates and plastic cutlery, arrived to the countryside in the family station wagon.

The upward and outward mobility of populations encouraged the view that objects could be ephemeral. One's wedding china might last a lifetime (even if one's marriage did not), but plastic flatware made for parties, picnics, and the kitchen table had fleeting utility. While most of these items were indifferently designed, others used bright colors, clever construction, and inventive packaging for a playful outlook on throw-away culture. "Plack," produced in France in

(NEXT SPREAD)

FIG 43. Dining ware from the Air France *Concorde*. Designed by Raymond Loewy/Compagnie d'Esthétique Industrielle (plastic beverage glass designed by Georges Patrix) for Air France. Manufactured by Bouillet Bourdelle (flatware), A. Raynaud and Cie (porcelain), Cristallerie de Souvigny (glass), Gedex (plastic). France, ca. 1976 (plastic beverage glass 1968). Stainless steel, glazed porcelain, glass, plastic, textile.

FIG 42. Prototype flatware for American Airlines. Richard Arbib. U.S.A., 1957. Anodized aluminum.

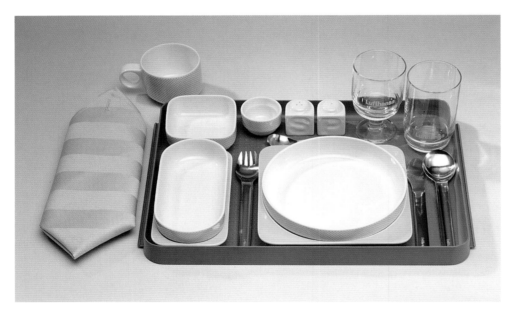

FIG 48. In-flight dining service for Lufthansa German Airlines. Designed by Wolf Karnagel for Lufthansa. Manufactured by WMF (flatware), Hutschenreuther (porcelain). Germany, 1986. Stainless steel, porcelain, glass, plastic.

FIG 46.Business-class dining service for Scandinavian Airlines System. Stainless-steel cutlery designed by Bo Bonfils, manufactured by Georg Jensen; porcelain designed by Ursula Munch-Petersen, manufactured by Royal Copenhagen; glassware designed by Gunnar Cyren, manufactured by Orrefors. Denmark, Sweden, 2001.

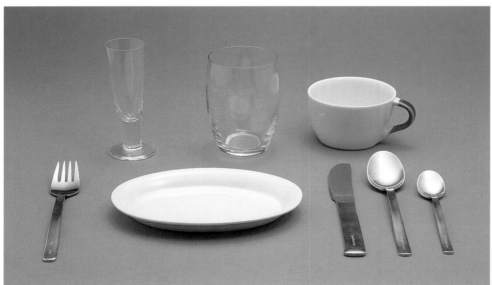

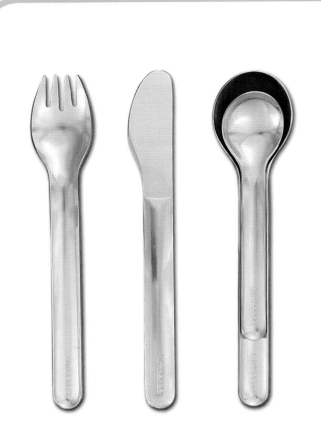

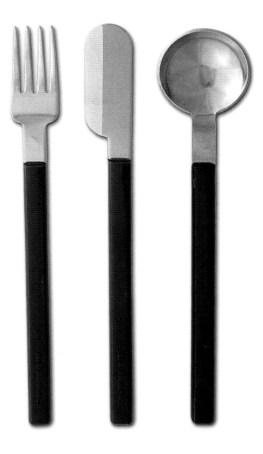

FIG 47. Flatware for
Lufthansa German Airlines.
Designed by Wolf Karnagel
for Lufthansa. Germany,
1986. Stainless steel.

FIG 44. Flatware for Air
France Economy Class.
Designed by Raymond
Loewy/Compagnie
d'Esthétique Industrielle
under the direction of
Evert Endt, for Air France.
France, ca. 1978. Stainless
steel, plastic.

FIG 45. Flatware for
Scandinavian Airlines
System (SAS): First Class
(1st–6th), Coach Class
(7th–9th). Designed by
Theresia Hvorslev for
SAS. Manufactured by
Mema Guld Och Silver
AB (First Class), A/S Norsk
Stålpress/Staalpress
(Coach). Lydkoping,
Sweden, 1967, 1971. Silver-
plated metal (First Class),
stainless steel (Coach).

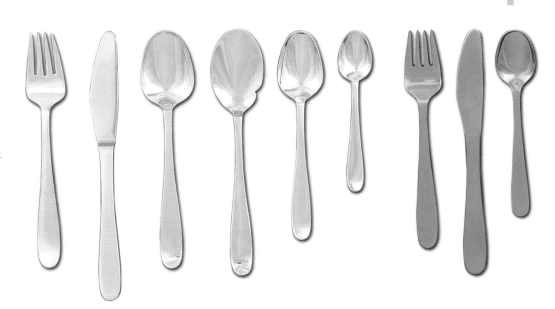

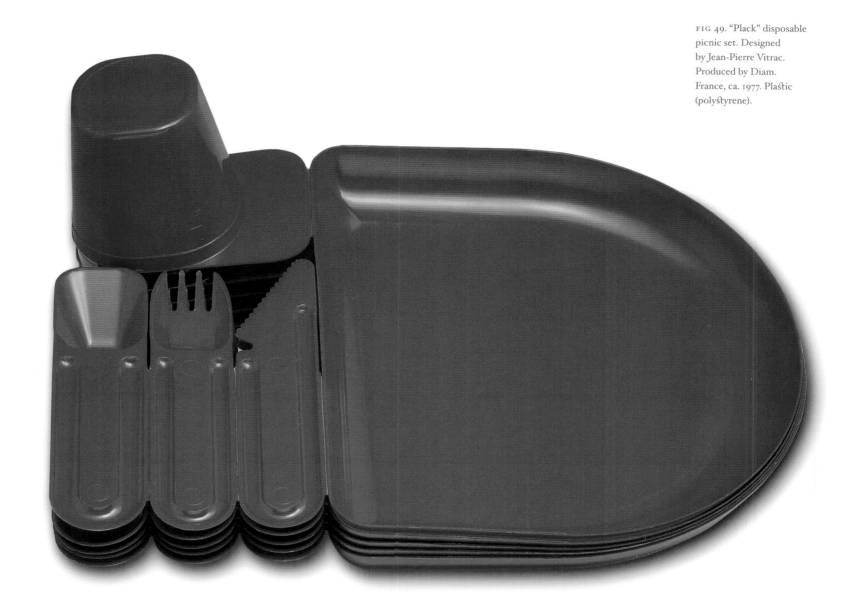

FIG 49. "Plack" disposable picnic set. Designed by Jean-Pierre Vitrac. Produced by Diam. France, ca. 1977. Plastic (polystyrene).

FIG 50. "Party Case 88" picnic/party set. Designed by Malcolm Foster. Manufactured by Oak Hill Industries Corporation. New York, New York, ca. 1986. Plastic.

1979, was a complete dinner service—plate, flatware, and beverage cup—molded in a single piece of polystyrene, designed to be snapped apart for use (fig. 49). The "Oak Hill Party Case" greeted shoppers in the mid-1980s in its own transparent PVC tote with a red webbed strap, affirming a life of casual entertaining on the go (fig. 50). These were objects one could love for awhile and leave without heartbreak.

The portable lifestyle was interpreted in permanent pieces as well, such as David Tisdale's 1986 "Picnic Flatware," which used anodized aluminum to saturate the table with brilliant color and stylish design, indoors and out (fig. 51). Anne Krohn Graham's 1978 traveling flatware reflected back on centuries of functional designs for mobile, multipurpose cutlery; beautifully produced in silver, this object was anything but temporary (fig. 52). Reusable travel sets employed carrying cases and nesting flatware designs to minimize weight and bulk in a suitcase, backpack, or picnic basket (figs. 53–57). These clever, functional designs embraced mobility while rejecting the throw-away urge equated with picnics and fast food.

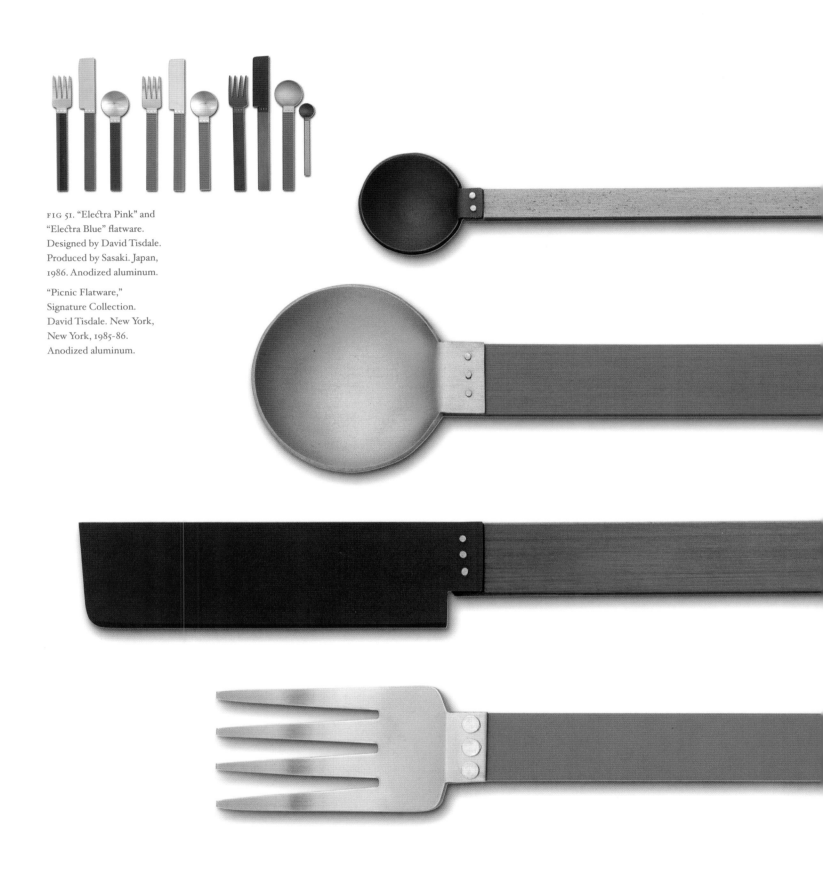

FIG 51. "Electra Pink" and "Electra Blue" flatware. Designed by David Tisdale. Produced by Sasaki. Japan, 1986. Anodized aluminum.

"Picnic Flatware," Signature Collection. David Tisdale. New York, New York, 1985-86. Anodized aluminum.

(NEXT PAGE)
FIG 52. Traveling flatware. Anne Krohn Graham. U.S.A., 1978. Silver.

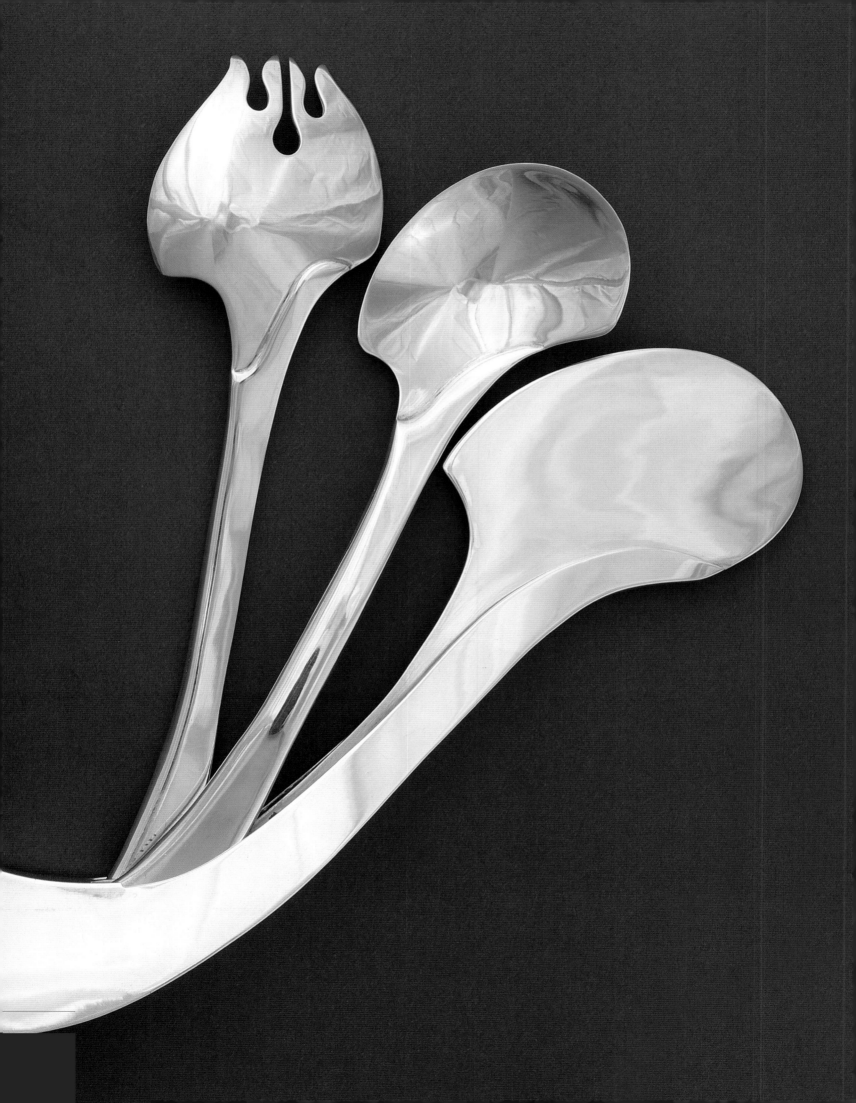

FIG 55. "Snac Pac" flatware and holder. Designed by Ernst Felix. Manufactured by Heinrich Böker and Co. Solingen, Germany, 1991. Plastic, stainless steel.

FIG 57. "Port-A-Pac" picnic set. Manufactured by Twinbird Industrial Co., Ltd. Tokyo, Japan, 1980s. Plastic, stainless steel.

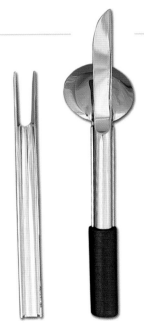

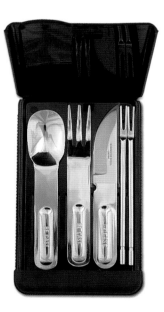

FIG 56. "Be Cast" portable flatware and case. Japan, 1980s. Stainless steel, plastic.

FIG 54. "Mono-Clip" nesting flatware. Designed by Peter Raacke. Manufactured by Mono-Metallwarenfabrik Seibel GmbH. Germany, designed 1972. Stainless steel.

FIG 53. "Uni" fork, knife, spoon, and holder. Designed by Carla Nencioni and Armando Moleri. Manufactured by Zani & Zani. Italy, 1971. Stainless steel, rubber.

Lifestyle Retailing

The marketing of modern design across the twentieth century sustained the mythology of the total lifestyle. While few families have lived in wholly modern environments—or, for that matter, ones that were coherently Colonial, Georgian, or Arts and Crafts—retailers and tastemakers promoted modern design through coordinated in-store displays, carefully art-directed photographs, and exhibitions and presentations that featured objects, such as tableware, as elements in a complete lifestyle. From the exquisitely detailed showrooms and exhibitions of the Wiener Werkstätte to displays created for the great encyclopedic department stores, useful objects were players in a coordinated dreamscape.

In 1902, the Wertheim department store in Berlin invited Peter Behrens to create a complete dining-room environment whose furnishings, tableware, light fixtures, and interior design were all connected by a single motif. Behrens's richly geometric installation was part of a larger exhibition at the store called *Moderne Wohnräume* (Modern Interiors), which introduced the public to advanced ideas in contemporary design and gave customers the opportunity to look, learn, and shop. As a contemporary critic explained, "It is very important that the crowds who daily flow through the store become acquainted with good taste, and realize that opulence is not the point."[28] On view was the image of a lifestyle attainable, at least in principle, by a broad public (fig. 58; also see von Drachenfels, opening spread).

In mid-twentieth-century New York, Russel and Mary Wright extended this point of view with their department-store demonstration rooms, where the expressively set table was the core of a beautiful and harmonious, yet practical and relaxed, domesticity.[29] In the 1980s, Bloomingdale's was a symbol for sleek New York style; to celebrate its 1986 centennial, the store commissioned Ward Bennett to design a collection of tableware, including the "Double Helix" flatware, whose pieces of stainless steel resembled twisted ribbons of steel (fig. 59).

Today, store displays are designed to help consumers imagine products in their own lives. The retailers' goal is to shift emphasis from the object itself to its role in a larger pattern of living, a total environment where all things are at home together. As social historian Sharon Zukin has written, "The social space of the store connects an entire range of products—and thus the image value of the designer or retailer—with the quality of life we desire. This romanticization of life through the display of goods is turned into 'lifestyle.'"[30] Today, branded stores such as Pottery Barn, Restoration Hardware, and IKEA provide such demonstrations of living for their customers.

Crate & Barrel, founded in Chicago in 1962, made Scandinavian modernism affordable and understandable to the American public. Popular flatware patterns included Jens Quistgaard's "Variation V," produced by Dansk (fig. 60). Crate & Barrel displayed its wares on shipping crates to dramatize the act of importing goods from abroad; merchandise was explained with consistent, museum-style shelf labels set in a sans-serif typeface (figs. 61, 62).

Founded in Sweden in 1943, IKEA globalized this approach to retailing, creating warehouse stores whose visual design—from the

FIG 58. Chair. Designed by Peter Behrens. Manufactured by Anton Blüggel for the Wertheim Department Store. Berlin, Germany, 1902. Wood (oak, pine), caning (not original).

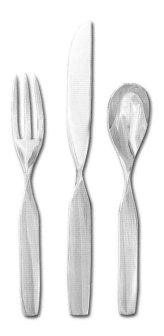

FIG 59. "Double Helix" fork, knife, and spoon. Designed by Ward Bennett. Manufactured by Sasaki. Japan, ca. 1987. Stainless steel.

FIG 60. "Variation V" fork,
knife, and spoon. Designed
by Jens H. Quistgaard.
Manufactured by Dansk
International Designs, Ltd.
Denmark, ca. 1955–60.
Stainless steel.

exterior building to the cafeteria layout and in-store graphics—depict
a lifestyle equipped with simple, affordable, disposable objects. By the
time IKEA opened its first store in the Unites States in 1985, the com-
pany already had outposts in Hong Kong, Australia, Saudi Arabia, and
Dubai, and it now has over two hundred locations in thirty-five coun-
tries. IKEA presents its lifestyle model uniformly around the world,
making little effort to adjust its products or pitch to particular markets.

Supplementing the larger retail environment, packaging has also
developed to build a tiny explanatory world around products (fig. 63).
Introduced in the 1970s, Don Wallance's "Design 10" flatware came in
its own clear plastic display box—a disposable museum case designed
to focus consumers' attention on the goods waiting eagerly inside
(fig. 64). Packaging also became, in some cases, an integral part of a
product's use, providing storage and display for the end user (fig. 65).

FIG 61. Photograph of
cutlery and kitchenware
displays, Crate and Barrel
store, Michigan Avenue,
Chicago, late 1970s.

FIG 62. Photograph of
flatware and tableware
displays, Crate and Barrel
store, Wells Street,
Chicago, ca. 1966.

LAUFFER®

Design 10

LEXAN® FLATWARE
RESIN

16 Piece Set
4 knives, 4 forks, 4 spoons
and 4 teaspoons

A new unique idea in flatware.
Design 10 complements your table
setting with an accent of color.
It is color fast, durable, heat resistant
and dishwasher safe.
Perfect for dining indoors or out.

® LEXAN is a Registered Trademark
of the General Electric Company.

MADE IN USA

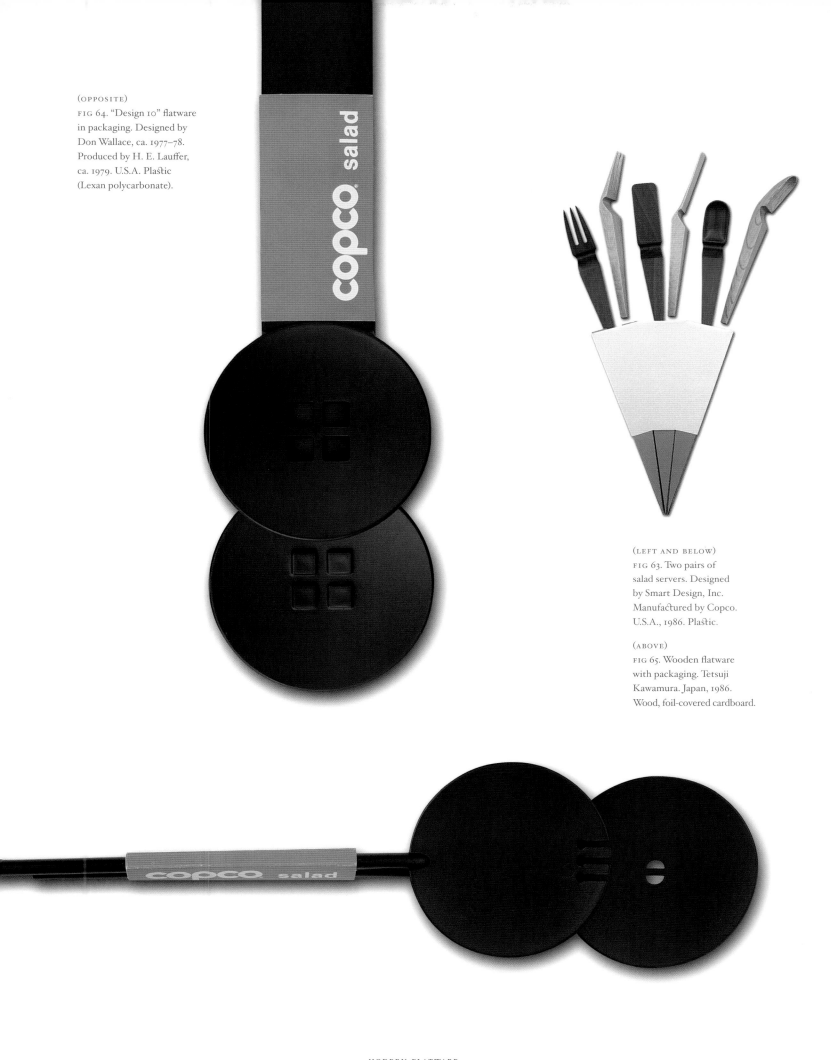

(OPPOSITE)
FIG 64. "Design 10" flatware
in packaging. Designed by
Don Wallace, ca. 1977–78.
Produced by H. E. Lauffer,
ca. 1979. U.S.A. Plastic
(Lexan polycarbonate).

(LEFT AND BELOW)
FIG 63. Two pairs of
salad servers. Designed
by Smart Design, Inc.
Manufactured by Copco.
U.S.A., 1986. Plastic.

(ABOVE)
FIG 65. Wooden flatware
with packaging. Tetsuji
Kawamura. Japan, 1986.
Wood, foil-covered cardboard.

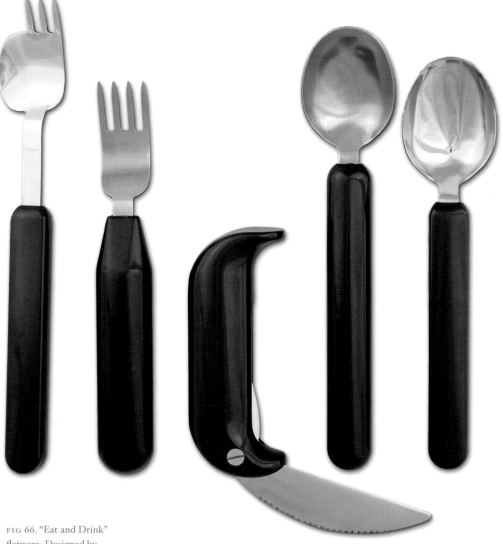

(OPPOSITE)
FIG 68. "Flamingo"
fork, knife, and spoon.
Designed by Mark P.
Wilson. Manufactured by
Curvware, Inc. U.S.A.,
1996. Stainless steel.

FIG 66. "Eat and Drink"
flatware. Designed by
Ergonomi Design
Gruppen. Manufactured
by RFSU Rehab.
Stockholm, Sweden, 1981.
Stainless steel, plastic.

FIG 67. "Eat and Drink"
flatware and tableware.
Designed by Ergonomi
Design Gruppen.
Manufactured by RFSU
Rehab. Stockholm,
Sweden, 1981. Stainless
steel, plastic.

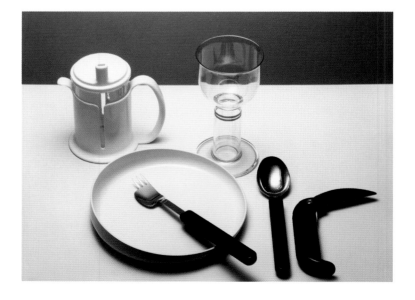

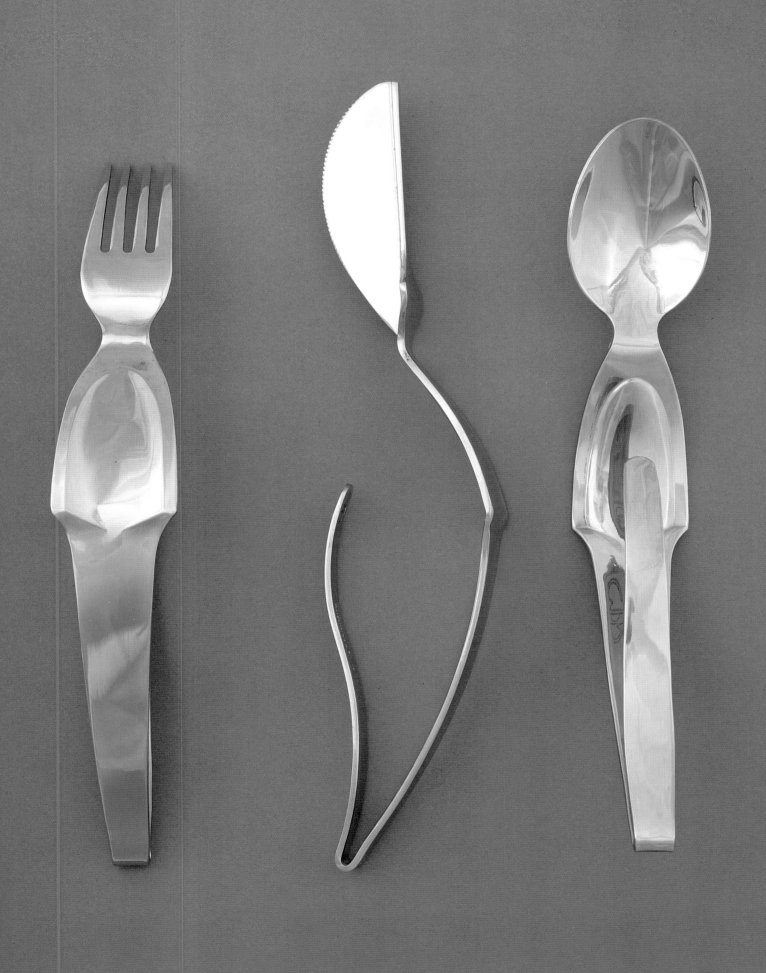

New Functions

Well-designed objects shape one's quality of life, yet not all objects work for all people. Since the 1980s, designers have increasingly turned attention to the needs of users with physical limitations. Kitchens, cooking tools, and eating utensils pose countless problems for people with limited hand and arm use, and several designs have helped overcome these challenges, becoming true orthopedic "human-limb objects," in Le Corbusier's terms.

The Ergonomi Design Gruppen created its "Eat/Drink" cutlery in Sweden in 1981. In contrast with the lavish silver services of late nineteenth-century America, which presented unique forms tailored to different food, the variations offered within the "Eat/Drink" system address the needs of different users. Exceptionally long, thin implements are designed for people who require wrist or forearm support, and thus prefer to hold their tools with a pen grip, while shorter, stubbier pieces are intended for people with joint impairments. The multiuse "knork" and "knoon" are each designed for people with only one functioning hand (figs. 66, 67).

Mark Wilson's "Curvware" of 1996 took a different approach. Departing more radically from tradition, each "Curvware" tool has a wishbone-like extension, which allows the implement to be gripped and held in various ways. The designer's goal was "to develop eating utensils which conform to the hand, instead of having the hand conform to the traditional straight-handled eating utensils." Here, a single design aims to satisfy multiple users (fig. 68).

Objects can be designed to limit behaviors as well as enable them. Armand G. Winfield designed plastic cutlery in the 1960s for life within the prison walls supervised by the New Mexico Corrections Department. These plastic tools were designed to break when used as a weapon (fig. 69). And for those imprisoned by their own appetites, the battery-operated "Slender Fork" flashes a red light when one's calorie allotment is exceeded (fig. 70).

FIG 69. Flatware for the State of New Mexico Corrections Department. Designed by Armand G. Winfield. U.S.A., ca. 1960. Plastic.

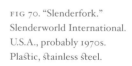

FIG 70. "Slenderfork." Slenderworld International. U.S.A., probably 1970s. Plastic, stainless steel.

(OPPOSITE)
FIG 71. "Nasturtium Leaves" servers. Robyn Nichols. U.S.A., 1991. Silver.

New Forms

Across the last century and into the new, craft traditions have continued to flourish alongside the mass production and mass marketing of tableware. Metalworkers creating pieces by hand for small markets have constructed exquisite, often poetic pieces in a broad range of decorative idioms. A strong practice persists among the international community of metalsmiths, yielding objects which reflect a spectrum of design thinking. For instance, Robyn Nichols creates objects in an elaborate vocabulary based in the natural world, while Joost During speaks in a reserved voice that is both lyrical and functional (figs. 71, 72).[31]

In the 1970s, many designers began viewing the modernist vocabularies of design as elements of a cultural language rather than as a canon of timeless truths. One playful set rendered each piece in the profile of a different animal (fig. 73). Ward Bennett's "Trylon" pattern reduced the handles of the knife, fork, and spoon to a pencil-thin line, while a set by the Czech designer Boris Sipek recalled the attenuated sculptures of Constantin Brancusi. Such forms are as elegant to the eye as they are alien to the hand (figs. 74, 75). A neo-Bauhaus classicism is seen in designs by Alain Carré, Massimo and Lella Vignelli, and Robert Wilhite, which articulated the components of flatware into abstracted geometric icons (figs. 76–78). These objects celebrate form and communication over anonymous function. Rather than address consumer lifestyles, they become a study of design itself as a historically evolving organism.

In the aftermath of such formal studies, many designers today are employing useful things as social commentary. Boris Bally, a metalsmith working in Providence, Rhode Island, creates objects from recycled road signs as well as from silver and other metals. His "Trussware" silverware brings industrial imagery to the tabletop (fig. 79). In 2002, in the Netherlands, where there is a longstanding tradition of building a cultural discourse through objects, Galerie Ra commissioned designers, artists, and craftspeople from around the world to rethink the form and

FIG 72. "Wishbone" fork, knife, and spoon. Designed by Joost During. Manufactured by Nambé. Santa Fe, New Mexico, 2003. Stainless steel.

(OPPOSITE)
FIG 73. Fork, knife, and spoon with case. Jean-Marie Patois. France, 1980s. Stainless steel, vinyl (case).

(NEXT SPREAD)
FIG 76. Prototype fork and knife. Designed by Alain Carré. Made by Puiforcat. France, 1974. Silver.

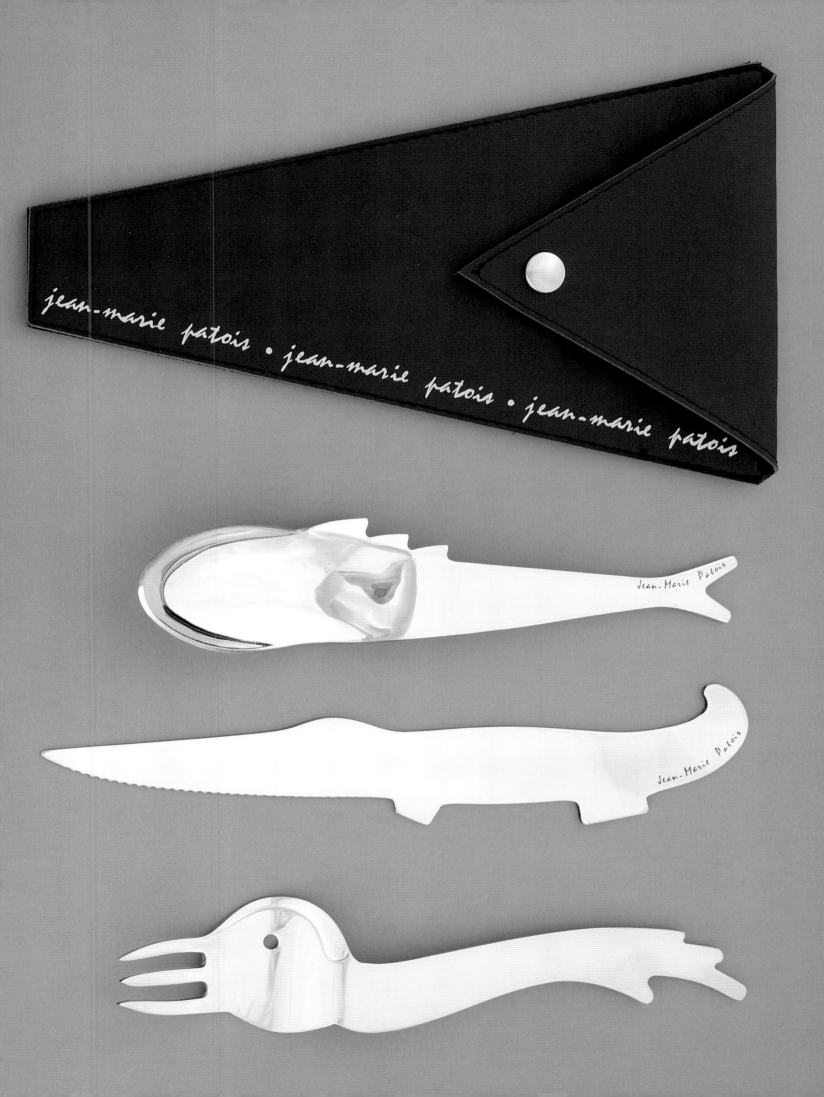

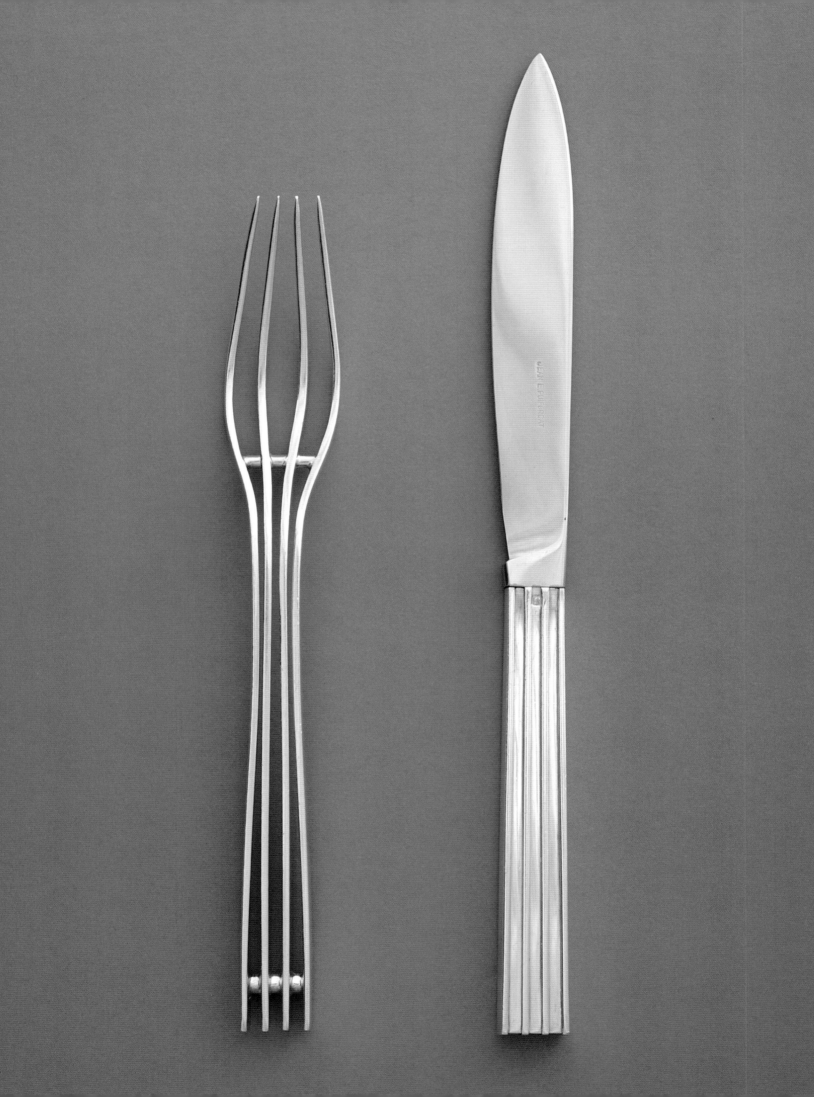

FIG 74. "Trylon" dinner
knife, fork, and soup
spoon. Designed by Ward
Bennett. Produced by
Supreme Cutlery division
of Towle Manufacturing
Company, Silversmiths.
U.S.A., 1980. Stainless steel.

FIG 75. Fork, knife, and
tablespoon. Designed by
Bořek Šípek for NEOTU.
Czech Republic, 1991.
Stainless steel, gold plate.

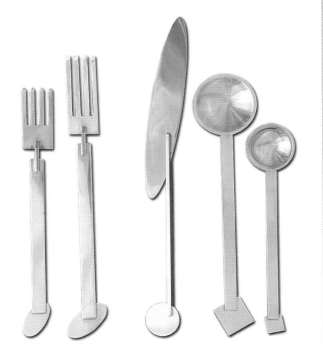

FIG 77. "Ciga Hotel" dinner
fork, dinner knife, and
tablespoon. Designed by
Lella Vignelli, Massimo
Vignelli, and David Law.
Made by Vignelli Designs,
Inc. Italy, 1979. Silver-
plated metal.

FIG 78. Salad fork, dinner
fork, knife, tablespoon, and
teaspoon. Designed by
Robert Wilhite. Made by S.
Dorman. U.S.A., 1982. Silver.

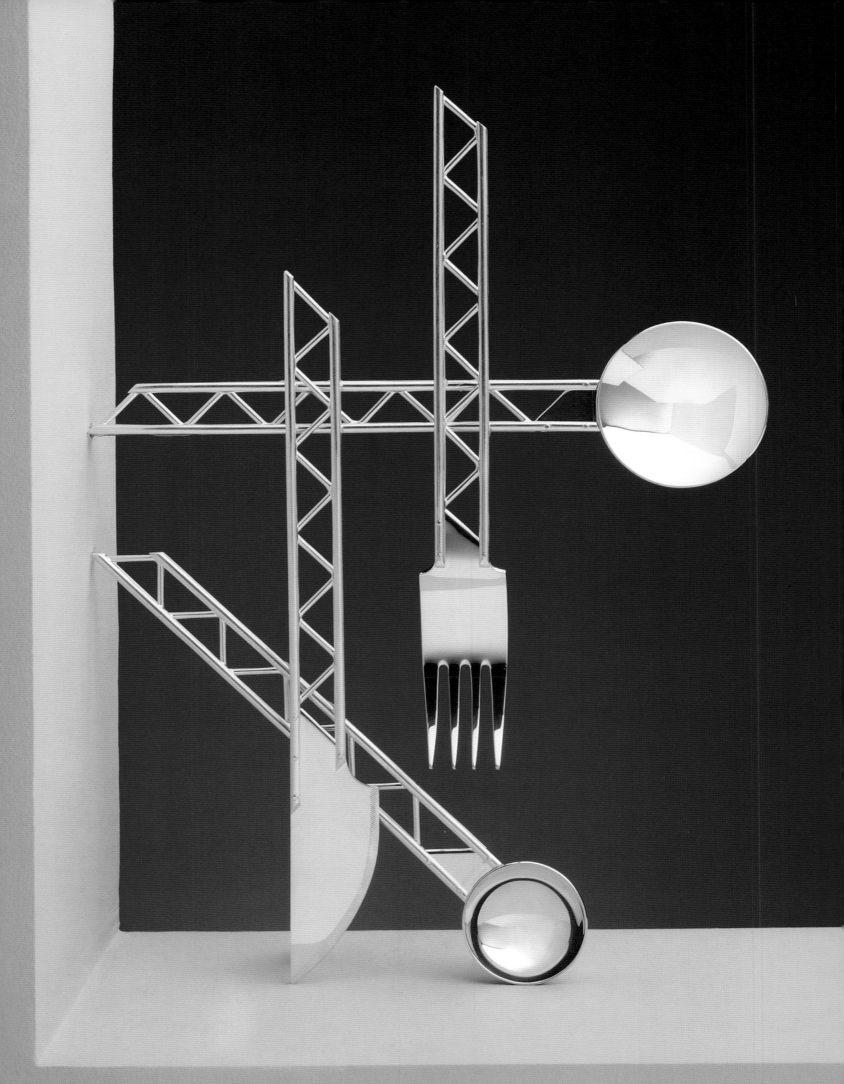

(OPPOSITE)

FIG 79. "Trussware" flatware. Boris Bally. Providence, Rhode Island, 1993. Silver.

FIG 80. "Finger Tool" spoon. Susanne Klemm. The Netherlands, 2002. Silver, rubber.

FIG 82. "Diet Spoon." Jiří Šibor. Czech Republic, 2002. Stainless steel.

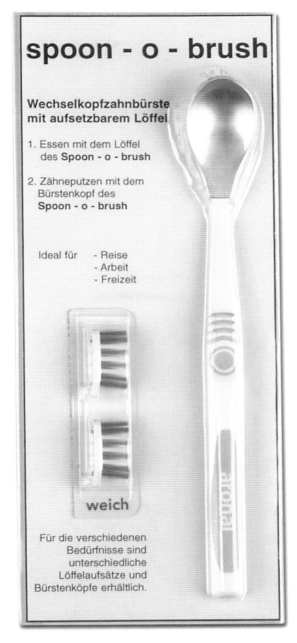

spoon - o - brush

Wechselkopfzahnbürste mit aufsetzbarem Löffel

1. Essen mit dem Löffel des **Spoon - o - brush**

2. Zähneputzen mit dem Bürstenkopf des **Spoon - o - brush**

Ideal für - Reise
 - Arbeit
 - Freizeit

weich

Für die verschiedenen Bedürfnisse sind unterschiedliche Löffelaufsätze und Bürstenköpfe erhältlich.

FIG 81. "Spoon-o-Brush." Sabine Lang. Germany, 2002. Silver, plastic.

function of the spoon. The results include spoons that incorporate
additional functions (finger tool, toothbrush), and spoons that reflect
on surging appetites (a diet spoon with an elegant hole sliced through
its bowl and spoons explaining how to behave at the table) (figs. 80–83).
Nature, as well as culture, continues to provide a source of ideas for
tableware. Michele Oka Doner creates objects whose forms and sur-
faces suggest natural processes of growth and dissolution (fig. 84),
while Ted Muehling fashions delicate pieces of cutlery after twigs,
stalks, and shells (see opening spread).

Conclusion

Forks and spoons are industrial objects that we put into our mouths.
Although a metal instrument with spikes on its end may be more alien
than the warmth of one's own fingers, the choice to mediate the pas-
sage of food from hand to mouth reflects centuries of civility as well
as the modern understanding of germs and hygiene. The constant
pressures of work and family life have made dining an informal and
sporadic event in many contemporary households. The growing
dependence on fast food and ready-made meals has diminished the
health, conviviality, and sensual pleasure of dining for many of us, and
added enormous loads of trash to the landfills of the developed world.
This book looks back across five centuries of flatware, exploring the
extraordinary variety of forms, functions, and meanings embodied in
these profoundly intimate objects. We have seen works of exceptional
beauty, outrageous excess, and ingenious functionality. We have seen
objects that are extensions of the human body and complements to
the organic world, as well as objects whose severe geometry sets them
apart from nature and tradition. The table is at the center of each
household's distinct style. It is a place of routine and ritual, of intimate
consumption and social exchange. Each time we cook a meal and
set the table, we design our own style of life. Relish every moment.

≈ Pictorial Overview ≈

Cooper-Hewitt, National Design Museum's permanent collection
includes extensive holdings of flatware and cutlery, consisting prima-
rily of European examples from the sixteenth through the twentieth
centuries and American pieces from the nineteenth and twentieth
centuries. In particular, the Robert L. Metzenberg collection, which
came to the Museum in 1985, boasts an astonishing variety of objects
from four centuries of European production. The following pages
provide a pictorial overview of flatware and cutlery design from the
permanent collection, arranged in general chronological order, to
augment the visual materials which accompany the essays.

Knife. Probably England,
mid 16th century. Steel.

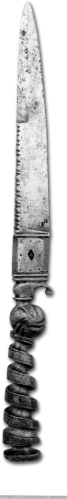

Knife. Probably Spain,
early 16th century. Steel.

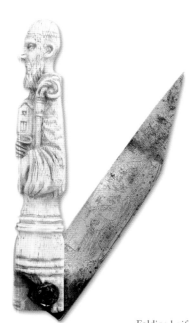

Folding knife. France or
Italy, mid 16th century.
Ivory, steel, gilding, brass.

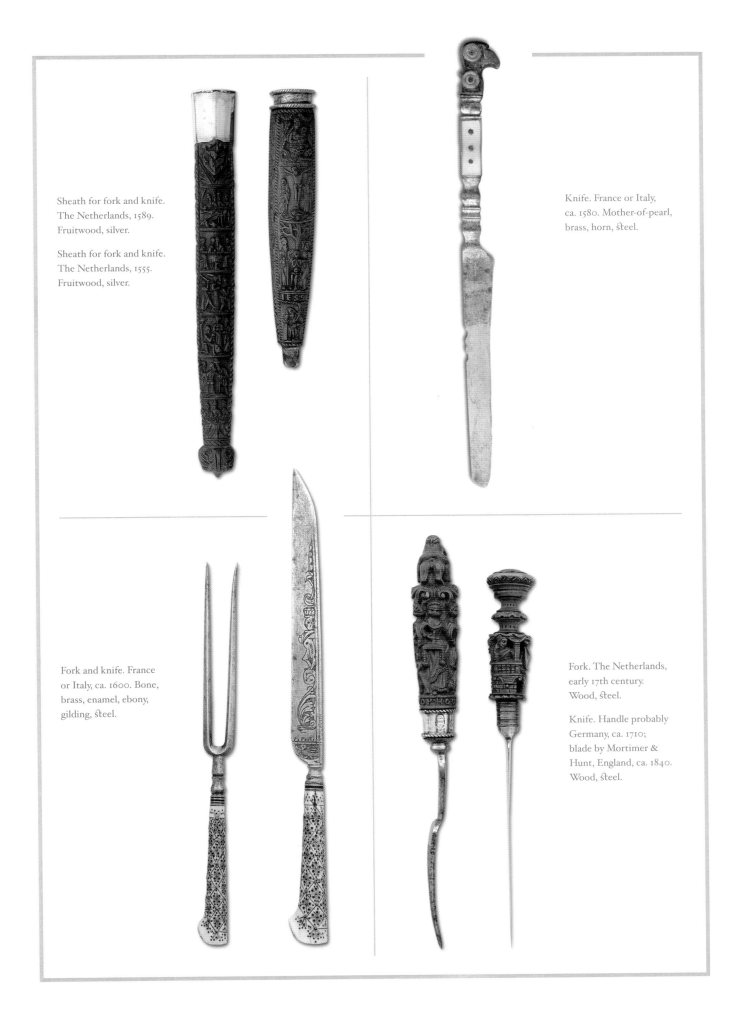

Sheath for fork and knife.
The Netherlands, 1589.
Fruitwood, silver.

Sheath for fork and knife.
The Netherlands, 1555.
Fruitwood, silver.

Knife. France or Italy,
ca. 1580. Mother-of-pearl,
brass, horn, steel.

Fork and knife. France
or Italy, ca. 1600. Bone,
brass, enamel, ebony,
gilding, steel.

Fork. The Netherlands,
early 17th century.
Wood, steel.

Knife. Handle probably
Germany, ca. 1710;
blade by Mortimer &
Hunt, England, ca. 1840.
Wood, steel.

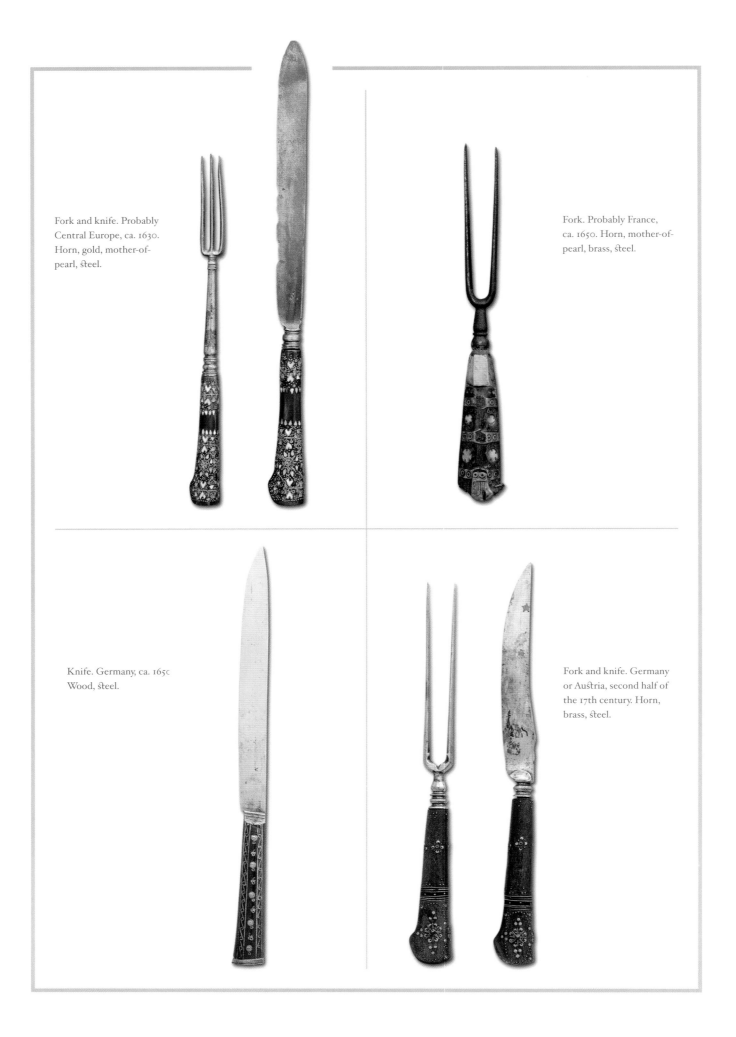

Fork and knife. Probably
Central Europe, ca. 1630.
Horn, gold, mother-of-
pearl, steel.

Fork. Probably France,
ca. 1650. Horn, mother-of-
pearl, brass, steel.

Knife. Germany, ca. 1650.
Wood, steel.

Fork and knife. Germany
or Austria, second half of
the 17th century. Horn,
brass, steel.

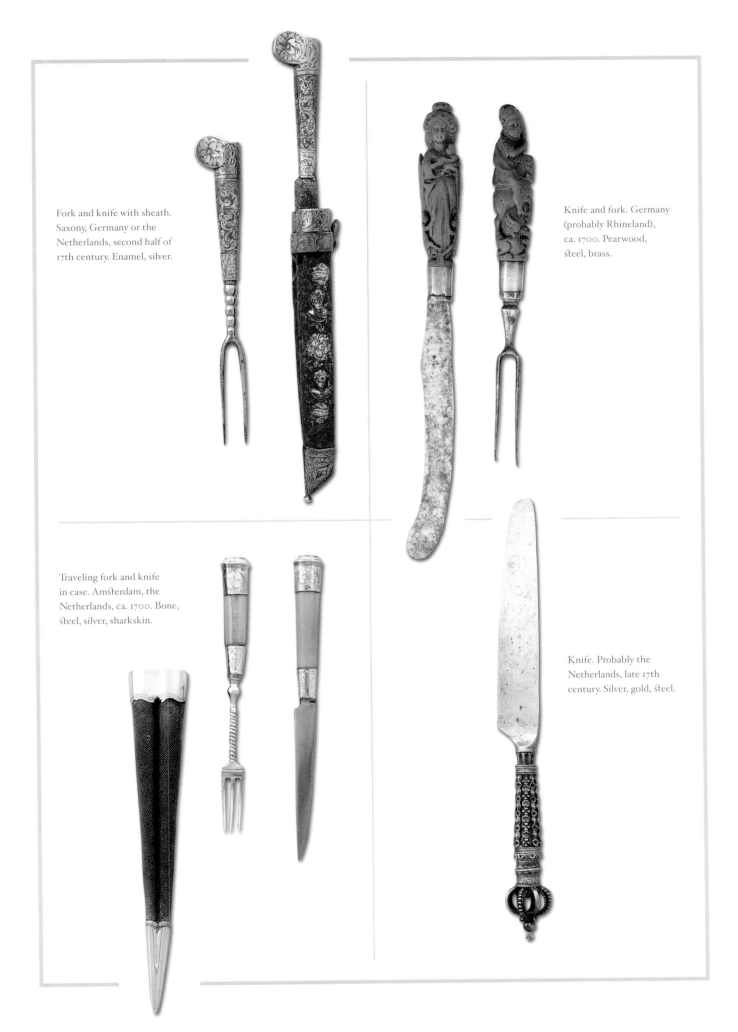

Fork and knife with sheath. Saxony, Germany or the Netherlands, second half of 17th century. Enamel, silver.

Knife and fork. Germany (probably Rhineland), ca. 1700. Pearwood, steel, brass.

Traveling fork and knife in case. Amsterdam, the Netherlands, ca. 1700. Bone, steel, silver, sharkskin.

Knife. Probably the Netherlands, late 17th century. Silver, gold, steel.

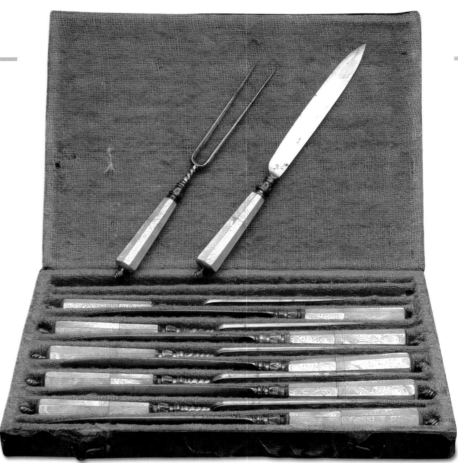

Set of 6 forks and knives
in case. Habaner, Hungary,
ca. 1690. Case made in
Paris, France, ca. 1800.
Mother-of-pearl, steel,
brass, leather, wood, wool.

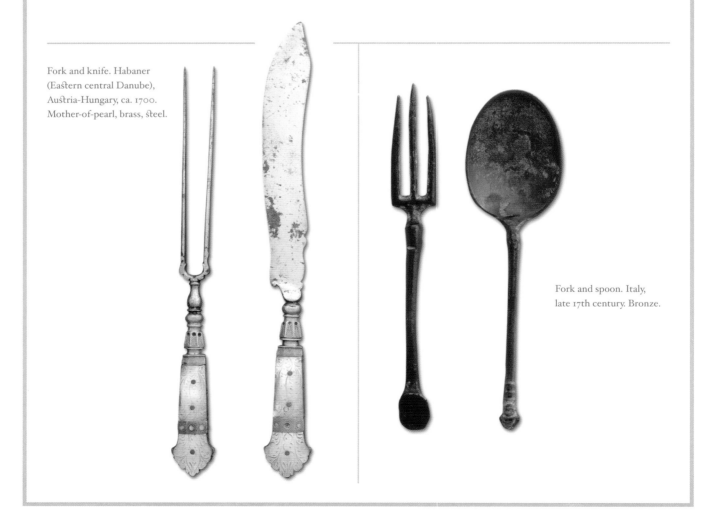

Fork and knife. Habaner
(Eastern central Danube),
Austria-Hungary, ca. 1700.
Mother-of-pearl, brass, steel.

Fork and spoon. Italy,
late 17th century. Bronze.

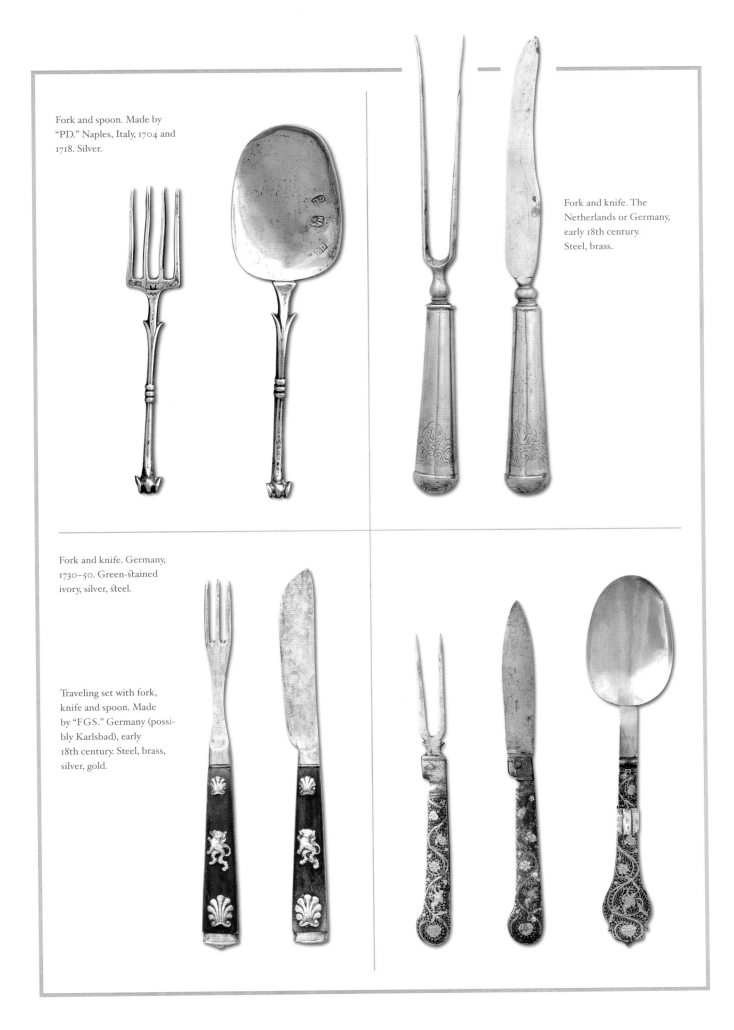

Fork and spoon. Made by "PD." Naples, Italy, 1704 and 1718. Silver.

Fork and knife. The Netherlands or Germany, early 18th century. Steel, brass.

Fork and knife. Germany, 1730–50. Green-stained ivory, silver, steel.

Traveling set with fork, knife and spoon. Made by "FGS." Germany (possibly Karlsbad), early 18th century. Steel, brass, silver, gold.

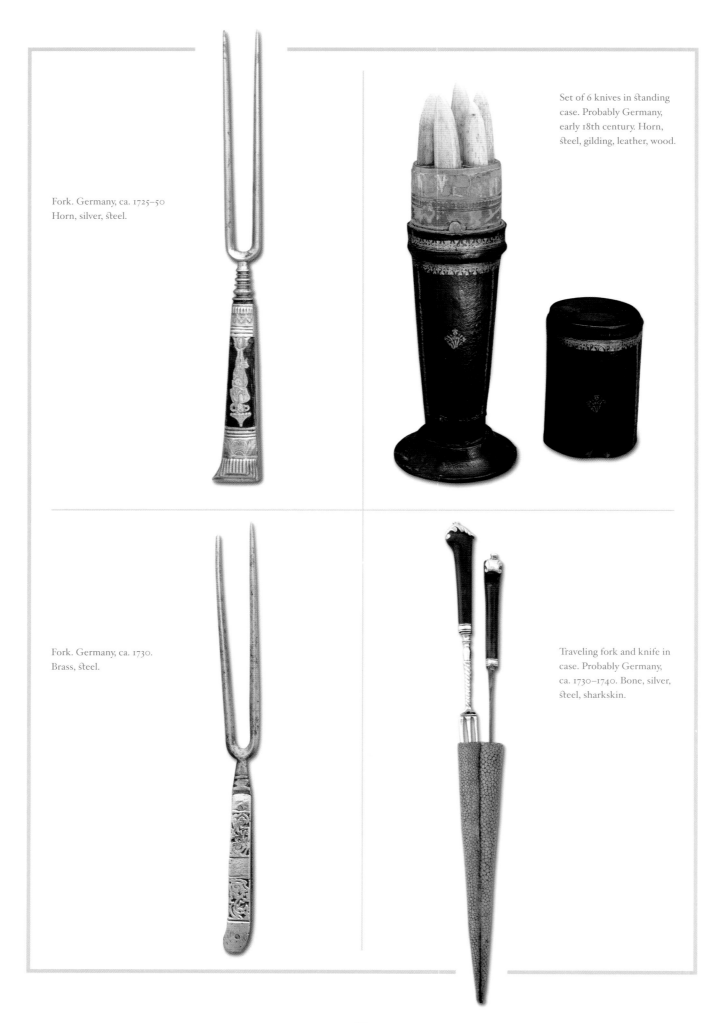

Fork. Germany, ca. 1725–50
Horn, silver, steel.

Set of 6 knives in standing
case. Probably Germany,
early 18th century. Horn,
steel, gilding, leather, wood.

Fork. Germany, ca. 1730.
Brass, steel.

Traveling fork and knife in
case. Probably Germany,
ca. 1730–1740. Bone, silver,
steel, sharkskin.

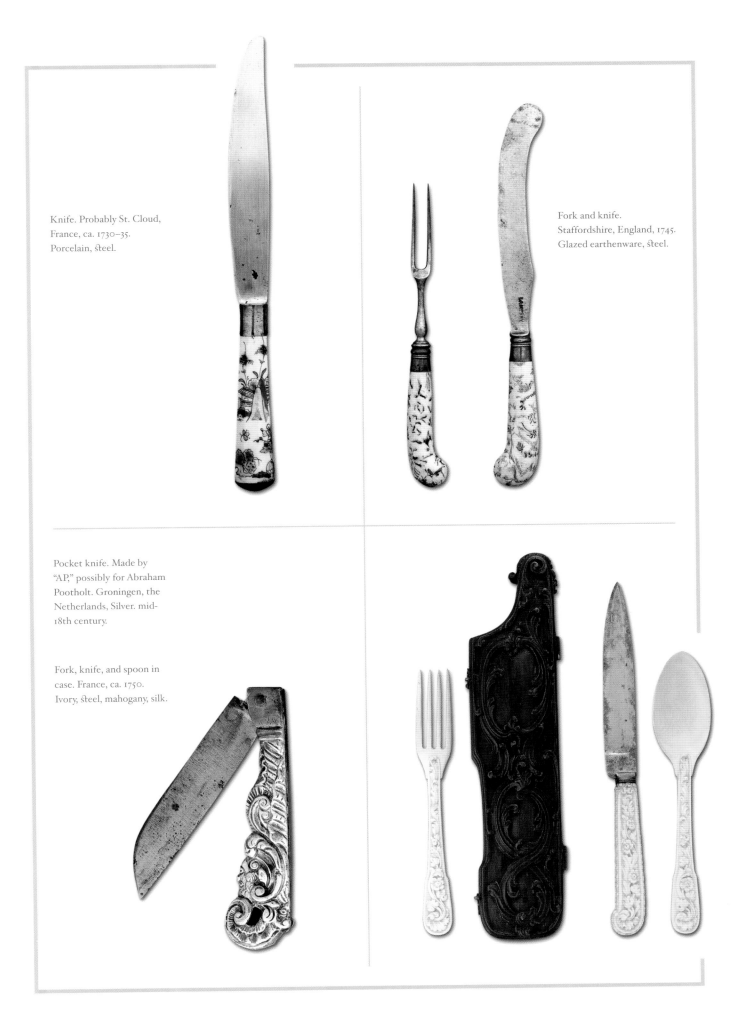

Knife. Probably St. Cloud,
France, ca. 1730–35.
Porcelain, steel.

Fork and knife.
Staffordshire, England, 1745.
Glazed earthenware, steel.

Pocket knife. Made by
"AP," possibly for Abraham
Pootholt. Groningen, the
Netherlands, Silver. mid-
18th century.

Fork, knife, and spoon in
case. France, ca. 1750.
Ivory, steel, mahogany, silk.

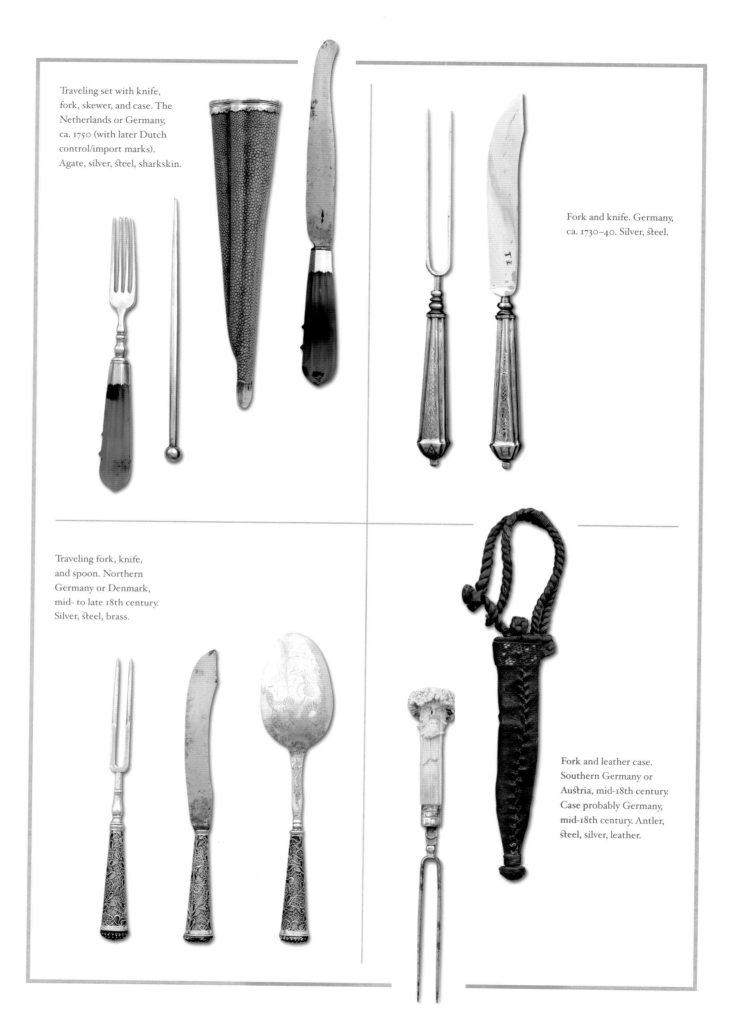

Traveling set with knife, fork, skewer, and case. The Netherlands or Germany, ca. 1750 (with later Dutch control/import marks). Agate, silver, steel, sharkskin.

Fork and knife. Germany, ca. 1730–40. Silver, steel.

Traveling fork, knife, and spoon. Northern Germany or Denmark, mid- to late 18th century. Silver, steel, brass.

Fork and leather case. Southern Germany or Austria, mid-18th century. Case probably Germany, mid-18th century. Antler, steel, silver, leather.

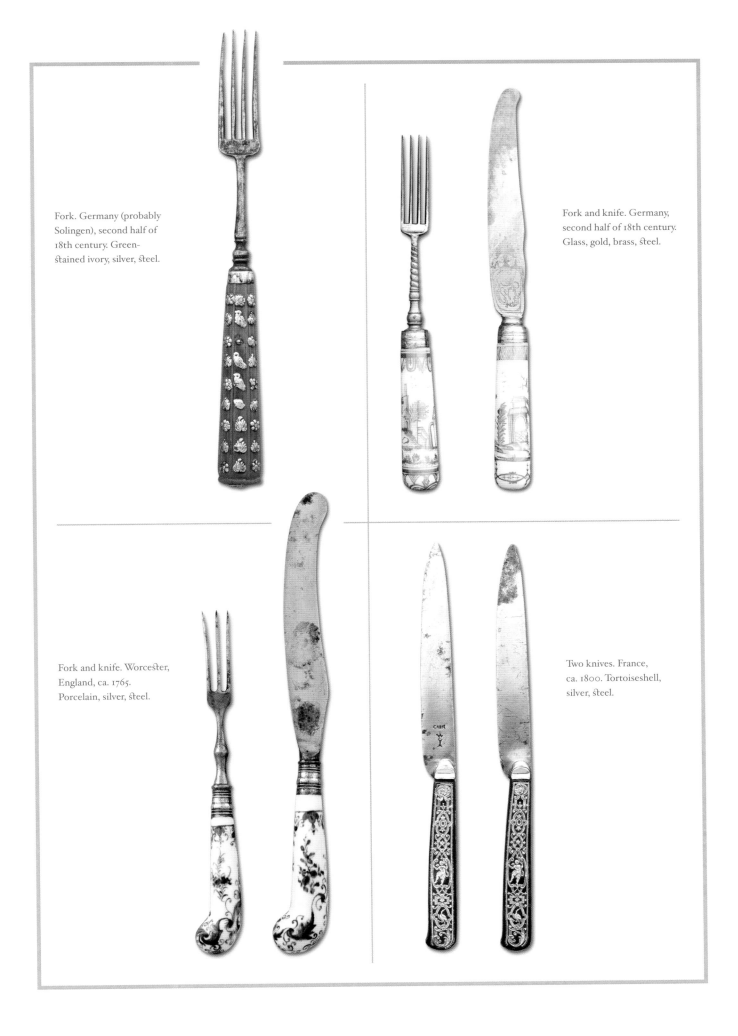

Fork. Germany (probably Solingen), second half of 18th century. Green-stained ivory, silver, steel.

Fork and knife. Germany, second half of 18th century. Glass, gold, brass, steel.

Fork and knife. Worcester, England, ca. 1765. Porcelain, silver, steel.

Two knives. France, ca. 1800. Tortoiseshell, silver, steel.

Folding fork, knife, and spoon. Karlsbad, Bohemia, ca. 1790–1800. Steel, gold, silver.

Folding fork, knife, and spoon. Bohemia (probably Karlsbad), ca. 1790. Gold, silver.

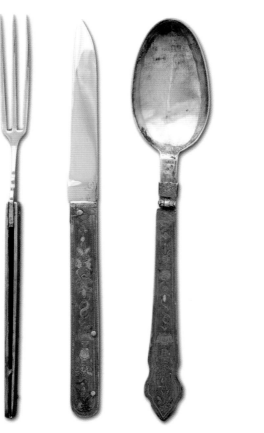

Teaspoon. Made by "DH." United States, ca. 1790–1800. Silver.

Chopsticks, knife, and case. Probably Japan, mid-19th century. Wood, bamboo, brass, ivory.

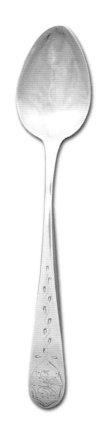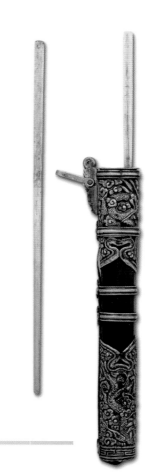

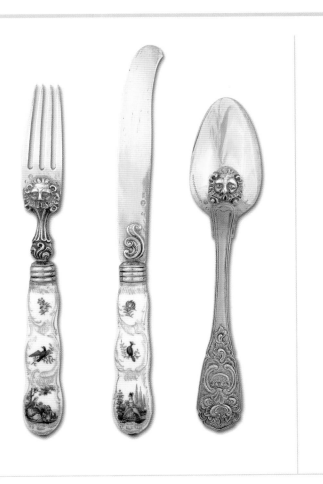

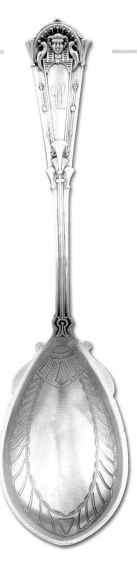

Fork, knife, and spoon. Made by "TM." Dresden, Germany, mid-19th century. Porcelain, silver, gilding.

Serving spoon. Manufactured by Whiting Manufacturing Co. North Attleboro, Massachusetts, ca. 1875. Silver.

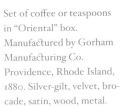

Set of coffee or teaspoons in "Oriental" box. Manufactured by Gorham Manufacturing Co. Providence, Rhode Island, 1880. Silver-gilt, velvet, brocade, satin, wood, metal.

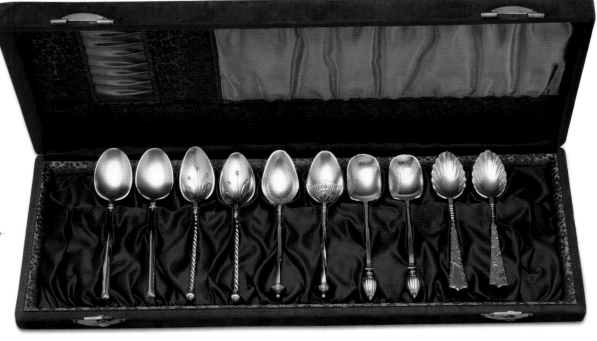

81-piece dessert service.
Mother-of-pearl-handled
service made and retailed
by F. Nicoud; silver service
made by C. V. Gibert.
Paris, France, ca. 1890.
Steel, silver; silvered and
gilt metal, mother-of-pearl.

Fork and knife with case.
Made by Francis Higgins.
London, England, 1884.
Silver-gilt, leather, velvet,
silk, satin.

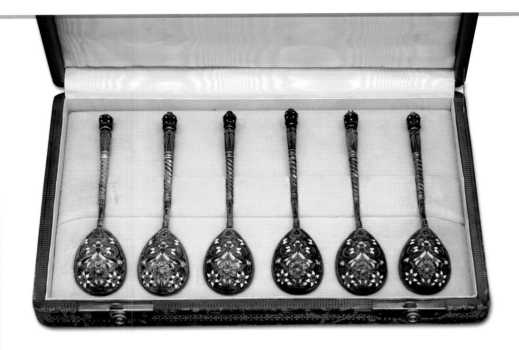

Spoons in case. Made by
Pavel Ovchinikov. Moscow,
Russia, ca. 1890. Retailed
by Theodore B. Starr, New
York. Enamel (cloisonné),
silver-gilt, leather, brass,
velvet, silk.

Five-piece carving set.
Manufactured by Gorham
Manufacturing Company.
Providence, Rhode Island,
1900. Horn, steel, silver, glass.

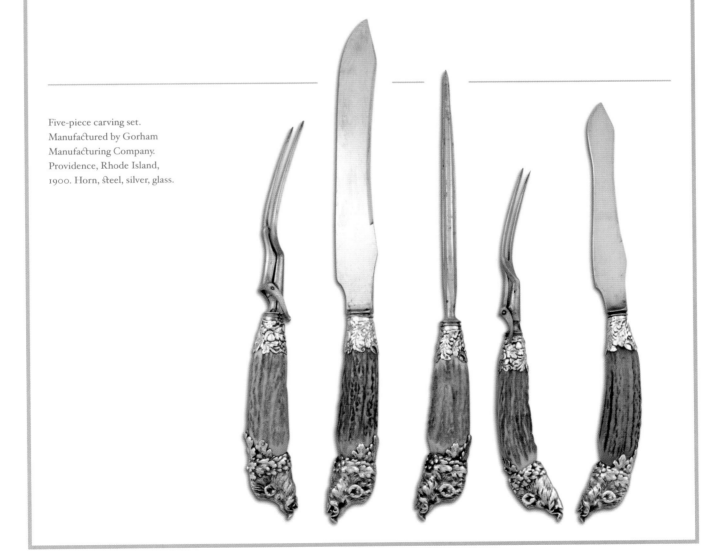

"Tulip" dessert fork and knife. Designed by Heinrich Vogeler. Manufactured by M. H. Wilkens & Söhne. Bremen, Germany, 1900–02. Silver.

"Moderne 1900 Palmier" place setting. Design attributed to Paul Follot. Manufactured by Maison Cardeilhac. Paris, France, 1904. Silver.

Six-piece place setting. Designed by Porter Blanchard. U.S.A., ca. 1970–80. Silver.

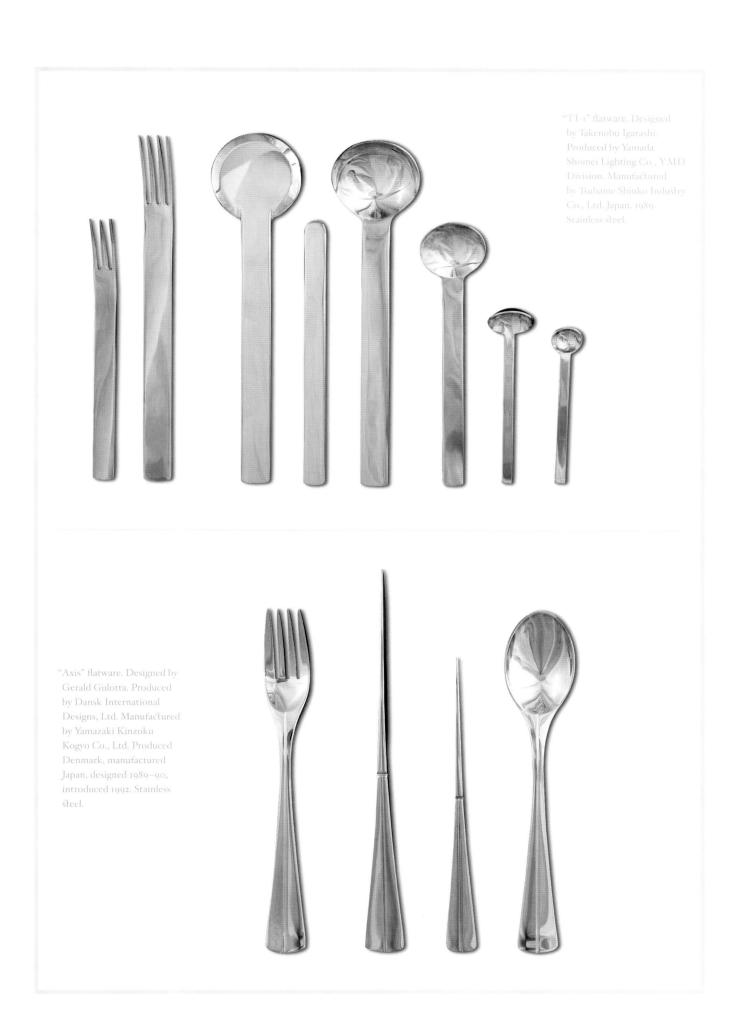

"TI-1" flatware. Designed by Takenobu Igarashi. Produced by Yamada Shomei Lighting Co., YMD Division. Manufactured by Tsubame Shinko Industry Co., Ltd. Japan, 1989. Stainless steel.

"Axis" flatware. Designed by Gerald Gulotta. Produced by Dansk International Designs, Ltd. Manufactured by Yamazaki Kinzoku Kogyo Co., Ltd. Produced Denmark, manufactured Japan, designed 1989–90, introduced 1992. Stainless steel.

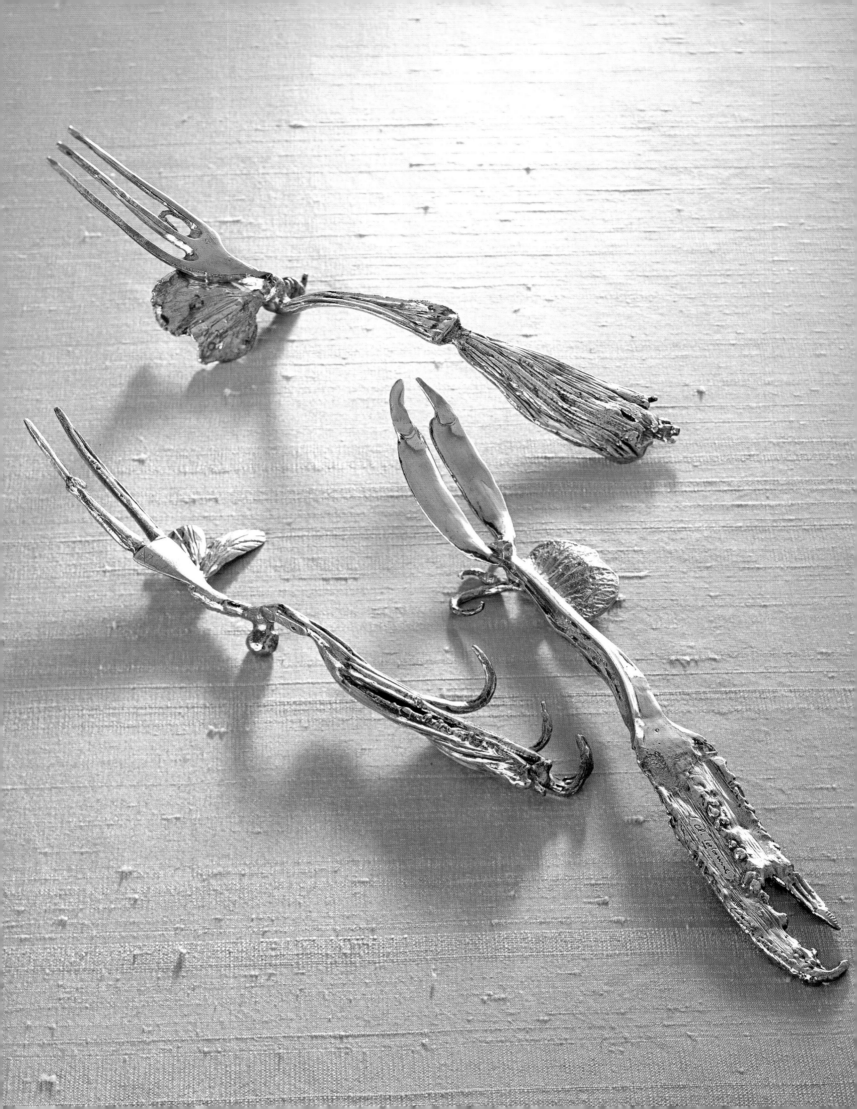

Endnotes

Introduction
BARBARA BLOEMINK

1. Progenitor of the current Cooper-Hewitt, National Design Museum, Smithsonian Institution, to which the Cooper Union collections were given in 1967.

2. This information is scratched on the reverse of the spoon handles and is the museum's catalogue card archive.

Historical Overview
SARAH D. COFFIN

1. Carolin C. Young, *Apples of Gold in Settings of Silver: Stories of Dinner as a Work of Art* (New York: Simon and Schuster, 2002), p. 83.

2. Cutlers in England, France, Germany, and elsewhere had their own guild separate from silversmiths and other metalworkers. In France, cutlers were further divided into blade and haft makers.

3. Mark Girouard, *Life in the Country House: A Social and Architectural History* (New Haven: Yale University Press, 1978), p. 104–06; he also points out that the word "dessert" comes from the French equivalent for the English term "void" repast, one of fruits and sweet wine that was served while the table was cleared of the main dishes.

4. *Sodoma Monks at Table with St. Benedict* fresco, 1505–08, Cloister of Monte Oliveto Maggiore, Buonconvento, Italy. This image also includes, however, a serving fork for serving the small fish they are about to eat—artistic license or an inroad in Italian ecclesiastical acceptance?

5. Iris Origo, *The Merchant of Prato* (London: Penguin, 1986), p. 271.

6. Ibid., p. 194.

7. Donald M. Frame, translator and introduction, *Montaigne's Travel Journal* (San Francisco: North Point Press, 1983), p. 76. Description from a dinner given by the Cardinal de Sens in Rome, 1580: "Everyone is served with a napkin to wipe his mouth and hands with; and in front of those to whom they want to do particular honor, who are seated beside or opposite the master, they place big silver squares on which their salt cellar stands, of the same sort as those put before the great in France. On top of this there is a napkin folded in four, and on this napkin the bread, knife, fork, and spoon. On top of all this there is another napkin, which you are to use, and leave the rest in the state it is in; for after you are at table, they give you beside this square, a silver or earthenware plate which you use. Of all that is served at table the carver gives portions on plates to those who are seated, in the order of seating, and they do not put their hand in the dish, least of all to the master's dish."

8. For a fifteenth-century example found in Britain, see Peter Brown, *Dining in England: A History of British Cutlery* (London, 1997); for a tenth-century Viking fork, see pp. 60–61, fig. 12d; for a Thames fin, possibly Dutch, of circa 1550, see figure on p. 73.

9. I am grateful to Philippa Glanville for this reference from her research in the archive of Carew Mildmay, Clerk to the Jewel-House 1625–49, on deposit in Somerset Record Office.

10. *Walpole Correspondence.* Yale Edition, vol. I, 12–13.

11. Alice Morse Earle, *Customs and Fashions in Old New England* (New York: Charles Scribner's and Sons, 1893), p. 136.

12. I am grateful to Jeanine Falino for drawing my attention to this set at the Massachusetts Historical Society.

13. George Washington's first invoice for silver after inheriting Mount Vernon in 1754 was for a cruet stand and for "2 Setts best Silver handle knives & forks, best London blades 11-0-0." See Kathryn C. Buhler, *Mount Vernon Silver* (Mount Vernon, VA: Mount Vernon Ladies' Association of the Union, 1957), p. 12.

14. George Washington, *Rules of Civility and Decent Behaviour in Company and Conversation* (Bedford: Applewood Books, 1988), p. 27.

15. Abbott L. Cummings, ed., *Rural Household Inventories 1675–1775* (Boston: Society for the Preservation of New England Antiquities, 1964), pp. 114–15.

16. Ibid., pp. 242–43.

17. Ibid.

18. Richard Bushman, *The Refinement of America Persons, Houses, Cities* (New York: Vintage, 1993), pp. 76–77.

19. William M. Milliken, "Early Christian Fork and Spoon," *Bulletin of the Cleveland Museum of Art*, no. 44, 1957, p. 186.

20. Peter Fuhring, "The Silver Inventory from 1741 of Louis, duc d'Orléans," *Cleveland Studies in the History of Art*, vol. 8, 2003, pp. 130–41.

21. Miguel de Cervantes, *Don Quixote de la Mancha* (1605–15), vol. IV, 74; trans. by Peter Anthony Motteux, Modern Library Giant Edition, cited in John Bartlett, *Familiar Quotations*, edited by Emily Morison Beck, 1980, p. 171, no. 5.

22. *Walpole Correspondence.* Yale Edition, vol. I, 13–14. Letters to and from the Reverend Mr. William Cole, June 1776. Walpole to Cole: "I have lately purchased three apostle spoons to add to the one you was so kind as to give me." Cole to Walpole: "You also mention a gift from me of a silver spoon, but I wish I had enough to complete your set, having been more than doubly paid for it by your generosity."

23. Norman Gask, "Early Maidenhead Spoons," *Connoisseur*, December 1933, p. 400.

24. Ibid.

25. Gask, *Connoisseur*, vol. 84, 1929, p. 92.

26. Jane C. Nylander. *Our Own Snug Fireplace: Images of the New England Home, 1760–1860* (New York: Alfred A. Knopf, Inc. and Yale University Press, 1994), pp. 61–62.

27. Christopher Morris, ed., *The Illustrated Journeys of Celia Fiennes 1685–c.1712* (London: Alan Sutton UK, 1995), p. 25.

28. This manuscript in the British Art Center at Yale details the number of dishes on the same page for the household to the "master cook and pages." Wild asparagus, which was to become very popular to a broader public later in the century, is, however, mentioned in Roman feasts.

29. Beineke Library, Yale University, uncatalogued "Genm Book 20010717-6t," especially p. 30.

30. Jacques-François Blondel, *Description des festes données par la ville de Paris: à l'occasion du mariage de Madame Louise-Elisabeth de France, et de dom Philippe, infant & grand amiral d'Espagne, les vingt-neuvième trentième août mil sept cent trente-neuf* (Paris: L'imprimerie de P.G. Le Mercier, 1740), p. 22. Presumably the "masked ladies" (author's translation).

31. Ibid.

32. Sloane Papers, cited in Laurence Kelly, *St Petersburg: A Travelers' Companion* (London: Constable and Robinson, 1981), pp. 268–70.

33. Kelly, p. 100. Kelly quotes a description of Prince Potemkin's farewell ball for Catherine the Great in the Tauride Palace, April 28, 1791, to celebrate the victory of the capture of Ismailia, from the *Mémoires secrets sur la Russie, particulièrement sur la fin du règne de Catherine II et le commencement de celui de Paul I by C.P. Masson.*

34. Jeannine Falino, "'The Pride Which Pervades Thro Every Class': The Customers of Paul Revere," in Jeannine Falino and Gerald W. R. Ward, eds., *New England Silver and Silversmithing, 1620–1815* (Boston: The Colonial Society of Massachusetts, 2001) where she states that "the purchase of common items such as spoons far outstripped hollowware purchases; in Revere's order, the ratio figured at nearly five to one and constituted the bulk of silver generated by his workshop."

35. Ibid., footnote 12, p. 177.

36. Winterthur has one for James Foster of Boston, 1800, with an invoice on the reverse including "4 doz. Knives and Forks." William Leverett of Boston of 1810 lists various types and has an invoice for "setts best London made green ivory handled knives and forks." I am grateful to Jeanne Solensky of the Winterthur Library for providing copies of these invoices.

37. Jay papers, Columbia University, as quoted in Elizabeth Betts Leckie, "A Historic Furnishings Report for the John Jay Historic Site," pp. 15–16.

38. Dyckman papers.

39. *150 ans de création : Le goût bourgeois : Christofle 150 ans d'art et de rêve, Dossiers d'Art*, July to August 2, 1991, p. 22, author's translation.

40. The style of the Coronation spoon is not at all in keeping with the style of Edward VII's coronation dinner, originally overseen by César Ritz, which involved fourteen courses in the French grande cuisine tradition. The king, however, did provide for a dinner for over 450,000 of London's poorest, which included roast beef and plum pudding in over 700 venues. See Richard Tames, *Feeding London* (London: Historical Publications, 2003), pp. 183–85.

41. Edith Wharton and Ogden Codman, Jr., *The Decoration of Houses*, introductory notes by John Barrington Bayley and William A. Coles (New York: Norton and Company, 1978), p. 2.

42. Ibid.

43. Hitoshi Mori, curator at the Industrial Arts Institute in Japan, has compiled a list of the Western designers who were in residence there in the 1950s and 1960s when it was headed by Isamu Kenmochi, an artist and good friend of Russel Wright. I am grateful to Robert Stearns of Arts Midwest for this information

Manufacturing and Marketing in Europe, 1600~2000

PHILIPPA GLANVILLE

1. C. Arminjon, *L'Art du Métal* (Paris: Imprimerie Nationale, 1998), pp. 57–58 and passim. A table of London cutlers marks can be found in Appendix 3 in S. Moore, *Cutlery for the Table* (London: Hallamshire, 1999); and J. B. Himsworth, *The Story of Cutlery* (London: Ernest Benn, 1953).

2. A. Somers Cocks, *Masterpieces of Cutlery and the Art of Eating*, exhibition catalogue (London: Victoria and Albert Museum, 1979).

3. Philippa Glanville, *Silver in Tudor and Early Stuart England* (London: Victoria and Albert Museum, 1990). Sources for this study: the Mary Rose Web site, "Food and Drink"; B. Lavery, *The Royal Navy's First Invincible 1744–1758* (London: National Maritime Museum, 1987), pp. 78–79; I. Noel Hume, *A Guide to Artifacts of Colonial America* (New York: Alfred A. Knopf, 1969), pp. 177–84; James Symonds, ed., *The Historical Archaeology of the Sheffield Cutlery and Tableware Industry 1750–1900* (Sheffield, England: Arcus Studies in Historical Archaeology, vol. 1, 2002), p. 54.

4. Arminjon, pp. 120–50; *Hans Peter Lans, Trésors D'Orfèvrerie* (Zurich: Suisse Landesmuseum, 2004), pp. 212–13; R. Lightbown, *Catalogue of Scandinavian and Baltic Silver at the Victoria and Albert Museum* (London: HMSO, 1975).

5. Peter Brown, ed., *British Cutlery: An Illustrated History of Design, Evolution, and Use* (York, England: York Civic Trust/Philip Wilson, 2001), pp. 26–27; H. Forsyth and G. Egan, *Toys, Trifles, and Trinkets: Base-Metal Miniatures from London* (London: Museum of London/Unicorn Press, 2005), p. 134; A. Grimwade, "New Light on the English Royal Plate," *Silver Society Journal*, vol. 7, autumn 1995, pp. 369–72.

6. Robert Barker, who has unrivaled knowledge of Jamaican sources, showed me these inventories.

7. Jennifer Goldsborough, *Silver in Maryland* (Baltimore: Maryland Historical Society, 1983), p. 27.

8. B. Carson, *Ambitious Appetites: Dining in Federal Washington* (Washington, DC: Octagon Museum, 1990), p. 152.

9. M. McInnis and A. Mack, *In Pursuit of Refinement: Charlestonians Abroad 1740–1860* (Columbia, SC: University of South Carolina Press, 1999), p. 15, note 24.

10. Old Bailey Proceedings online, www.oldbailey-online.org, 1674–1834, Oct. 18, 1769; S. Moore, *Cutlery for the Table* (London: Hallamshire, 1999), pp. 216–17.

11. T. Kent, *London Silver Spoonmakers 1500–1697* (London: John Bourdon Smith, 1981), introduction.

12. Glanville, pp. 184–88.

13. N. Verlet-Beaubourg, *Les Orfèvres du ressort de la Monnaie de Bourges* (Geneva: Librairie Droz, 1977), pp. 151–54.

14. J. Hatcher and T. C. Barker, *A History of British Pewter* (London: Longman, 1974), p. 107; National Archives, C 104/105, ledger for Dec. 26, 1710.

15. C. Hartop, *East Anglian Silver 1550–1750* (Cambridge, England: John Adamson, 2004), p. 118; Philippa Glanville, *Silver in England* (London: Unwin Hyman, 1987), p. 38; S. Schama, *The Embarrassment of Riches* (London: Fontana, 1988), pp. 306–10; Kent, *London Silver Spoonmakers 1500–1697*; C.-G. Cassan, *Les Orfèvres de la Normandie* (Paris: F. de Nobele, 1980), pp. 10–11.

16. T. A. Kent, "Salisbury Silver and Its Makers 1550–1700," *Silver Society Journal*, vol. 3, spring 1993, pp. 23–25.

17. A. Sale, "Some Silversmiths' inventories," *Silver Society Journal*, 2004, p. 46; J. M. Phillips, *American Silver: New York 1949*, pp. 14–16; Verlet-Reaubourg, pp. 188–89.

18. M. Bimbenet Privat, *Les Orfèvres et L'Orfèvrerie de Paris au XVII siècle*, two vols. (Paris: Musées, 2002), vol. 2, pp. 209, 215 (the earliest surviving set of twelve *couverts*).

19. T. A. Kent, *West Country Silver Spoons and Their Makers 1550–1750* (London: John Bourdon-Smith, 1992) p. 16.

20. A. Heal, *The London Goldsmiths 1200 to 1800* (David & Charles Newton Abbot, 1972), passim; K. Quickendon, "Boulton and Fothergill's Silversmiths," *Silver Society Journal*, 1995, vol. 7, p. 355, no. 45; and personal communication.

21. *Chester Silver at the Grosvenor Museum*, exhibition catalogue (Chester, England: Sotheby's, 1984), pp. 179–80.

22. H. Clifford, *Silver in London: The Parker and Wakelin Partnership 1760–1776* (London: Yale, 2004), pp. 55, 57, 85–87.

23. Glanville, *Silver in England*, p. 189.

24. T. Sinsteden, "Four Selected Assay Records of the Dublin Goldsmiths Company," *Silver Society Journal*, vol. 11, 1999, pp. 149, 154.

25. Old Bailey Sessions online.

26. P. Priestley and P. Benedikz, "The Early Records of the Birmingham Assay Office," *Silver Studies, The Journal of the Silver Society*, vol. 16, 2004, pp. 103–11; I am grateful to Tim Kent for comments on the Exeter assay records.

27. Historical Archive of Sheffield, pp. 45–46; H. Clifford, Royal *Goldsmiths: The Garrard Heritage*, exhibition catalogue (London: Garrards, 1991), p. 94.

28. I am grateful to David Beasley, Librarian at the Goldsmiths Company, London, for access to their plate inventories.

29. Inventory of the contents of the Governor's Palace taken 1778–80, Colonial Williamsburg Foundation, 1980 (Botetourt inventory dated 1770). H. Young, *The Genius of Wedgwood* (London: Victoria and Albert Museum, 1995), p. 151; B. S. Rabinovitch, *Antique Silver Servers for the Dining Table* (Concord, 1991).

30. "Von Uffenbach in Oxford," *Silver Studies, The Journal of the Silver Society*, vol. 16, 2004; miscellany, p. 116.

31. G. Crossley, "The Early Development of the Plated Trade," *Silver Society Journal*, vol. 12, 2000, pp. 27–28.

32. Symonds, pp. 5–6. Information from Julie Banham, currently completing a Ph.D. thesis on consumption in Sheffield.

33. Symonds, p. 54–56; Bilgi Kenber et al., *Les Cuilliers à Sucre dans l'Orfèvrerie Française du XVIII Siècle* (Paris: Editions Somogy, 2002), pp. 64–65.

34. Heal, plates 60, 74.

35. J. M. Phillips, *Beekman Mercantile Papers 1746–1799*, three vols. (New York: P. L. White, 1956), p. 90; Crossley, p. 29.

36. Sinsteden, p. 145; *Old English Pattern Books of the Metal Trades*, exhibition catalogue (London: Victoria and Albert Museum and HMSO, 1913).

37. I. M. G. Quimby, *American Silver at Winterthur* (Winterthur: University of Virginia Press, 1995), p. 339.

38. *Versailles et les Tables Royales en Europe*, exhibition catalogue (Paris : Réunion des Musées Nationaux, 1993), p. 166; Philippa Glanville, *The Hanover Service of George III* (Waddesdon Manor, 2003), p. 3; Glanville, *Silver in England*, pp. 191–92.

39. *The Finial*, Dec. 2004, p. 15; Ronald Grant; John Fallon, personal communication.

40. Rabinovitch, p. 58.

41. Advertisement for Birmingham plater James and Gibbs, trade directory 1818, fig. 2 in K. Pinn, "Introducing Close Plate," *Antique Metalware Society Journal*, vol. 11, June 2003.

42. Brasbridge, "Fruits of Experience," p. 44; Old Bailey Sessions online, 1823.

43. J. B. Himsworth, cited in J. Wynne-Williams, *The Design and Use of English Domestic Flatware 1850–1914*, Victoria and Albert/RCA History of Design MA thesis, 1992, p. 8.

44. Goldsborough, p. 37; D. D. Waters, *Elegant Plate: Three Centuries of Precious Metal in New York City* (New York: Museum of City of New York, 2000), vol. 1, p. 50.

45. *A Treatise on the Progressive Improvement and Present State of the Manufactures in Metal*, three vols. (London, 1831), p. 4; J. Culme, A *Directory of Goldsmiths, Silversmiths, and Allied Trades* (Woodbridge, England: Antique Collectors Club), vol. 1, p. 247.

46. Information from John Fallon, who is engaged in long-term research on the Barnard archives, Victoria and Albert Archive of Art and Design. I. Pickford's *Silver Flatware English Irish and Scottish 1660–1980* (Woodbridge: Antique Collectors Club, 1983) is the standard source.

47. S. Bury's *Victorian Electroplate* (London: Country Life, 1971) is still a good introduction to this dense period of innovation. *Christofle, 150 Ans d'Orfèvrerie* (Loches: Château de Loches, 1991).

48. British Library Tracts on Industrial Art 1845–54, Price List of George Walker and Co., 1849.

49. *Christofle, 150 Ans D'Orfèvrerie*.

50. I am grateful to T. Kent, who gave me copies from the 1854 Report on the Exeter Assay Office.

51. Waters, vol. 2, p. 156.

52. Victoria and Albert Archive of Art and Design, Elkington records; National Archives, TNA, BT 47/16.

53. C. Venables, *Silver in America 1840–1940: A Century of Splendour* (New York and Dallas: Dallas Museum of Art and Abrams, 1995), p. 135; P. Ennes and G. Mabille, *L'Art de la Table* (Paris: Flammarion, 1994), pp. 278–79.

54. A. Lohr, *Bremer Silber*, exhibition catalogue (Bremen: Bremer Landesmuseum, 1981), no. 269, p.140–51; *A Personal Touch: The Seawolf Collection: Late Nineteenth- and Twentieth-Century Silver*, exhibition catalogue (Rotterdam: Boymans van Beuningen Museum, 2003).

55. B. S. Rabinovitch and H. Clifford, *Contemporary Silver: Commissioning, Designing, Collecting* (New York: Rizzoli), 2000.

The Sexual Politics of Cutlery

CAROLIN C. YOUNG

1. Norbert Elias, *The Civilizing Process* (Oxford: Blackwell Publishing, rev. ed., 1994), p. 5.

2. Ibid., p. 47.

3. Ibid., p. 60.

4. Claude Lévi-Strauss, "The Culinary Triangle," *Parisian Review* 33 (1966), pp. 586–95.

5. Mark XVII.20; see also Matthew XXVI.23 and Luke XXII.21; according to John XIII.26, Jesus identifies his betrayer by dipping a sop and handing it to Judas.

6. William Shakespeare, *The Comedy of Errors*, IV.iii.64.

7. Geoffrey Chaucer, "The Squiere's Tale," *The Canterbury Tales*, line 602.

8. Exodus XXV.29.

9. Numbers VII.

10. E. A. Hammel, "Sexual Symbolism in Flatware," *The Kroeber Anthropological Society Papers* 37 (fall 1967), p. 25.

11. Ibid., pp. 25–26.

12. Ibid., p. 28.

13. Ronald Lightbrown, "The Coronation Spoon," in Claude Blair, gen. ed., *The Crown Jewels: The History of the Coronation Regalia in the Jewel House of the Tower of London* (London: The Stationery Office, 1998), vol. II, pp. 297–302.

14. "Celui qui estrine sa dame par amour, le jour de l'an, de couteau, sachez que leur amour refroidira," *L'Évangile des quenouilles*, quoted in Alfred Franklin, *La Civilité, l'étiquette, la mode, le bon ton du XIIIe au XIXe siècle* (Paris: Émile-Paul, 1908), vol. I, p. 304.

15. Homer, *The Odyssey*, Book III: lines 362–434.

16. St. Peter Damian (St. Petrus Damianus): "*cibos quoque suos manibus non tangebat, sed ab eunuchis ejus queque minutis concidebantur in frusta: quae mox illa quisbusdam fuscinulis aureis bidentibus ori suo, liguriens, adhibebat...*" *Institutio monialis*, XI, *Opera omnia*, 1783, vol. III, p. 780, quoted in Pasquale Marchese, *L'invenzione della forchetta. Spilloni schidioncini lingule imbroccatoi pironi forcule forcine e forchette dai Greci ai nostri forchettoni* (Soveria Mannelli (CZ): Rubbettino Editore, 1989), p. 42.

17. St. Bonaventure, *De disciplina circa comestionem*, quoted in Marchese, p. 47.

18. Marchese, p. 43.

19. Augustin Canabès, "La Propreté des mains et l'antiquité de la fourchette," *Mœurs intimes du passé*, première série (Paris: Editions Albin Michel, 1920), p. 248.

20. Barbara Ketcham Wheaton, *Savoring the Past: The French Kitchen and Table from 1300 to 1789* (New York: Touchstone Books, 1996), pp. 43–51.

21. Edmond Bonnaffé, *Inventaire des meubles de Catherine de Médicis en 1589. Mobilier, tableaux, objets d'art, manuscrits* (Paris: Auguste Aubry, 1874), p. 92.

22. Bartolomeo Scappi, *Opera di M. Bartolomeo Scappi, cuoco ... divisi in sei libri* (Venice: F. e M. Tramezino, 1570). The copy mentioned at the BnF is: FRBNF31308173.

23. C. Calviac, *La Civile honesteté pour les enfants, avec la manière d'aprendre à bien lire, prononcer et escrire: qu'avons mise au commencement* (Paris: L'Imprimerie de Richard Sutton, 1560).

24. Thomas Artus, sieur d'Embry, *Les Hermaphrodites; ou L'Isle des hermaphrodites nouvellement descouverte* (Paris, ca. 1605), pp. 157, 162.

25. John Hale, *The Civilization of Europe in the Renaissance* (New York: Atheneum, 1994), pp. 52–66; anti-Italian statements and texts cited by Hale include Ulrich von Hutten (1517), who discusses "children of Sodom in Florence"; Thomas Nashe, *The Unfortunate Traveler* (1594), which explains that there is nothing to be learned in Italy save "the art of atheisme, the art of epicurising, the art of whoring, the art of poysoning, the art of sodomitry"; and John Hall (1608), who stated that the Italians are commonly called "effeminate."

26. Eustachio Celebrino da Udine, *Opera nove che insegna apparechiar una mensa a uno convito: e etiam a tagliar in tavola de ogni sorte carne e dar li cibi secondo lordine che usano gli scalchi p[er] far honore a forestieri, inititulat[a] Refettorio* (Venice: 1526), in Benporat, "A Discovery at the Vatican – The First Italian Treatise on the Art of the Scalco (Head Steward)," *Petits Propos Culinaires* 30 (Nov. 1988), p. 44.

27. Juan Luis Vivès, *Les Dialogues de Louis Vivès* (1560), p. 121, quoted in Franklin, p. 288.

28. Calviac, unnumbered.

29. Martin Luther, quoted in Jochen Amme, *Bestecke: Die Egloffstein'sche Sammlung (15.–18. Jahrhundert) auf der Wartburg* (Stuttgart: Arnoldsche, 1994), p. 16.

30. Eliza Ware Farrar, *The Young Lady's Friend* (Boston: American Stationers' Co., 1837), pp. 346–47.

31. Vincenzo Cervio, *Il trinciante* (Bologna: Arnaldo Forni Editore, 1980; facsimile of the 1593 edition) pp. A, 7.

32. Béatrix Saule, "Tables Royales a Versailles," in Sylvie Messinger, ed., *Versailles et les Tables Royales en Europe* (Paris: Réunion des Musées Nationaux, 1993), p. 52, cites the princess Palatine, 22 January 1713; Monnier de Richardin, who on March 22, 1669 noted that the young princes never used forks; and Mademoiselle de Montpensier, who recorded that the young Louis XIV put his hands in the platter.

33. William P. Hood, Jr., with Roslyn Berlin and Edward Wawrynek, *Tiffany Silver Flatware: 1845–1905, When Dining Was an Art* (Woodbridge, England: Antique Collectors' Club, 1999), p. 74.

34. René Crevel, *Mr. Knife Miss Fork* (Paris: The Black Sun Press, 1931).

Implements of Eating

DARRA GOLDSTEIN

1. Martial. *Book XIV: The Apophoreta*. Text with introduction and commentary by T. J. Leary (London: Duckworth, 1996), p. 185. I have tweaked Leary's translation slightly.

2. The German sociologist Norbert Elias contends that the rise of the fork is a marker of "the civilizing process." See his discussion of the fork in *The Civilizing Process: Sociogenetic and Psychogenetic Investigations*, translated by Edmund Jephcott, revised edition edited by Eric Duning, et al. (London: Blackwell Publishers, 1994), esp. pp. 47–71.

3. Patrick Faas, *Around the Roman Table: Food and Feasting in Ancient Rome*, translated by Shaun Whiteside (New York: Palgrave, 1994), p. 74.

4. The Polish food historian Maria Dembinska believes that the fork developed at the Byzantine table "in part due to the Byzantine style of court cookery, in which the food came to table cut up in small pieces and served in a multitude of little dishes." But this reasoning does not fully explain its prominence, as the Romans also enjoyed food in small bites. Dembinska believes that the fork spread to Western Europe through the Cypriots by way of the Genoese. See Maria Dembinska, *Food and Drink in Medieval Poland: Rediscovering a Cuisine of the Past*, translated by Magdalena Thomas, revised and adapted by William Woys Weaver (Philadelphia: University of Pennsylvania Press, 1999), p. 42.

5. Bernard Rudofsky, *Now I Lay Me Down to Eat: Notes and Footnotes on the Lost Art of Living* (Garden City, NY: Anchor Books, 1980), p. 32.

6. This story is repeated in numerous sources. See, for example, Bridget Ann Henisch, *Fast and Feast: Food in Medieval Society* (University Park and London: The Pennsylvania State University Press, 1976), p. 185.

7. For a history of the sweet banquet, see C. Anne Wilson, ed., *"Banquetting Stuffe": The Fare and Social Background of the Tudor and Stuart Banquet* (Edinburgh: Edinburgh University Press, 1991).

8. By the beginning of the eighteenth century, sucket forks had fallen out of fashion. On suckets, see C. Anne Wilson, pp. 103–109, 135; on the sucket fork in America, see Louise Conway Belden, *The Festive Tradition: Table Decoration and Desserts in America, 1650–1900* (New York and London: W. W. Norton & Company, 1983), p. 115.

9. The earliest known English silver fork, dating to 1632, is illustrated in G. Bernard Hughes, "Evolution of the Silver Table Fork," *Country Life*, September 24, 1959, p. 364.

10. Rudofsky, p. 31.

11. Geoffrey Chaucer, "Prologue," *The Canterbury Tales,* translated into modern English by Nevill Coghill (London: Penguin Books, 2003), p. 6.

12. Quoted in Fernand Braudel, *Civilization and Capitalism 15th–18th Century*, vol.1, *The Structures of Everyday Life: The Limits of the Possible* (New York: Harper & Row, 1981) pp. 205–06.

13. James Cross Giblin, *From Hand to Mouth, or How We Invented Knives, Forks, Spoons, and Chopsticks and the Table Manners to Go with Them* (New York: Thomas Y. Crowell, 1987), p. 52.

14. Braudel, p. 206.

15. Leo Moulin, *Les liturgies de la table: une histoire culturelle du manger et du boire* (Anvers: Fonds Mercator, 1988), p. 193; my translation.

16. Giovanni Rebora, *Culture of the Fork: A Brief History of Food in Europe*. Translated by Albert Sonnenfeld (New York: Columbia University Press, 2001), pp. 15–16. Rebora's argument is of interest but does not explain why as late as the nineteenth century many Italians were still eating spaghetti with their fingers, as depicted in two works of art: J. Mieg's *Marché en Italie* (18th century) in the Musée des Beaux-Arts, Mulhouse, France; and "Il Maccaronaro,"

an illustration from G. Dura's *Nuova raccolta di costumi di Napoli* (Naples, 1833–1853). Both images are reproduced in Moulin, *Les liturgies de la table*, pp. 20, 91.

17. Mme de Maintenon, quoted in Alan Davidson, *The Oxford Companion to Food* (Oxford: Oxford University Press, 1999), p. 588.

18. Ulla Stöver, *Le Couvert: Geschichte und Geschichten um Tafelsilber* (Munich: Verlag Karl Thiemig, 1975), p. 18.

19. *The Aristocratic Journey; Being the Outspoken Letters of Mrs. Basil Hall Written during a Fourteen Months' Sojourn in America 1827–1828*, prefaced and edited by Una Pope-Hennessy (New York: G. P. Putnam's Sons, 1931), pp. 35–36.

20. Mrs. John Farrar, *The Young Lady's Friend. By a Lady* (Boston: American Stationers' Company, 1837), pp. 346–47.

21. On electroplating, see Dorothy Rainwater, "Victorian Dining Silver," *Dining in America 1850–1900*, edited by Kathryn Grover (Amherst, MA, and Rochester, NY: The University of Massachusetts Press and The Margaret Woodbury Strong Museum, 1987), p. 174.

22. "Hyper-Gentility," *Scribner's Monthly*, vol. 5, issue 5 (March 1873), p. 643.

23. Carolin C. Young, "Silverware," *The Oxford Encyclopedia of Food and Drink in America*, vol. 2 (New York: Oxford University Press, 2000), p. 435. See also William P. Hood, Jr., et al., *Tiffany Silver Flatware 1845–1905: When Dining Was an Art* (Woodbridge, England: Antique Collectors' Club, 1999), p. 76.

24. Florence Howe Hall, *Social Customs* (Boston: Estes and Laruiat, 1887), p. 87.

25. Henry Petroski, *The Evolution of Useful Things* (New York: Alfred A. Knopf, 1992), p. 11.

26. Ibid., p. 148.

27. Peter Brown, ed., *British Cutlery: An Illustrated History of Design, Evolution, and Use* (London: Philip Wilson Publishers, 2001), p. 51.

28. *True Politeness: A Hand-book of Etiquette for Ladies. By an American Lady* (New York: Manhattan Pub. Co., 1847), p. 50.

29. Rathbone Holmes, "Implements of the Table," *Art & Industry*, vol. 62, October 1957, p. 124.

30. Brown, p. 101.

31. For photographs showing a wide range of asparagus servers, see *Tiffany Silver Flatware*, 97–100.

32. *Food: A Culinary History*, edited by Jean-Louis Flandrin & Massimo Montanari, translated by Albert Sonnenfeld (New York: Columbia University Press, 1996), p. 371.

33. One commentator puts the date of the arrival of dining *à la russe* to France as 1810. See Gerard Brett, *Dinner is Served: A History of Dining in England, 1400–1900* (London: Rupert Hart-Davis, 1968), p. 119. For a discussion of the introduction of dining *à la russe* to England, see Valerie Mars, "À la Russe: The New Way of Dining," *Eating with the Victorians*, edited by C. Anne Wilson (Phoenix Mill, England: Suttton Publishing, 2004), p. 116. For a contemporary description of *le dîner à la russe*, see Charles Pierce, *The Household Manager: Being a Practical Treatise upon the Various Duties in Large or Small Establishments* (London, New York: G. Routledge & Co., 1857), pp. 148–58. Peter Brown, in *British Cutlery*, erroneously states that the chef Urbain Dubois's 1864 *La Cuisine Classique* "was the first work to fully explain service *à la russe*," though Dubois did help to popularize it. See Brown, p. 48.

34. The silver historian Don Soeffing believes that the fish knife and ice cream slice were, in fact, sometimes used interchangeably. See D. Albert Soeffing, "A Nineteenth-century American Silver Flatware Service," *Antiques*, September 1999, p. 328.

35. Rainwater, p. 182.

36. Ibid., pp. 181–182.

37. Braudel, p. 184.

38. As Andrew F. Smith points out, American housewives had been making potato chips ("shavings") for decades, and a recipe for fried potato "shavings" appears in Mary Randolph's 1824 *Virginia House-wife*. See the entry on "Snack Food" in *The Oxford Encyclopedia of Food and Drink in America*, p. 447.

39. *The Modern Priscilla*, March, 1909, p. 18.

40. Tongs in the form of scissors were mentioned in a German technological dictionary from 1784: Johann Karl Gottfried Jacobsson, *Technologisches Wörterbuch*, vol. 4 (Berlin/Stettin, 1781–99). Cited in Thomas Schürmann, "Cutlery at the Fine Table: Innovations and Use in the Nineteenth Century," *Food and Material Culture: Proceedings of the Fourth Symposium of the International Commission for Research into European Food History* (East Linton, Scotland: Tuckwell, 1998), p. 170.

41. Belden, p. 145.

42. Marie Kimball, *Thomas Jefferson's Cookbook* (Charlottesville: University Press of Virginia, 1976), p. 2.

43. Belden, p. 145.

44. http://www.loc.gov/exhibits/treasures/trio19.html.

45. Corinna Hawkes, "Transportation of Food," *The Oxford Encyclopedia of Food and Drink in America*, vol. 2, p. 553.

46. Sue Shepard, *Pickled, Potted, and Canned: The Story of Food Preserving* (London: Headline Book Publishing, 2000), pp. 235–36.

47. Petroski, *The Evolution of Useful Things*, p. 134. Most contemporary silver services now contain no more than twenty different pieces.

48. Cited in Young, "Silverware," p. 437.

49. See http://www.spork.org/, a Web site for spork aficionados. Here contributors admit that, although sporks are not well designed as eating utensils ("You cannot have soup with a spork, it is far too shallow; you cannot eat meat with a spork, the prongs are too small"), they have their followers. As for the splayd, another Web site explains that "splayd is actually a brand name of a utensil which was invented by an Australian, and has even been honored with a place named after it, Splayd Close…Many people…were blessed with engagement and wedding presents of a set of stylish splayds in the 1950s, 1960s, and 1970s in Australia." See the posting from January 29, 2004, at http://www. signposts. org.au/index. php/archives/2004/01/29/you-say-spork-i-say-splayd/.

50. Moscardino disposable eating utensils, designed by Giulio Iacchetti in 2000 and made of thermoplastic biodegradable material by La Civiplast Snc di Vittorio e Ciro Boschetti, Italy.

51. "The 'Edo' line of R&B tableware has been created specifically for this new style [nouvelle cuisine] of eating culture. A cutlery design which is in harmonious consonance with the sheer beautifulness of the food served: the formal aesthetic consequence matching the aesthetic standards of the new cuisine … Eating with the gourmet fork allows food handling with particular care and an extra touch of feel." See "EDO—The Gourmet Set," promotional brochure (Robbe & Berking, Flensburg, Germany, 1985).

52. The idea of a physical connection to our food was advocated in 1932 by the Italian Futurist F. T. Marinetti in his *Futurist Cookbook*, where he lists eleven rules for the perfect lunch, including "abolition of knife and fork for the plastic complexes that can produce pre-labial tactile pleasure." See F. T. Marinetti, *The Futurist Cookbook*, translated by Suzanne Brill, edited by Lesley Chamberlain (San Francisco: Bedford Arts, Publishers, 1989), p. 15. More recently, chefs at trendy restaurants like El Bulli in Rosas, Spain, and Moto in Chicago have begun to explore ways to heighten the

sensory experience of eating by offering diners new-fangled silverware that can hold herbs or an infusion of essential flavors.

The Design of Table Tools and the Effect of Form on Etiquette and Table Setting
SUZANNE VON DRACHENFELS

1. Margaret Visser, *The Rituals of Dinner* (New York: HarperCollins, 1991), p. 17.

2. Sara Paston-William, *The Art of Dining* (London: The National Trust, 1993), p. 189.

3. Visser, p. 188.

4. Frances Trollope, *Domestic Manners of the Americans*, 1832.

5. Michael Clayton, *Silver and Gold* (Woodbridge: Antique Collectors' Club, 1985, second ed.), p. 372.

6. Ian Pickford, *Silver Flatware, English, Irish and Scottish, 1660–1980* (Woodbridge: Antique Collectors' Club), p. 15.

7. Clayton, p. 192.

8. Pickford, p. 19.

9. C. B. Hartley, *The Gentlemen's Book of Etiquette*, 1875.

10. *The Courtier and the Countryman* by Breton, from Paston-Willams, p. 189.

11. Paston-Williams, p. 188.

12. Amy Vanderbilt, *Amy Vanderbilt's Complete Book of Etiquette* (New York: Doubleday and Company, 1954), p. 252.

13. Jill Bace, *Collecting Silver: The Facts at Your Fingertips* (London: Octopus Publishing Group, Miller's, 1999), p. 76.

14. Visser, p. 192.

15. Anonymous author called "the Man in the Club Window," *The Habits of Good Society*, 1859 and 1889; from Norbert Elias, *The History of Manners, the Civilizing Process,* vol. I (New York: Urizen Books, 1978).

16. Vanderbilt, p. 252.

17. Dorothy T. Rainwater and Donna H. Felger, *A Collectors Guide to Spoons around the World* (Nashville, TN: Everybody's Press, Inc, and Thomas Nelson, Inc., 1976), p. 67.

From "Fiddle" to Fatuous: The Proliferation of Cutlery and Flatware Designs in Nineteenth-Century America
JENNIFER GOLDSBOROUGH

1. The proliferation of both flatware and cutlery forms and patterns unquestionably attained its most extreme level in late Victorian America, but Reinhard W. Sanger points out a similar phenomenon, especially in regard to patterns, in Germany due to a similar historical and social situation: "Germany did not have the traditional styles based on royal precedent found in France and England. It is perhaps for this reason that Germans were freer and more resolute in implementing innovative and highly differentiated artistic influences in their metal work, including cutlery. Furthermore, the demand for silverware in the prospering German empire was so great that in 1905 Koch & Bergheld created another fourteen additional patterns alongside of the cutlery set no. 28600." Duncker, Vena, et al., *A Personal Touch: The Seawolf Collection, Late Nineteenth- and Twentieth-century Silver* (Rotterdam: Boymans Van Beuningen Museum, 2003), p. 224.

2. It has become conventional for Americans to refer to all knives, forks, spoons, and serving utensils for the table (especially if made of silver) as flatware. In England, the conventional term for these same objects is cutlery; the word flatware in England includes flat objects of silver such as plates, platters, trays, etc. The American convention will be used throughout this essay, and the reader is asked to understand knives as included in the flatware category.

3. Charles H. Carpenter, Jr., *Gorham Silver* (San Francisco: Alan Wofsy Fine Arts, 1997, revised edition), p. 30.

4. With the development of electroplated wares, terminology became a problem that has continued until the present day. Until 1907, solid silver made in the United States was not required to be made of any particular alloy formula nor marked in any way. During the nineteenth century, American silversmiths used a variety of quality levels for their solid-silver metal, usually close to the official coin standard of ninety out of one hundred parts pure. By the end of the century, most manufacturers had shifted to the British sterling standard of ninety-two and one-half parts pure silver, and in 1907, the federal government required that all silver sold in the United States be of the sterling standard and be so marked. There were no marking requirements for electroplated wares. Not surprisingly, customers were confused, especially since well-made electroplated wares are visually indistinguishable from solid silver when they are new. As sterling became the standard for solid silver, the American industry itself began to use the word sterling as a generic term for solid silver and to rather coyly refer to electroplate simply as silver. This somewhat deceptive terminology is very apparent in manufacturers' and retailers' advertisements and publications from the end of the nineteenth century onwards. In many twentieth-century American homes, before the recent ascendancy of stainless-steel wares, the term sterling referred primarily to solid-silver flatware; hollow-wares and trays of silver were given more detailed descriptive designations within a family. At the same time, the term silverware became the generic or common name for eating utensils made of any materials besides sterling silver. For example, a child might be asked to set the table with the silverware, even when the spoons and forks were made of plastic! Many manufacturers made flatware of both sterling and electroplate, in separate but similar patterns.

5. *The Statistical History of the United States from Colonial Times to the Present* (Stamford, CT: Fairfield Publishers, 1962), p. 371.

6. Electroplated or pressed-glass "spooners," spoon racks, or various spoon holders, and large sugar bowls with brackets from which spoons could be suspended decoratively were made so that the middle class could "show off" their silver spoons as part of the centerpiece on the dining (more often, perhaps, kitchen) table.

7. Carpenter, pp. 39, 54.

8. Ibid., p. 10.

9. Ibid., p. 158.

10. Ibid., p. 70.

11. Ibid., pp. 82–83.

12. George Sweet Gibb, *The Whitesmiths of Taunton: A History of Reed & Barton 1824–1943* (Cambridge, MA: Harvard University Press, 1946), p. 132.

13. Ibid.

14. Ibid., p. 254.

15. Ibid.

16. See, for example, Tiffany's "Japanese" or "Persian"; Sheibler's "Amaryllis"; Wood & Hughes's "Japanese" or "Cashmere" in solid silver; and Reed & Barton's "Japanese," "Brilliant," or "Orient"; or Meriden Britannia Company's "Saratoga" or "Lorne" patterns in electroplate.

17. William P. Hood, Jr., *Tiffany Silver Flatware, 1845–1905: When Dining Was an Art* (Woodbridge, England: Antique Collectors' Club, 1999), p. 210.

18. Carpenter, pp. 99–100.

19. Gibb, p. 334.

20. Hood, pp. 174–185.

21. Noel D. Turner, *American Silver Flatware, 1837–1910* (NY: A. S. Barnes and Co., 1972), p. 75.

22. Gibb, p. 256.

23. Carpenter, p. 214.

24. *Explaining Sterling Art and Design: Unit II of the Course in Selling Sterling Silver* (prepared by the Business Training Corporation, New York, for The Sterling Silversmiths Guild of America, 1927). The author of this essay wishes to thank Betty Proper of Joslin Hall Rare Books for bringing this unusual publication to her attention and making it available for research.

Modern Flatware and the Design of Lifestyle

ELLEN LUPTON

1. See Heinz L. Ansbacher, "Life Style: A Historical and Systematic Review," *Journal of Individual Psychology* 23, 1967, pp. 191–212. See also Reinhard Bendix, *Max Weber: An Intellectual Portrait* (New York: Doubleday, 1962), pp. 85–86, 258–60; and Alfred Adler, *The Science of Life*, Heinz L. Ansbacher, ed. (Garden City, NY: Doubleday and Company, 1969).

2. Pierre Bourdieu, *Distinction: A Social Critique of the Judgment of Taste*, translated by Richard Nice (Cambridge, MA: Harvard University Press, 1979, 1984).

3. On the Vienna Secession and Art Nouveau, see Kirk Varnedoe, *Vienna 1900: Art, Architecture, and Design* (New York: Museum of Modern Art, 1986); Jane Kallir, *Viennese Design and the Wiener Werkstätte* (New York: Galerie St. Etienne and George Braziller, 1986); and Michael Huey, *Viennese Silver: Modern Design, 1780–1918* (Ostfildern, Germany: Hatje Cantz Publishers, 2003).

4. Peter Haiko, *Josef Maria Olbrich Architecture* (New York: Rizzoli, 1988), and Reinhard W. Sänger, *The German Silver Flatware* (Stuttgart: Arnoldsche, 1991).

5. Kathryn B. Heisinger and George Marcus, *Landmarks of Twentieth-century Design* (New York: Abbeville Press, 1993).

6. Quotation from the *Hamburger Fremdenblatt*, October 17, 1906, quoted in Waltraud Neuwirth, *Josef Hoffmann: Place Settings for the Vienna Workshop* (Vienna: Dr. Waltraud Neuwirth, 1982). Translated from German by Heinz Gerstle.

7. Edward S. Cooke, Jr., "George Washington Maher," in *"The Art That Is Life": The Arts and Crafts Movement in the United States*, edited by Wendy Kaplan (Boston: Museum of Fine Arts, 1987), p. 396–97.

8. Le Corbusier, *The Decorative Art of Today*, translated by James Dunnett (Cambridge, MA: MIT Press, 1987, first published in 1925). See also Nancy Troy, *Modernism and the Decorative Arts in France: Art Nouveau to Le Corbusier* (New Haven: Yale University Press, 1991).

9. *Danish Design*, ed. Svend Erik Møller, trans. Mogens Kay-Larsen (Copenhagen: Det Danske Selskab, 1974).

10. Karin Kirsch, *The Weissenhofsiedlung: Experimental Housing Built for the Deutscher Werkbund, Stuttgart, 1927* (New York: Rizzoli, 1989).

11. On French dining, see Catherine Arminjon, "The Art of Dining," in *L'Art de Vivre: Decorative Arts and Design in France 1789–1989* (New York: The Vendome Press and Cooper-Hewitt Museum, 1989), pp. 144–69.

12. Françoise de Bonneville, *Jean Puiforcat* (Paris: Editions du Regard, 1986).

13. Charlotte and Peter Fiell, *Scandinavian Design* (Cologne: Taschen, 2002).

14. Dorothy Draper, *Decorating is Fun! How to Be Your Own Decorator* (New York: Literary Guild, 1939), p. 4.

15. Steuben's glass-handled flatware has been variously attributed to Walter Dorwin Teague, Jr., and to Frederick Carder, whose tenures at Steuben briefly overlapped; Teague replaced Carder in 1933. See April Kingsley, "The Making of Modern Art Glass," in *Craft in the Machine Age: The History of Twentieth-Century American Craft, 1920–1945*, Rosemarie Haag Bletter and Janet Kardon, eds. (New York: Harry N. Abrams, 1995), pp. 88–90.

16. David Riesman, *The Lonely Crowd* (New Haven: Yale University Press, 1950), pp. 142, 144.

17. Russell Lynes, *The Tastemakers: The Shaping of American Popular Taste* (New York: Dover, 1980, first published in 1949).

18. Betty Friedan, *The Feminine Mystique* (New York: Dell, 1963).

19. Betty Friedan, "The Feminine Mystique, from the Woman Who Coined the Phrase," in *Modern American Women, A Documentary History*, edited by Susan Ware (Chicago: The Dorsey Press, 1989), pp. 286–97.

20. Russel and Mary Wright, *Guide to Easier Living* (New York: Simon and Schuster, 1950).

21. Donald Albrecht, Robert Schonfeld, and Lindsay Stamm Shapiro, *Russel Wright: Creating American Lifestyle* (New York: Cooper-Hewitt, National Design Museum and Harry N. Abrams, 2001).

22. Siegfried Giedion, *Mechanization Takes Command: A Contribution to an Anonymous History* (New York: W. W. Norton & Company, 1948), pp. 623–25.

23. Don Wallance, *Shaping America's Products* (New York: Reinhold, 1956), p. 122.

24. Vanni Pasca, "Italian Design: Elements of History," *1950/2000: Theater of Italian Creativity* (Milan: Cosmit, 2003), pp. 16–31.

25. Quoted in Marco Romanelli, *Gio Ponti: A World* (London: Design Museum, 2002), p. 54. See also Lisa Licitra Ponti, *Gio Ponti: The Complete Work* (Milan: Leonardo, 1990).

26. *Carlo Scarpa: The Complete Work* (Milan: Electa Editrice, 1984).

27. Russell Flinchum, *Henry Dreyfuss, Industrial Designer: The Man in the Brown Suit* (New York: Rizzoli, 1997).

28. Quoted in *Berlin 1900–1933: Architecture and Design*, ed. Tilmann Buddensieg (New York: Cooper-Hewitt Museum, 1987), p. 91. See also Wendy Kaplan, *The Arts and Crafts Movement in Europe and America: Design for the Modern World, 1880–1920* (London: Thames & Hudson, 2004), pp. 81–85; and Alan Windsor, *Peter Behrens, Architect and Designer* (New York: Whitney Library of Design, 1981).

29. Donald Albrecht and Robert Schonfeld credit Russel and Mary Wright as inventors of "lifestyle marketing," placing the table at the center this total domestic vision. Albrecht, p. 11.

30. Sharon Zukin, *Point of Purchase: How Shopping Changed American Culture* (New York and London: Routledge, 2004), p. 221.

31. Rosanne Raab is a leading scholor of contemporary metalwork. Her curatorial projects have included the exhibitions *Silver in Service* (College of New Rochelle, 1987) and *Benchmarkers: Women in Metal* (The National Ornamental Metal Museum, Memphis, Tennessee, 1998). See also "Exhibition in Print: Flatware: Function + Fantasy," forthcoming in *Metalsmith* magazine, 2005; co-curated with Boris Bally.

All objects, unless otherwise noted, are from the permanent collection of Cooper-Hewitt, National Design Museum, Smithsonian Institution.

Title page

Spoon. Nuremberg, Germany, ca. 1600–30. Coral, silver, gilding. The Robert L. Metzenberg Collection, Gift of Eleanor L. Metzenberg, 1985-103-82

Introduction

BARBARA BLOEMINK

Frontispiece: "St. Thomas" apostle spoon. Exeter, England, ca. 1661. Silver, parcel gilding. Museum purchase through gift of Joseph Holtzman and from General Acquisitions Endowment Fund, 6389.1.2005

1. "Zeug" (Tools) flatware. Designed by Michael Schneider. Manufactured by Mono-Metallwarenfabrik Seibel GmbH. Germany, designed 1994; produced ca. 1997. Stainless steel. Museum purchase from Walter R. Scholz Memorial Fund, 1998-12-1/4

2. Spoon. Norway (possibly Bergen), ca. 1700. Silver. Gift of Samuel P. Avery, 1898-6-18

3. Fork and knife. Augsburg and Meissen (near Dresden), Germany, 1737–39. Porcelain, silver, gilding, steel. Gift of Eleanor and Sarah Hewitt, 1931-41-19-a,b

4. Sugar tongs. Probably William Esterbrook. London, England, 1825. Silver, gilding. Gift of Sarah Cooper Hewitt, 1931-66-2

5. Cake tongs from an 81-piece dessert service. Made by C. V. Gibert; retailed by F. Nicoud. Paris, France, ca. 1890. Silver. Museum purchase from Smithsonian Institution Collections Acquisition Program, Decorative Arts Association Acquisition, and Sarah Cooper-Hewitt Funds, 1996-56-39-a,b

6. Forks, knives, and spoons from a flatware set. Made by Claude Lalanne (b. 1925). France, 1966. Silver. Museum purchase from Decorative Arts Association Acquisition Fund in honor of John L. Marion, 1990-137-1/9

7. Drawing: *Design for a Serving Spoon*. Italy, late 16th century. Pen and brown ink, brush and brown wash on brown laid paper. 6 5/16 x 3 1/8 in. (160 x 79 mm). Museum purchase through gift of various donors and from Eleanor G. Hewitt Fund, 1938-88-2605

Historical Overview

SARAH COFFIN

Opening spread: Fork and knife. Germany, ca. 1720–50. Steel, glass beads, thread. The Robert L. Metzenberg Collection, gift of Eleanor L. Metzenberg, 1985-103-55,56

1. Newspaper Image: "New York City. Dinner in Celebration of the 45th Anniversary of the Psi Upsilon Fraternity, in the Grand Banquet Hall of the Metropolitan Hotel, May 3d.," 1878. Cooper-Hewitt, National Design Museum, Smithsonian Institution, Kubler Collection, #5481

2. *The Feast of Belshazzar*. Frans Francken II (1581–1642). Flanders, ca. 1616. Oil on copper. Signed on the right-hand fold of the tablecloth: D.J.ffrancK.IN. Courtesy Salomon Lilian.

3. "Types of Knives" from *Opera*. Written by Bartolomeo Scappi. Venice, Italy, 1570. Engraving. Courtesy Bibliothèque Nationale de France.

4. Print: *Two Knives*. Designer: Francesco Salviati (1510–1563). Engraver: Aegidius Sadeler (1570–1629) after Cherubino Alberti (1553–1615). Italy, ca. 1640. Engraving on cream laid paper. Plate: 9 11/16 x 4 9/16 in. (246 x 116 mm). Sheet: 11 7/16 x 6 9/16 in. (290 x 166 mm). Gift of William H. Schab, 1944-84-1

5. Traveling set in case. Northern Italy, early 17th century. Mother-of-pearl, steel, leather, gilding, cotton cord. The Robert L. Metzenberg Collection, gift of Eleanor L. Metzenberg, 1985-103-253-a/g

6. Plate from *Schatzbehalter der wahren Reichtumer des Heils*. Printed by Anton Koberger (ca. 1445–1513). Germany, 1491. Courtesy The Walters Art Museum, Baltimore, 91.1085.

7. Knife. France or Italy, late 16th to mid-17th century. Steel, niello, brass, enamel, emerald, gilding. The Robert L. Metzenberg Collection, gift of Eleanor L. Metzenberg, 1985-103-44

8. Fork and knife. Germany, 17th century. Brass, horn, bone, steel. The Robert L. Metzenberg Collection, gift of Eleanor L. Metzenberg, 1985-103-10,11

9. (LEFT) Two knives. The Netherlands or Flanders, 1621–22. Silver, steel. Engraved on smaller knife handle "Elisabet * Le * Brun * Sans Dieu Rien. Anno. 1.6.2.2."; engraved on larger knife handle "Maria Brainne 1621." The Robert L. Metzenberg Collection, gift of Eleanor L. Metzenberg, 1985-103-75,76

(RIGHT) Pair of knives. The Netherlands, ca. 1618; case, 18th century. Silver, steel, gilding; silk velvet with raised metallic embroidery. Engraved on handles "Johanna Bouwens 1618." Bequest of Richard Cranch Greenleaf, in memory of his mother, Adeline Emma Greenleaf, 1962-58-11-a,b

10. Print: *Designs for Two Knife Handles*. Jan Theodor de Bry (1561–1623). The Spanish Netherlands, 16th century. Engraving on laid paper. Image: 4 3/16 x 3 1/4 in. (106 x 82 mm). Sheet: 7 1/2 x 5 in. (191 x 127 mm). Museum purchase from General Acquisitions Endowment and through gift of Mrs. Edward C. Post, 1995-47-1

11. Prints: *Design for Knife Handle*. Designer: after Heinrich Aldegrever (1502–ca. 1558). Engraver: Monogrammist S.L. Germany, mid-16th century. Niello engraving on paper. 1992-195-1: 2 13/16 x 2 3/4 in. (71 x 16 mm). 1992-195-2: 2 3/4 x 9/16 in. (70 x 15 mm). 1992-195-3: 2 13/16 x 2 3/4 in. (71 x 16 mm). 1992-195-4: 1 9/16 x 9/16 in. (39 x 15 mm). Museum purchase through gift of Adam G. Norrie in memory of Eloise Lawrence Breese, 1992-195-1/4

12. Knife. The Netherlands, ca. 1700–20. Agate, silver, steel. The Robert L. Metzenberg Collection, gift of Eleanor L. Metzenberg, 1985-103-128

13. Knife. Probably France, second half of 16th century. Steel, gilding, agate. The Robert L. Metzenberg Collection, gift of Eleanor L. Metzenberg, 1985-103-45

14. Various forks, knives, and spoon with enamel handles. The Netherlands, ca. 1660. Enamel, gilding, brass, silver, steel, colored glass. The Robert L. Metzenberg Collection, gift of Eleanor L. Metzenberg, 1985-103-64/72

15. Two knives. Southern Germany, first half of 18th century. Ivory, steel, silver, gilding. Right knife blade possibly re-cut. The Robert L. Metzenberg Collection, gift of Eleanor L. Metzenberg, 1985-103-160,161

16. (LEFT TO RIGHT) Fork and knife. France, ca. 1675. Ivory, steel, silver. The Robert L. Metzenberg Collection, gift of Eleanor L. Metzenberg, 1985-103-176-b,c

"Tipsy Tavener" fork. Alpine Region, Southern Germany or Switzerland, late 18th to mid-19th century. Ivory, later silver-plated metal tines. Gift of the Estate of David Wolfe Bishop, 1951-84-15

Fork and knife. Germany or the Netherlands (handle possibly colonial), ca. 1675–1700. Ivory, brass, steel. The Robert L. Metzenberg Collection, gift of Eleanor L. Metzenberg, 1985-103-153,154

Knife. Southern Germany, late 17th century (blade later). Ivory, stainless steel. The Robert L. Metzenberg Collection, gift of Eleanor L. Metzenberg, 1985-103-175

17. Set of six small knives, forks, and spoons. Made by Thomas Tysoe (2 spoons); some other pieces marked IH crowned (possibly Jean Harache); some apparently unmarked. England, ca. 1690. Silver, gilding, steel. Courtesy Albert Collection.

18. Traveling fork and knife with shagreen case. England, 1675–1700. Agate, silver, steel, sharkskin, wood, metal. The Robert L. Metzenberg Collection, gift of Eleanor L. Metzenberg, 1985-103-109/111

19. *Bildnis der Familie des Basler Zunftmeisters Hans Rudolf Faesch* (View of the family of the Basel guild master Hans Rudolf Faesch), H. H. Kluber. Switzerland, 1559. Oil on panel. Courtesy Historisches Museum Basel, 1997.51.

20. *Marriage at Cana*. Paolo (Caliari) Veronese (1528–1588). Venice, Italy, 1562–63. Oil on canvas. Courtesy Louvre, Paris, France, INV 142.

21. Detail of *Marriage at Cana*. Left foreground to background (includes portraits of King Francis I of France, Sultan Suleyman the Magnificent, and Emperor Charles V). Paolo (Caliari) Veronese (1528–1588). Venice, Italy, 1562–63. Oil on canvas. Courtesy Louvre, Paris, France, INV 142.

22. *Die Heilige Familie beim Mahl* (The Holy Family at Table). Attributed to Jan Mostaert (ca. 1472/73–1555/56). The Netherlands, 1495–1500. Oil on oak panel. Courtesy Wallraf Richartz Museum Cologne, WRM 471.

23. Detail of monks at table from *Scenes from the Life of Saint Benedict: the Saint obtains flour*. Giovanni Antonio Bazzi, called Il Sodoma (1477–1549). Italy, 1505–08. Fresco. Courtesy Abbey, Monte Oliveto Maggiore, Italy.

24. Set of knives. London, England, ca. 1610. Silver, gold, ivory, ebony, steel. The Robert L. Metzenberg Collection, gift of Eleanor L. Metzenberg, 1985-103-83/88

25. Drawing: *Design for a Salt Cellar and Egg Dish with Fork and Spoon*. Ottavio Strada (1550–1612) after Francesco Salviati (1510–1563). Italy, ca. 1560. Pen and brown ink, brush and brown wash over traces of charcoal or black chalk, ruled lines in leadpoint on cream laid paper. 16⅞ x 11 in. (429 x 279 mm). Museum purchase from Smithsonian Institution Collections Acquisition Program and General Acquisitions Endowment Funds, 1996-20-1

26. Fork. Probably Northern Germany, second half of 17th century. Brass, steel. The Robert L. Metzenberg Collection, gift of Eleanor L. Metzenberg, 1985-103-16

27. Fork. France, ca. 1550. Iron. The Robert L. Metzenberg Collection, gift of Eleanor L. Metzenberg, 1985-103-32

28. Traveling set in case. Probably Italy, late 17th century. Silver, steel, leather, silk. The Robert L. Metzenberg Collection, gift of Eleanor L. Metzenberg, 1985-103-254-a/h

29. Three screw-handles, spoon, knife, fork, skewer. Probably Italy, late 17th century. Silver, steel. The Robert L. Metzenberg Collection, gift of Eleanor L. Metzenberg, 1985-103-254-b/h

30. Six forks and six knives in knife box. England, ca. 1720–40. Brass, steel, sharkskin, wood, brass, silk. The Robert L. Metzenberg Collection, gift of Eleanor L. Metzenberg, 1985-103-279-a/m

31. Miniature fork and spoon set. Made by John Coney (1655/56–1722). Boston, Massachusetts, ca. 1700. Silver. Courtesy Museum of Fine Arts, Boston, Gift of Mr. and Mrs. Dudley Leavitt Pickman, 31.222-223.

32. Fork. Probably England, ca. 1700–10. Silver. Courtesy Mabel Brady Garvan Collection, Yale University Art Gallery, 1930.1397.

33. Fork and knife used by George Washington. London, England, 1755–57. Silver, steel. Courtesy National Museum of American History, Smithsonian Institution, 1199.

34. Four meat forks. One made by William Sumner I, 1799; two made by William Eley, William Fearn, and William Chawner, 1808; one made by William Chawner, 1825. London, England. Silver. Gift of Unknown Donor, n-a-3001/3004

35. Ingots to finished handmade Hanoverian pattern dessert fork. Made for James Robinson, Inc. England, 1999. Silver. Gift of James Robinson, Inc., 2005-17-2-a/f

36. Table fork. Made by John Blake. London, 1792. Silver. Courtesy Private Collection.

37. Set of table forks with Royal Bourbon arms of France and table knives in case. Forks made by Jean-Charles Cahier (knife handles unmarked). Paris, France, 1819–38. Knife blades by Gerlach, Warsaw, Poland. Silver, steel, leather, velvet, brass (case). Gift of Mr. and Mrs. Arthur Wiesenberger, 1960-189-1-a/f, -2-a/f, case unnumbered

38. Christening spoons. Alpine or Central Europe, 19th century. Painted and gilded wood. Gift of Karl J. Freund, 1913-11-1/4

39. Spoon. Germany or Holland, early 18th century. Pewter. Gift of Unknown Donor, n-a-3009

40. "Funeral" spoon. Made by Cornelius van der Burch (1653–1699). New York, New York, 1684. Silver. Courtesy Mabel Brady Garvan Collection, Yale University Art Gallery, 1936.215.

41. Sloane Christening set. Manufactured by Tiffany & Co. New York, New York, ca. 1882. Silver. Courtesy Tiffany & Co. Archives, B1999.26.01-.07.

42. Folding spoon. Germany, ca. 1700–10. Brass. The Robert L. Metzenberg Collection, gift of Eleanor L. Metzenberg, 1985-103-262

43. Folding fork, knife, and spoon. Northern Germany or Denmark, ca. 1827. Silver, steel, gilding. The Robert L. Metzenberg Collection, gift of Eleanor L. Metzenberg, 1985-103-255/257

44. Pair of teaspoons (with crest of the Verplanck family). Made by Daniel van Voorhis (1751–1824). New York, New York, ca. 1790–1800. Silver. L. 5⅜ in., 16 Grams (13.7 cm, 0.514 Troy Ounces) each. Courtesy The Metropolitan Museum of Art, Gift of Margaret Jacot Quillard and Frances Jacot Quillard, 1952 (52.100.3-4).

45. Fork and knife with case. France or Flanders, early 17th century. Ivory, steel. The Robert L. Metzenberg Collection, gift of Eleanor L. Metzenberg, 1985-103-149-a/c

46. Fork and knife with case. Balkan region, probably Greece, ca. 1700. Silver, steel, wood. The Robert L. Metzenberg Collection, gift of Eleanor L. Metzenberg, 1985-103-100-a/c

47. Fork and knife with case. The Netherlands, ca. 1730. Silver, steel, sharkskin. The Robert L. Metzenberg Collection, gift of Eleanor L. Metzenberg, 1985-103-139-a/c

48. Fork, knife, and spoon. Germany, ca. 1680–1700. Ivory, gilding, steel. The Robert L. Metzenberg Collection, gift of Eleanor L.Metzenberg, 1985-103-146/148

49. Folding fork and spoon bowl. Germany or the Netherlands, ca. 1640. Silver. The Robert L. Metzenberg Collection, gift of Eleanor L. Metzenberg, 1985-103-78-a,b

50. Folding fork, knife, and spoon. Bohemia/Germany, ca. 1720–50. Brass, steel. The Robert L. Metzenberg Collection, gift of Eleanor L. Metzenberg, 1985-103-258/260

51. Folding fork, knife, and spoon. Germany, ca. 1700. Silver, steel. The Robert L. Metzenberg Collection, gift of Eleanor L. Metzenberg, 1985-103-246/248

52. Folding fork and spoon bowl. Probably Augsburg, Germany, ca. 1690. Silver. The Robert L. Metzenberg Collection, gift of Eleanor L. Metzenberg, 1985-103-77-a,b

53. Traveling set with case including fork, spoon, knife, corkscrew, salt and pepper container, and cup. Paris, France, 1809–19. Silver, ebony, ivory, horn, steel, leather. The Robert L. Metzenberg Collection, gift of Eleanor L. Metzenberg, 1985-103-280-a/j

54. Two traveling sets (closed and open)

(LEFT) Fork, knife, and spoon with case. France, ca. 1798–1809. Ivory, silver, steel, sharkskin, copper. The Robert L. Metzenberg Collection, gift of Eleanor L. Metzenberg, 1985-103-197/200

(RIGHT) Etui: fork and knife. Probably Germany, ca. 1790. Ivory, mother-of-pearl, pewter, steel. The Robert L. Metzenberg Collection, gift of Eleanor L. Metzenberg, 1985-103-133-a,b

55. "Colorings" flatware and holders. Designed by George Schmidt (b. 1940). Produced by George Schmidt, Inc. Manufactured by IDG. U.S.A., ca. 1986. Plastic. Gift of George Schmidt, Inc., 1988-1-3-a/e,-4-a/e

56. Manuscript: *The Establishment of the Yearly Charge of our Dyett with Incidents for Housekeeping…* Author: George I, King of Great Britain (r. 1714–27). Cover (h x w): 470 x 300 mm. Courtesy Yale Center for British Art, Paul Mellon Collection, Gunnis MS 30.

57. Fork and knife. Sheffield, England, or Germany, ca. 1760. Steel. The Robert L. Metzenberg Collection, gift of Eleanor L. Metzenberg, 1985-103-17,18

58. *Two Ladies and an Officer Seated at Tea.* Attributed to Nicolaas Jansz Verkolje (1673–1746). The Netherlands, ca. 1715–20. Oil on canvas. Courtesy V&A Images/Victoria and Albert Museum, P.51-1962.

59. Page spread from *Raggvaglio della solenne comparsa fatta in Roma, gli otto di gennaio MDCLXXXVII…*, pp. 62–63. John Michael Wright (ca. 1617–ca. 1694). Published by Nella Stamperia di Domenico Antonio Ercole. Rome, Italy, 1687. Courtesy Smithsonian Institution Libraries, Washington, DC.

60. Sugar sculpture from *Raggvaglio della solenne comparsa fatta in Roma, gli otto di gennaio MDCLXXXVII…*p. 65. John Michael Wright (ca. 1617–ca. 1694). Published by Nella Stamperia di Domenico Antonio Ercole. Rome, Italy, 1687. Courtesy Smithsonian Institution Libraries, Washington, DC.

61. Plate from *Description des festes données par la ville de Paris : à l'occasion du mariage de Madame Louise-Elisabeth de France, et de dom Philippe, infant & grand amiral d'Espagne, les vingt-neuvième & trentième août mil sept cent trente-neuf.* Printed by P. G. Le Mercier; plates engraved by Jacques-François Blondel. France, 1740. Courtesy Smithsonian Institution Libraries, Washington, DC.

62. Detail of plate from *Description des festes données par la ville de Paris : à l'occasion du mariage de Madame Louise-Elisabeth de France, et de dom Philippe, infant & grand amiral d'Espagne, les vingt-neuvième & trentième août mil sept cent trente-neuf.* Printed by P. G. Le Mercier; plates engraved by Jacques-François Blondel. France, 1740. Courtesy Smithsonian Institution Libraries, Washington, DC.

63. Fork and knife. France or Germany, ca. 1680–1700. Horn, silver, steel. The Robert L. Metzenberg Collection, gift of Eleanor L. Metzenberg, 1985-103-140,141

64. Spoon. Made by 'PB.' Bergen, Norway, 1804. Silver, gilding. Gift of Richard C. Greenleaf, 1951-85-4

65. Spoon. Made by Erik Barck (1697–1718). Vasteras, Sweden, ca. 1715. Silver. Gift of Samuel P. Avery, 1903-1-36

66. (LEFT) Knife. China (handle) and France (blade), ca. 1710. Porcelain, silver, steel. The Robert L. Metzenberg Collection, gift of Eleanor L. Metzenberg, 1985-103-225

(RIGHT) Knife. China (handle) and France (blade), early 18th century. Porcelain, steel, silver, gilding. The Robert L. Metzenberg Collection, gift of Eleanor L. Metzenberg, 1985-103-216

67. Fork and knife. Meissen, Germany, ca. 1730–40. Porcelain, steel, silver. The Robert L. Metzenberg Collection, gift of Eleanor L. Metzenberg, 1985-103-189,190

68. Knife. Made by Ferner Workshop. Thuringen, Germany, ca. 1750. Porcelain, steel, gilding. The Robert L. Metzenberg Collection, gift of Eleanor L. Metzenberg, 1985-103-182

69. (LEFT) Fork and knife. Germany, ca. 1730–50. Glass beads, thread, steel. The Robert L. Metzenberg Collection, gift of Eleanor L. Metzenberg, 1985-103-53,54

(RIGHT) Fork and knife. Germany, ca. 1730–50. Glass beads, thread, steel. The Robert L. Metzenberg Collection, gift of Eleanor L. Metzenberg, 1985-103-57,58

70. Forks and knives. Probably Sheffield, England, ca. 1790. Green-stained ivory, steel, silver. Gift of Francis B. Lothrop, 1959-56-1-a,c,e,f

71. Drawing: *Design for a Centerpiece*. Designer possibly Italian. Russia, 1800–25. Pen and black ink, brush and watercolor and gouache, graphite on off-white wove paper. 4 ¾ x 12 ⅝ in. (121 x 321 mm). Museum purchase through gift of various donors, 1901-39-2156

72. *The Dinner Party*. Henry Sargent (1770–1845). U.S.A., ca. 1821. Oil on canvas. 61 ⅝ x 49 ¾ in. (1565.3 x 1263.6 mm). Courtesy Museum of Fine Arts, Boston. Gift of Mrs. Horatio Appleton Lamb in memory of Mr. and Mrs. Winthrop Sargent, 19.13

73. "Coronation" presentation spoon. Designed by Archibald Knox (1864–1933). Made by Liberty and Company. Birmingham, England, 1901. Silver, enamel. Museum purchase from Smithsonian Institution Collections Acquisition Program and Sarah Cooper-Hewitt Funds in honor of David Revere McFadden, 1996-17-1

74. Spoon. Made by "P. Ya." Vologda, Russia, 1844. Silver, niello, gilding. Museum purchase through gift of Mrs. A. Murray Young, 1958-18-1

75. Detail of back of spoon with view of a city, possibly Vologda. Vologda, Russia, 1844. Silver, niello, gilding. Museum purchase through gift of Mrs. A. Murray Young, 1958-18-1

76. Kovsh. Made by V. Sasikov. Moscow, Russia, 1861. Silver, niello, gilding. Gift from the Thomas W. Evans Collection from University of Pennsylvania School of Dental Medicine, 1983-69-19

77. "Audubon" ice spoon. Patent to Edward C. Moore as "Japanese," 1871. Manufactured by Tiffany & Co. New York, New York, ca. 1871–91. Silver, gilding. Courtesy Tiffany & Co. Archives, C1993.41.

78. Set of knives. Manufactured by Gorham Manufacturing Company. Providence, Rhode Island, ca. 1880. Silver. Museum purchase from General Acquisitions Endowment, 1996-81-2/5

79. Place setting from J. P. Morgan special commission dessert service. Designed by Edward C. Moore. Manufactured by Tiffany & Co. New York, New York, 1889. Silver, gilding. Courtesy Eric Streiner.

80. (LEFT TO RIGHT) "Pointed End" fork. Designed and manufactured by Arthur J. Stone. Made by George C. Erickson. Gardner, Massachusetts, 1918–32. Silver. Gift of Anonymous Donor, 1981-71-3

 "Pointed End" butter knife. Designed and manufactured by Arthur J. Stone. Made by Charles S. Brown. Gardner, Massachusetts, 1911–36. Silver. Gift of Anonymous Donor, 1981-71-8

 Sauce ladle. Manufactured by Old Newbury Crafters. Newburyport, Massachusetts, 1955–65. Silver. Gift of Anonymous Donor, 1981-71-12

81. Pair of chopsticks. Possibly retailed by Tiffany & Co. New York, New York, early 20th century. Silver. Courtesy Tiffany & Co. Archives, B1995.08.01.

82. "Padova" pasta server. Designed by Elsa Peretti (b. 1940), ca. 1984. Made for Tiffany & Co. Padova, Italy, ca. 2005. Silver. Courtesy of Tiffany & Co.

83. Large serving spoon. Michele Oka Doner (b. 1945). U.S.A., 1997. Silver. Courtesy of the artist.

Manufacturing and Marketing in Europe, 1600–2000

PHILIPPA GLANVILLE

Opening spread: (LEFT) Fork and knife. Augsburg and Meissen (near Dresden), Germany, 1737–39. Porcelain, silver, gilding, steel. Gift of Eleanor and Sarah Hewitt, 1931-41-19-a,b

(RIGHT) Fork and knife. The Netherlands or Germany, early 18th century. Steel, brass. The Robert L. Metzenberg Collection, gift of Eleanor L. Metzenberg, 1985-103-79,80

1. (LEFT) Wedding knife. England, early 17th century. Ivory, silver, iron, steel. The Robert L. Metzenberg Collection, gift of Eleanor L. Metzenberg, 1985-103-89

 (RIGHT) Knife. France or Italy, early to mid 16th century. Brass, steel. The Robert L. Metzenberg Collection, gift of Eleanor L. Metzenberg, 1985-103-27

2. Set of forks and knives. Made by William Boswell. London, England, late 17th century. Agate, silver, steel. Gift of Francis B. Lothrop, Mrs. George Batchelder, and Jordan Abbott, 1957-29-3-a/f,-4-a/e

3. Detail of cutler's mark on knife in fig. 2. Made by William Boswell. London, England, late 17th century. Agate, silver, steel. Gift of Francis B. Lothrop, Mrs. George Batchelder, and Jordan Abbott, 1957-29-3-c

4. Plate from *L'art de donner à dîner, de découper les viandes, de servir les mets, de déguster les vins, de choisir les liqueurs, etc.* (The Art of Giving a Dinner...). Emile Marco de Saint-Hilaire (d. 1887). Published by Urbain Canel, libraire. Paris, France, 1828. Courtesy Smithsonian Institution Libraries, Washington, DC.

5. Folding spoon and case. Germany, ca. 1710. Horn, silver, leather, paper. Gift of Samuel P. Avery, 1903-1-39-a/c

6. Traveling set with knife, fork, toothpick, and case. Tyrol, Austria, 19th century. Ibex horn, horn, steel, leather, paper. The Robert L. Metzenberg Collection, gift of Eleanor L. Metzenberg, 1985-103-276-a/d

7. Spoon, bowl, and square plate used on the HMS *Invincible*. England, mid-18th century. Wood. Courtesy The Historic Dockyard, Chatham, The Invincible Collection.

8. Spoon. Made by Hans Henrikson Wettersten (active 1682–1726). Vadstena, Sweden, ca. 1700. Silver. Gift of Samuel P. Avery, 1903-1-35

9. Fork and knife. England, ca. 1660–90. Ivory, silver, iron, enamel, steel. The Robert L. Metzenberg Collection, gift of Eleanor L. Metzenberg, 1985-103-92,93

10. Knife box containing dinner and dessert knives and forks. London, ca. 1775. Mahogany veneer with silver mounts, silver flatware (Mark of William Abdy), steel blades (Marked 'LOOKER' possibly for William Henry Locker, London). Courtesy V&A Images/Victoria and Albert Museum, W. 65-1950.

11. Folding pocket knife. France or England, ca. 1695–1700. Ivory, silver, steel, brass, enamel. The Robert L. Metzenberg Collection, gift of Eleanor L. Metzenberg, 1985-103-169

12. Spoon with *lion sejant* handle and detail (above). Made by AB. Provincial England, ca. 1630–35. Silver, parcel gilt. L. 6 ⅞ in. (175 mm). Courtesy The Metropolitan Museum of Art, Bequest of Mary Strong Shattuck, 1935 (35.80.92)

13. Engraving: *The Fair at Guibray in Normandy near the village of Fallaize.* Engraved by A. Maillard (after drawing by F. Chauvel, engraved by Cochin, and published by C. Jollain, Paris, 1658). Published by Mancel. Caen, France, 1841. Courtesy Cliché Bibliothèque de Caen, FN E 503.

14. Tablespoon. England, ca. 1680–90. Silver. Gift of Dr. Richard Grant, 1989-58-1

15. Ladle. Sheffield, England, ca. 1770–80. Silver-plated copper. Bequest of Walter Phelps Warren, 1986-61-4

16. Dessert service. Made by William Eley, William Chawner, and William Fearn. London, England, 1808. Silver, gilding. Courtesy Partridge Fine Arts PLC.

17. Fork, knife, and spoon in case. Made by Joseph Willmore. Birmingham, England, 1829–30. Ivory, silver, leather, velvet. Gift of Mr. and Mrs. Richard Morrill, 1990-21-1/4

18. Creamware gravy or sauce ladle. England, ca. 1760–70. Glazed earthenware. Gift of Unknown Donor, n-a-256

19. Plate I, "Coutelier" (Cutler), from *Encyclopédie, ou, Dictionnaire raisonné des sciences, des arts et des métiers. Recueil de planches, sur les sciences, les arts libéraux, et les arts méchaniques : avec leur explication,* vol. III. Written by Denis Diderot (1713–1784). Published by Chez Briasson... David...Le Breton...Durand... Paris, France, 1751–65. Courtesy Smithsonian Institution Libraries, Washington, DC.

20. Matthew Boulton Pattern Book, MS 3782/21/2 previous ref., vol. 169 (part 2), p. 121, 1780s. Courtesy Birmingham City Archives, Birmingham Central Library, United Kingdom.

21. Trade card for the London Silver Plate Manufactory. England, 1788. Engraving. Courtesy Guildhall Library, Corporation of London, United Kingdom/Bridgeman Art Library.

22. "The Steel Manufacturers of Sheffield: The 'Hull' or Workshop, of the Razor-Grinder. With the Use of a Fan," *Illustrated London News,* January 20, 1866, pg. 56. Courtesy General Research Division, The New York Public Library, Astor, Lenox and Tilden Foundation.

23. Fork and knife. England, early 19th century. Silver, steel. Gift of Mr. and Mrs. Richard Morrill, 1992-41-5,6

24. Detail of blade mark from knife in fig. 23. England, early 19th century. Silver, steel. Blade stamped 'THORNHILL / (N)EW BOND ST' and 'LONDON MADE' (in semi-circle). Gift of Mr. and Mrs. Richard Morrill, 1992-41-5

25. Engraving: the Christofle silver-plating workshop, in *Les grandes usines de France* (The Great Factories of France). Engraved by H. Linton. Written by Turgan. Published by A. Bourdilliat. Paris, 1860. Courtesy Musée et Archives Christofle.

26. "Butter knives," from Elkington Drawing Book no. 1, folios 71–72. England, 1840–73. Courtesy V&A Images/Victoria and Albert Museum, AAD/1979/3.

27. "Sundries," including sardine tongs and lobster crackers, from Elkington Drawing Book no. 4, folios 75–76. England, ca. 1870. Courtesy V&A Images/Victoria and Albert Museum, AAD/1979/3.

28. Twenty-six fruit and dessert knives and six dessert servers, including a cherry spear, cake server, and ice cream server, in tray. Manufactured and retailed by F. Nicoud. Paris, France, ca. 1890. Silvered and gilt metal, mother-of-pearl, sueded fabric on wood core. Museum purchase from Smithsonian Institution Collections Acquisition Program, Decorative Arts Association Acquisition, and Sarah Cooper-Hewitt Funds, 1996-56-52/82-b

29. Canteen Case made for Millenium Canteen commission project. Made by Andrew Skelton. England, 1997. Oak and sycamore woods, stainless steel, fishing line. Courtesy Sheffield Hallam University and Sheffield Galleries & Museums Trust.

30. Salad knife and fork made for Millenium Canteen commission project. Made by Chris Knight. England, 1997. Silver, stainless steel. Courtesy Sheffield Hallam University and Sheffield Galleries & Museums Trust.

The Sexual Politics of Cutlery
CAROLIN C. YOUNG

Opening spread: Fork and spoon. Nuremberg, Germany, ca. 1600–30. Coral, silver, gilding. The Robert L. Metzenberg Collection, Gift of Eleanor L. Metzenberg, 1985-103-81,82

1. Fork and knife with case. France, ca. 1675. Ivory, steel, silver, sharkskin. The Robert L. Metzenberg Collection, gift of Eleanor L. Metzenberg, 1985-103-176-a/c

2. Spoon. Probably the Netherlands, ca. 1740–60. Silver. Engraved with armorials, supporters, and the name "Willoughby de Eresby 1779." Gift of Samuel P. Avery, 1903-1-33

3. Spoon. Italy, ca. 1600. Bronze. The Robert L. Metzenberg Collection, gift of Eleanor L. Metzenberg, 1985-103-28

4. Set of 12 "Apostle" spoons and "Master" spoon. 11 "Apostle" spoons and "Master" made by William Cawdell (1560–1625), 1592. "St. Andrew" spoon made by Martin Hewitt, 1613. London, England. Silver, parcel gilt (Master). Each approx. L. 7⅛ in. (181 mm). Courtesy The Metropolitan Museum of Art, Gift of Mr. & Mrs. James B. Mabon, 1967 (67.166.1-13).

5. "Brooklyn Bridge" souvenir spoon. Manufactured by Tiffany & Co. New York, New York, ca. 1883. Silver. Courtesy Tiffany & Co. Archives, C1994.09.

6. "Empire State Building" souvenir spoon. Manufactured by Tiffany & Co. New York, New York, ca. 1931. Silver. Courtesy Tiffany & Co. Archives, C1994.08.

7. The Coronation Spoon. England, second half of 12th century. Silver, gilding, pearls. 26.7 cm. (RCIN 31733). Courtesy Crown ©/The Royal Collection © 2005, Her Majesty Queen Elizabeth II.

8. Knife. Probably Italian, 17th century. Brass, steel. The Robert L. Metzenberg Collection, gift of Eleanor L. Metzenberg, 1985-103-13

9. Pair of knives with case. The Netherlands, ca. 1618; case, 18th century. Silver, gilding, steel, silk velvet with raised metallic embroidery. Engraved on handles "Johanna Bouwens 1618." Bequest of Richard Cranch Greenleaf, in memory of his mother, Adeline Emma Greenleaf, 1962-58-11-a/c

10. Fork. Baltic Region, possibly Danzig, ca. 1650. Amber, bone amber, steel. The Robert L. Metzenberg Collection, gift of Eleanor L. Metzenberg, 1985-103-123

11. Detail from Glossaria. Rabanus Maurus. Germany, 1023. Courtesy Montecassino, Archivio dell'Abbazia, cod. 132.

12. Fork. Italy or France, ca. 1550. Bronze, gilding, steel. The Robert L. Metzenberg Collection, gift of Eleanor L. Metzenberg, 1985-103-20

Implements of Eating
DARRA GOLDSTEIN

Opening spread: Traveling fork and knife in case. Amsterdam, the Netherlands, ca. 1700. Bone, silver, steel, sharkskin. The Robert L. Metzenberg Collection, gift of Eleanor L. Metzenberg, 1985-103-137-a/c

1. "Cochleare" spoon. Romano-British, ca. AD 300. Bronze. Courtesy Sheffield Galleries & Museums Trust.

2. Plate XCIV from Liber chronicarum, Registrum huius operis libri cronicarum cu[m] figuris et ymagi[ni]bus ab inicio mu[n]di. Written by Hartmann Schedel (1440–1514). Printed by Anton Koberger (ca. 1445–1513). Nuremberg, Germany, 1493. Courtesy Smithsonian Institution Libraries, Washington, DC.

3. Fork from a traveling set. Hungary, ca. 1690. Mother-of-pearl, horn, steel. The Robert L. Metzenberg Collection, gift of Eleanor L. Metzenberg, 1985-103-99

4. The Wedding Feast. Sandro Botticelli (1444/45–1510). Florence, Italy, 1483. Oil on canvas. Courtesy Private Collection/Bridgeman Art Library.

5. Pair of sucket forks. Made by William Rouse (1639–1704/05). Boston, Massachusetts, 1677. Silver. Courtesy Museum of Fine Arts, Boston, Gift of John and Mary Coolidge, 1996.122.1-2.

6. Sucket fork. Austria or France, ca. 1840–45. Silver, wood. The Robert L. Metzenberg Collection, gift of Eleanor L. Metzenberg, 1985-103-33

7. Detail from plate, "A Prospect of the Inside of Westminster Hall...," from The History of the Coronation of...James II...King of England, Scotland, France and Ireland, and of Queen Mary...in...Westminster...the 23 of April 1685...Francis Sandford (1630–1694). Printed by T. Newcomb. London, England, 1687. Courtesy Avery Architectural and Fine Arts Library, Columbia University.

8. Fork and knife. The Netherlands, ca. 1660. Enamel, silver, steel. The Robert L. Metzenberg Collection, gift of Eleanor L. Metzenberg, 1985-103-64/67

9. Fork and knife. England, ca. 1690. Brass, steel. The Robert L. Metzenberg Collection, gift of Eleanor L. Metzenberg, 1985-103-104,105

10. Fork and knife. Europe, ca. 1700. Silver, steel. The Robert L. Metzenberg Collection, gift of Eleanor L. Metzenberg, 1985-103-2,3

11. Folding fork and spoon. The Netherlands, possibly Zeeland, early 17th century, with later inscription "R Brijsma Anno 1753." Silver. The Robert L. Metzenberg Collection, gift of Eleanor L. Metzenberg, 1985-103-102-a,b

12. The Soup Eater. Peter Jakob Horemans (1700–1776). Flanders, 1764. Oil on canvas. Courtesy Bayerische Staatsgemälde-sammlungen.

13. Detail of Manners at Table, 1800, vol. 1, p. 131. Lewis Miller (1796–1882). U.S.A., 1865. Watercolor. Courtesy the York County Heritage Trust, York, PA.

(Unnumbered) Grape scissors. Made by C. V. Gibert; retailed by F. Nicoud. Paris, France, ca. 1890. Silver. Museum purchase from Smithsonian Institution Collections Acquisition Program, Decorative Arts Association Acquisition, and Sarah Cooper-Hewitt Funds, 1996-56-38

14. Knife with dragon on handle. Made by C. V. Gibert; retailed by F. Nicoud. Paris, France, ca. 1890. Silver. Museum purchase from Smithsonian Institution Collections Acquisition Program, Decorative Arts Association Acquisition, and Sarah Cooper-Hewitt Funds, 1996-56-48

15–18. (CLOCKWISE FROM TOP LEFT) Bon bon spade, cherry spear, ice-cream knife, and cake tongs. Retailed by F. Nicoud; silver servers made by C. V. Gibert. Paris, France, ca. 1890. Silvered and gilt metal, mother-of-pearl, silver. Museum purchase from Smithsonian Institution Collections Acquisition Program, Decorative Arts Association Acquisition, and Sarah Cooper-Hewitt Funds, 1996-56-39a,b,-49,-78,-80

(Unnumbered) Detail of bon bon spade. Made by C. V. Gibert; retailed by F. Nicoud. Paris, France, ca. 1890. Silver. Museum purchase from Smithsonian Institution Collections Acquisition Program, Decorative Arts Association Acquisition, and Sarah Cooper-Hewitt Funds, 1996-56-49

(TOP) Sugar sifter and (BOTTOM) berry spoon. Made by C. V. Gibert; retailed by F. Nicoud. Paris, France, ca. 1890. Silver. Museum purchase from Smithsonian Institution Collections Acquisition Program, Decorative Arts Association Acquisition, and Sarah Cooper-Hewitt Funds, 1996-56-41,42

Group of teaspoons. Made by C. V. Gibert; retailed by F. Nicoud. Paris, France, ca. 1890. Silver. Museum purchase from Smithsonian Institution Collections Acquisition Program, Decorative Arts Association Acquisition, and Sarah Cooper-Hewitt Funds, 1996-56-25/27,-29,-31/36

19. Tea scoop. Made by Samuel Pemberton. Birmingham, England, 1809. Silver, mother-of-pearl. Bequest of Mrs. John Innes Kane, 1926-37-147.

20. Tea scoop. The Netherlands, 1833. Silver. Gift of Eleanor and Sarah Hewitt, 1931-64-36

21. Sugar spoon. Designed by Josef Hoffmann (1870–1956). Produced by Alexander Sturm & Company. Vienna, Austria, ca. 1902. Silver, turquoise. Courtesy Private Collection.

22. "Assyrian Head" sugar tongs. Manufactured by the Meriden Britannia Company. Meriden, Connecticut, 1885–86. Silver-plated metal. Museum purchase from the Decorative Arts Association Acquisition Fund, 1996-79-6

23. (LEFT) Punch ladle. London, 1731, with later engraving on reverse "D / RE / 1785." Silver, wood. Gift of Dr. Charles W. Lester in memory of his wife, Marianne Stebbins Lester, 1971-74-1

(CENTER) Punch ladle. Made by "SA," probably for Stephen Adams II. London, 1808. Silver, horn. Gift of Sarah Cooper Hewitt, 1931-61-24

(RIGHT) Punch ladle. France or the Netherlands, ca. 1830. Silver, wood. Gift of Sarah Cooper Hewitt, 1931-66-4

24. "Wave Edge" asparagus tongs. Patent to Charles Grosjean, 1884. Manufactured by Tiffany & Co. New York, New York, ca. 1891–1902. Silver. Courtesy Tiffany & Co. Archives, C1993.30.

25. "English King" asparagus server. Patent to Charles Grosjean, 1885. Manufactured by Tiffany & Co. New York, New York, ca. 1885–91. Silver. Courtesy Tiffany & Co. Archives, C1993.35.

26. *Still Life with Asparagus,* after 1880. Philippe Rousseau (French, 1816–1887). Oil on fabric. Courtesy The Cleveland Museum of Art, Bequest of Noah L. Butkin, 1980.284.

27. Frontispiece from *The Book of Household Management.* Written by Isabella Beeton. Published by Ward, Lock, & Co. New York and London, 1888. Courtesy the Fales Library & Special Collections, New York University Libraries.

28. "Assyrian Head" servers including (clockwise) fish knife, sugar tongs, punch ladle, berry spoon, tablespoon, cheese scoop, serving spade, cake knife, fish fork. Manufactured by the Meriden Britannia Company. Meriden, Connecticut, 1885–86. Silver-plated metal. Museum purchase from the Decorative Arts Association Acquisition Fund, 1995-148-7/9; 1996-79-1/6

29. "Rosette" fried chicken tongs. Pattern introduced 1868. Manufactured by Gorham Manufacturing Company. Providence, Rhode Island, early 20th century. Silver. From the Collection of Ms. Andrea J. Albert.

30. "Chrysanthemum" Saratoga chip server. Patent to Charles Grosjean, 1880. Manufactured by Tiffany & Co. New York, New York, ca. 1910. Silver. Courtesy John and Maggie Olson.

31. Lobster fork. Made by John Polhamus; retailed by Tiffany & Co. New York, New York, ca. 1855. Silver. Courtesy Tiffany & Co. Archives, C1993.69.01.

32. "Tafelservice und Hummerschalen" depicting seafood service of lobster-claw implements, tureen, and condiment and toothpick holders. Germany, 1883. Engraving. Cooper-Hewitt, National Design Museum, Smithsonian Institution, Kubler Collection, #629

33. "Catlin" pattern serving spoon. Patent to Charles Grosjean. Manufactured by Tiffany & Co. New York, New York, ca. 1884–91. Silver. Courtesy Tiffany & Co. Archives, C2002.01.

34. "Wave Edge" ice cream server. Patent to Charles Grosjean, 1884. Manufactured by Tiffany & Co. New York, New York, ca. 1884–91. Silver. Courtesy Tiffany & Co. Archives, C1993.25.

35. (LEFT) Ice-cream saw. Manufactured by Dominick and Haff. New York, New York, ca. 1880. Silver, gilding. Courtesy Karen Zukowski and David Diamond.

(RIGHT) Ice-cream hatchet. Manufactured by Gorham Manufacturing Company. Providence, Rhode Island, ca. 1870–80. Silver. Courtesy Karen Zukowski and David Diamond.

36. Detail of "Venetian macaroni spoon" from *Reed & Barton, artistic workers in silver & gold plate,* p. 315. Published by Reed & Barton. Taunton, Massachusetts, 1884. Courtesy Smithsonian Institution Libraries, Washington, DC.

37. Macaroni server. U.S.A., ca. 1865. Silver, gilding. Museum purchase from Decorative Arts Association Acquisition and Dona Guimaraes Funds, 1995-147-1

38. Tiffany & Co. design drawing for strawberry fork, model #1093. New York, New York, no date. Courtesy Tiffany & Co. Archives, OL2006.04.

39. Sardine fork. Manufactured by George W. Shiebler & Co. New York, New York, ca. 1885. Silver, gilding. Courtesy Karen Zukowski and David Diamond.

40. "Vine" oyster fork. Design attributed to Edward C. Moore, ca. 1872. Manufactured by Tiffany & Co. New York, New York, ca. 1872–91. Silver, gilding. Courtesy Tiffany & Co. Archives, C1993.83.

41. *Oysters.* Edouard Manet (1832–1883). France, 1862. Oil on canvas. Courtesy National Gallery of Art, Washington, Gift of the Adele R. Levy Fund, Inc., 1962.3.1.(1657)/PA.

42. "Olive Spoons and Forks," from *Spoons, forks, knives, etc. made by the Meriden Britannia Co....,* catalogue no. 43, p. 41. Published by Meriden Britannia Company. Meriden, Connecticut, ca. 1890. Courtesy Smithsonian Institution Libraries, Washington, DC.

43. Olive fork/spoon. Manufactured by Tiffany & Co. New York, New York, ca. 1880–91. Silver. Courtesy Tiffany & Co. Archives, C1993.125.

44. Drawing: *Designs for Cutlery.* Pietro Belli (1780–1828). Italy, 1815–30. Pen and brush and brown ink, graphite on light blue paper. 16 15/16 x 12 3/16 in. (430 x 309 mm). Museum purchase through gift of various donors and from Eleanor G. Hewitt Fund, 1938-88-5783

45. Fish servers. England or U.S.A., ca. 1880. Silver-plated metal, ivorine. Museum Purchase from Sarah Cooper-Hewitt Fund, 1996-80-1,2

46. Fish slice. Germany or U.S.A., ca. 1940. Bakelite, chromed metal. Gift of Robert Lerch, 2004-28-1

47. Skewers. France and Italy, mid- to late 19th century. Silver. Gift of Mrs. Abram S. Hewitt, 1931-44-34-b/37-a,-38/40,-42,-43

48. Plate 5, "Hâtelets pour ornement de mets chauds et froids" (Skewers to decorate hot and cold foods), from *Artistic Cookery*, opposite p. 8. Urbain Dubois. Published by Longmans, Green & Co. London, England, 1870. Courtesy Science, Industry & Business Library, The New York Public Library, Astor, Lenox and Tilden Foundations.

49. "Community Plate: Adam Design," from *Illustrated catalogue and price list, 1918, A.C. Becken Company, wholesale jewelers*. Published by A. C. Becken Company. Chicago, Illinois, 1918. Courtesy Smithsonian Institution Libraries, Washington, DC.

50. "Nuovo Milano" ice cream spoon. Designed by Ettore Sottsass (b. 1917) in consultation with Alberto Gozzi. Manufactured by Alessi. Italy, designed 1987. Stainless steel. Courtesy Alessi spa.

51. Spaghetti twirling fork. Made by Kristen Alexandra Milano (b. 1971). U.S.A., 1999. Silver. Courtesy of the artist.

52. "Moscardino" disposable sporks. Designed by Giulio Iacchetti (b. 1966) and Matteo Ragni (b. 1972). Produced by Pandora Design. Milan, Italy, 2000. Mater-Bi™ (biodegradable starch-based polymer). Courtesy S. Jordan Kim.

53. "Edo" chopstick or fork, knife, and spoons. Designed by Bibs Hosak-Robb (b. 1955). Manufactured by Robbe & Berking. Germany, 1985. Silver-plated metal. Gift of Robbe and Berking Silber, 1991-65-1/4.

54. "Eat Alien" tools. Designed by Titti Cusartelli (b. 1965). From *Cutlery*. Published by Giorgetti. Italy, 1997.

The Design of Table Tools and the Effect of Form on Etiquette and Table Setting

SUZANNE VON DRACHENFELS

Opening spread: Five-piece place setting designed for the Wertheim Department Store Dining Room display. Designed by Peter Behrens (1868–1940). Manufactured by Martin Josef Rückert. Berlin, Germany, 1902. Silver, silver-gilt. Museum purchase from Paula Cooper Noyes and Decorative Arts Association Acquisitions Funds, 1996-106-1/3,-5,-6

1. Fork and knife. England, ca. 1720–40. Brass, steel. The Robert L. Metzenberg Collection, gift of Eleanor L. Metzenberg, 1985-103-279-d,h

2. (LEFT) Fruit knife. France, late 19th century. Mother-of-pearl, silver. Gift of Mr. and Mrs. John M. Thompson in memory of Mr. and Mrs. G. Auclair, 1990-67-2

 (RIGHT) Dessert knife. Paris, France, 1819–38. Mother-of-pearl, silver. Gift of Mr. and Mrs. John M. Thompson in memory of Mr. and Mrs. G. Auclair, 1990-67-1

3. Knife grasp appropriate for cutting from seventeenth century to present. Drawing by Tsang Seymour Design, Inc.

4. Table fork and knife. Made by Bow Factory. England, ca. 1750. Porcelain, silver, steel. The Robert L. Metzenberg Collection, gift of Eleanor L. Metzenberg, 1985-103-205, 207

5. Standard grip for fish knife to enable boning and skinning without tearing the flesh. Drawing by Tsang Seymour Design, Inc.

6. This spoon grip, which came about in the second half of the eighteenth century, was encouraged by the arched form of the handle's stem. It is still in use today. Drawing by Tsang Seymour Design, Inc.

7. Table fork and knife. St. Cloud, France, ca. 1740. Porcelain, steel, silver. The Robert L. Metzenberg Collection, gift of Eleanor L. Metzenberg, 1985-103-226, 227

 Plate and mustard pot with spoon. Chantilly, France, ca. 1750. Porcelain. Plate: Museum purchase through gift of Georgiana L. McClellan, 1957-15-1; mustard pot: Gift of Mrs. John Jay Ide in memory of John Jay Ide, 1977-52-17-a/c

 Wine glass. Swiss, late 18th century. Glass. Gift of the C. Helme and Alice B. Strater Collection, 1976-1-55

8. Spoon. Prussia, ca. 1722. Silver. Engraved on handle "A.M.S. G.S. / .1.7.2.2." Gift of Eleanor and Sarah Hewitt, 1931-64-34

9. Fork and knife. England, late 18th to early 19th century. Silver, steel. Gift of Mr. and Mrs. Richard Morrill, 1992-41-5,6

 Plate. Chelsea, England, ca. 1753–56. Porcelain. Gift of Irwin Untermyer, 1957-11-6

 Creamware salt cellar. England, ca. 1760. Glazed earthenware. Gift of Mrs. William Meeker Wood, 1910-29-1

 Drinking glass. England or Ireland, late 18th century. Glass. Gift of Mr. and Mrs. Thomas L. Wolf, 1979-62-1

10. The late 18th-century fork conformed to the hand, with a broad terminal for the thumb to encourage the correct holding position, then as now. Drawing by Tsang Seymour Design, Inc.

From "Fiddle" to Fatuous: The Proliferation of Cutlery and Flatware Designs in Nineteenth-century America

JENNIFER F. GOLDSBOROUGH

Opening spread: Dinner fork, soup spoon, dessert knife, butter knife. Designed by Frederick Carder (1863–1963) under the direction of Walter Dorwin Teague (1883–1960). Manufactured by Steuben. U.S.A., ca. 1934. Glass, silver-plated metal. Museum purchase from General Acquisitions Endowment, 2005-5-1/4

1. "Persian" melon knife. Patent to Edward C. Moore, 1872. Manufactured by Tiffany & Co. New York, New York, ca. 1872–91. Silver. Courtesy Tiffany & Co. Archives, C1993.62.

2. Scallop fork. Manufactured by Tiffany & Co. New York, New York, ca. 1885. Silver, gilding. Courtesy Tiffany & Co. Archives, C1993.127.

3. "Chrysanthemum" flatware and servers. Manufactured by Tiffany & Co. New York, New York, 1880–91. Silver. Gift of Susan Dwight Bliss, 1957-61-42,44-a,46-a,49-a,54,55,56,58-a

4. Spoon. Made by Frederick J. Posey. Hagerstown, Maryland, 1820–42. Silver. Gift of Thomas S. Tibbs, 1959-181-1

5. "Assyrian Head" ladle. Manufactured by Meriden Britannia Company. Meriden, Connecticut, 1885–86. Silver-plated metal. Museum purchase from the Decorative Arts Association Acquisition Fund, 1995-148-7

6. "Wave Edge" griddle cake server. Patent to Charles Grosjean, 1884. Manufactured by Tiffany & Co. New York, New York, ca. 1884–91. Silver. Courtesy Tiffany & Co. Archives, C1993.20.

7. "Vine" pea server. Design attributed to Edward C. Moore, ca. 1872. Manufactured by Tiffany & Co. New York, New York, ca. 1872–91. Silver. Courtesy Tiffany & Co. Archives, C1993.84.

8. Patent application for Tiffany & Co.'s "Wave Edge" spoon or fork handle (LEFT) and design drawing for "Wave Edge" spoon handle (RIGHT). Submitted by Charles Grosjean. New York, New York, July 15, 1884. Courtesy Tiffany & Co. Archives.

9. "Lap Over Edge" berry scoop. Patent to Charles Grosjean, 1880. Manufactured by Tiffany & Co. New York, New York, ca. 1891–1902. Silver, gold. Courtesy Tiffany & Co. Archives, C1993.112.

10. "Audubon" place setting. Original patent to Edward C. Moore as "Japanese," 1871. Manufactured by Tiffany & Co. Rhode Island, 2001. Silver. Courtesy Tiffany & Co. Archives, C2001.02.01-.05.

11. "Bird's Nest" ice spoon. Manufactured by Gorham Manufacturing Company. Providence, Rhode Island, ca. 1870. Silver, parcel gilding. Courtesy John and Maggie Olson.

12. "Olympian" crumber. Manufactured by Tiffany & Co. New York, New York, 1878. Silver. Courtesy Tiffany & Co. Archives, C1993.40.

13. "Persian" ice-cream knife. Designed by Edward C. Moore, 1872. Manufactured by Tiffany & Co. New York, New York, 1872–1904. Silver, parcel gilding. Gift of Anonymous Donor, 1957-100-13

14. Serving spoon custom-designed for William K. Vanderbilt. Patent to Charles Grosjean, ca. 1885. Manufactured by Tiffany & Co. New York, New York, 1885. Silver. Courtesy Tiffany & Co. Archives, C1994.21.

15. Cherry forks. Manufactured by Tiffany & Co. New York, New York, ca. 1908. Silver. Courtesy Tiffany & Co. Archives, C1993.181.01

16. "Daisy" soup ladle with turtles. Manufactured by Tiffany & Co. New York, New York, ca. 1870–80. Silver. Courtesy Tiffany & Co. Archives, C1993.121.

17. "Squirrel" child's set. Manufactured by Tiffany & Co. New York, New York, ca. 1915. Silver. Courtesy Tiffany & Co. Archives, C1994.02.02,.03,.05,.07.

18. (LEFT) "Medallion" sifting spoon. Design patented 1862. Manufactured by Ball, Black & Co. New York, New York, ca. 1865. Silver. Museum purchase from the Decorative Arts Association Acquisitions Fund, 1995-148-2

(RIGHT) "Medallion" serving spoon. Made by William Gale, Jr. New York, New York, ca. 1866. Silver, gilding. Museum purchase through gift of Katharine Cornell, 1998-61-1

19. Ad for "1847 Rogers Bros.," *The Modern Priscilla*, p. 23. Meriden Britannia Company, division of International Silver Company, Meriden, Connecticut. Published by The Priscilla Publishing Co. Boston, Massachusetts, November 1909. Courtesy Smithsonian Institution Libraries, Washington, DC.

Modern Flatware and the Design of Lifestyle

ELLEN LUPTON

Opening spread: Spoons with handles cast from bayberry, mulberry, and lilac twigs. Made by Ted Muehling (b. 1953). U.S.A., ca. 2005. Silver. Courtesy Ted Muehling.

1. "A Light's Drawing" cup, dishes, placemat, and napkin. Designed by Sandra Bautista (b. 1978). Produced by BOSA. Italy, 2005. Stoneware, textile (cotton, linen). Courtesy Sandra Bautista.

2. Dinner fork, knife, spoon. Designed by Joseph Maria Olbrich (1867–1908). Manufactured by Christofle. Designed in Darmstadt, Germany; made in Paris, France, 1901. Silver-plated metal, steel. Museum purchase through gift of Christie's in honor of Joseph Holtzman, 2001-12-1/3

3. "Flaches Modell" (Flat Model) dessert fork, knife. Designed by Josef Hoffmann (1870–1956). Produced by Wiener Werkstätte. Austria, 1903. Silver. Museum purchase from Friends of Applied Arts and Industrial Design, General Acquisitions Endowment, and Morrill Acquisitions Funds, 2002-3-1,2

4. Chair for the dining room of the Purkersdorf Sanatorium. Designed by Josef Hoffmann (1870–1956). Manufactured by Thonet Brothers. Austria, 1904–06. Beechwood, leather, metal. Museum purchase from Combined Funds and through gift of Crane and Co., 1968-6-1

5. Twelve-piece place setting from the Rockledge silver service. Designed by George Washington Maher (1864–1926) for Ernest and Grace King. Manufactured by Gorham Manufacturing Company. Providence, Rhode Island, 1911–12. Silver, gilding. Museum purchase from Smithsonian Institution Collections Acquisition Program and Decorative Arts Association Acquisition Funds, 1995-49-1/12

6. Dinner fork and knife. Designed by Fritz August Breuhaus de Groot (1883–1960). Manufactured by Henckels. Germany, 1931. Silver-plated metal, stainless steel. Gift of Broehan Art Inc., 2001-19-2,3

7. Poster: *Couverts Deetjen*. Jean Adrien Mercier (1899–1995). France, 1930. Lithograph on paper, backed on linen. 62¾ x 46¾ in. (1594 x 1188 mm). Museum Purchase from Smithsonian Institution Collections Acquisition Program and through the gift of Lucy Work Hewitt, 1996-8-1

8. "Grand Prix" flatware service. Designed by Kay Bojesen (1886–1958). Manufactured by Rosendahl. Denmark, designed 1932, produced 1980. Stainless steel. Gift of Peter Condu, 1992-25-4-a/e,-g/p,-s/z

9. Illustration: Fork, knife, spoon produced by Puiforcat, from *Jean Puiforcat, orfèvre sculpteur*. Published by Flammarion. Paris, France, 1951. Courtesy Smithsonian Institution Libraries, Washington, DC.

10. Drawing: *Design for a Punch Ladle*. Jean Elysée Puiforcat (1897–1945). Mexico, 1943. Pen and black ink, graphite on cream tracing paper. 15 15/16 X 14½ in. (405 x 368 mm). Gift of John Finguerra in memory of his brother Jim Finguerra, 1995-164-10

11. Drawing: *Design for a Coffeepot, Sugar Bowl, and Creamer*. Jean Elysée Puiforcat (1897–1945). Mexico, 1942. Pen and black ink, brown ink, brown pastel (on verso), graphite on cream tracing paper. 11⅛ x 18 3/16 in. (282 x 462 mm). Gift of John Finguerra in memory of his brother Jim Finguerra, 1995-164-69

12. "Acorn" carving knife and fork. Designed by Johan Rohde (1856–1935). Manufactured by Georg Jensen Sølvsmedie. Copenhagen, Denmark, designed 1915, produced after 1945. Silver, stainless steel. Gift of Anonymous Donor, 1986-109-7,8

13. (LEFT) "Blossom" pierced spoon or sugar sifter. Manufactured by Georg Jensen Sølvsmedie. Copenhagen, Denmark, designed 1912, produced after 1944. Silver. Gift of Mrs. Neville J. Booker, 1944-26-2

(CENTER) Sauce ladle, model number 93. Manufactured by Georg Jensen Sølvsmedie. Copenhagen, Denmark, designed in 1910, produced ca. 1915–32. Ivory, silver. Gift of Mrs. Neville J. Booker, 1944-26-1

(RIGHT) "Snail" serving spoon. Manufactured by Georg Jensen Sølvsmedie. Copenhagen, Denmark, designed in 1908, produced ca. 1915–27. Silver. Gift of Mrs. Neville J. Booker, 1944-26-3

14. (TOP) Serving fork and spoon, model number 38. Design attributed to Arthur Georg Jensen (1866–1935). Manufactured by Georg Jensen Sølvsmedie. Copenhagen, Denmark, designed ca. 1915–20, produced ca. 1955–60. Silver. Gift of Anonymous Donor, 1986-109-5/6

(BOTTOM) Serving fork and spoon, model number 83. Design attributed to Arthur Georg Jensen (1866–1935). Manufactured by Georg Jensen Sølvsmedie. Copenhagen, Denmark, designed ca. 1915–20, produced ca. 1955–60. Silver. Gift of Anonymous Donor, 1986-109-3,4

15. "AJ" flatware. Designed by Arne Jacobsen (1902–1971). Manufactured by Georg Jensen Sølvsmedie. Copenhagen, Denmark, designed 1957, produced ca. 1990. Stainless steel. Gift of Royal Scandinavia A/S, 1999-10-1/12

16. "Odin" butter knife, dinner fork, dinner knife, iced tea spoon. Designed by Jens H. Quistgaard (b. 1919). Produced by Dansk International Designs, Ltd. Designed in Denmark, ca. 1960, manufactured in Japan, ca. 1985. Stainless steel. Gift of Dansk International Designs, Ltd., 1987-6-1/2, -4, -7

17. "Blue Shark" luncheon and dinner flatware. Designed by Svend Siune (b. 1935). Manufactured by Georg Jensen Sølvsmedie. Denmark, 1965. Stainless steel. Gift of Mel Byars, 1991-59-29/33

18. "Maya" flatware including fish fork and knife, cold meat fork, and soup spoon. Designed by Tias Eckhoff (b. 1926). Manufactured by Norsk Stålpress. Norway, 1961. Stainless steel. Gift of Norsk Stålpress, 1994-13-1/3, -10, -11,-18,-19

19. Flatware and cake server with Bakelite handles. Manufactured by Rostfrei, Steakmates, Hull, Cardinal. Germany and U.S.A., ca. 1938–41. Bakelite, stainless steel. Courtesy Dr. Robert Lerch.

20. Cocktail knives and holder. Germany, ca. 1938–41. Bakelite, stainless steel. Courtesy Dr. Robert Lerch.

21. Illustration: Mexican-themed "Patio Supper for Unexpected Guests," from *How to Take a Trick a Day with Bisquick, as Told to Betty Crocker by Screen Stars, Society Stars, Home Stars and Homemaking Editors*. Published by General Mills, Inc. U.S.A., 1935. Reprinted with the permission of General Mills, Inc.

22. Drawing: Design for "Highlight" or "Pinch" Flatware for John Hull Cutlers Corporation. Designed by Russel Wright (1904–1976). U.S.A., 1948. Brush and green and white gouache, black ink and wash, black chalk over graphite on chartreuse paper mounted on board. 20 ⅞ x 19 in. (531 x 482 mm). Gift of Russel Wright, 1976-15-9

23. "The all-in-one room," from *Guide to Easier Living*. Written by Russel and Mary Wright. Published by Simon and Schuster. New York, New York, 1951. Courtesy Smithsonian Institution Libraries, Washington, DC, and Russel and Mary Wright.

24. Photograph: Grip and form studies for "Design 1" flatware designed by Don Wallance (1909–1990). U.S.A., ca. 1953–54. Gift of David and Gregory Wallance, 1991-81-1

25. Illustration: "Nocturne, Gorham, Sterling," from *Litho-media: A Demonstration of the Selling Power of Lithography*. Published by Litho-media. New York, New York, 1939. Courtesy Smithsonian Institution Libraries, Washington, DC.

26. "Classic Column" flatware. Designed by Marion Weeber Welsh (1905–2000). Produced by Ekco Products International Co. Manufactured by Epic. Japan, 1967. Bequest of Marion Weeber Welsh, 2006-2-92/101

27. Prototype cutlery for Krupp Bendorf. Designed by Gio Ponti (1891–1979). Italy, 1933. Stainless steel. Courtesy Gio Ponti Archives/ S. Licitra-Milano.

28. "Conca" cutlery for Krupp Italia. Designed by Gio Ponti (1891–1979). Italy, 1951. Stainless steel. Courtesy Gio Ponti Archives/ S. Licitra-Milano.

29. Design drawing: "Conca" cutlery for Krupp Italia. Gio Ponti (1891–1979). Italy, 1951. Courtesy Gio Ponti Archives/ S. Licitra-Milano.

30. Prototype "Hollow Handle" cutlery for Krupp Italia. Designed by Gio Ponti (1891–1979). Italy, 1956. Stainless steel. Courtesy Gio Ponti Archives/ S. Licitra-Milano.

31. Prototype "Positive-Negative" plate and tablecloth with "Conca" flatware. Designed by Gio Ponti (1891–1979). Italy, 1953. Courtesy Gio Ponti Archives/ S. Licitra-Milano.

32. Prototype "Arched Cutlery" for Christofle. Designed by Gio Ponti (1891–1979). Made by Lino Sabatini (b. 1925). Italy, 1955. Silver. Courtesy Gio Ponti Archives/ S. Licitra-Milano.

33. Place setting and fitted roll. Designed by Carlo Scarpa (1906–1978). Manufactured by Cleto Munari. Vicenza, Italy, designed 1977, produced ca. 1986. Silver, stainless steel, felt (roll). Gift of Cleto Munari, 1987-20-1/8

34. "Boca" flatware. Designed by Sergio Asti (b. 1926). Manufactured by H. E. Lauffer. Italy, ca 1976. Stainless steel. Gift of Mel Byars, 1991-59-17/21

35. "Bambino" children's place setting. Designed by Lorenza Bozzoli and Massimo Giacon. Manufactured by Alessi. Italy, designed in 2003, produced in 2005. Plastic (PMMA, PP). Courtesy Alessi spa.

36. Photograph: Interior of Dining Car, Vestibule Train (*La Rabida*), from *The book of the fair; an historical and descriptive presentation of the world's science, art, and industry, as viewed through the Columbian Exposition at Chicago in 1893*, chapter XVIII—Transportation, p. 553. Hubert Howe Bancroft (1832–1918). Published

by The Bancroft Co. Chicago, Illinois, 1893. Courtesy Smithsonian Institution Libraries, Washington, DC.

37. Publicity photograph. Dining car appointments for the *20th Century Limited* train. Designed by Henry Dreyfuss (1904–1972) for the New York Central System. New York, New York, 1938. Gift of Henry Dreyfuss, 1972-88-1

38. Illustration: *20th Century Limited* train "King Size Diner" car, from *Book of the Century, Flagship of New York Central's Great Steel Fleet*. Designed by Henry Dreyfuss (1904–1972) for the New York Central System, 1948 (update of 1938 design). Gift of Henry Dreyfuss, 1972-88-1

39. Illustration: "L'heure du dîner dans la grande salle à manger" (Dinner in the grand dining room of the ocean liner *Normandie*), *Le paquebot "Normandie."* Published by L'Illustration. Paris, France, 1935. Courtesy Smithsonian Institution Libraries, Washington, DC.

40. Illustration: "Les couverts de table 'Orfèvrerie Christofle' de *Normandie*" (Flatware produced by Christofle for the ocean liner *Normandie*), in *Le paquebot "Normandie."* Published by L'Illustration. Paris, France, 1935. Courtesy Smithsonian Institution Libraries, Washington, DC.

41. Photograph: Place setting from the ocean liner SS *United States* featuring International Silver Co. flatware and sterling China Co. stoneware. ca. 1952. Courtesy Smithsonian Institution, NMAH/Transportation.

42. Prototype flatware for American Airlines. Designed by Richard Arbib (1917–1995). U.S.A., 1957. Anodized aluminum. Courtesy Jean S. and Frederic A. Sharf.

43. Dining ware from the Air France *Concorde*. Designed by Raymond Loewy (1893–1986)/Compagnie d'Esthétique Industrielle (plastic beverage glass designed by Georges Patrix (1920–1992)) for Air France. Manufactured by Bouillet Bourdelle (flatware), A. Raynaud & Cie (porcelain), Cristallerie de Souvigny (glass), Gedex (plastic). France, ca. 1976 (plastic beverage glass 1968). Stainless steel, glazed porcelain, glass, plastic, woven textile. Gift of Air France, 1989-24-2,-5/8,-14,-17,-18,-20

44. Flatware for Air France Economy Class. Designed by Raymond Loewy (1893–1986)/Compagnie d'Esthétique Industrielle under the direction of Evert Endt for Air France. France, ca. 1978. Stainless steel, plastic. Gift of Stephen and Dorothy Globus, 1990-32-1/3

45. Flatware for Scandinavian Airlines System (SAS): First Class (LEFT), Coach Class (RIGHT). Designed by Theresia Hvorslev (b. 1935) for SAS. Manufactured by Mema Guld Och Silver AB (First Class), A/S Norsk Stålpress/Staalpress (Coach Class). Lydkoping, Sweden, 1967, 1971. Silver-plated metal (First Class), stainless steel (Coach Class). Gift of the designer Theresia Hvorslev, 2001-16-1/5,-7/9

46. Business Class dining service for Scandinavian Airlines System (SAS). Stainless-steel cutlery designed by Bo Bonfils (b. 1941), manufactured by Georg Jensen; porcelain designed by Ursula Munch-Petersen (b. 1937), manufactured by Royal Copenhagen; glassware designed by Gunnar Cyren (b. 1935), manufactured by Orrefors. Denmark (cutlery, porcelain), Sweden (glassware), 2001. Courtesy Helena Kåberg and Scandinavian Airlines System.

47. Flatware for Lufthansa German Airlines. Designed by Wolf Karnagel (b. 1940) for Lufthansa German Airlines. Germany, 1986. Stainless steel. Gift of Lufthansa German Airlines, 1988-37-21/23

48. In-flight dining service for Lufthansa German Airlines. Designed by Wolf Karnagel (b. 1940) for Lufthansa German Airlines. Manufactured by WMF (flatware), Hutschenreuther (porcelain). Germany, 1986. Stainless steel, porcelain, glass, plastic, woven textile. Gift of Lufthansa German Airlines, 1988-37-1,-3/12,-20/23,-29,-39

49. "Plack" disposable picnic set. Designed by Jean-Pierre Vitrac (b. 1944). Produced by Diam. France, ca. 1977. Plastic (polystyrene). Gift of Vitrac Design, 1989-42-1/4

50. "Party Case 88" picnic/party set. Designed by Malcolm Foster. Manufactured by Oak Hill Industries Corporation. U.S.A., ca. 1986. Plastic. Gift of Oak Hill Industries Corporation, 1987-21-1/89-a/d

51. "Electra Pink" and "Electra Blue" flatware. Designed by David Tisdale (b. 1956). Produced by Sasaki. Japan, 1986. Anodized aluminum. Gift of Sasaki, 1988-48-6,-8,-10/11,-13,-15

"Picnic Flatware," Signature Collection. Designed and made by David Tisdale (b. 1956). U.S.A., 1985. Anodized aluminum. Museum purchase from Eleanor G. Hewitt Fund, 1986-94-1/3,-10

52. Traveling flatware. Designed by Anne Krohn Graham. U.S.A., 1978. Silver. Gift of Aaron Faber Gallery, 1979-60-1/3.

53. "Uni" fork, knife, spoon, and holder. Designed by Carla Nencioni (b. 1925) and Armando Moleri (b. 1928). Manufactured by Zani & Zani. Italy, 1971. Stainless steel, rubber. Gift of Mel Byars, 1991-59-180/183

54. "Mono-Clip" spoon, fork, and knife. Designed by Peter Raacke (b. 1928). Manufactured by Mono-Metallwarenfabrik Seibel GmbH. Germany, designed 1972. Stainless steel. Gift of Mel Byars, 1991-59-22, -25, -28

55. "Snac Pac" flatware and holder. Designed by Ernst Felix. Manufactured by Heinrich Böker and Co. Solingen, Germany, 1991. Plastic, stainless steel. Gift of Zona Alta Projects, 1992-40-1-a/d

56. "Be Cast" portable flatware and case. Japan, 1980s. Stainless steel, plastic. Gift of Max Pine, 1999-53-21/26.

57. "Port-A-Pac" picnic set. Manufactured by Twinbird Industrial Co., Ltd. Tokyo, Japan, 1980s. Plastic, stainless steel. Gift of David McFadden, 1988-50-1/8

58. Chair. Designed by Peter Behrens (1868–1940). Manufactured by Anton Blüggel for the Wertheim Department Store. Berlin, Germany, 1902. Wood (oak, pine), caning (not original). Museum purchase from General Acquisitions Endowment, 1985-121-1

59. "Double Helix" flatware. Designed by Ward Bennett (1917–2003). Manufactured by Sasaki. Japan, ca. 1987. Stainless steel. Gift of Sasaki, 1988-48-2/3,-5

60. "Variation V" fork, knife, and spoon. Designed by Jens H. Quistgaard (b. 1919). Produced by Dansk International Designs, Ltd. Designed Denmark, 1955, manufactured Japan, ca. 1955–60. Stainless steel. Gift of Dansk International Designs, Ltd. 1987-6-18,-19, -22

61. Photograph: Cutlery and kitchenware displays, Crate and Barrel store, Michigan Avenue, Chicago, Illinois, late 1970s. Courtesy Crate and Barrel.

62. Photograph: Flatware and tableware displays, Crate and Barrel store, Wells Street, Chicago, Illinois, ca. 1966. Courtesy Crate and Barrel.

63. Two pairs of salad servers. Designed by Smart Design, Inc. (design team: Annie Breckenfeld, Linda Celantano, Tom Dair, John Lonczak, Brent Markee, Davin Stowell, Tucker Viemeister). Manufactured by Copco. U.S.A., 1986. Plastic (injection molded polystyrene). Gift of Smart Design, Inc., 1987-14-17-a,b;-18-a,b

64. "Design 10" flatware in packaging. Designed by Don Wallance (1909–1990). Produced by H. E. Lauffer. U.S.A., designed ca. 1977–78, produced ca. 1979. Plastic (Lexan polycarbonate). Gift of David and Gregory Wallance, 1991-81-1

65. Two sets of wooden flatware (with packaging for one set). Designed by Tetsuji Kawamura. Japan, 1986. Wood, painted wood, foil-covered cardboard (packaging). Gift of Tetsuji Kawamura, 1997-33-7/13-a/d

66. "Eat and Drink" flatware. Designed by Ergonomi Design Gruppen. Manufactured by RFSU Rehab. Stockholm, Sweden, 1981. Stainless steel, plastic (polycarbonate). Gift of RFSU Rehab, 1982-76-1/5

67. "Eat and Drink" flatware and tableware. Designed by Ergonomi Design Gruppen. Manufactured by RFSU Rehab. Stockholm, Sweden, 1981. Stainless steel, plastic (melamine, polycarbonate). Gift of RFSU Rehab, 1982-76-1/8

68. "Flamingo" fork, knife, and spoon. Designed by Mark P. Wilson (b. 1955). Manufactured by Curvware, Inc. U.S.A., 1996. Stainless steel. Gift of Curvware, Inc., 1997-174-1/3

69. Flatware for the State of New Mexico Corrections Department. Designed by Armand G. Winfield (b. 1919). U.S.A., ca. 1960. Plastic. Gift of Armand G. Winfield, 1993-76-10, -11, -14

70. "Slenderfork." Produced by Slenderworld International. U.S.A., probably 1970s. Stainless steel, plastic. Gift of Unknown Donor, n-a-2300

71. "Nasturtium Leaves" servers. Designed and made by Robyn Nichols. U.S.A., 1991. Silver. Gift of Roseanne Raab Associates, 1992-44-1,2

72. "Wishbone" flatware. Designed by Joost During (b. 1970). Manufactured by Nambé. Santa Fe, New Mexico, 2003. Stainless steel. Courtesy the designer.

73. Fork, knife, spoon with case. Designed by Jean-Marie Patois. France, 1980s. Stainless steel, vinyl (case). Gift of David McFadden, 1988-115-1/3

74. "Trylon" flatware. Designed by Ward Bennett (1917–2003). Produced by Supreme Cutlery division of Towle Manufacturing Co., Silversmiths. Designed U.S.A., manufactured Japan, 1980. Stainless steel. Gift of Ward Bennett, 1986-53-15/17

75. Fork, knife, and tablespoon. Designed by Bořek Šípek (b. 1949) for NEOTU. Czech Republic, 1991. Stainless steel, gold plate. Museum purchase from Decorative Arts Association Acquisition Fund, 1992-32-1, -3, -4

76. Prototype fork and knife. Designed by Alain Carré (b. 1945). Made by Puiforcat. France, 1974. Silver. Courtesy Michele Oka Doner.

77. "Ciga Hotel" dinner fork, dinner knife, tablespoon. Designed by Lella and Massimo Vignelli (b. 1934, 1931) and David Law (b. 1937). Made by Vignelli Designs, Inc.

Designed U.S.A., made Italy, 1979. Silver-plated metal. Gift of Lella and Massimo Vignelli, 1985-54-12/14

78. Salad fork, dinner fork, knife, tablespoon, teaspoon. Designed by Robert Wilhite (b. 1946). Made by S. Dorman. U.S.A., ca. 1982. Silver. Gift of Robert Wilhite, 1992-45-1/5

79. "Trussware" flatware. Made by Boris Bally (b. 1961). Providence, Rhode Island, 1993. Silver. Courtesy Boris Bally.

80. "Finger Tool" spoon. Made by Susanne Klemm (b. 1965). The Netherlands, 2002. Silver, rubber. Courtesy Galerie Ra Amsterdam.

81. "Spoon-o-Brush." Made by Sabine Lang (b. 1976). Germany, 2002. Silver, plastic. Courtesy Galerie Ra Amsterdam.

82. "Diet Spoon." Made by Jiří Šibor (b. 1966). Czech Republic, 2002. Stainless steel. Courtesy Galerie Ra Amsterdam.

83. "A Silver Dessert Spoon with the Necessary Instructions for a Faultless Performance at the Dinner Table" and "Training Spoon." Made by Sarah Jane Ross (b. 1971). Australia, 2002. Silver, resin (Dessert Spoon), copper, enamel (Training Spoon). Courtesy Galerie Ra Amsterdam.

84. Spatula. Made by Michele Oka Doner (b. 1945). U.S.A., 1998. Silver. Courtesy the artist.

Pictorial Overview

Knife. Probably England, mid-16th century. Steel. The Robert L. Metzenberg Collection, gift of Eleanor L. Metzenberg, 1985-103-25

Knife. Probably Spain, early 16th century. Steel. The Robert L. Metzenberg Collection, gift of Eleanor L. Metzenberg, 1985-103-15

Folding knife. France or Italy, mid-16th century. Ivory, steel, gilding, brass. The Robert L. Metzenberg Collection, gift of Eleanor L. Metzenberg, 1985-103-178

Sheath for fork and knife. The Netherlands, 1589. Fruitwood, silver. The Robert L. Metzenberg Collection, gift of Eleanor L. Metzenberg, 1985-103-42-a,b

Sheath for fork and knife. The Netherlands, 1555. Fruitwood, silver. The Robert L. Metzenberg Collection, gift of Eleanor L. Metzenberg, 1985-103-29-a,b

Knife. France or Italy, ca. 1580. Mother-of-pearl, brass, horn, steel. The Robert L. Metzenberg Collection, gift of Eleanor L. Metzenberg, 1985-103-46

Fork and knife. France or Italy, ca. 1600. Bone, brass, enamel, ebony, gilding, steel. The Robert L. Metzenberg Collection, gift of Eleanor L. Metzenberg, 1985-103-39,40

Fork. The Netherlands, early 17th century. Wood, steel. The Robert L. Metzenberg Collection, gift of Eleanor L. Metzenberg, 1985-103-52

Knife. Handle probably Germany, ca. 1710; blade by Mortimer & Hunt, England, ca. 1840. Wood, steel. The Robert L. Metzenberg Collection, gift of Eleanor L. Metzenberg, 1985-103-51

Fork and knife. Probably Central Europe, ca. 1630. Horn, gold, mother-of-pearl, steel. The Robert L. Metzenberg Collection, gift of Eleanor L. Metzenberg, 1985-103-35,36

Fork. Probably France, ca. 1650. Horn, mother-of-pearl, brass, steel. The Robert L. Metzenberg Collection, gift of Eleanor L. Metzenberg, 1985-103-59

Knife. Germany, ca. 1650. Wood, steel. The Robert L. Metzenberg Collection, gift of Eleanor L. Metzenberg, 1985-103-34

Fork and knife. Germany or Austria, second half of 17th century. Horn, brass, steel. The Robert L. Metzenberg Collection, gift of Eleanor L. Metzenberg, 1985-103-37,38

Fork and knife with sheath. Saxony, Germany, or the Netherlands, second half of 17th century. Enamel, silver. The Robert L. Metzenberg Collection, gift of Eleanor L. Metzenberg, 1985-103-62-a/c

Knife and fork. Germany (probably Rhineland), ca. 1700. Pearwood, steel, brass. The Robert L. Metzenberg Collection, gift of Eleanor L. Metzenberg, 1985-103-49,50

Traveling fork and knife in case. Amsterdam, the Netherlands, ca. 1700. Bone, steel, silver, sharkskin. The Robert L. Metzenberg Collection, gift of Eleanor L. Metzenberg, 1985-103-137-a/c

Knife. Probably the Netherlands, late 17th century. Silver, gold, steel. The Robert L. Metzenberg Collection, gift of Eleanor L. Metzenberg, 1985-103-6

Set of six forks and knives in case. Habaner, Austria-Hungary, ca. 1690. Case made in Paris, France, ca. 1800. Mother-of-pearl, steel, brass, leather, wood, wool. The Robert L. Metzenberg Collection, gift of Eleanor L. Metzenberg, 1985-103-277-a/m

Fork and knife. Habaner (Eastern-central Danube), Austria-Hungary, ca. 1700. Mother-of-pearl, brass, steel. The Robert L. Metzenberg Collection, gift of Eleanor L. Metzenberg, 1985-103-94,95

Fork and spoon. Italy, late 17th century. Bronze. The Robert L. Metzenberg Collection, gift of Eleanor L. Metzenberg, 1985-103-30,31

Fork and spoon. Made by "PD." Naples, Italy, 1704, 1718. Silver. The Robert L. Metzenberg Collection, gift of Eleanor L. Metzenberg, 1985-103-8,9

Fork and knife. The Netherlands or Germany, early 18th century. Steel, brass. The Robert L. Metzenberg Collection, gift of Eleanor L. Metzenberg, 1985-103-79,80

Fork and knife. Germany, 1730–50. Green-stained ivory, silver, steel. The Robert L. Metzenberg Collection, gift of Eleanor L. Metzenberg, 1985-103-131,132

Traveling set with fork, knife, and spoon. Made by "FGS." Germany (possibly Karlsbad), early 18th century. Steel, brass, silver, gold. The Robert L. Metzenberg Collection, gift of Eleanor L. Metzenberg, 1985-103-249/251

Fork. Germany, ca. 1725–50. Horn, silver, steel. The Robert L. Metzenberg Collection, gift of Eleanor L. Metzenberg, 1985-103-19

Set of six knives in standing case. Probably Germany, early 18th century. Horn, steel, gilding, leather, wood. The Robert L. Metzenberg Collection, gift of Eleanor L. Metzenberg, 1985-103-283-a/h

Fork. Germany, ca. 1730. Brass, steel. The Robert L. Metzenberg Collection, gift of Eleanor L. Metzenberg, 1985-103-12

Traveling fork and knife in case. Probably Germany, ca. 1730–40. Bone, silver, steel, sharkskin. The Robert L. Metzenberg Collection, gift of Eleanor L. Metzenberg, 1985-103-134-a/c

Knife. Probably St. Cloud, France, ca. 1730–35. Porcelain, steel. The Robert L. Metzenberg Collection, gift of Eleanor L. Metzenberg, 1985-103-231

Fork and knife. Staffordshire, England, 1745. Glazed earthenware, steel. The Robert L. Metzenberg Collection, gift of Eleanor L. Metzenberg, 1985-103-210,211

Pocket knife. Made by "AP," possibly for Abraham Pootholt. Groningen, the Netherlands, mid-18th century. Silver. Gift of Eleanor and Sarah Hewitt, 1931-48-96

Fork, knife, and spoon in case. France, ca. 1750. Ivory, steel, mahogany, silk. The Robert L. Metzenberg Collection, gift of Eleanor L. Metzenberg, 1985-103-193/196

Traveling set with knife, fork, skewer, and case. The Netherlands or Germany, ca. 1750 (with later Dutch control/import marks). Agate, silver, steel, sharkskin. The Robert L. Metzenberg Collection, gift of Eleanor L. Metzenberg, 1985-103-118-a/d

Fork and knife. Germany, ca. 1730–40. Silver, steel. The Robert L. Metzenberg Collection, gift of Eleanor L. Metzenberg, 1985-103-4,5

Traveling fork, knife, and spoon. Northern Germany or Denmark, mid- to late 18th century. Silver, steel, brass. The Robert L. Metzenberg Collection, gift of Eleanor L. Metzenberg, 1985-103-272/274

Fork and leather case. Southern Germany or Austria, mid-18th century. Case probably Germany, mid-18th century. Antler, steel, silver, leather. The Robert L. Metzenberg Collection, gift of Eleanor L. Metzenberg, 1985-103-155-a,b

Fork. Probably Solingen, Germany, second half of 18th century. Green-stained ivory, silver, steel. The Robert L. Metzenberg Collection, gift of Eleanor L. Metzenberg, 1985-103-130

Fork and knife. Germany, second half of 18th century. Glass, gold, brass, steel. The Robert L. Metzenberg Collection, gift of Eleanor L. Metzenberg, 1985-103-179,181

Fork and knife. Worcester, England, ca. 1765. Porcelain, silver, steel. The Robert L. Metzenberg Collection, gift of Eleanor L. Metzenberg, 1985-103-191,192

Two knives. France, ca. 1800. Tortoiseshell, silver, steel. The Robert L. Metzenberg Collection, gift of Eleanor L. Metzenberg, 1985-103-106,107

Folding fork, knife, and spoon. Karlsbad, Bohemia, ca. 1790–1800. Steel, gold, silver. The Robert L. Metzenberg Collection, gift of Eleanor L. Metzenberg, 1985-103-239/241

Folding fork, knife, and spoon. Probably Karlsbad, Bohemia, ca. 1790. Gold, silver. The Robert L. Metzenberg Collection, gift of Eleanor L. Metzenberg, 1985-103-265/267

Teaspoon. Made by "DH." U.S.A., ca. 1790–1800. Silver. Gift of Mrs. Abram S. Hewitt, 1931-44-29

Chopsticks, knife, and case. Probably Japan, mid-19th century. Wood, bamboo, brass, ivory. Gift of the Estate of Harrison Salisbury, 1995-173-3-a/d

Fork, knife, and spoon. Made by "TM." Dresden, Germany, mid-19th century. Porcelain, silver, gilding. The Robert L. Metzenberg Collection, gift of Eleanor L. Metzenberg, 1985-103-186/188

Serving spoon. Manufactured by Whiting Manufacturing Co. North Attleboro, Massachusetts, ca. 1875. Silver. Museum purchase from the Decorative Arts Association Acquisition Fund, 1995-148-3

Set of coffee or teaspoons in "Oriental" box. Manufactured by Gorham Manufacturing Co. Providence, Rhode Island, 1880. Silver-gilt, velvet, brocade, satin, wood, metal. Gift of Dona Guimaraes, 1986-113-2/12

Eighty-one-piece dessert service. Mother-of-pearl-handled service made and retailed by F. Nicoud; silver service made by C. V. Gibert. Paris, France, ca. 1890. Steel, silver; silvered and gilt metal, mother-of-pearl. Museum purchase from Smithsonian Institution Collections Acquisition Program, Decorative Arts Association Acquisition, and Sarah Cooper-Hewitt Funds, 1996-56-1/82-a/d

Fork and knife with case. Made by Francis Higgins. London, England, 1884. Silver-gilt, leather, velvet, silk, satin. Gift of Janet Mavec, 1987-77-1-a/c

Spoons in case. Made by Pavel Ovchinikov; retailed by Theodore B. Starr, New York. Moscow, Russia, ca. 1890. Enamel (cloisonné), silver-gilt, leather, brass, velvet, silk. Gift of Mary T. Cockcroft, 1944-44-3-a/g

Five-piece carving set. Manufactured by Gorham Manufacturing Company. Providence, Rhode Island, 1900. Horn, steel, silver, glass. Bequest from the estate of Julian Clarence Levi, 1972-5-3-a/e

"Tulip" dessert fork and knife. Designed by Heinrich Vogeler (1872–1942). Manufactured by M. H. Wilkens & Söhne. Bremen, Germany, 1900–02. Silver. Gift of Torsten Broehan, Berlin, 2002-18-2,3

"Moderne 1900 Palmier" (Palm Tree) dinner fork, knife, spoon, and teaspoon. Design attributed to Paul Follot (1877–1941). Manufactured by Maison Cardeilhac. Paris, France, 1904. Silver. Museum purchase from Morrill Acquisitions Fund, 1998-24-1/4

Six-piece place setting. Designed by Porter Blanchard (1886–1973). U.S.A., ca. 1970–80. Silver. Gift of Mr. William E. Woolfenden, 1992-151-1/6

"TI-1" Flatware. Designed by Takenobu Igarashi (b. 1944). Produced by Yamada Shomei Lighting Co., YMD Division. Manufactured by Tsubame Shinko Industry Co., Ltd. Japan, 1989. Stainless steel. Gift of Gallery 91 and Yamada Shomei, 1990-109-2-a/h

"Axis" flatware. Designed by Gerald Gulotta. Produced by Dansk International Designs, Ltd. Manufactured by Yamazaki Kinzoku Kogyo Co., Ltd. Produced Denmark, manufactured Japan, designed 1989–90, introduced 1992. Stainless steel. Gift of Dansk International Designs, Ltd., 1998-69-9,-11/13

Endnotes

(CLOCKWISE FROM TOP) Dinner fork, fish fork, lunch fork. Made by Claude Lalanne (b. 1925). France, 1966. Silver. Museum purchase from Decorative Arts Association Acquisition Fund in honor of John L. Marion, 1990-137-2,-4,-8

Cover

Spoon from flatware set. Made by Claude Lalanne (b. 1925). France, 1966. Silver. Museum purchase from Decorative Arts Association Acquisition Fund in honor of John L. Marion, 1990-137-5

Back Cover (hardcover)

"Flaches Modell" (Flat Model) dessert fork and knife. Designed by Josef Hoffmann (1870–1956). Produced by Wiener Werkstätte. Austria, 1903. Silver. Museum purchase from Friends of Applied Arts and Industrial Design, General Acquisitions Endowment, and Morrill Acquisitions Funds, 2002-3-1,2

Selected References

Ainslie, John A. "Knife and Fork Handles and the Bow Collector." In *Connoisseur* 131, #530, April 1953, pp. 14–17.

Allinder, Ronald C. *The Eating Tool: Its Development and Suitability to American Dining*, M.S. Thesis, Illinois Institute of Technology, 1960.

Amme, Jochen. *Bestecke: Die Egloffstein'sche Sammlung (15–18. Jahrhundert) auf der Wartburg*. Stuttgart: Arnoldsche, 1994.

Amme, Jochen. *Historic Cutlery: Changes in Form from the Early Stone Age to the Mid-20th Century*. Stuttgart: Arnoldsche, 2002.

Arminjon, Catherine. "The Art of Dining." In *L'Art de Vivre: Decorative Arts and Design in France 1789–1989*. New York: The Vendome Press and Cooper-Hewitt, National Design Museum, 1989.

Arthus (Artus), Thomas, sieur d'Ambry. *Les hermaphrodites; ou L'Isle des hermaphrodites nouvellement descouverte*. Paris, ca. 1609.

Ashford, R. "Folding Fruit Knives." In *Antique Collector*, vol. 48, no. 8, August 1977, pp. 60–63.

Bace, Jill. *Collecting Silver: The Facts at Your Fingertips*. London: Octopus Publishing Group, 1999.

Bailey, Charles Thomas Peach. *Knives and Forks*. London and Boston: The Medici Society, 1927.

Beard, Charles R. "Wedding Knives." In *Connoisseur* 85, no. 342, February 1930, pp. 91–97.

Belden, Louise Conway. *Festive Tradition: Table Decoration and Desserts in America, 1650–1900*. New York and London: W. W. Norton & Co, 1983.

Benporat, Claudio. "A Discovery at the Vatican: The First Italian Treatise on the Art of the Scalco (Head Steward)." In *Petits Propos Culinaires*, vol. 30, Nov. 1988, pp. 41–45.

Benker, Gertrud. *Alte Bestecke: Beitrag zur Geschichte der Tischkultur*. Munich: Georg D. W. Callwey, 1978.

Beresford-Evans, J., and L. Bruce Archer. "Design Analysis: Stainless Steel Cutlery and Flatware." In *Design*, no. 114, June 1958, pp. 39–46.

Blakemore, K. *Guide to Flatware*. London: Heywood, 1955.

Bober, Phyllis Pray. *Art, Culture, and Cuisine: Ancient and Medieval Gastronomy*. Chicago: The University of Chicago Press, 1999.

de Bonneville, Françoise, Nina Bogin and Vincea McClelland, trans. *Jean Puiforcat*. Paris: Editions du Regard, 1986.

Bouilhet, Henri, Melville Wallace, trans. *Christofle: Silversmiths Since 1830/150 ans d'Orfèvrerie*. Paris: Chêne/Hachette, 1981.

Bourdon-Smith, J. H. *Catalogue of Early English Spoons*, exhibition catalogue. London: Timothy Arthur Kent, 1981.

Brett, Gerard. *Dinner Is Served: A History of Dining in England, 1400–1900*. London: Rupert Hart-Davis, 1968.

Brown, Peter. *Dining in England: A History of British Cutlery*. London: Philip Wilson, Publishers, Ltd., 1997.

Brown, Peter. *Pyramids of Pleasure: Eating and Dining in 18th-century England*. York: York Civic Trust, 1990.

Brown, Peter, ed. *British Cutlery. An Illustrated History of Design, Evolution, and Use*, exhibition catalogue. London: Philip Wilson Publishers, Ltd., 2001.

Brown, Peter, and Ivan Day. *Pleasures of the Table: Ritual and Display in the European Dining Room 1600–1900*, exhibition catalogue. York: York Civic Trust, 1997.

Brown, W. H. "Eating Implements." In *Antique Collecting* 29, September 1995, pp. 21–23.

Buhler, Kathryn C. *American Silver, 1655–1825, in the Museum of Fine Arts, Boston*, vols. 1 and 2. Greenwich, CT: Museum of Fine Arts, Boston, and New York Graphic Society, 1972.

Buhler, Kathryn C. *Mount Vernon Silver*. Mount Vernon, VA: The Mount Vernon Ladies' Association of the Union, 1957.

Buhler, Kathryn C., and Graham Hood. *American Silver, Garvan and Other Collections in the Yale University Art Gallery*, Vols. 1 and 2. New Haven, CT, and London: Yale University Press, 1970.

Bushman, Richard. *The Refinement of America Persons, Houses, Cities*. New York: Vintage, 1993.

Byrnes, James B. *Fêtes de la palette: An Exhibition of European Paintings and Decorative Arts, from the Mid-sixteenth through the Mid-eighteenth Century Dedicated to the Delights of the Bountiful Table*, exhibition catalogue. New Orleans: Isaac Delgado Museum of Art, 1964.

Carpenter, Charles H., Jr. *Gorham Silver*. New York: Dodd, Mead, 1982.

Carpenter, Charles H., Jr., with Mary Grace Carpenter. *Tiffany Silver*. New York: Dodd, Mead, 1978.

Charleston, Robert Jesse. "English Porcelain." In *Antiques Review*, June/August 1951.

Clayton, Michael. *Silver and Gold*. London: Hamlyn Publishing Group, 1969.

Clifford, Helen, Molly Pearce, et al. *Millennium Canteen*. Sheffield, UK: Sheffield City Council, 1998.

Coryat, Thomas. *Coryats Crudities Hastily gobbled up in five Moneths travells in France. Savoy, Italy, rhetis, comonly called the Grisons country, Helvetia alias Switzlerland, some parts of Germans, and the Netherlands; Newly digested in the hungry iare of ODCOMBE in the County of Somerset, & now dispersed to the nourishment of the travelling Members if this Kingdome*. London: W. S., 1611.

Cuming, H. S. "On the Sheaths of Girdle Knives." In *Journal of the British Archaeological Association* 17, 1861, pp. 113–18.

Cummings, Abbott Lowell. *Rural Household Inventories Establishing the Names, Uses & Furnishings of Rooms in the Colonial New England Home 1675-1775*. Boston: Society for the Preservation of New England Antiquities, 1964.

Davidson, Alan. *The Oxford Companion to Food*. Oxford: Oxford University Press, 1999.

Day, Ivan. *Eat, Drink & Be Merry: The British at the Table, 1600–2000*, exhibition catalogue. London: Philip Wilson Publishers, Ltd., 2000.

Defenbacher, D. S., and Walker Art Center. *Knife/Fork/Spoon: The Story of Our Primary Implements and the Development of Their Form*, exhibition catalogue. Minneapolis: Walker Art Center, 1951.

Dembinska, Maria, Magdalena Thomas, trans., revised and adapted by William Woys Weaver. *Food and Drink in Medieval Poland: Rediscovering a Cuisine of the Past*. Philadelphia: University of Pennsylvania Press, 1999.

Dodington, Ellen Marriott. *Don Wallance: Changing the Look of American Flatware through Craft and Industry*. M.A. thesis, Cooper-Hewitt, National Design Museum and Parsons School of Design, 2002.

von Drachenfels, Suzanne. *The Art of the Table: A Complete Guide to Table Setting, Table Manners, and Tableware*. New York: Simon and Schuster, 2000.

Draper, Dorothy. *Decorating is Fun! How to Be Your Own Decorator*. New York: Literary Guild, 1939.

Earle, Alice Morse. *Customs and Fashions in Old New England*. New York: Charles Scribner's and Sons, 1893.

Elias, Norbert. *The Civilizing Process*. New York: Urizen Books, 1978.

Elias, Norbert, Edmund Jephcott, trans., edited by Eric Duning et al. *The Civilizing Process: Sociogenetic and Psychogenetic Investigations*, revised edition. London: Blackwell Publishers, 1994.

Faas, Patrick, Shaun Whiteside, trans. *Around the Roman Table: Food and Feasting in Ancient Rome*. New York: Palgrave, 1994.

Falino, Jeannine. "The Pride Which Pervades thro every Class: The Customers of Paul Revere." In *New England Silver & Silversmithing: 1620–1815*. Boston: Colonial Society of Massachusetts, 2001.

Falino, Jeannine, and Gerald W. R. Ward. *New England Silver & Silversmithing: 1620–1815*. Boston: Colonial Society of Massachusetts, 2001.

Flandrin, Jean-Louis, and Massimo Montanari, English edition by Albert Sonnenfeld. *Food: A Culinary History*. New York: Columbia University Press, 1996.

Frame, Donald M., trans. and introduction. *Montaigne's Travel Journal*. San Francisco: North Point Press, 1983.

Les Français et la Table. Paris: Ministère de la Culture, Editions de la Réunion des Musées Nationaux, 1985.

Fuhring, Peter. "The Silver Inventory from 1741 of Louis, duc d'Orléans." In *Cleveland Studies in the History of Art* 8, 2003, pp. 130–46.

Gask, Norman. "Early Maidenhead Spoons." In *Connoisseur* 92, no. 388, December 1933, pp. 400–01.

Gask, Norman. *Old Silver Spoons of England*, reprint. London: Spring Books, 1973.

Gibb, George Sweet. *The Whitesmiths of Taunton: A History of Reed and Barton 1824–1943*. Cambridge, MA: Harvard University Press, 2005.

Giblin, James Cross. *From Hand to Mouth, or, How We Invented Knives, Forks, Spoons and Chopsticks & the Table Manners To Go with Them*. New York: Thomas Y. Crowell, 2005.

Girouard, Mark. *Life in the English Country House: A Social & Architectural History*. New Haven: Yale University Press, 1978.

Glanville, Philippa. *Silver: History and Design*. New York: Harry N. Abrams, 1997.

Glanville, Philippa. *Silver in England*. New York: Holmes & Meier, 1987.

Glanville, Philippa, and Hilary Young, eds. *Elegant Eating: Four Hundred Years of Dining in Style*. London: V&A Publications, 2002.

Glaub, Bodo. *Bestecke mit Tiermotiven und aus Tierischem Material*. Cologne: no date.

Glaub, Bodo. *Historiches Bestecke*. Cologne: Bestiarium, no date.

Glaub, Bodo. *Messer, Loffel, Gabel: Sammlung Bodo Galub und Bestecke aus der Sammlung des Museums*. Frankfurt am Main: Museum fur Kunsthandwerk Frankfurt am Main, 1964.

Grotkamp-Schepers, Barbara, and Reinhard Sänger. *Bestecke des Jugendstils: Bestandskatalog des Deutsches Klingenmuseum Solingen*. Bonn: Arnoldsche, 2000.

Grover, Kathryn. *Dining in America 1850–1900*. Amherst, MA, and Rochester, NY: The University of Massachusetts Press and the Margaret Woodbury Strong Museum, 1987.

Gruber, Alain. *Silverware*. New York: Rizzoli, 1982.

Gruber, Alain. *Weltliches Silber: Katalog der Sammlung des Schweizerishen Landesmuseums Zurich*. Zurich: Verlag Berichthaus, 1977.

Hagan, Tere. *Silverplated Flatware*. Paducah, NY: Collector books, 1984.

Harris, Leon. "Jewelry for the Table: The Ultimate in One-Upmanship." In *Connoisseur* 216, February 1986, pp. 62–63.

Hayward, John Forrest. *English Cutlery: Sixteenth to Eighteenth Century*. London: H. M. Stationery Office, 1956.

Heisinger, Kathryn B., and George Marcus. *Landmarks of Twentieth-century Design*. New York: Abbeville Press, 1993.

Henisch, Bridget Ann. *Fast and Feast: Food in Medieval Society*. University Park, PA, and London: The Pennsylvania State University Press, 1976.

Holmes, Rathbone. "Implements of the Table." In *Art and Industry* 63, no. 376, October 1957, pp. 122–27.

Hood, William P., Jr., Roslyn Berlin, and Edward Wawrynek. *Tiffany Silver Flatware, 1845–1905: When Dining Was an Art*. Woodbridge, Suffolk: Antique Collectors' Club, 2000, reprinted 2003.

Hood, William P., Jr., Roslyn Berlin, and Edward Wawrynek. "Markings on Antique Tiffany Silver Flatware." In *New York Silver Society Newsletter*, Spring 1999, pp. 1, 4, 5, 8.

Hood, William P., Jr., Roslyn Berlin, and Edward Wawrynek. "Tiffany's Japanesque flatware," *The Magazine Antiques* 158, no. 2, August 2000, pp. 184–93.

Hood, William P., Jr., Charles S. Curb, and John R. Olson. "Dining with Bugs: Insects on American Silver Flatware, Part One." In *Silver Magazine*, vol. 33, no. 4, July/August 2001, pp. 24–32.

Hood, William P., Jr., Charles S. Curb, and John R. Olson. "Dining with Bugs: Insects on American Silver Flatware, Part Two." In *Silver Magazine*, vol. 33, no. 5, September/October 2001, pp. 28–36.

Hood, William P., Jr., Dale E. Bennett, Charles S. Curb, and John R. Olson. "American Silver Fish Servers, 1840–1910, Part One." In *Silver Magazine*, vol. 34, no. 6, November/December 2002, pp. 18–29.

Household Utensils in Denmark. Geneva: The International Trade Centre, 1979.

Hughes, George Bernard. "Evolution of the Silver Table Fork." In *Country Life*, vol. 126, no. 3264, September 24, 1959, pp. 364–65.

Hughes, George Bernard. "Keeping Georgian Food Hot." In *Country Life*, vol. 144, no. 3747, December 26, 1968, pp. 1702–03.

Hughes, George Bernard. "Old English Table Knives and Forks." In *Country Life*, vol. 107, no. 2770, February 17, 1950, pp. 450–52.

Hughes, George Bernard. "Old English Wedding Knives." In *Country Life*, vol. 105, no. 2723, March 25, 1949, pp. 666–67.

Hughes, George Bernard. "Silver Scoops for Marrow Bones." In *Country Life*, vol. 128, no. 3327, December 8, 1960, pp. 1448, 1450.

Huxtable, Aida Louise. "Stainless Comes to Dinner." In *Industrial Design*, vol. 1, no. 4, August 1954, pp. 30–37.

Kane, Patricia, with contributions by Jeannine J. Falino [et al.] and the assistance of Karen L. Wight & Edgard Moreno. *Colonial Massachusetts Silversmiths and Jewelers: A Biographical Dictionary Based on the Notes of Francis Hill Bigelow & John Marshall Phillips*. New Haven: Yale University Art Gallery, 1998.

Karsten, Bill. *Silver Folding Fruit Knives*. Knoxville, TN: Knife World Publications, 1986.

Kelly, Laurence. *St. Petersburg: A Traveller's Companion*. New York: Atheneum, 1983.

Kroh, Patricia. *Contemporary Table Settings: A Hostess Handbook with Fruit and Flower Arrangements, Menus and Recipes*. Garden City, NY: Doubleday and Company, Inc., 1966.

Lepper-Binnewerg, Antoinette. *Carl Pott: Das Nutzlizliche Wolkommen Gestalten*. Hamburg: Jo Klatt Design + Verlag, 1993.

Lutteman, Helena Dahlbück, and Marriane Uggla, trans. *The Lunning Prize*, exhibition catalogue. Stockholm: Nationalmuseum, 1986.

Lynes, Russell. *The Tastemakers: The Shaping of American Popular Taste*. New York: Harper, 1954.

Marquardt, Klaus. *Eight Centuries of European Knives, Forks, and Spoons: An Art Collection*. Stuttgart: Arnoldsche, 1997.

Masterpieces of Cutlery and the Art of Eating, exhibition catalogue. London: Victoria & Albert Museum, 1979.

"Metal Tableware." In *Design*, no. 110, February 1958, pp. 48–52.

Milliken, William M. "Early Christian Fork and Spoon." In *Bulletin of the Cleveland Museum of Art*, no. 44, 1957, pp. 184–87.

Møller, Svend Erik, ed., Mogens Kay-Larsen, trans. *Danish Design*. Copenhagen: Det Danske Selskab, 1974.

Moore, Simon. *Cutlery for the Table: A History of British Table and Pocket Cutlery*. Sheffield: Hallamshire, 1999.

Moore, Simon. "Folding Fruit Knives and Forks." In *The Antique Dealer & Collector's Guide*, September 1975, pp. 77–83.

Morel, Andreas. *Der gedeckte Tisch. Zur Geschichte der Tafelkultur*. Zurich: Punktum, 2001.

Mostre Giorgetti. *Cutlery*, exhibition catalogue. Mandova, Italy: Corraini Editore, 1997.

Moulin, Leo. *Les liturgies de la table: une histoire culturelle du manger et du boire*. Anvers: Fonds Mercator, 1988.

Museum of Contemporary Crafts. *Designed for Silver: International Design Competition*, exhibition catalogue. New York: The International Silver Company, 1960.

Neuwirth, Waltraud, Heinz Gerstle, trans. *Josef Hoffmann: Place Settings for the Vienna Workshop*. Vienna: Dr. Waltraud Neuwirth, 1982.

Newman, Harold, ed. *An Illustrated Dictionary of Silverware*. London: Thames and Hudson, 1987.

Osterberg, Richard. *Sterling Silver Flatware for Dining Elegance*. Atglen, PA: Schiffer, 1994.

Page, C. *La Coutellerie depuis l'origine jusqu'à nos jours*. Chatellerault, France: H. Rivière, 1904.

Le Pain, le Fromage et le Couteau. Arnay-le-Duc, France: Maison Régionale des Arts de la Table, 1983.

Paston-Williams, Sara. *The Art of Dining: A History of Cooking & Eating*. London: The National Trust, 1993, reprinted 1999.

Peterson, Harold L. *American Knives: The First History and Collector's Guide*. New York: Charles Scribner's Sons, 1958.

Petroski, Henry. *The Evolution of Useful Things*. New York: Alfred A. Knopf, 1992.

Pickford, Ian. *Silver Flatware: English, Irish, and Scottish, 1660–1980*. Suffolk: Antique Collectors' Club, 1983.

Pierce, Charles. *The Household Manager: Being a Practical Treatise upon the Various Duties in Large or Small Establishments*. London, New York: G. Routledge & Co., 1857.

Ponti, Lisa Licitra. *Gio Ponti: The Complete Work*. Milan: Leonardo, 1990.

Puiforcat, Jean. *Jean Puiforcat: Orfèvre Sculpteur*. Paris: Flammarion, 1951.

Puiforcat, Louis-Victor. *L'Orfèvrerie Française et Etrangère*. Paris: Garnier Frères, 1981.

Raab, Roseanne. *Borne with a Silver Spoon: A Salute to the American Metalsmith*, vols. 1 and 2, New York: Roseanne Raab Associates, 1993, 1994.

Rabinovitch, Benton Seymour. *Antique Silver Servers for the Dining Table: Style, Function, Foods and Social History*. Concord, MA: Joslin Hall Publishing, 1991.

Rabinovitch, Benton Seymour, and Helen Clifford. *Contemporary Silver: Commissioning, Designing, Collecting*. London: Merrell Publishers, Ltd., 2000.

Rainwater, Dorothy T., and Donna H. Felger. *A Collector's Guide to Spoons around the World*. Hanover, PA: Everybodys Press and Thomas Nelson, Inc., 1976.

Rebora, Giovanni, Albert Sonnenfeld, trans. *Culture of the Fork: A Brief History of Food in Europe*. New York: Columbia University Press, 2001.

Replacements, Ltd. *Stainless Steel Flatware Guide*. Greensboro, NC: Page/Frederiksen Publications, 1998.

Romanelli, Marco. *Gio Ponti: A World*. London: Design Museum, 2002.

Rudowsky, Bernard. *Now I Lay Me Down to Eat: Notes and Footnotes on the Lost Art of Living*. Garden City, NY: Anchor Books, 1980.

Rupert, Charles Gideon. *Apostle Spoons: Their Evolution from Earlier Types, and the Emblems Used by the Silversmiths*. London: Oxford University Press, 1929.

Sänger, Reinhard W. *Das deutsche Silber-Besteck: Biedermeier-Historismus-Jugenstil (1805–1918)*. Stuttgart: Arnoldsche, 1991.

Saule, B. *Versailles et les tables royales en Europe*. Paris: Réunion des Musées Nationaux, 1993.

Scappi, Bartolomeo. *Opera de M. Bartolomeo Scappi, cuoco segret de Papa Pio Quinto, divisa in sei libri...* Venice: F.e M. Tramezino, 1570.

Scarzella, Patricia. *Steel and Style: The Story of Alessi Household Ware*. Princeton, NJ: Princeton Architectural Press, 1987.

Schuermann, Thomas. "Cutlery at the Fine Table: Innovations and Use in the Nineteenth Century." In *Food and Material Culture: Proceedings of the Fourth Symposium of the International Commission for Research into European Food History*. East Linton, Scotland: Tuckwell, 1998.

Sheffield City Museums. *Ibesta 64: An Exhibition of Antique and Modern Cutlery from the Bodo Glaub Collections, Cologne*, exhibition catalogue. Sheffield: Sheffield City Museums, 1964.

Singleton, H. Raymond. *A Chronology of Cutlery*. Sheffield: Sheffield City Museums, 1973.

Smith, Andrew. *The Oxford Companion to Food and Wine in America*. New York: The Oxford University Press, 2000.

Snell, Doris Jean. *Art Nouveau & Art Deco Silverplated Flatware*. Des Moines: Wallace-Homestead, 1976.

Snell, Doris Jean. *Silverplated Flatware*. Des Moines: Wallace-Homestead, 1971.

Snodin, Michael. *English Silver Spoons*. London: Charles Betts Books, 1982.

Snodin, Michael, and Gail Belden. *Spoons*. Radnor, PA: Chilton Book Company, 1976.

"Stainless Steel Flatware." In *Consumer Reports*, vol. 21, November 1956, pp. 529–33.

Sterling Flatware Pattern Index, 2nd edition. Radnor, PA: Jewelers' Circular-Keystone and Chilton Company, 1989.

Stevenson, A. "A Review of Bow & Worcester Knife and Fork Hafts." In *Transactions of the English Ceramic Circle* 13, part 3, 1989, pp. 194–99.

Stevenson, A. "A Review of Chelsea, Chelsea - Derby and Derby Knife Hafts." In *Transactions of the English Ceramic Circle* 14, part 1, 1990, pp. 50–58.

Stoever, Ulla. *Le Couvert: Der Geschichte um Tafel.* Munich: Karl Thiemig, 1975.

Strong, Roy. *Feast: A History of Grand Eating.* London: Jonathan Cape, 2002.

Stutzenberger, Albert. *American Historical Spoons: The American Story in Spoons.* Rutland, VT: Charles E. Tuttle Co., 1971.

Symonds, R. W. "Dining Parlours and Their Furnishing. Temp. 1660 to 1840." In *The Connoisseur*, vol. 113, no. 492, June 1944, pp. 92–98.

Tames, Richard. *Feeding London.* London: Historical Publications, 2003.

Thornton, Peter. *The Italian Renaissance Interior, 1400–1600.* New York: Harry N. Abrams, 1991.

Thornton, Peter. *Seventeenth-century Interior Decoration in England, France, and Holland.* New Haven: Yale University Press, 1978.

Toynbee, Paget. "Walpole's Journal of Visits to Country Seats." In *Walpole Society Yearbook*, vol. 16 (1927–28).

Turner, Noel D. *American Silver Flatware 1837–1910.* South Brunswick, NJ: A. S. Barnes and Co., 1972.

Van Trigt, Jan, and Dr. Alain Gruber, introduction. *Cutlery: From Gothic to Art Deco, The J. Hollander Collection*, exhibition catalogue. Antwerp: Pandora, 2003.

Vanderbilt, Amy. *Complete Book of Etiquette.* New York: Doubleday & Company, 1954.

Venable, Charles L. *Silver in America 1840–1940: A Century of Splendor.* New York: Harry N. Abrams, 1995.

Visser, Margaret. *The Rituals of Dinner: The Origins, Evolution, Eccentricities, and Meaning of Table Manners.* New York: Penguin, 1992.

Wallance, Don. *Shaping America's Products.* New York: Reinhold, 1956.

Ward, Barbara McLean, and Gerald W. R. Ward. *Silver in American Life: Silver from the Mabel Brady Garvan and Other Collections at Yale University*, exhibition catalogue. New York: The American Federation of the Arts, 1979.

Wells, E. Hargord. "The Battle of Stainless Steel." In *Art and Industry*, vol. 64, no. 389, November 1958.

Wheaton, Barbara Ketchum. *Savoring the Past: The French Kitchen and Table 1300–1789.* New York: Touchstone Books, 1996.

Williams, Susan. *Savory Suppers and Fashionable Feasts: Dining in Victorian America.* Knoxville, TN: The University of Tennessee Press, 1996.

Wills, G. "18th-century Knife Cases." In *Country Life* 116, no. 3004, August 12, 1954, pp. 489–90.

Wilson, C. Anne. *Banquetting Stuffe: The Fare and Social Background of the Tudor and Stuart Banquet.* Edinburgh: Edinburgh University Press, 1991.

Wilson, C. Anne. *Eating with the Victorians.* Gloucestershire: Sutton Publishing, 2004.

Wolk, Michael. *Designing for the Table: Decorative and Functional Products.* New York: Library of Applied Design, PBC International, 1992.

Wright, Mary, and Russel Wright. *Guide to Easier Living.* New York: Simon and Schuster, 1951.

Wyler, Seymour B. *The Book of Old Silver.* New York: Crown, 1963.

Young, Carolin C. *Apples of Gold in Settings of Silver: Stories of Dinner as a Work of Art.* New York: Simon and Schuster, 2002.

Index

Acknowledgments

Sarah Coffin, Ellen Lupton, Darra Goldstein, and Cooper-Hewitt would like to thank the following organizations and individuals, listed in no particular order, for their invaluable help and cooperation during the preparation of this exhibition and book:

At Cooper-Hewitt: Debbie Ahn, Tom Andersen, Bill Berry, Elizabeth Broman, Susan Brown, Jennifer Brundage, Perry C. Choe, Jennifer Cohlman, Lucy Commoner, Jocelyn Crapo, Gail S. Davidson, Barbara Duggan, Ellen Ehrenkranz, Melanie Fox, Eliza Gilligan, Lauren Gray, Monica Hampton, Bonnie Harris, Gregory Krum and The Shop staff, Bruce Lineker, Karl Ljungquist, Mei Mah, Audrey Malachowsky, Floramae McCarron-Cates, Matilda McQuaid, Laurie Olivieri, Robert Paasch, Andrea Quintero, Wendy Rogers, Sandra Sardjono, Larry Silver, Katie Vagnino, Stephen Van Dyk. Interns: Priscilla Beal, Paul Bodnar, Chloe Chelz, Ellen Dodington, Katherine Hall, Joanna Leathers, Earl Martin, Shax Riegler, Christine Ritok, Shabana Shahabuddin, Jessica Thomas, Megan Thompson, Barbara Veith, Elizabeth Welden.

Formerly of Cooper-Hewitt:
Todd Olson

Donors to the exhibition: Alessi spa, Boris Bally, Maarten Baptist, Scandinavian Airlines System (SAS), Sam Baron, Sandra Bautista, Inoue Ribbon Industry Co, Ltd., James Robinson, Inc., Helena Kåberg, Janet Torelli, Hog Wild Toys, Cordelia Rose.

At The Tiffany & Co. Foundation:
Maggie Wei.

Lenders to the exhibition: Andrea Albert, Boris Bally, Karin Berntsen, Homaro Cantu, Maureen Connor, David Diamond and Karen Zukowski, Vanessa Dressen, Joost During, Kathleen Fink, Tanja Friedrichs, Gio Ponti Archives, Susanne Klemm, Sabine Lang, Robert Lerch, MD, Man Ray Trust, Kristen Alexandra Milano, Kajsa Öberg, John R. Olson, MD, Sarah Jane Ross, Jean S. and Frederic A. Sharf, Jiří Šibor, Harley Spiller, a.k.a. Inspector Collector, Eric Streiner, Richard Walraven, Christian Witt-Dörring, Lori Zabar, André Zweiacker.

At the Man Ray Trust: Eric Browner, Roger Browner, Stephanie Browner.

At The Metropolitan Museum of Art: Christine Brennan, Roger Haapala, Jessie McNab, Jeffrey Munger, Clare Vincent, Beth Carver Wees, Deanna Cross and the Image Library staff.

At The Minneapolis Institute of Art: Jennifer Carlquist, Christopher Monkhouse.

At The Museum of Fine Arts, Boston: Malcolm Rogers, Kim Pashko, Erin M. A. Schleigh, Gerald Ward.

At the Smithsonian's National Museum of American History: Katie Ahrens, Dave Burgevin, Lisa Kathleen Graddy, Michael Harrison, Debra Anne Hashim, Paul F. Johnston, Jennifer Strobel, William Yeingst.

At The Tiffany & Co. Archives: Louisa Bann, Meghan Magee, Annamarie V. Sandecki.

At the Yale Center for British Art: Constance Clement, Karen Denavit, Elisabeth Fairman, Maria Rossi, Melissa Gold Fournier.

At the Yale University Art Gallery: Patricia E. Kane, Erin Eisenbarth, Suzanne Warner.

In addition:
William Allman, Hannah Armstrong, Don Faustino Avagliano, Rainer Baum, Gerald Beasley, Barbara Bair, David Bishop, Peter B. Brown, Patrizio Chiarparini, Dorian Church, Erin Clements, Samantha Collenette, Carol Conover, Rachel Conroy, Isabella Croy, Daniela Danzi, Jeannine Falino, Marina Fröhling, Cynthia Funke, Michael Gunn, Tambra Johnson, Mike Kelly, Emy Kim, Kathleen Kornell, Karen Lawson, Salvatore Licitra, Salomon Lilian, Tom Lisanti, Alison Marsh, Michael Melia, Michael Mitchell, Kenneth Miller, Lucy Morton, Simon Quinn, Eizo Okada, Stephen Parks, Roxanne Peters, Becky Preiss, Rosanne Raab, Letitia Roberts, Burkard von Roda, Marco Romanelli, Kendra Roth, David Savage, Charles Schiller Photography, Pamela Duncan Silver, Michael Slade, Jeremy Smith, Kevin Tierney, Julie Tozer, John Ward, Philip Wilson, Ann Wright, Suzanne Vierthaler, At Alessi: Gloria Barcellini, Jan Vingerhoets, Francesa Appiani, Antonella DeMartino, Hiroko Usui, Newport Symposium staff, At Galerie Ra: Paul Derrez, At Michele Oka Doner studio: Aaron Yassin, At Ted Muehling Studio: Amy Kreiling, Loring McAlpin

Photographic Credits

We are grateful to the organizations and individuals listed below for their permission to reproduce images in this book. Every effort has been made to trace and contact the copyright holders of the images reproduced; any errors or omissions shall be corrected in subsequent editions. All images refer to figure numbers unless otherwise stated.

COVER: © Smithsonian Institution, photo by Charles Schiller Photography.

BACK COVER (HARDCOVER): © Smithsonian Institution, photo by Matt Flynn.

TITLE PAGE SPREAD: © Smithsonian Institution, photo by Charles Schiller Photography.

INTRODUCTION: All photos © Smithsonian Institution, photo by Matt Flynn.

CHAPTER 1: All photos © Smithsonian Institution, photo by Matt Flynn; except: opening spread: © Smithsonian Institution, photo by Charles Schiller Photography; 2: © Salomon Lilian; 3: © Bibliothèque Nationale de France; 6: © The Walters Art Museum, Baltimore; p. 30–31: © Smithsonian Institution, photo by Charles Schiller Photography; 17: Albert Collection, photo by Clarissa Bruce; 19: HMB P. Portner; 20: © Réunion des Musées Nationaux/Art Resource, NY; 21: © Erich Lessing/Art Resource, NY; 22: © Rheinisches Bildarchiv Cologne; 23: © Scala/Art Resource, NY; 31, 72: © 2006 Museum of Fine Arts, Boston; 32, 40: Mabel Brady Garvan Collection, Yale University Art Gallery; 33: National Museum of American History, Smithsonian Institution; 36: Private Collection, photo by Matt Flynn; 41, 77, 81: © Tiffany & Co. Archives 2006; 44: Image: © 2005 The Metropolitan Museum of Art;

56: Yale Center for British Art, Paul Mellon Collection; 58: © V&A Images/Victoria and Albert Museum; 59–62: Smithsonian Institution Libraries, Washington, DC, photo by Matt Flynn; 79: Sotheby's and Eric Streiner; 82: © Tiffany & Co., photo by Josh Haskin.; 83: Michele Oka Doner, photo by Matt Flynn.

CHAPTER 2: All photos © Smithsonian Institution, photo by Matt Flynn; except: opening spread: © Smithsonian Institution, photo by Charles Schiller Photography; 4, 19: Smithsonian Institution Libraries, Washington, DC, photo by Matt Flynn; 7: © The Historic Dockyard, Chatham, The Invincible Collection; 10, 26, 27: © V&A Images/Victoria and Albert Museum; 12: Image: © 2005 The Metropolitan Museum of Art; 13: Cliché Bibliothèque Municipale de Caen; 16: Partridge Fine Arts PLC; 20: Birmingham City Archives, Birmingham Central Library, UK; 21: Guildhall Library, Corporation of London, UK/Bridgeman Art Library; 22: General Research Division, The New York Public Library, Astor, Lenox and Tilden Foundations; 25: © Musée et archives Christofle; 28: © Smithsonian Institution, photo by Andrew Garn; 29, 30: Sheffield Hallam University and Sheffield Galleries & Museums Trust.

CHAPTER 3: All photos © Smithsonian Institution, photo by Matt Flynn; except: opening spread: © Smithsonian Institution, photo by Charles Schiller Photography; 4: Image: © 2005 The Metropolitan Museum of Art; 5, 6: Tiffany & Co. Archives 2006; 7: Crown © / The Royal Collection © 2005, Her Majesty Queen Elizabeth II; 11: Montecassino, Archivio dell' Abbazia.

CHAPTER 4: All photos © Smithsonian Institution, photo by Matt Flynn; except:

opening spread, 14, 15, 16, 17, 18, p. 129, 131–35: © Smithsonian Institution, photo by Charles Schiller Photography; 2, 36, 42, 49: Smithsonian Institution Libraries, Washington, DC, photo by Matt Flynn; 4: © Private Collection/ Bridgeman Art Library; 5: © 2006 Museum of Fine Arts, Boston; 7: Avery Architectural and Fine Arts Library, Columbia University; 12: © Blauel / Gnamm – Artothek; 13: York County Heritage Trust, York, PA; 21: © Asenbaum Photo Archive; 24, 25, 31, 33, 34, 38, 40, 43: © Tiffany & Co. Archives 2006; 26: © The Cleveland Museum of Art; 27: The Fales Library & Special Collections, New York University Libraries; 29: Ms. Andrea J. Albert, photo by Larry Stanley; 30: © William Hood, photo by Larry Stanley; 35, 39: Karen Zukowski and David Diamond, photo by Matt Flynn; 41: Image © Board of Trustees, National Gallery of Art, Washington, photo by Robert Grove; 48: Science, Industry & Business Library, The New York Public Library, Astor, Lenox and Tilden Foundations; 50: Alessi Spa, photo by Matt Flynn; 51: Kristen Alexandra Milano, photo by Robert Diamante; 52: Pandora Design, photo by Matt Flynn; 54: Giorgetti, Italy.

CHAPTER 5: All photos © Smithsonian Institution, photo by Matt Flynn; except: opening spread: © Smithsonian Institution, photo by Charles Schiller Photography

CHAPTER 6: All photos © Smithsonian Institution, photo by Matt Flynn; except: opening spread: © Smithsonian Institution, photo by Charles Schiller Photography; 1, 2, 6, 7, 8, 9, 10, 12, 14, 15, 16, 17: © Tiffany & Co. Archives 2006; 11: © William Hood, photo by Thomas R. Dubrock; 19: Smithsonian Institution Libraries, Washington, DC, photo by Matt Flynn.

CHAPTER 7: All photos © Smithsonian Institution, photo by Matt Flynn; except: opening spread: Ted Muehling, photo by Charles Schiller Photography; 1: Sandra Bautista; 4: © Smithsonian Institution, photo by Dave King; 9, 25, 36, 39, 40: Smithsonian Institution Libraries, Washington, DC, photo by Matt Flynn; 19, 20: Dr. Robert Lerch, photo by Matt Flynn; 21: General Mills, Inc., photo by Matt Flynn; 23: Smithsonian Institution Libraries, Washington, DC, and Russel and Mary Wright, photo by Matt Flynn; 27–32: Gio Ponti Archives/S. Licitra-Milano; 35: Alessi Spa, photo by Matt Flynn; 41: Smithsonian Institution, NMAH/ Transportation; 42: Jean S. and Frederic A. Sharf; 46: Helena Kåberg and Scandinavian Airlines System, photo by Matt Flynn; 58: © Smithsonian Institution, photo by Dennis Cowley; 61, 62: Crate and Barrel; 67: © Smithsonian Institution, photo by Victor Schrager; 72: Joost During; 76, 84: Michele Oka Doner, photo by Matt Flynn; 79: Boris Bally, photo by Dean Powell; 80–83: Galerie Ra Amsterdam, photo by Tom Haartsen.

PICTORIAL OVERVIEW: All photos © Smithsonian Institution, photo by Matt Flynn.

ENDNOTES: © Smithsonian Institution, photo by Charles Schiller Photography.

All Tiffany & Co. Archives images are not to be published or reproduced without prior permission. No permission for commercial use will be granted except by written license agreement.